LIVING IN THE 20th CENTURY

TEXT AND PHOTOGRAPHIC RESEARCH BY Bronwyn Dalley

PHOTOGRAPHS FROM Archives New Zealand

LIVING IN THE 20th CENTURY
NEW ZEALAND HISTORY IN PHOTOGRAPHS, 1900–1980

BRIDGET WILLIAMS BOOKS
CRAIG POTTON PUBLISHING

In association with the Ministry for Culture and Heritage

First published in 2000 by
Bridget Williams Books Limited (P O Box 5428, Wellington, New Zealand) and
Craig Potton Publishing Limited (P O Box 555, Nelson, New Zealand).

ISBN 1877242 128

Front cover photographs
UPPER PANEL: Greco family, Island Bay, Wellington, 1962, photograph by D. Nicholson, p.184
LOWER PANEL: picking hops, Motueka, 1940s, p.207; women cooking over steam, 1900s-10s, p.193;
Hi Fives, 1950s, photograph by Ans Westra, p.82; school picnic, Hawke's Bay, 1937, p.21
Back cover photographs
UPPER PANEL: weighing baby, Waterloo Plunket Rooms, 1950s, p.244
LOWER PANEL: Bastion Point, May 1978; fishing, 1940s, p.242; Hauhungaroa Workingmen's Club, 1950s-60s,
photograph by J. Fijn, p.10; WAAC quarters, New Caledonia, 1944, p.169

Cover design: Mission Hall Design Group, Wellington
Internal design: Afineline, Wellington
Typesetting: Archetype, Wellington
Printing: Astra Print, Wellington

CONTENTS

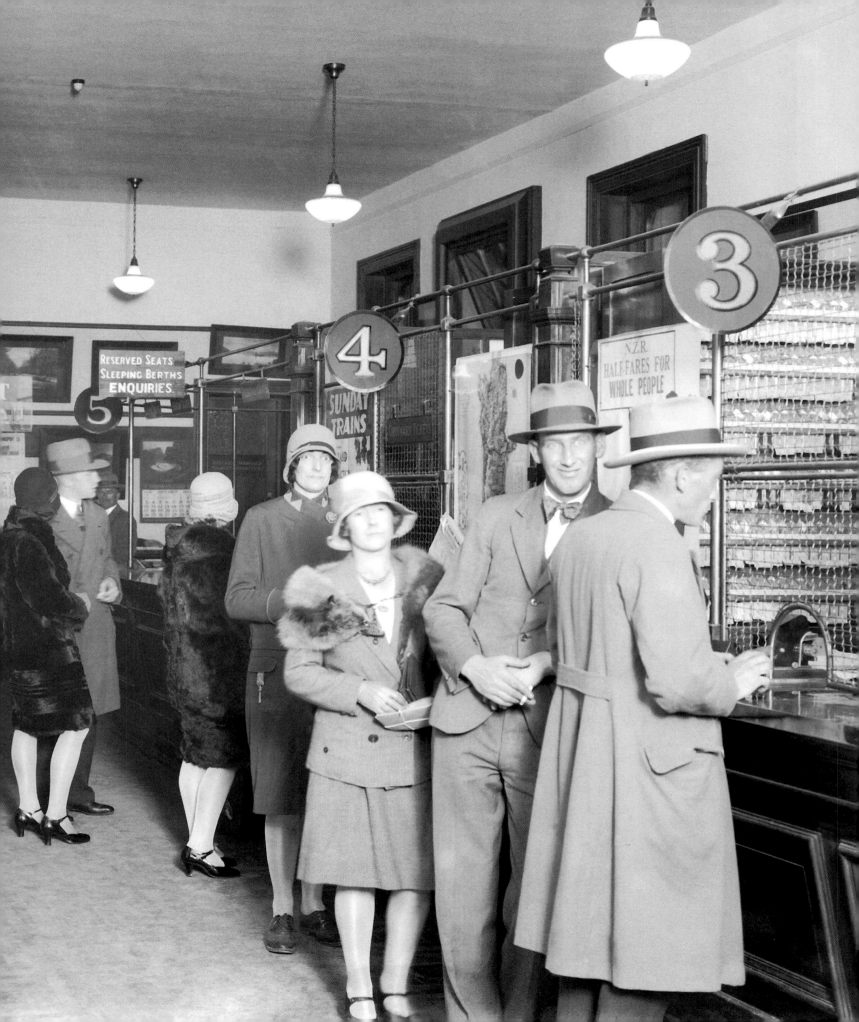

PREFACE

Living in the Twentieth Century draws exclusively on the photographic collection at Archives New Zealand. This rich store contains about a million images from the late 1860s to the mid-1990s, focusing on the middle years of the twentieth century. Few of the photographs have been published before, so this book offers 'fresh' views of our past. It is my hope that the publication of *Living in the Twentieth Century* will encourage greater use of the Archives New Zealand photographic collection.

The co-operation of Archives New Zealand has been crucial to this project. Acting Chief Archivist Chris Hurley supported the project, as did Christel McClare and Tony Connell. Reference, retrieval and reprographic staff processed my file requests with speed and good humour. Special thanks to Archives staff most familiar with the collection: Alan Bekhuis, Kim Lasenby, Geoff Shepherd, Alison Whyte and Jonathan London. I am grateful to Howard Biggs, whose organisation and expertise made all the difference at the end, and to Shane Jackson, who processed a never-ending and ever-changing order for photographs. Ralph Anderson provided the prints for this book – which included some photographs he took while working for the National Publicity Studio. Permission to use their photographs was granted by John Ashton and Ans Westra, who also provided prints of her work.

Paul Thompson, Mike Thomason, Max Quanchi and Charlotte Macdonald offered guidance on using photographs as historic sources. A paucity of published material on aspects of daily life in the last hundred years meant that I sought advice on diverse subjects: men's razors, the construction of hay stacks, the 'rules' of 4 Square, or the art of catching eels. The replies came from too many people to thank individually. I appreciated the input of Bill Oliver and a team of readers who offered suggestions on the text and photographs. Some speculative comments remain, and I would be glad to hear from readers who can shed more light on topics discussed, or the photographs included.

The project was begun at the Historical Branch, Department of Internal Affairs, and completed when the History Group (formerly the Historical Branch) joined the Ministry for Culture and Heritage. For their encouragement and advice, I thank my colleagues, especially Kathryn Hastings, Megan Hutching, Ian McGibbon, Gavin McLean, and Ross Somerville; David Green's careful attention to detail improved the text. Claudia Orange warmly supported the project, and Jock Phillips' appreciation of photographs and his knowledge of this country's cultural history were crucial.

Many hands turned the text and photographs into a book. Robyn Sivewright worked with flair and tireless attention to detail on the internal design. Hilary Stace compiled the index and Rachel Scott proof-read the text. Co-publishers Craig Potton Publishing and Bridget Williams Books brought together the skills of photographic editor Robbie Burton and publisher Bridget Williams.

Special thanks to Lynette Dalley, Chris Hilliard, Conal McCarthy, Margaret McClure, and Grant Phillipson; Bronwyn Labrum's friendship and support were invaluable. Greatest thanks to Rob Forlong.

Bronwyn Dalley
WELLINGTON, 2000

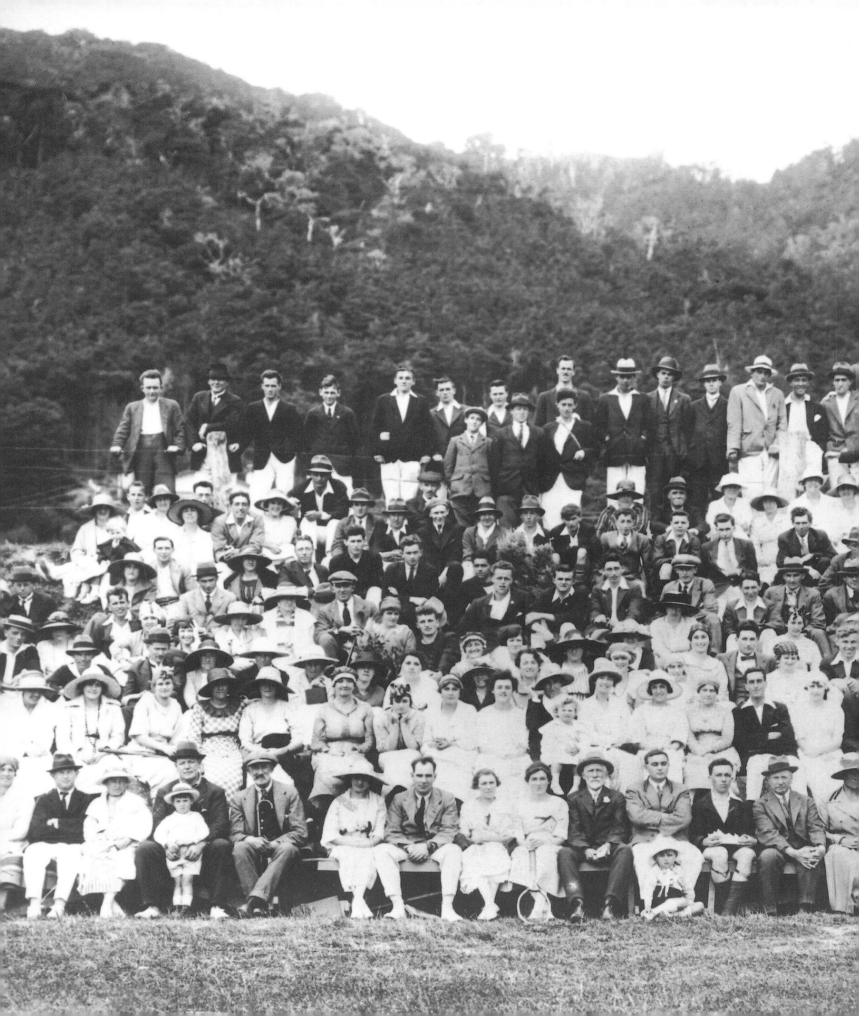

Introduction

Photography is as old as the European settlement of Aotearoa.[1] A month after the invention of photography was announced in Paris, three New Zealand Company emigrant ships left England for Wellington's Port Nicholson. New Zealand's first known attempt at photography occurred less than a decade later, in 1847. It was a portrait of Eliza Grey, whose husband George was governor.[2] Although this early attempt was unsuccessful, it marked the beginning of a rich photographic record of New Zealand.

Living in the Twentieth Century explores everyday life in New Zealand from 1900 to the mid-1980s. Captioned photographs and short essays show where people lived, how they communicated with each other, what they ate and wore, how they worked and played, and shared some of the significant public events of the century. The changing rhythms of daily life for Maori and Pakeha, town and country, men and women, young and old are the subject of this book. The photographs are drawn exclusively from the collection at Archives New Zealand, and many are published here for the first time. *Living in the Twentieth Century* is a history of things 'as they were' and as they were becoming, in the decades leading to the present.

LIVING IN THE CENTURY The twentieth century was a time of massive change in New Zealand. Periods of national and global crisis loomed large – the First World War and the 1918 influenza epidemic, the depression of the 1920s and 1930s, the Second World War, the Cold War, and the recent economic recession. The century opened with the Liberals in power, enacting the social policies for which New Zealand became world famous, such as old-age pensions (introduced in 1898). As in other nations, socialism was a significant political force in the first half of the century, and in 1935 the first Labour government was elected with a landslide victory. More conservative political voices generally dominated national politics from the 1950s. In the last two decades of the century, a 'revolution of the Right' saw some of the things New Zealanders had taken for granted swept away or altered as many apparently stable systems and principles were rejected.[4]

Picnics were popular in the first half of the century. Here the staff of the Public Trust Office pose for the camera during their annual picnic in the 1920s.

Office picnic, Days Bay, Wellington, 1920s

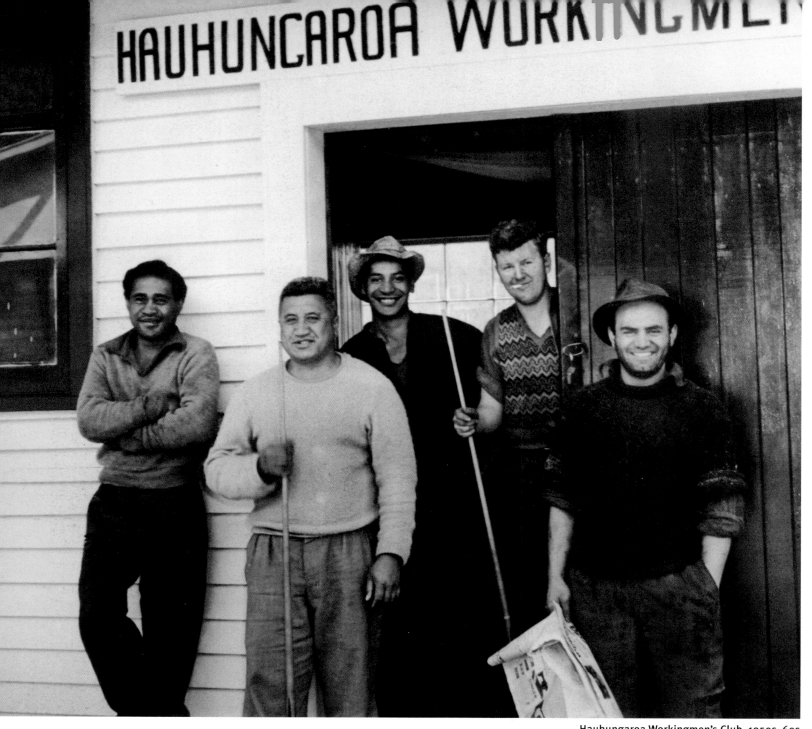

HAUHUNGAROA WORKINGMEN'S

Hauhungaroa Workingmen's Club, 1950s–60s

For much of the century, working-men's clubs provided a social centre for members — a place where they could meet friends, and perhaps share a drink. Many clubs also had sports teams (darts, billiards or bowls). These men stand in the doorway of the Hauhungaroa Workingmen's Club in the central North Island in the 1950s or 1960s.

Over the course of the century, the country's population more than quadrupled, from 830,000 in 1901 to almost 3.8 million in 1997; the Maori population particularly climbed, from 45,000 at the beginning of the century to more than half a million at the end. In 1901, New Zealand was an agricultural, rural nation, with more than half the population living in country areas; but from 1911 more people lived in towns and cities. The shift for Maori came later, with large numbers moving to the cities from the 1950s. From the 1980s, 85 per cent of the population lived in urban centres, with the majority clustered in Auckland, Hamilton, Wellington, Christchurch and Dunedin.[5]

New Zealanders in the late twentieth century were better educated, more mobile, healthier, and had a greater range of employment and leisure opportunities than their counterparts in 1900. The technological changes over the century were huge. Cars and planes replaced horses and ships; radio

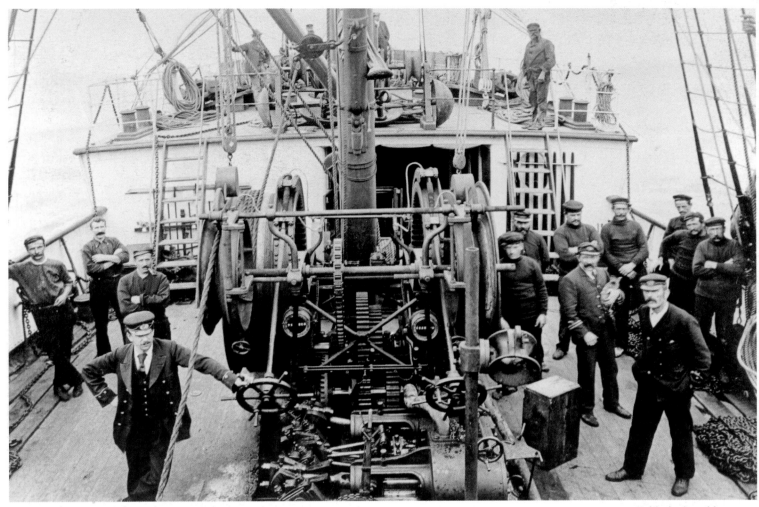

Cable-laying ship, 1900s

and television beamed information and entertainment into homes, while e-mail and computers challenged the way people communicated with each other. In the home, ovens, microwaves, fridges, automatic washing machines and dryers were designed to make life more convenient and free up time for other activities. New fabrics that needed no ironing, meals made in an instant by adding water, and immediate access to information through the Internet affected the material conditions of people's lives. Domestic work was no longer the drudgery it had been when everything was done by hand; time saved on domestic work (this was normally women's time) could be used in leisure pursuits, paid work, or making the home more comfortable.

Change came at a different pace for different New Zealanders. Auckland grew faster than other areas: by the 1990s it was three times the size of any other urban centre, and contained 30 per cent of the population. Throughout the century, provincial and rural fortunes waxed and waned with booms and slumps in the international and local economy; the last decades, however, brought long-term challenges to the farming sector, and many regions experienced severe economic downturn. Maori and Pakeha marched to different beats for much of the century, not only because of different cultures, but also because of unequal access to social, economic and political resources. Life expectancy for Maori remained lower than that for Pakeha, reflecting a lower standard of living that was evident throughout the century. The experiences of women have seldom matched those of men, while people of ethnic backgrounds other than Pakeha or Maori have known another 'New Zealand'. Although I often speak of 'New Zealand society' in this book, I also try to highlight the great differences that term can mask.

Clothing has long been an indicator of status in the workplace. On the ship that laid communication cables in Cook Strait in the first decade of the century, the crew wear a casual uniform of caps, jerseys or jackets, and heavy trousers. Officers are distinguished by jackets and caps that mark their seniority in pips and stripes, as well as by more formal collars and ties.

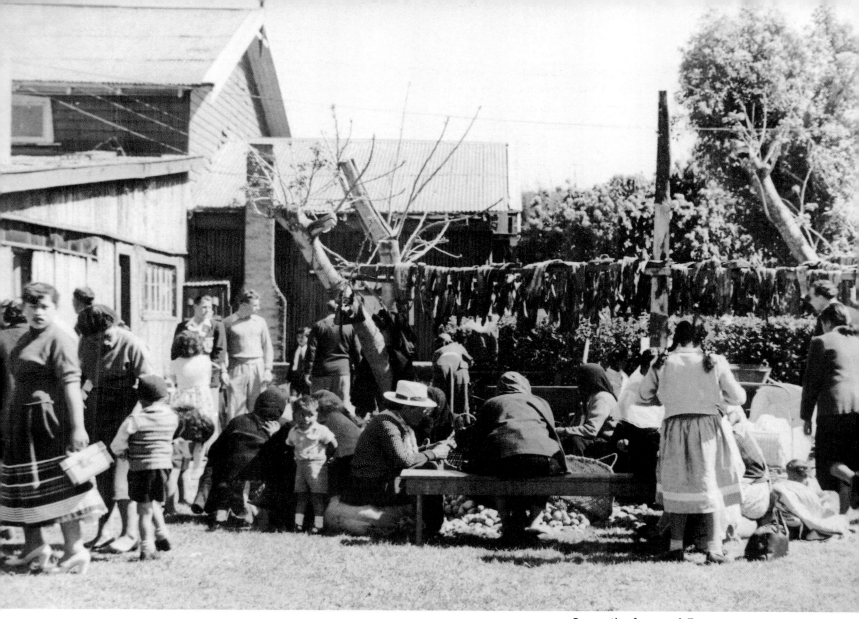

Many Maori moved into towns and cities during the 1950s in search of employment, but rural communities remained strong and active. In this photograph of women preparing food for a hui at Turangawaewae, Ngaruawahia, perhaps in the 1950s, rows of dried eels hang in the breeze. Eels were collected commercially in small quantities, mainly for export, but for Maori they were a favourite food. Eels were relatively easy to harvest from rivers or muddy creeks, using either hand lines baited with pieces of meat or worms, or eel traps. Traditionally, travelling Maori gave dried eel as koha (gifts) to their hosts.

Living in the Twentieth Century takes as its subject matter not political events or national structures but ordinary activities — things done on a daily basis, such as eating, drinking, dressing, or working, activities of the home, the workplace, the street or the sports field.[6] As wars are fought, elections contested, the demographic profile changes, cities grow, and the economy contracts or expands, the daily lives of people go on, and remain both unexamined and sometimes inaccessible historically.[7] We may be aware of the changes in clothing — the disappearance of corsets, for example, or the arrival of bikinis — but we may be less familiar with reasons for these changes. If we turn our gaze from labour relations to the grimy table in the smoko room or the clothing worn by working men, we may gain other insights into work and its place in people's lives — the need for time off, the camaraderie, the subtle changes occurring in masculine behaviour. In its attention to the everyday life of New Zealanders, *Living in the Twentieth Century* draws out the many layers of the past.

Specific dates in New Zealand history — 1914 (and the First World War), 1935 (and the first Labour government), 1945 (and the Second World War), 1984 (and the fourth Labour government) — conventionally separate one period from another. Adjectives such as colonial, Victorian, modern, interwar, postwar, New Right also evoke changes over time. Some of these turning points or descriptions take on different meanings when everyday life is considered. *Living*

in the Twentieth Century takes two periods as markers of change: the First World War and the 1920s, and the Second World War and postwar years of the 1950s and 1960s.

The First World War has been seen as the catalyst for a sense of nationhood and (for Pakeha) a sense of 'belonging' in New Zealand; this was a 'coming of age' that encompassed the 'Anzac spirit'.[8] The massive loss of life, the increased organisation of society, and the 1918 influenza epidemic all had a profound effect on New Zealand life, but *Living in the Twentieth Century* examines some other ways that the First World War separated the world of the nineteenth century from that of the twentieth.

In most Western societies, for example, people's appearance altered dramatically. For women, the confinement of Victorian dress ended. Greater opportunities for paid work or leisure, and the organising work generated by patriotic fervour, demanded a freer style of dress. Skirts that swept the ground, complicated hairstyles and rigid corsets all restricted the movement required by the war effort. Change was already on the way — fashionable hemlines were creeping up the ankles by 1910 — but the war completed the transformation. Women's dress in the 1920s was worlds away from that of a decade earlier. For men, too, the war simplified dress, and some of the Victorian accoutrements disappeared — the cane, the gloves, the fob watch.

The international conflict of 1914–18 exposed some of the deficiencies in the country's health system, and during the 1920s a new emphasis was placed on personal fitness and well-being as the basis for a healthy nation. Sport and physical exercise were promoted for both men and women — although for women fitness and health were all too often seen only in terms of child-bearing and mothering. Many sports became popular during the 1920s: among them, swimming, tramping, body-building, women's cricket and lifesaving.

Society and landscape were both altered after the Great War by an explosion in new ways of communicating. Private car ownership saw roads spread out across the country, and many people travelled more and further (particularly in rural districts). Telecommunications systems grew rapidly as businesses as well as private homes installed telephones — 33,000 in 1910, more than 160,000 by 1930.[9] Quick and effective communication over greater distances allowed business and government to operate more efficiently.

The next great shift in the everyday lives of New Zealanders occurred during and after the Second World War. During the 1950s, the migration of rural Maori to towns and cities in search of employment accelerated. Larger numbers of Maori and Pakeha now interacted on a daily basis, and major questions of adjustment and challenge emerged. A range of Maori groups and associations sprang up in response to urban migration: cultural groups, welfare organisations such as the Maori Women's Welfare League (1951), and community centres such as the Maori Community Centre in Auckland (1948). Life in rural Maori communities remained vigorous, however, and a number of the photographs in *Living in the Twentieth Century* represent Maori life away from the cities: political meetings and other hui on rural marae, the preparation of hangi and other food for hui, rural housing and health care.

The Second World War has been viewed as a time of austerity, as it undoubtedly was, and the 1950s have also been seen as years of order and regulation. The emphasis on all the children born after the war (the 'postwar baby boom') and a political focus on family and domestic life have helped to create the illusion of a society that was settled and safe: these were the years of full employment, when Mum cooked the Sunday roast, Dad dug the vegetable garden, and children played in suburban backyards. But they are seen also as dull years, when people were intolerant of difference, and resistant to challenge. *Living in the Twentieth Century* departs from these conventions to present the postwar years as a time of change, even of adventure and experimentation.[10]

Patterns of eating and drinking, for example, began to change from the 1950s. In the first half of the century, the British culinary heritage dominated Pakeha cooking, although this was adapted

Early in the century, teaching was one of the few occupations open to women with university degrees. Miss North of Wellington Girls' College was photographed at her desk in the middle of the century; she wears the academic gown common to graduate teachers of the period.

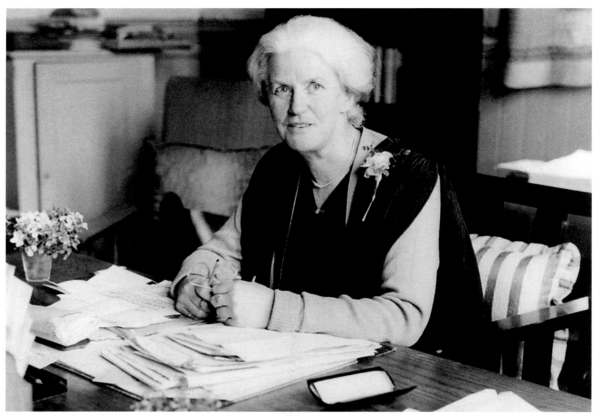

Miss North, Wellington, 1950s

to the plentiful supply of meat, milk and cheese. American influences came first via the media, aided perhaps by the soldiers stationed in the country during the 1940s; increasing numbers of New Zealanders returning from overseas also helped to widen New Zealanders' experience of food and drink. The war refugees and other migrants arriving in New Zealand from the late 1930s made the largest impact, however, bringing with them a rich and diverse culture that included food and drink along with music, theatre, and other aspects of European life. German Jews, Dutch and central Europeans introduced salamis, yoghurts, new styles of bread and cheeses, and a taste for coffee rather than tea. Greeks and Italians brought a range of Mediterranean foods: garlic, pasta, olives, and new ways of using vegetables such as tomatoes, peppers and zucchini. Most of the immigrants also brought a preference for drinking wine (with meals) rather than beer or spirits (in public bars). Cookery books published in the 1950s and 1960s featured the new ingredients alongside the more traditional foods of New Zealand kitchens. Changes in food alone suggest that the 1950s contained the roots of subsequent innovation and of New Zealand's opening to the wider world.

Amongst the significant markers of change in postwar New Zealand is the paid employment of women, and especially of married women. For much of the century, women made up around 20 per cent of the paid workforce. Most of these women were single, earning money in the brief period between leaving school and getting married. The proportion of women in the workforce increased steadily from the late 1950s and by the end of the century, women made up almost 45 per cent of the paid labour force.[11] *Living in the Twentieth Century* explores the impact of these changes in the chapters on clothing, food, recreation and work. Women's role in paid employment has also influenced that most recognisable feature of twentieth-century New Zealand life: the suburban sprawl. The new suburbs built between the late 1930s and the late 1950s rested on the assumption that married women were full-time homemakers and mothers; sections contained space for children to play and for large vegetable or fruit gardens. New suburbs that sprang up in the 1970s

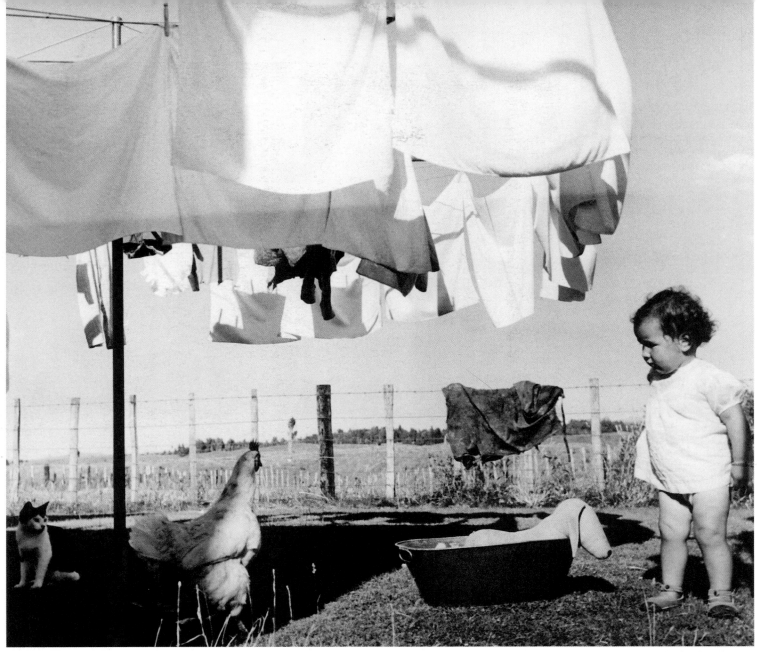

The backyard, 1957

The emphasis on children and families during the 1950s is captured in this photograph of nappies on the washing line and a healthy toddler with toys and pets.

and 1980s had much smaller sections, and the garden was more of a hobby. Houses in these later suburbs often had two garages for the cars required by the double-income home.

Living in the Twentieth Century looks most closely at the second and third quarters of the century. The collection at Archives New Zealand (from which these photographs are drawn) focuses particularly on these middle decades, which were also formative years in our history. Economic depression, war, the flowering of the welfare state, rapid population growth and the expansion of cities, Maori urbanisation, postwar security and protest, as well as considerable social change mark these decades. The impact of these middle years continued to be felt through to the end of the century and beyond: the groundswell of change from the 1980s onwards has carried New Zealand into a different era.

THE PHOTOGRAPHIC COLLECTION Archives New Zealand holds the records of most government agencies, and its photographic collection of approximately a million items charts the activity of the state from the 1860s to the early 1990s. It is, however, much more than simply an official government

15

Government photographers recorded many aspects of life in New Zealand. These cubs and scouts were photographed at a jamboree in 1967.

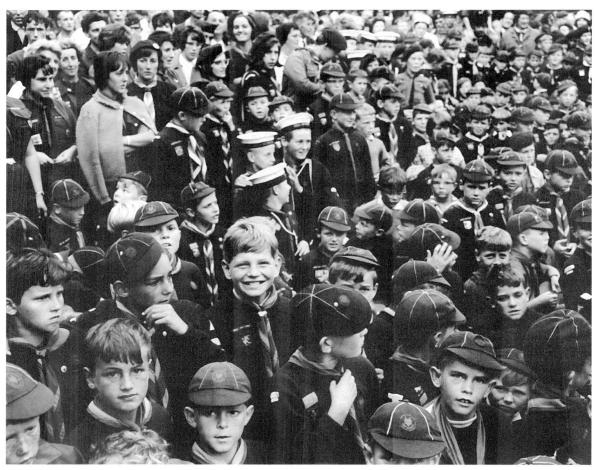

Cubs and scouts, 1967

record of New Zealand. From 1901 the government had its own photographic branch which took photographs of New Zealand life and scenery for publicity purposes. The work of this branch expanded from the late 1940s as the Labour government emphasised the promotional function of government agencies. In its 40 years of operation, professional photographers employed in the National Publicity Studio (as this branch became known in 1945) took thousands of images of life in New Zealand.[12] They toured the country photographing events large and small, famous people and ordinary New Zealanders. These 'official' photographers visited netball matches and beaches, ventured into shopping centres and onto building sites, took photographs inside welfare homes and hospitals for the mentally ill.

National Publicity Studio photographers (and their predecessors) also took photographs for other government departments. They recorded in detail aspects of farming, horticulture and primary production for the Department of Agriculture. The state housing programmes from the late 1930s were captured, in photographs of interiors and exteriors of different state houses, and the building of state housing suburbs in the Hutt Valley and Auckland. The National Publicity Studio also photographed national events: royal tours, the 1974 Commonwealth Games held in Christchurch, visits by overseas dignitaries, and international events such as expositions.

Some government agencies, notably the Railways Department and the Forest Service, employed their own full-time photographers, who photographed the landscape, houses and the ordinary people employed in those departments. The Forestry collection also includes a comprehensive study of New Zealand's flora and fauna, both introduced and indigenous. The departments of Maori Affairs, Health and Labour contracted photographers to work on special projects, as did

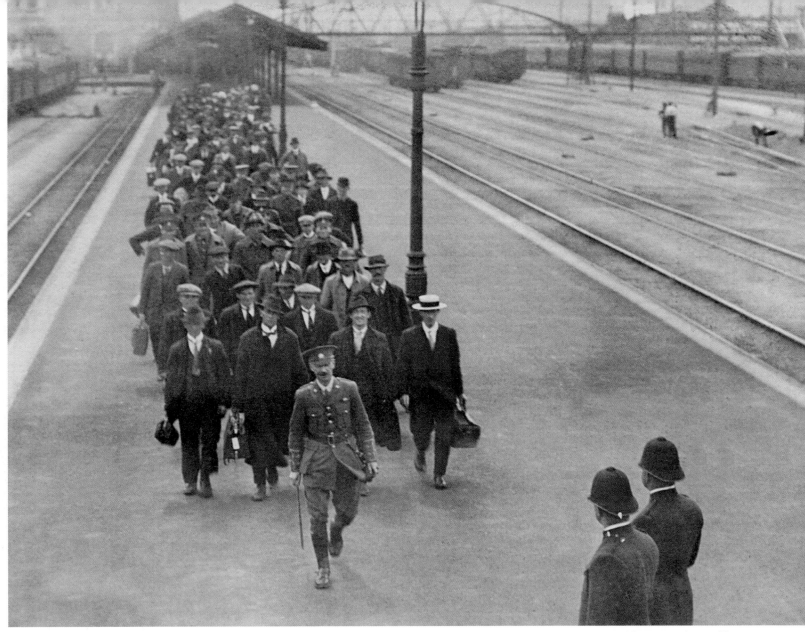

First World War recruits, Wellington

This photograph of First World War recruits comes from the Railways collection of Archives New Zealand. Up and down the country young men signed up for the armed forces, and columns of recruits like these on the platform of Wellington Railway Station marched off to training camp. Within a few days, suits, hats and caps would be cast aside in favour of uniforms, and the straggling column would be turned into a neat marching unit.

School Publications in the Department of Education. Maori Affairs, for example, periodically engaged photographers Ans Westra and John Ashton to produce images for articles in *Te Ao Hou*, the department's record of Maori life first published in the 1950s.

The Archives New Zealand collection also holds a more informal record of New Zealand life. Sometimes these are snapshots taken by staff members, or by people unconnected with the work of government — those attending school jubilees, for example, who gave old photographs of school activities to be used in anniversary publications or events. The Railways collection includes many photographs of tracks, tunnels and roads under construction before the 1940s, and many are taken by staff members. Photographs of picnics and social occasions feature in a number of government collections, such as the records of various schools and of departments such as the Government Printing Office and the Post and Telegraph Department. The Dental School collection contains albums of photographs taken by students of their work and time off, as well as official graduation and school photos. The Patents Office acquired images when photographers placed a copyright on their photographs, as many did before the 1920s. 'Unofficial' records are also found in the papers of individuals that have been deposited in Archives New Zealand. The papers of politicians, for

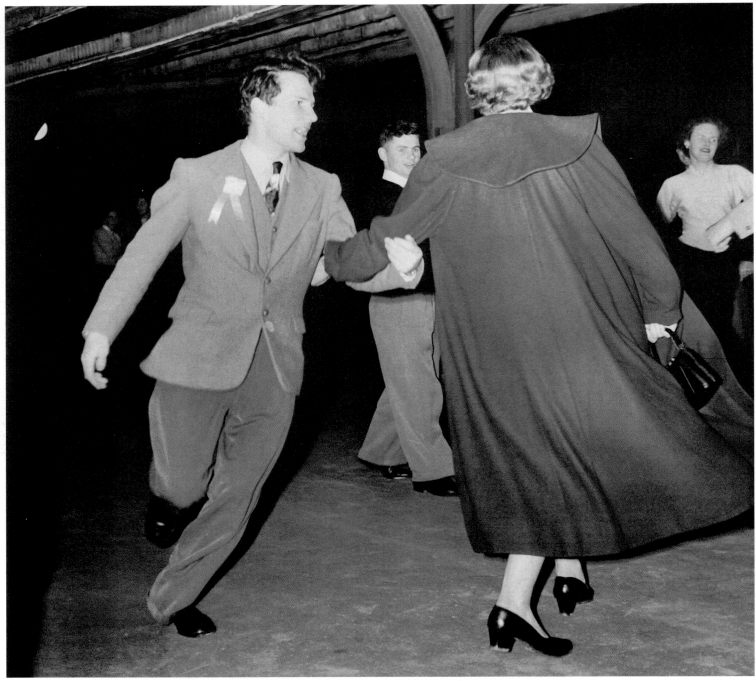

Dancing on a railway platform, Hawke's Bay, 1955

The 1950s have often been painted as a period of youthful rebellion and adult conservatism. These dancers photographed at night on a railway platform were returning from the Hastings Blossom Festival in 1955. There was more to the 1950s than the jive and the twist.

example, contain photographs of political campaigns as well as their private lives; most notable here is the large collection related to the life and times of Walter Nash, which also includes many unpublished photographs of Peter Fraser and early Labour Party activity.

The collection covers a surprising breadth of twentieth-century New Zealand life under the guise of 'government activity', but some aspects are not included. The bulk of the images date from the late nineteenth century to the early 1980s. The relative lack of images from the 1980s and 1990s results partly from the government restructuring of that period. In the 1980s the National Publicity Studio closed and government departments lost their dedicated photographers. Government agencies have also retained their more recent images for ongoing use.

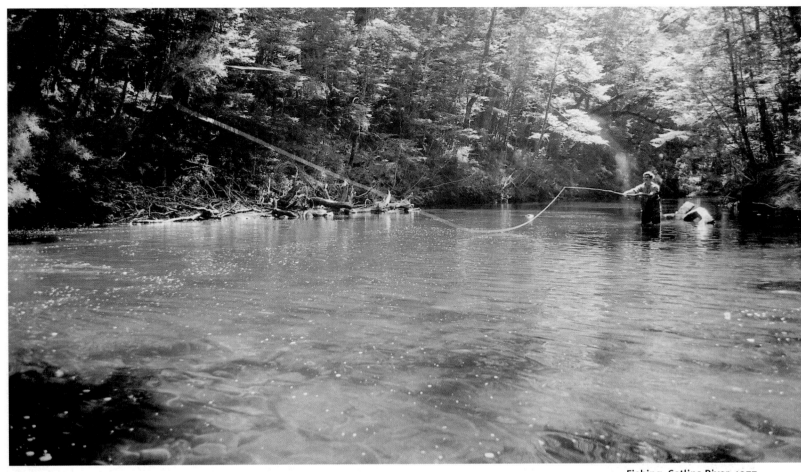

Fishing, Catlins River, 1977

The landscape or New Zealanders in the 'great outdoors' featured in photographs commissioned by some government departments. This photograph of fly-fishing displays the beauty of the Catlins River on the South Otago coast, but it also records a popular form of recreation.

Not surprisingly, family and private life is not represented in this collection as much as it is in other photographic archives such as the Alexander Turnbull Library. There are relatively few images of wedding parties, christenings, birthdays, private funerals or private moments in the Archives New Zealand collection. Missing too are images of some of the important challenges and political movements that emerged in New Zealand during the century. I found no photographs depicting 1970s feminism, for example, and few of the Maori protests that persisted in different forms throughout the century. Although the collection focuses on government activity, those challenging the actions of the state were seldom photographed. Union activities such as strikes, demonstrations and pickets are scarcely represented; war and military activity, rather than opposition to these, were photographed.

The combination of official and unofficial photographs in the collection makes it a rich and exciting repository for historians. 'Social reality' photographs, documentary accounts of New Zealand life, family moments and publicity shots are all to be found within it. The photographers employed by government departments interpreted their brief — if they had one at all — very widely, recording many aspects of life in addition to the specific activity of the agency concerned. The standard of these photographers was often high: John LeCren (Railways) and John Johns (Forestry) were known for their photographs of working people and the environment; the photographs Ans Westra and John Ashton took for Maori Affairs or School Publications provide an important — if not always comfortable — record of life in rural and Maori society in the 1950s and 1960s.[13]

The work of official government photographers (especially the National Publicity Studio and its predecessors) has not always enjoyed a good reputation. Photographic historians William Main and

John Turner use terms such as 'superficially beautiful', 'conservative' and 'unimaginative' to describe many of their images.[14] John Pascoe, employed by the Department of Internal Affairs in the 1940s to photograph New Zealand during the Second World War, was particularly scathing about romantic pictorialism: 'New Zealand in the past has suckled men who have photographed barrels of lush pastureland dominated by posterish Egmont, trainloads of pseudo-Maori dances, while Mount Cook from the bathroom window of the Hermitage has sadly slunk through lots of lenses.' He argued for the photography of social realism: 'Where are the documentary stories of the gold prospectors, the deer killers, the growth of the dairy factory, the monotony of wharf labour, the discomfort of a miner's calling, the adaptation of the Maori worker to city life and environment?'[15]

I have selected the photographs in *Living in the Twentieth Century* because of their depiction of everyday life in this country, and this has generally excluded the scenic shot and the political photograph. I have found the 'everyday' in a broad range of images at Archives New Zealand. Some were taken for publicity purposes: a photograph of young women sipping cocktails on the verandah of the Chateau was probably taken for the walls of tourist offices, but it also has much to say about dress, drinking habits, travel and holidays. Many photographs in *Living in the Twentieth Century* probably were taken while the subject was unaware or the photographer's visit was unexpected, but some are indubitably 'posed' for the camera. There are photographs of Victorian families sitting rigidly staring into the camera, grim-faced and straight-backed;[16] there are the formal lines of sports teams and office groups; and there are images of children at play and adults window-shopping. All, however, offer glimpses of everyday life and values. I have taken heed of the caution when searching for 'authenticity' in historical photographs: 'nothing is more contrived than the natural, or more carefully prepared than the spontaneous shot'.[17] The photographer who photographed the children at play may well have waited patiently for the right angles or the best light to capture the performance in front of the lens. A rigid Victorian family may well have presented themselves as they wished to be seen: a solid, respectable, upright, God-fearing family. The concepts of 'natural' and 'posed' are not necessarily helpful, if the quest is for information about social history and the particularities of life in the past.

HISTORY IN PHOTOGRAPHS Historical photographs link the past to the present. We can see what people looked like and what they wore, we can peer inside their houses and visit the places where they worked or played. We view people and places arrested in time: the forever-young faces of soldiers who never returned from the war, the closely packed houses in turn-of-the-century urban slums, the opposing lines of police and anti-apartheid protestors. What we see can jolt us by its unexpected familiarity or by its unanticipated difference. The lifelike detail of photographs confirms an historical presence, insisting that this person was there or that this event happened. As Keith Sinclair wrote: 'it is important to *see* [Premier Richard] Seddon or [Governor George] Grey as well as to read about them. Photographs give us some sense of their personal presences.'[18]

Like other historical sources, photographs require reading and interrogation. They fix and frame moments in time, providing an abbreviation of the past rather than a transparent reflection of history 'as it was'. The realistic detail that is part of their attraction can be deceptive, for the frame of a photograph acts as a boundary, obscuring more than it reveals. Cultural historian Raphael Samuel warns: 'The power of ... pictures is the reverse of what they seem. We may think we are going to them for knowledge about the past, but it is the knowledge we bring to them which makes them historically significant, transforming a more or less chance residue of the past into a precious icon.'[19]

Living in the Twentieth Century offers snapshots, rather than a comprehensive account, of everyday activities in New Zealand in the twentieth century. In my search for representations of the daily lives of New Zealanders, I have drawn on a collection of photographs sometimes framed by

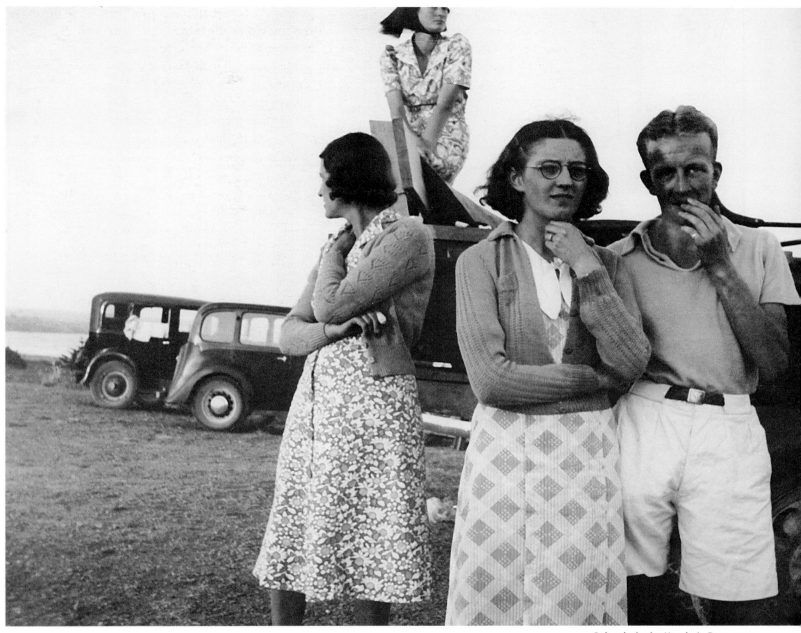

School picnic, Hawke's Bay, 1937

the requirements of the state. From this apparent contradiction comes a rich, detailed and often surprising account of the past; there are many stories to be read in these images of our history. Photographs lend themselves well to social history because of their capacity to elucidate the mundane as well as the spectacular.[20] *Living in the Twentieth Century* highlights the commonplace in photographs that were not necessarily taken to exemplify such things. In a country famous for its welfare state, and a century significantly marked by government intervention, the photographic record left by New Zealand's official photographers or the unknown staff of government departments yields up extraordinary glimpses into ordinary lives in the last hundred years.

The Archives New Zealand collection includes snapshots from family or informal occasions. These people were photographed at a school picnic in Hawke's Bay in 1937.

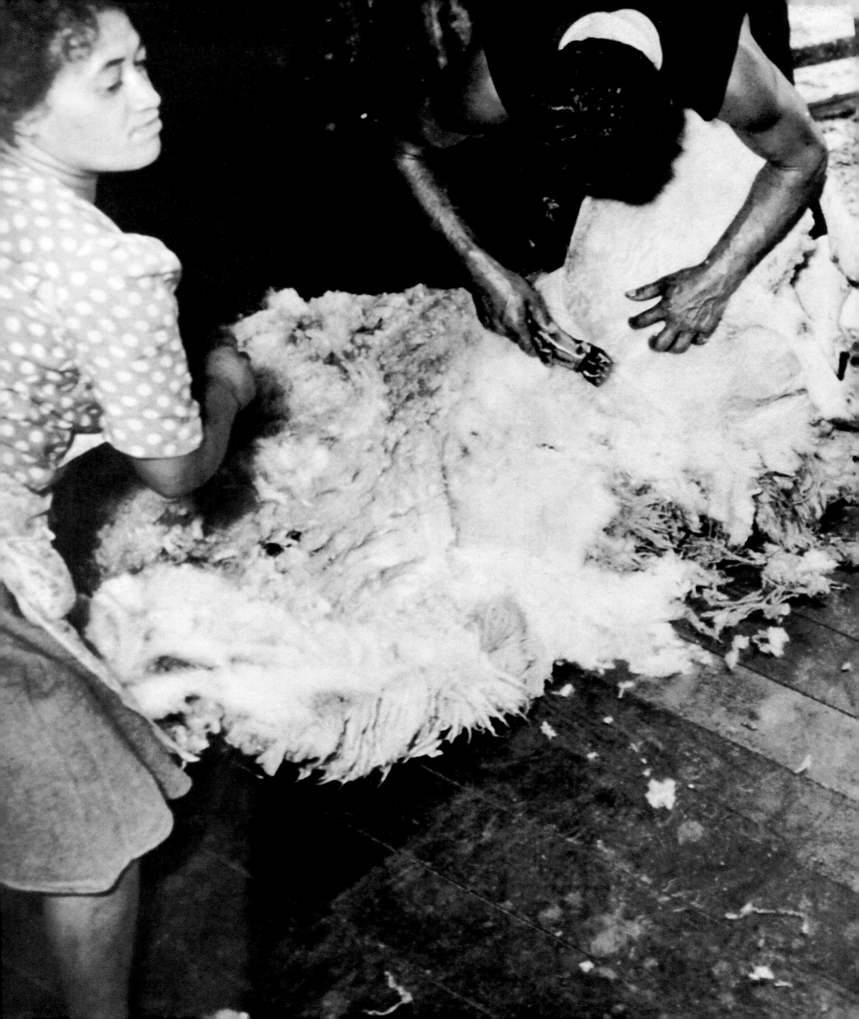

All in a Day's Work
Paid and Unpaid Work

Work structures daily life, influencing when people eat, what they wear, how they take 'time out'. While work is usually regarded as a task undertaken for pay outside the home, unpaid work (often by women) in the house, on the farm or in the community also makes a major contribution to the lives of individuals and to the economy. Paid or unpaid, work lies at the heart of much of New Zealand life.[1]

The photographs in this chapter show people working in a range of situations: mustering cattle, doing the accounts, tending to the sick, pouring concrete and making the dinner. The emphasis is on paid work, primarily because the Archives New Zealand photographic collection records more in the public sphere than in the domestic. Perhaps for official reasons also, work rather than unemployment was photographed, and images of workers protesting about their pay or conditions are rare.

Over the first eight decades of the twentieth century, the emphasis of New Zealanders' paid work shifted from physical to mental activity. Early in the century nearly a third of the male workforce was employed in the primary sector (agriculture, horticulture, mining and forestry). The proportion had fallen to a quarter by 1955, and an eighth in 1996. Throughout the period, about 5 per cent of women workers were in the primary sector. As the importance of primary industries to the economy declined somewhat in mid-century, secondary industries (manufacturing and construction) expanded. A quarter of male workers and a fifth of female workers were employed in manufacturing and construction in 1926. The proportions reached a peak of two-fifths and a quarter respectively in the 1960s, and fell to 36 and 13 per cent in 1996. As the century wore on, the tertiary (or service) sector grew in importance.[2] This sector, which includes services such as transport and communications, community and

Shearing was a major source of seasonal employment in rural areas throughout the century. Maori shearing gangs were often whanau-based: entire families formed gangs that moved from farm to farm during the shearing season. As in this photograph, women frequently worked as rouseabouts, collecting the fleece from the shed floor. While the great tradition of blade shearing has been celebrated in song and legend throughout Australia and New Zealand, high levels of skill were still required for the electric shears used by these shearers, working at Puketiti Station, near Te Puia on the East Coast, perhaps in the 1950s or 1960s.

Puketiti Station, Te Puia, 1950s–60s

social service work, finance, hospitality and trade, and education, employed 39 per cent of male and 76 per cent of female workers in the 1920s, and 65 and 79 per cent respectively in the mid-1990s.

Some of the reasons for these shifts were political. Employment in the primary sector relied on New Zealand selling its products in international markets, many of which developed policies protecting their own agricultural and horticultural products against foreign competition. This was particularly so in the last quarter of the century. Great Britain had long been New Zealand's major export market for primary produce, but its entry into the European Economic Community in 1973 forced this country to seek new markets and develop new trade agreements. Other reasons were economic and global: the recessions of the late 1920s and 1930s, and from the mid-1970s, also reduced the international market for New Zealand's primary produce. In the 1980s, the New Zealand government removed farm subsidies, and at the same time restructured its management of mining and forestry resources; many jobs were lost as a result.[3] The changes were not spread evenly over the country or across the primary sector. In the last quarter of the century, some farmers diversified, and 'boutique' or specialist ventures sprang up; some were very profitable and created new employment opportunities. The kiwifruit industry, for example, boomed from the late 1970s in areas such as the Bay of Plenty; the expansion of the wine industry began in the same period.[4]

The manufacturing sector went through cycles of growth and contraction. Railway workshops, vehicle assembly plants and factories to process locally grown produce were significant employers for most of the century. Local manufacturing was protected by import licensing from 1938 until the 1980s; when the economy was deregulated in the last two decades of the century, jobs in the secondary sector contracted.[5] In the 1960s a number of large manufacturing industries, such as motor vehicle assembly plants, expanded in the growing suburbs of Auckland and Wellington, where migrants from the Pacific Islands and Maori moving into cities sought work. With the removal of the tariffs on imported cars, these plants began to close in the 1980s, and, as in many industries, large factory floors became a thing of the past.[6]

Service industries were not immune from the effects of changing government policy or private sector disinvestment. Some areas of the tertiary sector, notably transport, declined as large government departments such as Railways were restructured. Others, however, grew in the latter part of the century, particularly community and social service work, the financial sector, tourism and hospitality, business services, education and the telecommunications industry. Urbanisation, and a more highly educated and qualified workforce, also contributed to the continued growth of the tertiary sector.

By the late twentieth century, many New Zealanders were familiar with unemployment and redundancy. People recalled the poverty and social disorder of the 1930s depression, when an eighth of the workforce was calculated as unemployed. The unemployment of the 1980s and 1990s saw more New Zealanders out of work for longer periods, and some groups – young people and Maori especially – were disproportionately affected.

While changes in the economy meant that over the century fewer workers were employed in agriculture, for example, and more in education, paid and unpaid work were affected by the introduction of new technologies. The mechanisation of agriculture steadily reduced the number of farm workers over the first 50 years (removing thereby a valuable source of casual labour that had carried many unemployed through the 1930s depression). And the introduction of washing machines, refrigerators and other electrical appliances into most homes from the mid-1950s altered the nature of domestic work just when women were entering the paid workforce in greater numbers. Most directly affected, however, were jobs in transport, manufacturing and telecommunications. The arrival of the automobile as the primary mode of transport in the 1920s, for example, meant that work associated with horse-drawn transport disappeared: occupations such as farriers, coachbuilders, stablehands, blacksmiths and wheelwrights all ceased to exist.

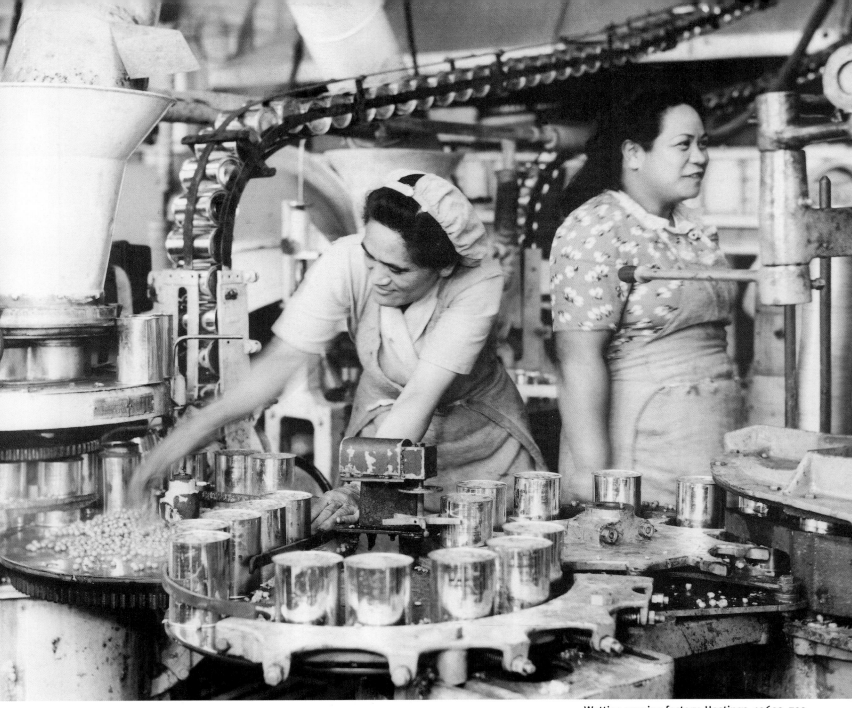

Watties canning factory, Hastings, 1960s–70s

Women's experience of work has had its own pattern, one not necessarily reflecting shifts in the country's economic structure. Women have remained a minority in the paid workforce, but grew from about 20 per cent at the beginning of the century to almost 45 per cent at the end.[7] Both world wars created greater employment opportunities for women in transport, manufacturing, agriculture and horticulture, but these gains were short-lived.[8] In the 1950s, in particular, a 'back-to-the-home' ethos encouraged women to commit themselves to the care of home and family. Until the 1920s, the majority of women in paid employment were in domestic service (in such numbers that women dominated the service sector).[9] The work was hard, the hours long and the pay poor; it was not surprising that women abandoned domestic service in droves for more lucrative and higher-status work in factories, shops and offices (and in these quite different roles, women still dominated the service sector at the end of the century).

Factory work became increasingly mechanised during the century, and factory workers took their places on production lines. These two women surrounded by machinery at the Watties canning factory in Hastings in the 1960s or 1970s worked on the pea canning line. These women ensured that the cans were full, and then clamped on the lids; 140 tins passed each woman each minute.

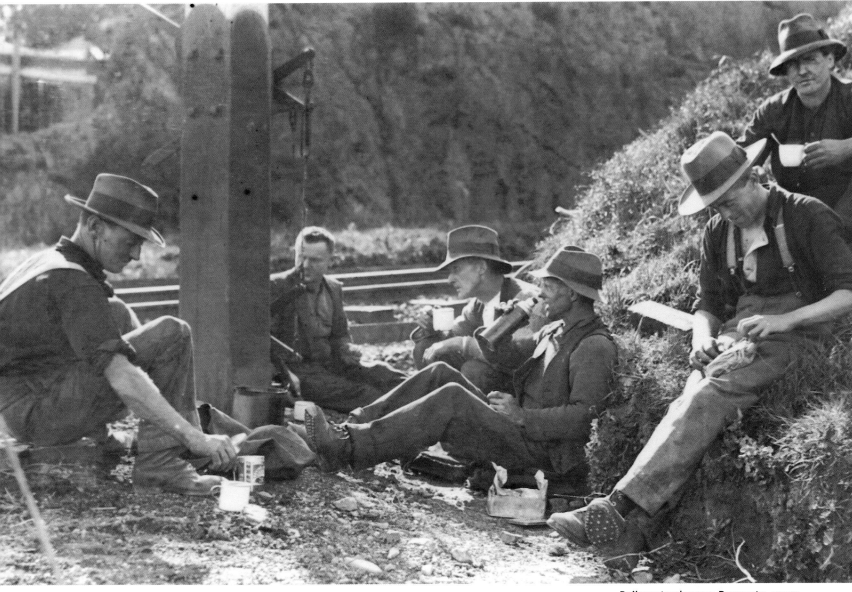

Railway track gang, Paremata, 1930s

Smoko was an important part of the working day. This gang of railway track layers in the 1930s have set up their lunch spot on a grassy bank near the track. These men have brought their own provisions: a billy, a flask of hot tea or soup, enamel mugs, and sandwiches in cake tins.

Until the 1960s, paid women workers were primarily single. Women who were separated or widowed, or poised briefly between education and marriage, might find employment, but few people expected married women to continue earning money. Indeed, government regulations prevented their doing so in the public service in the 1920s and 1930s, and some employers expected married women to make way for men in times of recession. Despite the promotion of women's importance to home and family, a general shortage of labour in the 1960s opened up many employment areas for women, married and single. New opportunities in manufacturing complemented those in offices, health, education, childcare and social services.[10]

The postwar emphasis on obtaining household consumer goods placed a burden on families, and paid work by women was one way to lighten this.[11] Washing machines and other goods were desirable in themselves; putting the clothes into an automatic washing machine, for example, was simpler and quicker than washing them by hand. But consumer goods were also promoted as a way to free up women to enter the paid workforce; time saved on domestic chores could be spent earning money.

Declining fertility and family size also accelerated women's entry into the workforce. From the 1960s many women with school-aged children worked; some had to because of economic circumstances, while others wanted to have both a career and a family. The feminist movement of the 1970s emphasised women's right to paid employment, and campaigned for issues such as equal pay and recognition of women's contribution to the household economy, whether in paid or unpaid labour. The slogan that 'women [or girls] can do anything' fostered an awareness of the range of jobs that women could perform, and from the 1970s areas of employment once dominated by men were opened up to women.

At the end of the century, however, women remained clustered in jobs that paid less and had lower status than men's; they were also more likely to be in part-time employment. Some of the achievements of the feminist movement — equal pay legislation, legislation for maternity leave and other provisions to improve women's lot in the workplace — did not remove pay differentials between women and men, or alter the lower status accorded to significant areas of women's work, such as childcare. While the difference in pay and status between women's and men's paid work had become less visible since the 1960s, the gap endured.

Maori and Pacific Island workers were also to be found in poorer-paid and lower-status jobs. Before the 1940s, most Maori in employment worked in agriculture or the timber trade. The migration of Maori into urban areas during and after the Second World War coincided with a labour shortage, and Maori workers moved easily into the growing secondary industries of manufacturing, processing and construction. They were joined by people from the Pacific Islands from the 1960s. Such jobs were among those hardest hit by the late-century economic recession, and unemployment levels for Maori and Pacific Islanders were three times those of Pakeha in the 1990s.[12] The disappearance of work in rural and provincial areas late in the century also affected Maori communities badly, and regions such as Northland and the East Coast with large Maori populations had the highest unemployment levels.

A major feature of working life in the first half of the century was the evolution of the trade union movement, which concerned itself with the rights of workers and the circumstances in which they worked.[13] From the 1890s, trade unions campaigned for (and gradually established) many improvements in working conditions, including set breaks for lunch, hygienic and safe working environments, and the payment of allowances for travel and work clothing. The first Labour government (elected in 1935) introduced compulsory union membership, and improved working conditions and pay. From the 1950s, however, strikes, pickets, demarcation disputes and protests about unfair dismissals, safety issues or wage cuts made some New Zealanders, and many politicians, impatient with unions' so-called 'hard-line' approach. The 1951 waterfront dispute, in which more than 22,000 workers went on strike in support of the watersiders, was one of the major confrontations between unions and government.[14] Watersiders and timber workers were also involved in industrial disputes during the 1960s and 1970s. Compulsory unionism and collective wage bargaining (giving blanket coverage for workers across a sector, industry or workplace) disappeared with the Labour Relations Act 1987. Four years later, the Employment Contracts Act removed much of the machinery that had governed workplace relations for a century. Some workers found that their working conditions improved, while others did not, but the legislation and its changes undermined the role and place of unions.

Legislation stipulating hours of work created significant differences in people's lives. In the first third of the century, these could be very long. Domestic service was one of the worst: in 1906, the Wellington Domestic Workers' Union failed to secure a mandatory 68-hour week. Weekly half-holidays in manufacturing and service industries, and the introduction of statutory holidays, gave workers clear time off. It was not until the mandatory 40-hour week was introduced in 1936 that work time was clearly differentiated from time off.

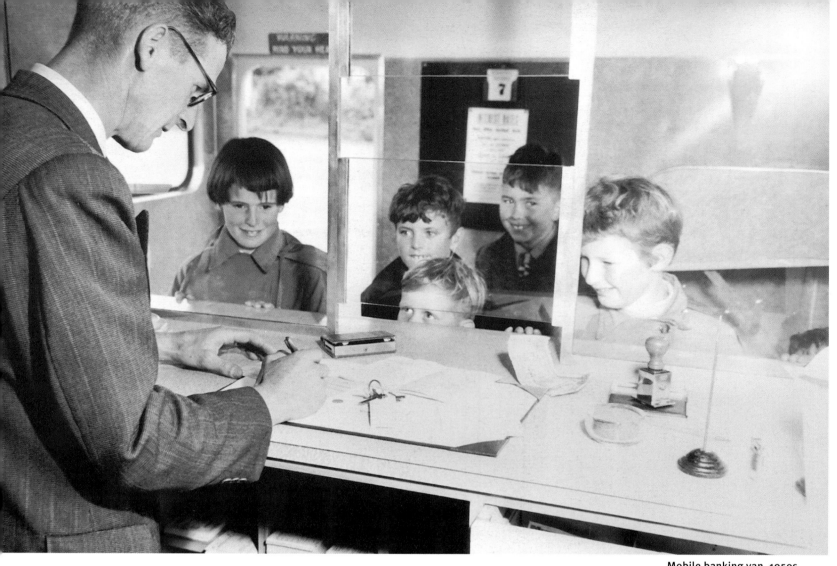

Mobile banking van, 1950s

In the second half of the century, white-collar work expanded; both men and women could be found 'behind the counter' in shops or restaurants, in the tourism industry, in banks or other financial institutions. Here children gather at a mobile Post Office banking van in a suburban street, probably in the 1950s.

With the 40-hour week, the weekend emerged as a time for leisure, recreation, home and family rather than work. The regulation of shop hours also distinguished the week from the weekend and work from leisure. Compulsory half-day closing for all shops on Saturdays, introduced in 1894, marked off Saturday afternoon as a special time.[15] Half-day closing ended in 1980, weekend trading took off, and the distinction between week and weekend disappeared for many New Zealanders.[16] Shoppers gained the freedom to purchase any goods at any time, but at the expense of the traditional weekend for those who worked in the service sector.

Wages and awards, half-holidays and weekends meant little to the enormous army of unpaid domestic workers who maintained homes and families.[17] Running a household was often shared by women and men in accordance with contemporary ideas about women's and men's work.[18] As these ideas shifted during the century, the balance between women's and men's contributions changed. Unpaid domestic work was a full-time job for many women, particularly married women. Until at least the 1970s, housework, and feeding and clothing the family were primarily women's responsibilities. Unlike men's household work — tending to the outside of the house, mowing the lawns, digging the vegetable garden — women's domestic work was an everyday activity, whether or not they were also in paid work, and whether or not they were married. Married women's greater participation in the paid workforce, combined with the ideas of the late twentieth-century women's movement, led to a renegotiation of household tasks in some families from the 1980s. Yet regardless of moves towards sexual equality, women continued to do most of the domestic work.

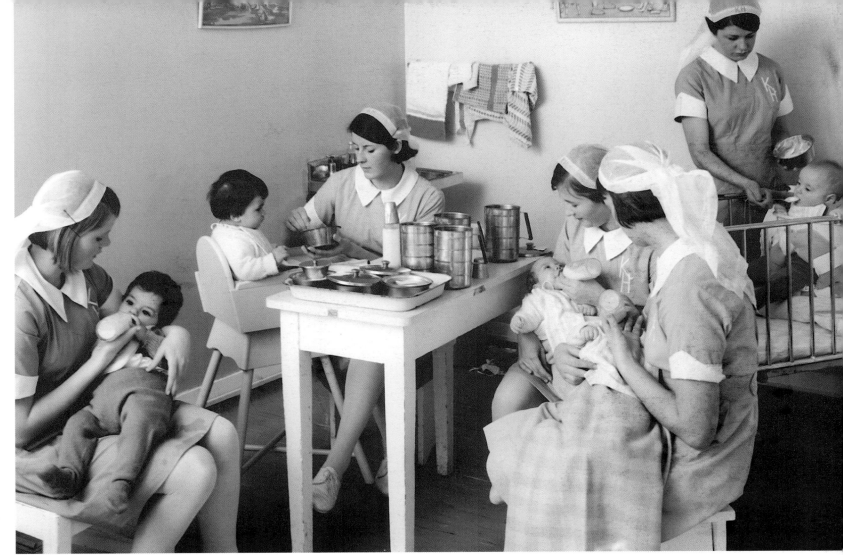

Karitane home, Melrose, 1967

The conditions of housework, however, changed significantly over the century. Reliable cooking appliances, electricity and the development of artificial fibres all dramatically altered the work done and the time spent on it. Synthetic clothes were easier to wash and maintain, and reduced the need to spend long hours at the tub or over an ironing board; the Sunday roast was simpler to prepare in an electric oven than a coal range. Cheaper clothing and the availability of packaged and processed foods meant that women did not have to make clothes for the family or bake weekly, although many women continued to do so for pleasure or for economy. Labour-saving household devices sometimes raised expectations.[19] In the later 1950s, for example, as baking became quicker with electric mixers and more sophisticated stoves, a wider range of cakes, biscuits, desserts and preserves began to appear on the table.

Domestic work had many of the same functions and effects as paid labour: its patterns structured the day and the week; it affected what type of leisure was taken, and with whom it was spent. Unpaid domestic labour has affected daily experience, often in ways that are less obvious than paid work, throughout the century.

These nurses and their charges were photographed at the Karitane home in the Wellington suburb of Melrose in 1967. These homes were established by the Plunket Society (founded in 1907) to provide maternity care for new mothers and their babies. At the time of this photograph, women would often transfer to a Karitane home after giving birth in a public hospital. They could spend up to a fortnight 'in the home', resting and learning how to care for their babies.

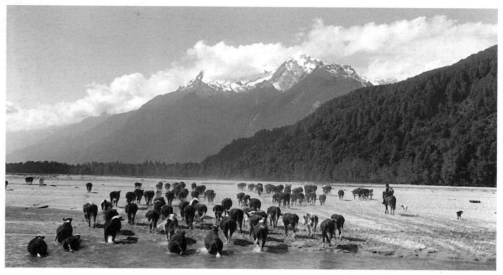

Mustering on the Arawhata River, 1940s–50s

WORKING THE LAND One of the most evocative images of rural life in New Zealand is high-country mustering on the big cattle and sheep stations to be found in Canterbury, Otago, Southland and Hawke's Bay. **ABOVE** Here a member of the Nolan family crosses the Arawhata River in South Westland with a mob of cattle in the middle of the century. Mustering on this station took three full days; the cattle were then auctioned at the Whataroa sale (by Mr D. Hindman of the National Mortgage Corporation), and some would have been sent to the freezing works. **LEFT** Official photographers accompanied the Nolans on this dramatic expedition; documenting the agricultural industries gave the government superb opportunities to create spectacular images of the New Zealand landscape and rural way of life.

Whataroa saleyards, 1940s–50s

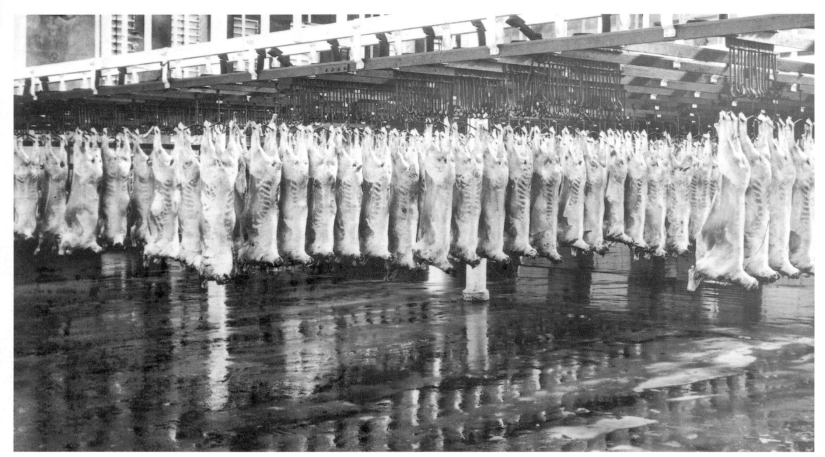

Auckland cool store, pre-1950

WORKING THE LAND The introduction of refrigerated shipping in the 1880s enabled vast quantities of New Zealand meat to be transported to markets on the other side of the world, and the meat industry became a crucial part of the New Zealand economy for the next century. **ABOVE** The carcasses hanging from hooks in this Auckland cool store, perhaps in the first half of the century, indicate the scope of an industry that provided much seasonal work. Until the interwar period, animals were slaughtered and processed by skilled butchers on 'killing boards' in freezing works. The introduction of the chain system altered the nature of the work, and separate tasks were assigned to different workers. **FAR RIGHT** In the Ngauranga freezing works near Wellington in 1949, a butcher strips the hide from a cow in an image that eloquently captures the visceral reality of the industry. His was a task requiring specific skills and responsibilities, just as stripping the fleece, slitting the stomach, and washing the interior were the jobs of men on the chain at the Whakatu freezing works in Hawke's Bay in 1983. **RIGHT** The difference in working conditions between these two photographs is marked. A black singlet, work trousers and a hard hat constituted the 'uniform' of the Ngauranga butcher, and a cigarette hangs from his mouth. Hygiene was to become more important, and conditions were cleaned up from the 1960s, until interiors such as Whakatu's were the norm: a crisp white uniform of gumboots, apron, hat, singlet and pants, a steady stream of water, and gutters built into the floor to drain away the blood and flesh. The freezing works employed many Maori in both urban and provincial areas in the second half of the century, and Maori communities were particularly hard hit when the freezing industry was deregulated and several major works closed in the 1980s. Whakatu was one of the first: its chains stopped in 1986, three years after this photograph was taken, with the loss of 1500 jobs at the peak of the season.

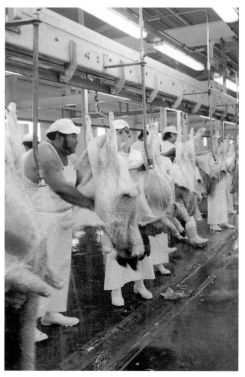

Whakatu freezing works, 1983

OPPOSITE **Ngauranga freezing works, 1949**

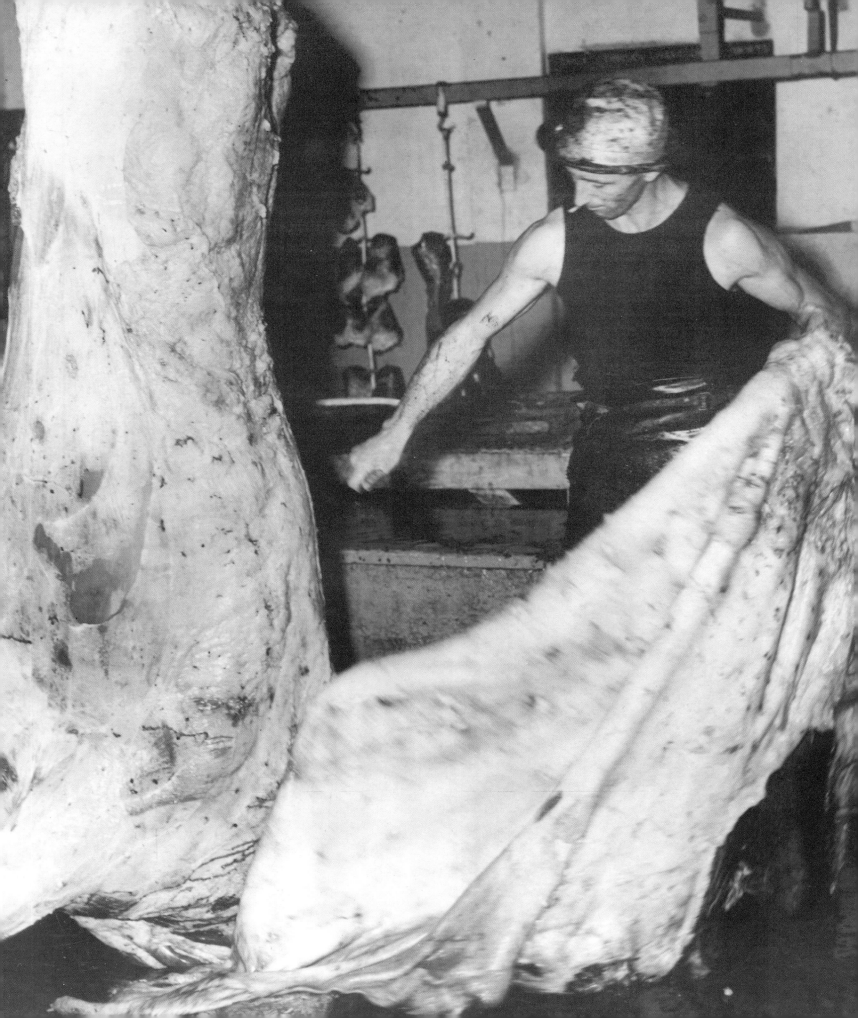

Riverdale Co-operative Dairy Factory, 1900s–20s

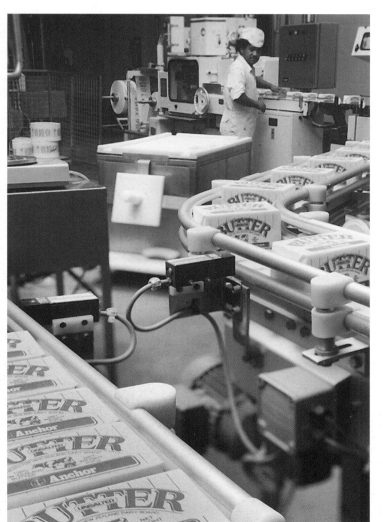

WORKING THE LAND Horse-drawn carts line up outside the Riverdale Co-operative Dairy Factory Company Ltd, Taranaki, alongside a single car early in the century. **ABOVE** These dairy farmers, like others in areas such as Northland, Waikato and Southland, visited the factory twice each day to drop off their milk supply. By the end of the First World War, more than 500 dairy co-operatives were scattered around the country to receive milk and cream from the surrounding areas. **FAR LEFT** Thirty years later, factory milk trucks were calling on farmers to collect milk and cream for factories like that of the Sunbeam Company in the Bay of Plenty, shown here in the 1940s or 1950s. This factory was mechanised, with butter wrapped and packed automatically in a simple production line requiring only a couple of staff. **LEFT** Dairy factories looked different again 30 years on: at this Anchor factory in the 1980s a worker in a white uniform monitors butter on a conveyor belt from a control panel.

Anchor factory, 1986

Sunbeam Company, Bay of Plenty, 1940s–50s

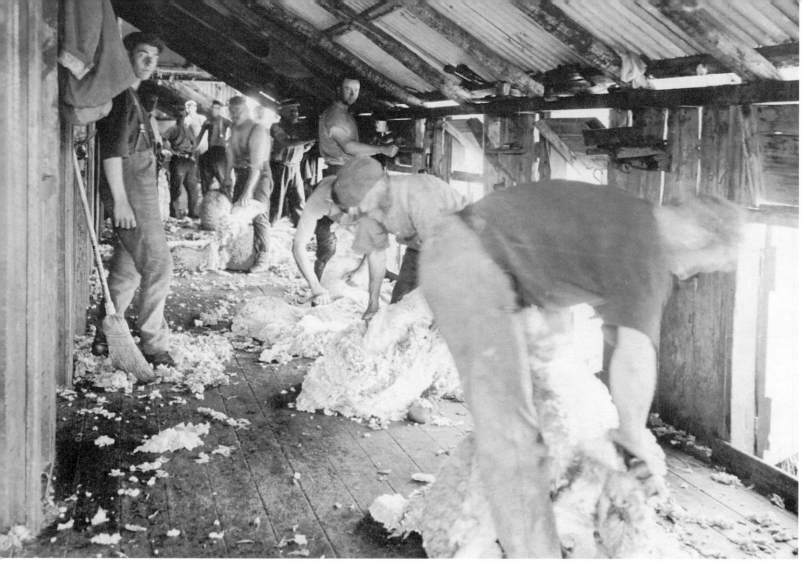

Mt White Station, Canterbury, 1915

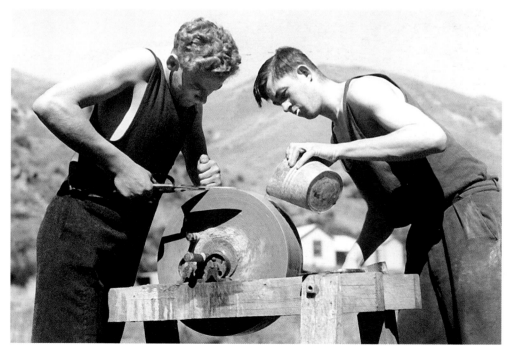

Sharpening the blades, 1940s–50s

WORKING THE LAND Wool, with meat and dairy products, helped support the New Zealand economy throughout the century. **ABOVE** Shearers at Canterbury's Mt White Station are shown using manual blade shears in 1915, well after mechanical methods had been introduced in the late 1880s. Electricity connections did not reach some parts of rural New Zealand until the middle of the twentieth century, and some shearers preferred to use blade shears on fine-wool merino sheep. **LEFT** Sharpening the blades was a regular task; here two shearers in the middle of the century use a manually-operated grindstone.

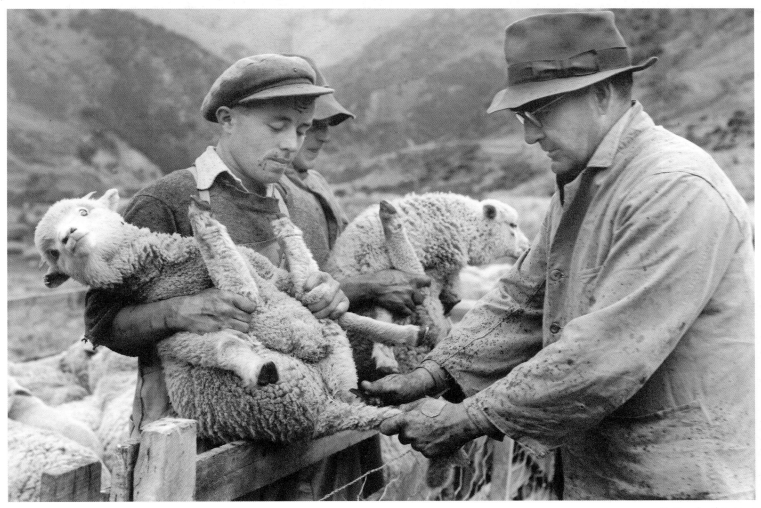

Tailing lambs, 1950

Deer farming, 1984

WORKING THE LAND Sheep farmers' annual round included preventive care of their flock – drenching and dosing to keep the animals disease-free, and docking. Each season's lambs were rounded up to have their tails removed; rubber rings were used to cut off the blood supply, or the tails were simply chopped off with a knife. **ABOVE** This photograph was taken by government photographers in 1950 for use in publications issued by the Department of Agriculture.

Changing export markets and economic crises forced primary production to diversify in the 1980s. The removal of farm subsidies in 1985 particularly affected sheep farmers, some of whom invested in more lucrative forms of production. One of these was deer farming, which offered good returns on venison and velvet. **LEFT** In this photograph from 1984, a farmer on a farm bike equipped with a mini-trailer feeds out to his herd of deer enclosed by characteristically high fences. Women's paid work off the farm sometimes supplemented farm income in the 1980s. In such cases, as this photograph suggests, the work of childcare was shared by the men on the farm.

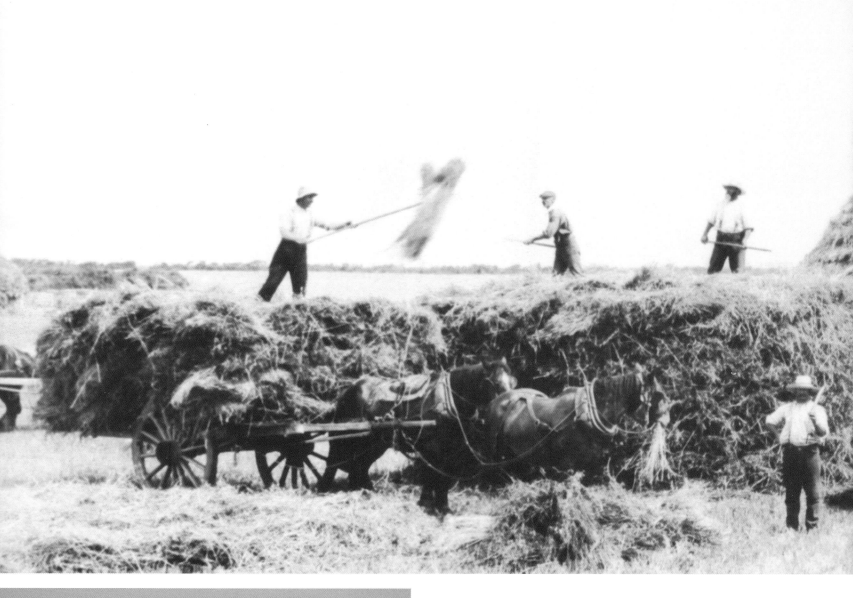

Harvesters, Hawke's Bay, 1978

WORKING THE LAND These men were photographed in 1915 during the last 'wheat boom' in Canterbury. **ABOVE** Harvesting required several teams of horses and men, many of whom wandered from farm to farm in search of work during the harvesting season. The men on the left of the photograph stand on small piles made up of sheaves of wheat, which they pass along the line to the men at the top of the large stack, who arrange them with the ears of grain pointing upwards. A mobile threshing mill would later arrive at the stacks. Despite mechanisation, with reapers and traction engines in use in many parts of the country by the end of the nineteenth century, harvesting remained labour-intensive and was an important source of employment for unskilled workers in the first quarter of the century.

The horse teams that had dominated heavy field work were mostly replaced during the 1930s and 1940s by tractors. **LEFT** This fleet of harvesters photographed in 1978 would have required only five workers for a

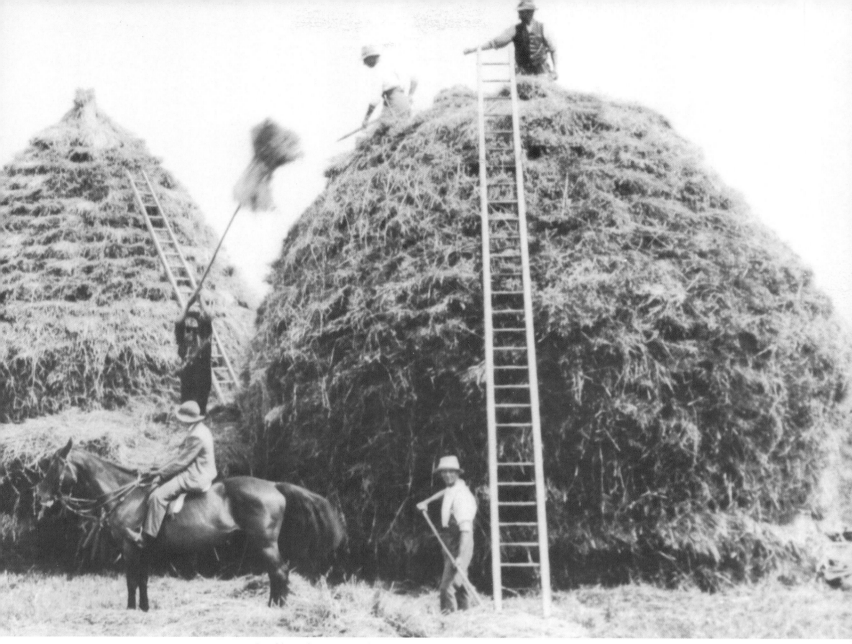

Stacking wheat, Canterbury, 1915

couple of hours to bring in the crop. In fruit and vegetable growing districts such as Hawke's Bay, the replacement of people by machines from the 1960s reduced the amount of seasonal work available in the rural community.

In some industries, harvesting by hand ensured that produce was not damaged. **RIGHT** At this Bay of Plenty kiwifruit orchard in the late 1970s, workers pick the fruit and place it in sack-like aprons secured around their chests and backs. During the 1970s, the Bay of Plenty enjoyed a boom as kiwifruit became fashionable in international markets; kiwifruit orchards took over from dairy farming as the dominant local industry and provided much-needed employment. High prices for fruit in immaculate condition put a premium on good handling methods.

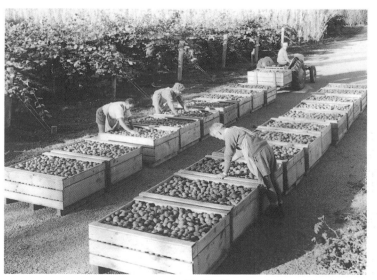

Kiwifruit orchard, Bay of Plenty, 1977

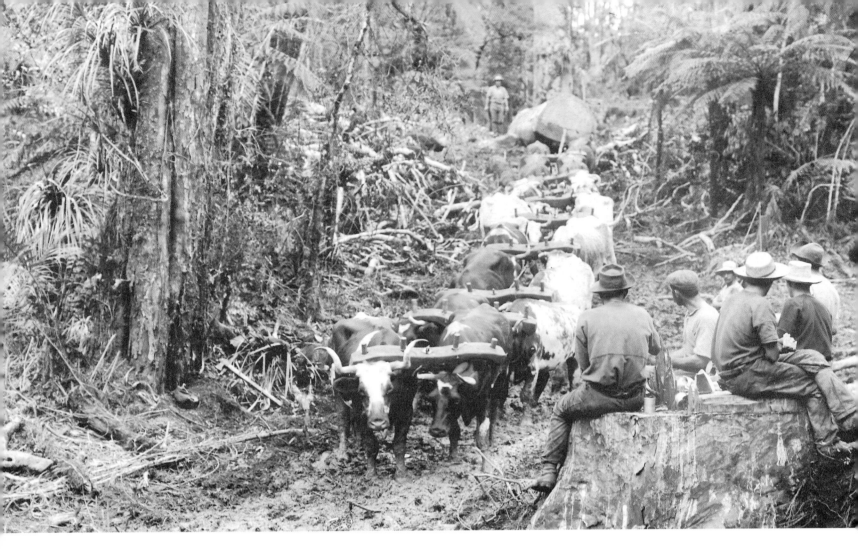

EXTRACTING RESOURCES The 'heroic' task of turning bush into pasture in a 'new' land was readily captured in photographs of bushfelling and kauri forest logging — activities that continued into the second decade of the twentieth century in some places. **ABOVE** This photograph of men watching a team of oxen dragging a section of a kauri log along a forest track may suggest loss and devastation to modern eyes, but it also shows the significance of the timber trade as a source of employment. Six bushmen look on, sipping mugs of tea, while a teamster follows the oxen train. These men would have chopped down the tree, loaded it onto the oxen train, and perhaps cleared the path through the bush so the log could be hauled to a mill. This was physically demanding work, with a reputation for making or attracting hard-living and hard-drinking men.

Exotic forests transformed parts of rural New Zealand from the second quarter of the century. Swathes of land in the Bay of Plenty and the volcanic plateau of the North Island were planted in pines, and townships sprang up around sawmills and timber-processing areas. Maori were a significant part of the labour force that planted, thinned and chopped down trees. The work was dangerous, and by the second half of the century, when these two photographs were taken, safety equipment was mandatory **RIGHT, FAR RIGHT**

Tree-felling, Kaingaroa, 1969

Logging the kauri forest, 1900s–20s

Forestry nursery, Whakarewarewa, 1924

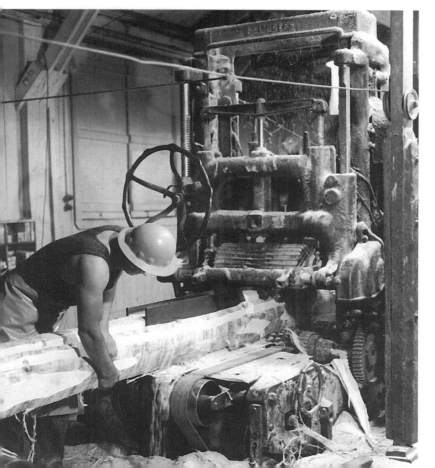

EXTRACTING RESOURCES In this photograph from around 1924, a group of Maori work in the government's forestry nursery at Whakarewarewa, near Rotorua. **ABOVE** One man ploughs a small furrow, while (behind him) several women rake the ground level. Another group plant small seedlings. By the mid-1920s, the growing Maori population was putting pressure on the limited amount of land remaining in Maori ownership, and Maori farmers often struggled to be efficient on poor land and with few resources. Forestry work, which was both regular and seasonal, could be a lifeline for impoverished Maori communities.

Waipa sawmill, 1971

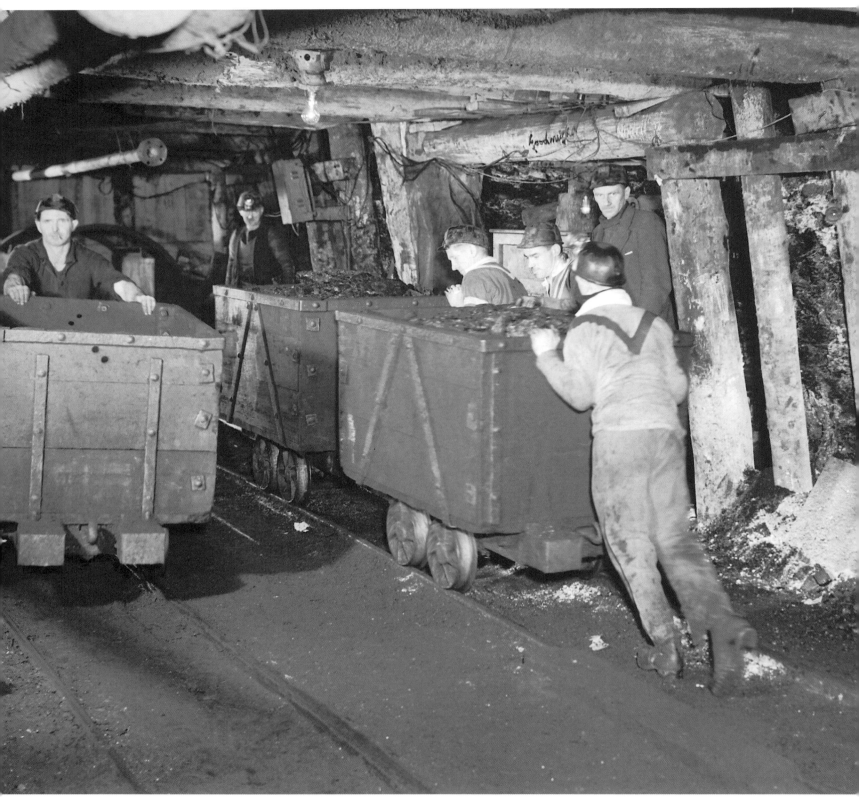

Down the Blackball mine, 1930s

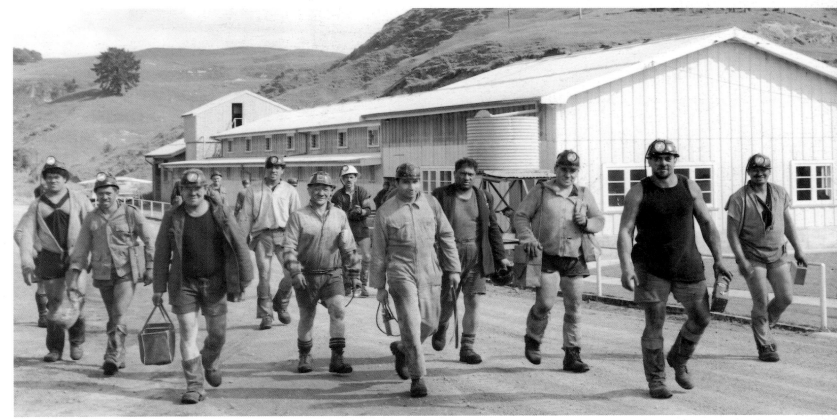

Rotowaro mine, Huntly, 1969

EXTRACTING RESOURCES While forestry expanded during the century, another great extractive industry declined. Coal-mining also provided work for unskilled and semi-skilled labourers, and in the early part of the century was a focus for militant union activity (as timber-processing became later). **LEFT** The Blackball mine (photographed here about 1930) was situated on one of the most prolific coal seams. Most of the men in the small settlement of Blackball were employed down the mine, as truckers such as the ones in this photograph, or as hewers working at the coal face. The West Coast was the most significant mining area until the 1950s, by which time mines around Huntly in Waikato were supplying about the same amount of coal. **ABOVE** Here a group of miners return from a day's work at the Rotowaro mine in Waikato in 1969, carrying their lunch boxes and still wearing their hard hats with lamps.

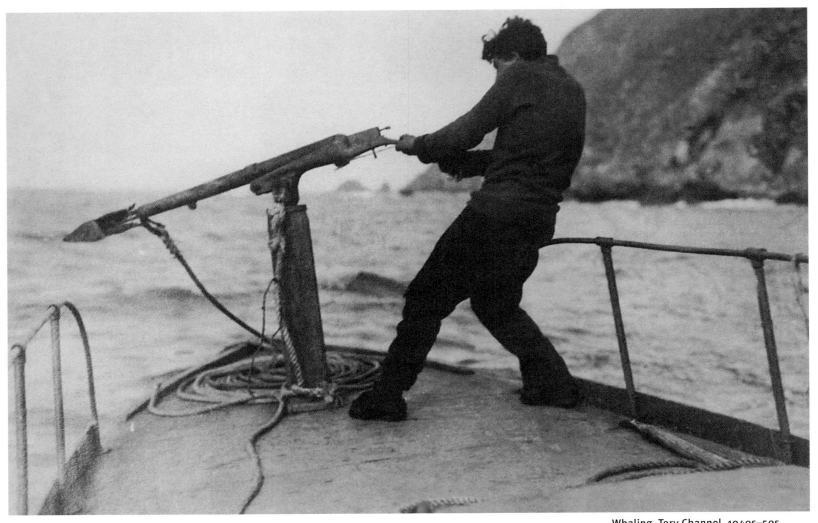

Whaling, Tory Channel, 1940s–50s

SEA AND PORT Whaling has been a dramatic part of the country's history, but by the early twentieth century it had almost disappeared. One or two small shore whaling stations were still operating into the middle of the century. **ABOVE** This photograph of a whaler aiming a harpoon at a whale was taken in Tory Channel. Until 1960 the Heberley family ran a seasonal whaling station in Tory Channel, providing work for the family and local people, both on the boats and in the flensing process by which the whales were stripped of their blubber for oil.

Until the 1980s, the fishing industry was dominated by small commercial enterprises, sometimes based on family or migrant groups, such as the Italians who operated out of Island Bay in Wellington. Typically, fishing boats were crewed by a handful of men and based at smaller ports. **RIGHT** The fisherman here is bringing in his catch off the Otago coast in 1954. Changes in the fishing industry from the 1980s, such as the quota system, pushed many small operators out of business.

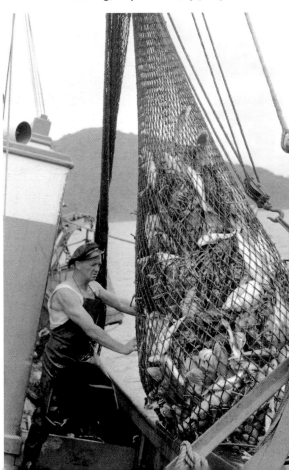

Fishing, Otago, 1954

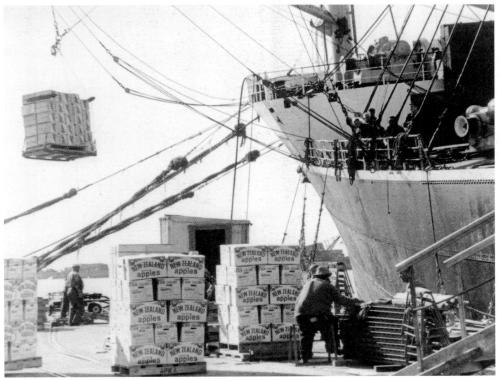

Loading apples for export, 1940s

SEA AND PORT The centrality of seaborne freight to an island economy gave waterside workers a key role in the labour market. As in other heavily unionised occupations, waterside work was often broken down into specific and separate tasks. **TOP LEFT** In this photograph of apples being loaded for export, this demarcation probably meant that the men preparing the pallets of apple cartons in the foreground would not do any of the tasks performed by the men on deck.

Loading freight for export and local markets was mechanised in the last third of the century by the introduction of huge containers and the machinery that went with them. **BOTTOM LEFT** Here men stretch taut the cables and chains securing planks of timber to the deck of an enormous ship bound for Japan, to which much timber was exported from the 1960s. The waterside workers' union was among the most outspoken and militant from the late nineteenth century. Labour disputes on the waterfront tied up trade in 1951, when the watersiders were locked out (or on strike) for 151 days; the government declared a State of Emergency, brought in the military to load ships, and deregistered the watersiders' union, effectively sapping its strength. During the 1960s and 1970s, labour protests disrupted the schedules of the freight and passenger ferries between the North and South Islands. Such disruptions usually provoked a strong government response and outrage from businesses and holidaymakers. The power of the waterfront unions was further reduced by the labour market changes of the late 1980s, but by then the containerisation of shipping had markedly changed the nature of work on the wharves.

Timber ship, Port of Napier, 1978

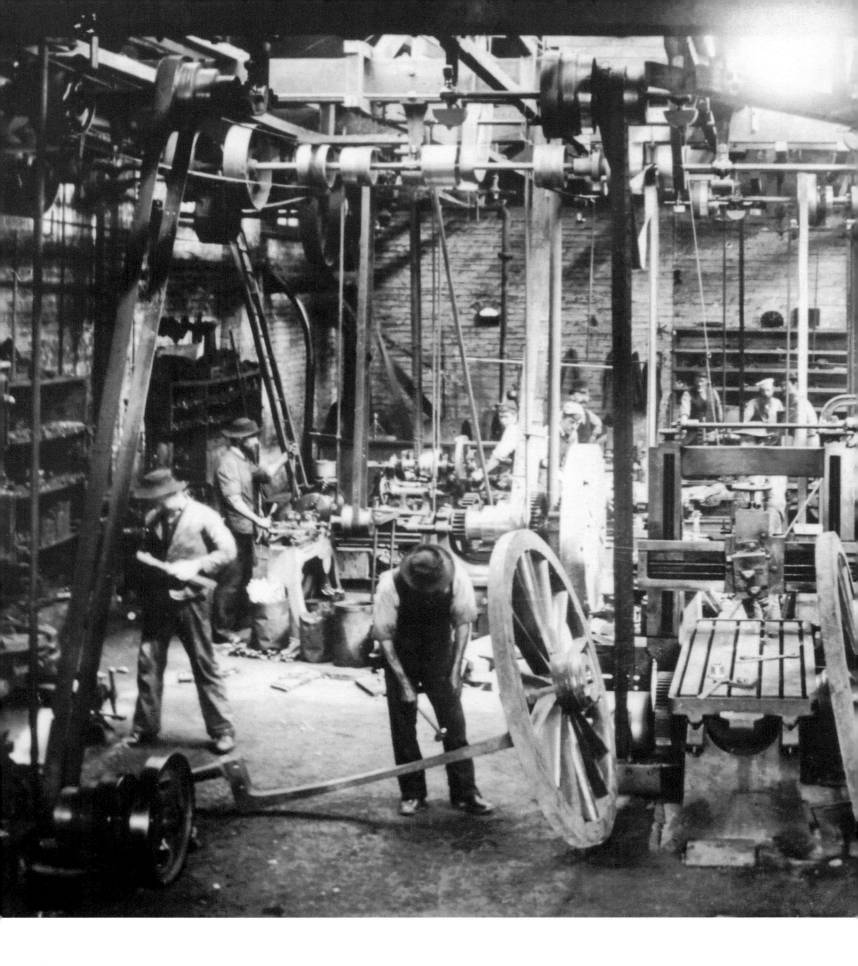

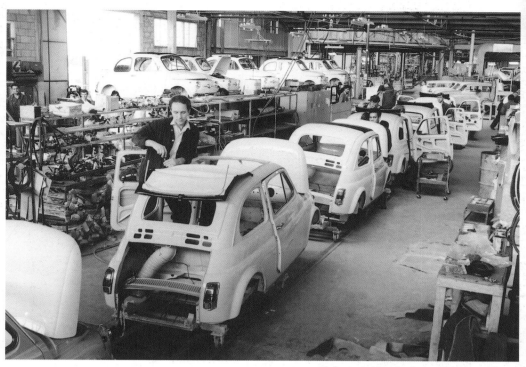

Fiat assembly plant, Auckland, 1966

THE FACTORY Motor vehicle assembly plants provided work for large numbers of skilled and semi-skilled workers from the 1960s to the 1980s. **ABOVE** The workers in this busy Auckland factory are assembling Fiats in 1966. Within two decades, plants such as this began to close as the economy slid into recession and the removal of tariffs made imported cars much cheaper.

Most factories in the early twentieth century were small, employing a handful of skilled trades-people and apprentices. **LEFT** Around a dozen workers can be seen in this wheelwrights' workshop in 1903, a time when the wheelwright's trade was at its height. The photograph portrays the dangerous conditions often faced by workers in engineering workshops and foundries. The floor is littered with pieces of metal, chunks of wood, empty boxes and tools. The lathes will be steam-powered; cables, belts and shafts lie and hang about the shop. Manoeuvring around the machinery could be as tricky as operating it, and workplace accidents were relatively common.

Wheelwrights' workshop, 1903

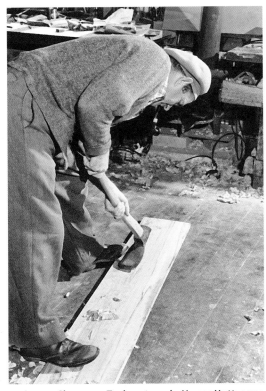

James Chapman-Taylor at work, Upper Hutt, 1954

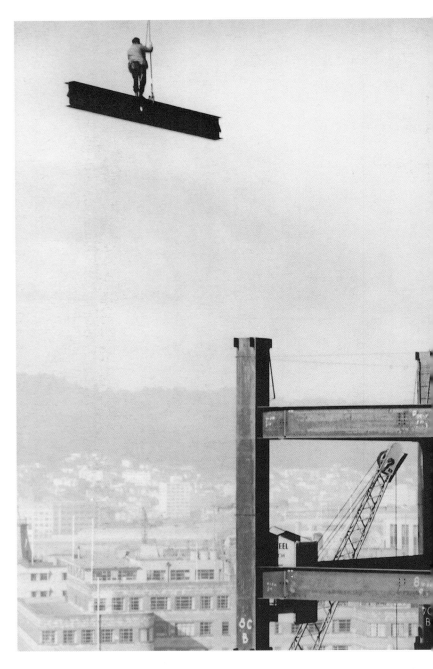

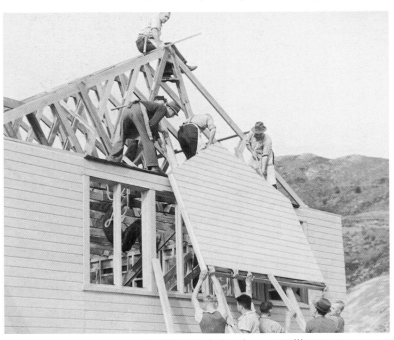

Prefabricated state house, Wellington, 1940s–50s

THE BUILDING INDUSTRY As the public sector grew in the first 20 years of the twentieth century, initiatives by national and local government created more work in the building trades. New post offices, public libraries and government offices were built in the major centres. The welfare state facilitated private home ownership, and the building of state houses from the late 1930s involved large numbers of workers and private companies. In 1940 alone, 5,000 new state houses were built by nearly 200 firms employing 5,000 workers. **BOTTOM LEFT** Some of the carpenters and labourers built state houses on site, but others, such as the builders photographed here, erected the prefabricated housing that was introduced in 1943. At the other end of the housing market, highly skilled craftsmen designed and built houses, and sometimes the furniture they contained. **TOP LEFT** James Chapman-Taylor, photographed here in his studio adzing rimu in 1954, had a career spanning 60 years, during which he designed and built more than 80 houses.

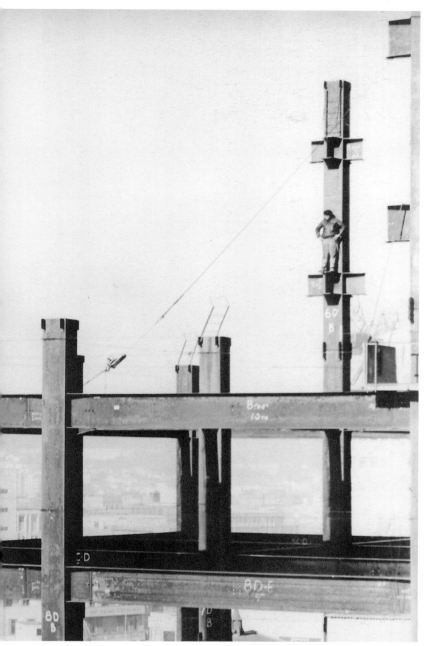

Reserve Bank building, Wellington, 1969

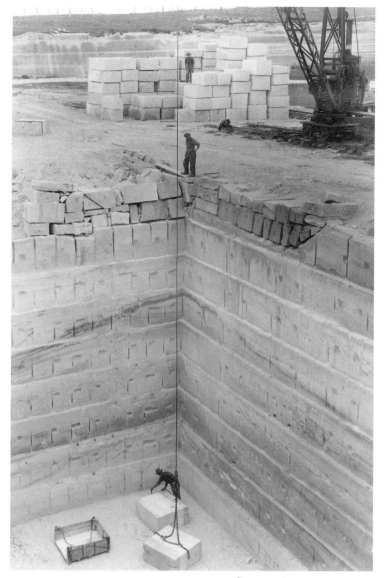

Oamaru stone quarry, 1920s

THE BUILDING INDUSTRY More spectacular building work was available on the multi-storey structures erected in major towns and cities. **ABOVE LEFT** Construction began on the Reserve Bank building in Wellington in 1969; this photograph (taken in September 1969) shows builders engaged in the precarious process of securing the beams in place. The Reserve Bank was one of many buildings constructed in the last third of the century after the demolition of local landmarks and historic buildings. In this case a central-city church had been pulled down; part of the 'New Zealand Government State Fire Insurance' building visible behind beam '8DB' would be replaced with a glass tower in the 1980s.

Homes and public buildings in Otago were sometimes made of Oamaru stone, a pale limestone with good insulating qualities that was quarried around Oamaru in North Otago. **ABOVE RIGHT** Some of the quarries were vast pits where the stone was chiselled out in layers before being removed by crane, stacked and shipped off.

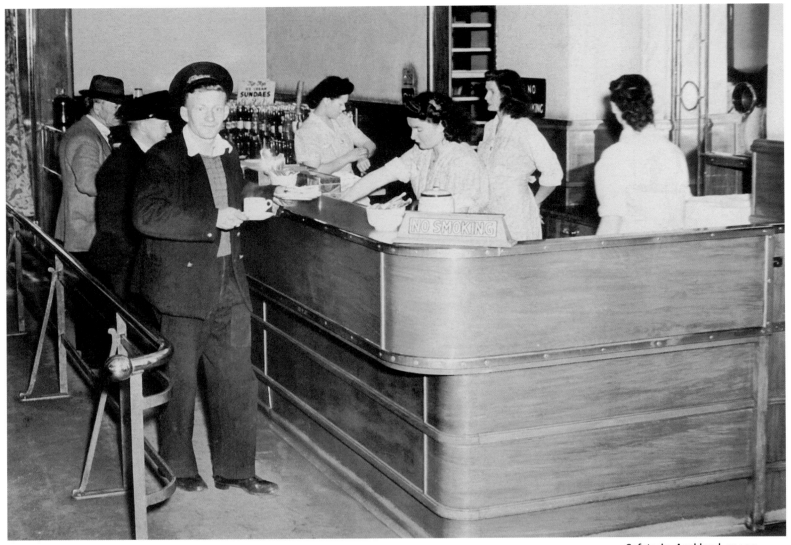

Cafeteria, Auckland, 1940s

BEHIND THE COUNTER In shops, tea-rooms and supermarkets in all parts of the country, women have stood or sat behind the counter in large numbers, for they have dominated the service industry throughout the century. **TOP RIGHT** While relative quiet might characterise a Timaru bookstall or stationer's in 1950, the number of staff behind the counter in an Auckland cafeteria in the 1940s suggests that the business was likely to be brisk. **ABOVE** In a workplace in which time was of the essence, one of the staff is checking her watch, perhaps for the next break or shift.

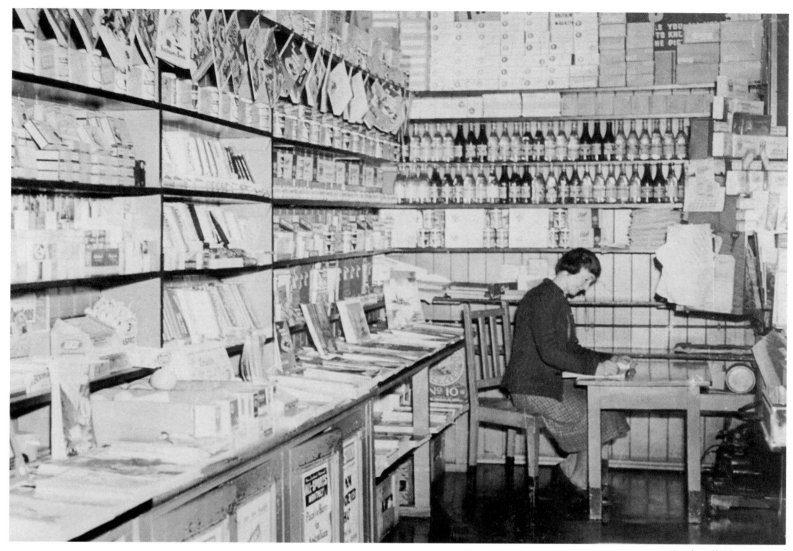

Bookstall, Timaru, 1950

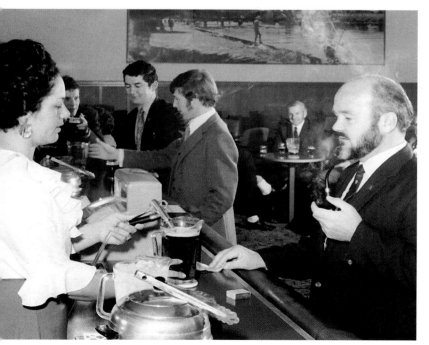

Serving beer, Kaiti, 1971

BEHIND THE COUNTER Women's and temperance groups opposed the employment of barmaids in the early part of the century on the grounds that the work was thought to 'coarsen' women; from 1910, most barmaids were banned. For Maori, there were additional barriers: fears about the effects of alcohol on the Maori population led to a prohibition on Maori women even being served in pubs in some parts of the country until the later 1960s. The convention that prohibited all women from entering the public bars of hotels was broken only with the demise of the six o'clock swill in 1967, after which public bars stayed open longer and began to lose some of their more unpleasant characteristics. Despite these prohibitions, women continued to work in hotels, especially if they were related to the hotel-keeper, but barmaids were not officially allowed back behind the bar until the 1960s. **LEFT** A few years after the ban was lifted, this Maori woman was photographed serving in the lounge bar of a hotel at Kaiti, a suburb of Gisborne, in 1971.

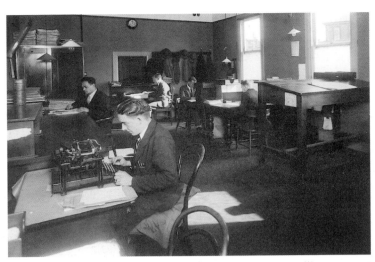

Refreshment Branch, Railways Department, Wellington, 1932

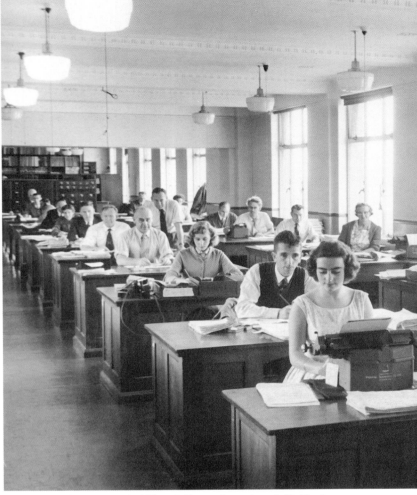

Chief Accountant's Office, Railways Department, Wellington, 1959

IN THE OFFICE Clerical work and typewriting shifted from being a man's job to a woman's during the century. **ABOVE** The photograph of the staff of the Refreshment Branch of the Railways dates from 1932, but male-dominated city offices became less common from the 1920s. Men's participation in the First World War created opportunities for women in clerical work which continued for the rest of the century. Despite the introduction of equal pay legislation (covering public servants in 1960 and the private sector in 1972), women's pay was usually less than men's, even for the same type of work, and some employers believed that women had less interest in advancement and responsibility. **TOP RIGHT** By the 1950s, when the photograph of the Chief Accountant's Office of the Railways was taken, women and men were sharing desk work. Significantly, only women operate the typewriters: their small and nimble fingers were thought to make them natural typists. The men here probably had the more responsible job of handling the accounts. **FAR RIGHT** By the 1980s, as the photograph of a State Insurance Office shows, the clerical office had become an all-female environment, with early computers replacing typewriters.

Banking technology and automatic payments have largely made the weekly pay packet redundant. For most of the century, however, people received their pay in cash directly from their employers, and for large organisations, security was an issue. **RIGHT** This photograph shows the pay office for the Public Works Department at Taihape while the North Island Main Trunk Railway Line was being built. The office handled a considerable amount of cash, and the men worked behind drawn curtains, with a rifle handy in case of emergency.

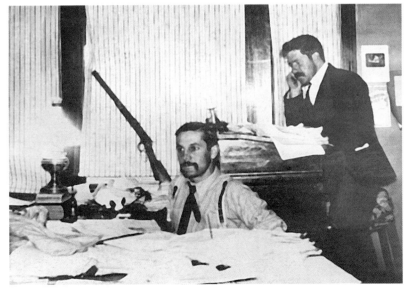

Pay office, Public Works Department, Taihape, 1906

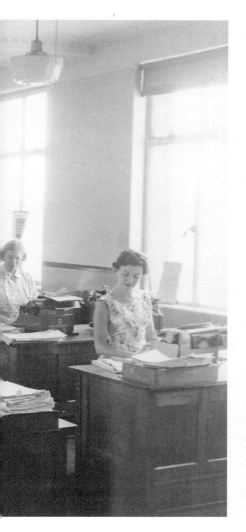

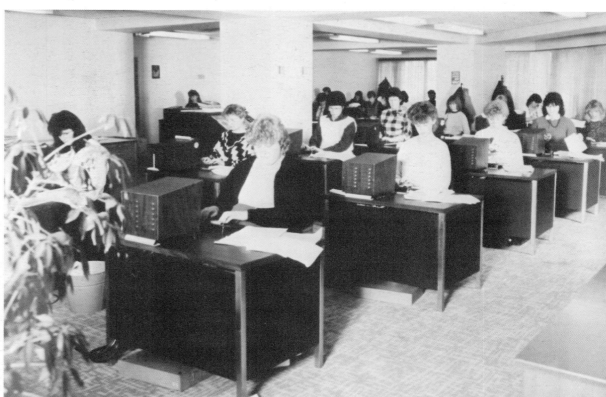

State Insurance Office, 1980s

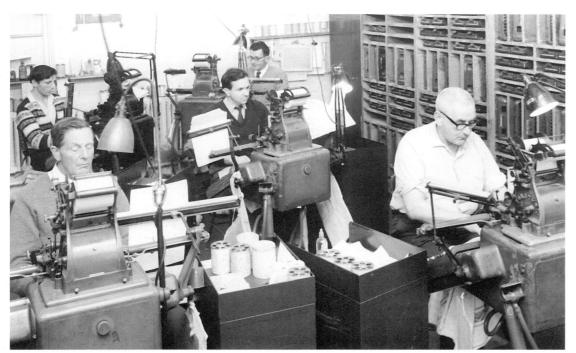

Government Printing Office, 1966

IN THE OFFICE The Government Printing Office was established to produce official publications and print legislation. **LEFT** These men in the keyboard section in 1966 were probably monotype operators, using technology that had replaced the centuries-old method of typesetting by hand. Two decades later, computers would further transform the nature of this work. Men and women would sit in front of computer screens with a range of fonts at their fingertips; their role would be formatting and designing text rather than keying it in.

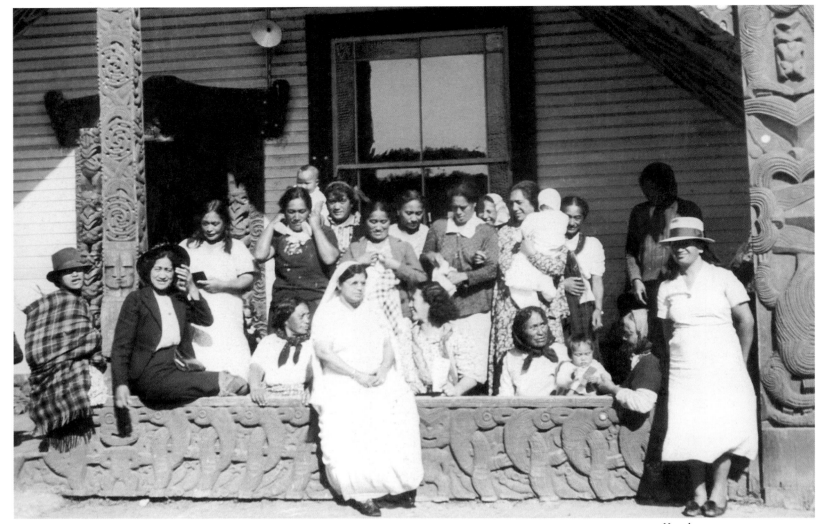

Maori nurses, 1920s–30s

FOR THE PUBLIC'S HEALTH New Zealand's first district nursing scheme began in 1901 when Nurse Sybilla Maude led a small team of nurses into the homes of the sick in Christchurch. This scheme was the fore-runner of a system administered by the Department of Public Health that expanded into remote parts of the country from the 1910s. **RIGHT** Here a district nurse prepares for her rounds in Northland in 1928; to reach a scattered population on rough roads, district nurses in country areas had to be able to ride as well as nurse.

District nurses could visit anyone who needed care, but a special Maori Health Nursing Scheme was established early in the century to allow Maori nurses to train and administer to the health needs of their people; although theoretically nationwide, this scheme worked most intensively in the Maori communities in Northland, the East Coast and the central North Island. **ABOVE** Many of the nurses involved in this scheme were Pakeha, but some Maori women trained as nurses and worked in their own communities, like the nurses photographed here, perhaps in the 1920s or 1930s.

District nurse, Kaipara, 1928

FOR THE PUBLIC'S HEALTH Until the late 1930s, government-appointed Native Medical Officers (who were also in general practice) worked in Maori communities, particularly in the North Island. The Native Medical Officer scheme was abandoned after the Social Security Act 1938 changed the way that medical fees were paid, and Maori health care became part of more general medical attendance. **TOP RIGHT** A government photographer accompanied this rural doctor on his rounds in the Whangaroa district in 1950. Dr Williams called on Maori families, checking on the health of youngsters in particular; by this time health professionals were well aware of the generally lower standard of living among Maori. The photographs were also commissioned to show the poor condition of Maori housing in rural districts.

Nursing was one of the few professions open to women at the beginning of the century, and their employment opportunities increased as the public health system expanded from the 1920s. **MIDDLE RIGHT** This photograph shows schoolboys being inoculated, perhaps against polio in the 1950s. At this time, women dominated nursing, and comparatively few trained as doctors. During the last quarter of the century, however, more women became doctors, and men began to enter nursing. The training and dedication required in nursing were not reflected in the profession's pay or status; like other professions dominated by women, nursing remains relatively low-paid.

The increased use of technology in the health sector has sometimes required more rather than fewer staff. **BOTTOM RIGHT** In this photograph of an operating theatre, perhaps in the 1970s, several professionals are on duty, as surgeons, anaesthetists, surgical nurses and supervisors. The rows of scalpels, scissors and other medical instruments set out on trolleys, the lights and the television monitor giving the surgeons another view of their progress — all convey an atmosphere of concentration and skilled work.

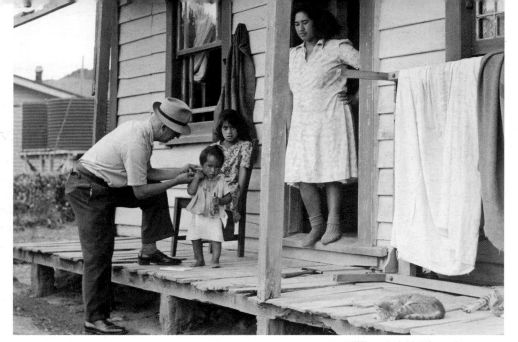

Dr Williams' visit, Whangaroa, 1950

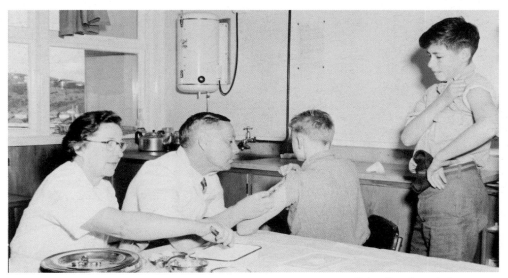

Schoolboy inoculation, 1950s

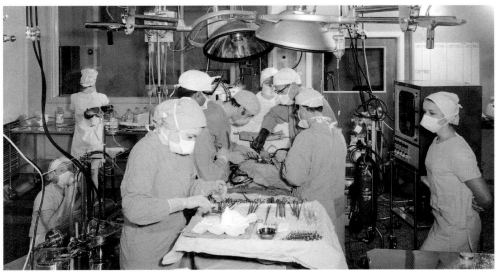

Operating theatre, 1970s

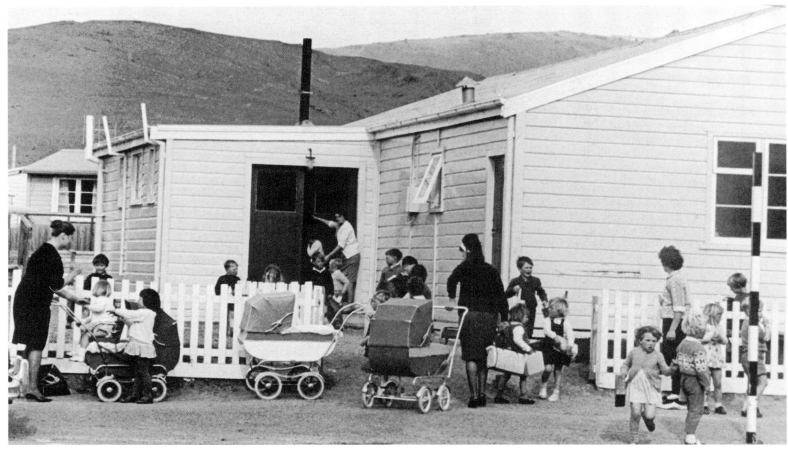

Day care, Otematata, North Otago, 1960s

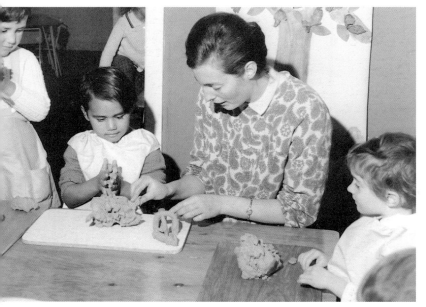

Hillsborough Playcentre, 1968

CHILDCARE — FOR LOVE OR MONEY The care of children has involved a mixture of paid and unpaid labour, as these two photographs illustrate. **ABOVE** The women collecting their youngsters from the Otematata day-care centre in the 1960s would have had few opportunities for paid employment in the hydro settlement. While their children were at the centre, their time was probably spent in housework, caring for smaller children, or community activity. Some of the women may have worked as unpaid helpers at the centre, as pay for childcare workers was often low and the centres tended to be under-staffed. The Playcentre movement that began in the 1940s was based on the active participation of parents, and encouraged children to develop at their own pace. **LEFT** At the Hillsborough Playcentre, photographed here in 1968, an adult assists the children playing with clay.

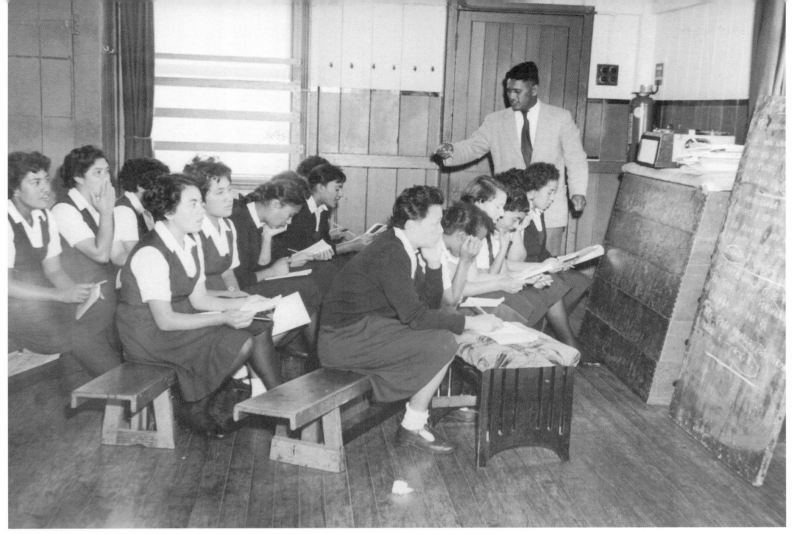

Hoani Waititi teaching te reo, 1950s

CHILDCARE — FOR LOVE OR MONEY During the 1980s the teaching of Maori language to young children was boosted with the establishment of kohanga reo (Maori language nests), the first of which opened in 1982. Most teachers in kohanga reo and kura kaupapa Maori (Maori primary schools), as well as their fund-raisers and supporters, have been women. **RIGHT** The role of kuia, who spoke Maori fluently and passed on their knowledge, was crucial, but the young mothers and older sisters photographed here with their children and siblings were also important in the kohanga reo movement. **ABOVE** An earlier teacher, Hoani Waititi, wrote two important language texts in co-operation with the Maori Language Advisory Committee; these remained the standard teaching guides for te reo for a number of years. The class photographed here was perhaps at the Queen Victoria School for Maori Girls, where Hoani Waititi taught periodically in the 1950s.

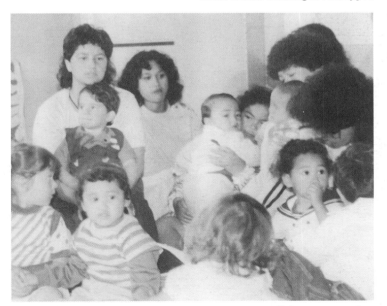

Kohanga reo, 1980s

AROUND THE HOME The work of running the New Zealand home has been gender-specific. House-work has primarily been women's responsibility, whether or not they were also in paid employment. In the years immediately following the Second World War, when domesticity and home life were emphasised, one of women's essential tasks was to make the home comfortable for their husbands. **TOP RIGHT** The photograph of the couple in Auckland's Symonds Street flats in the middle of the century captures a domestic moment. After the day at the office, this man's work was done. He could relax, put his feet up and read the paper; he did not expect to prepare meals or do housework. Her work, however, continued into the evening, with a meal to be cooked and darning to be done.

Men's household work was outdoors — visible, semi-public tasks that showed a man was a good provider who kept his household in shape and added value to the property. Tending the vegetable garden, building fences, mowing lawns and laying down drives were all usually done by men. **RIGHT** These two men are pouring concrete for a path at their Auckland home in 1969 — a job undertaken in many a New Zealand suburban street on many a Saturday morning.

Symonds Street flats, Auckland, 1940s

Pouring concrete, Auckland, 1969

Dixon Street flats, Wellington, 1940s

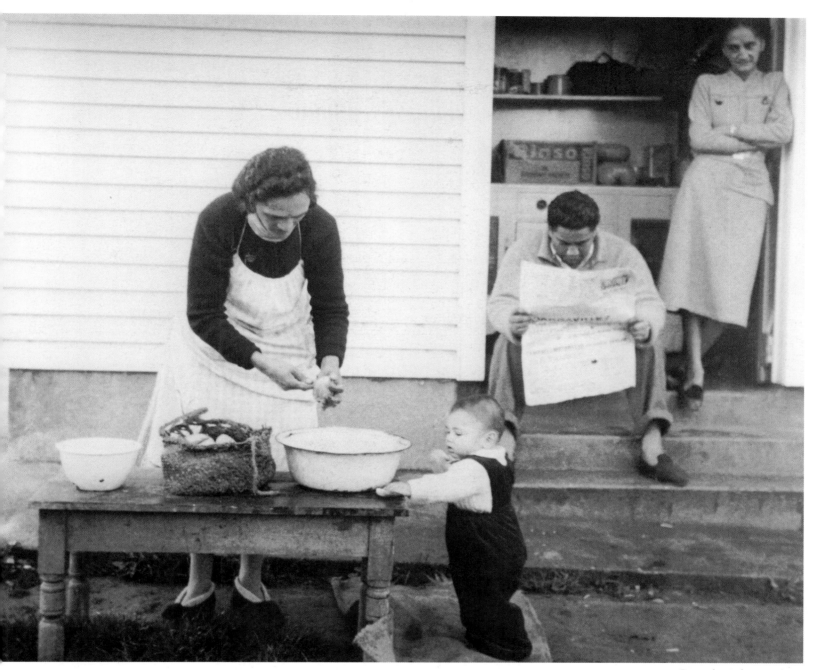

Preparing toheroa, 1950s

AROUND THE HOME Household work such as cooking, cleaning and washing fell to women until late in the century, although the context and methods altered radically over time. These two women are preparing meals under very different circumstances, and probably with different knowledge of food and cooking techniques. **ABOVE** Surrounded by members of her family, this Maori woman is preparing freshly gathered toheroa for fritters, a messy job best done outside; the photograph was one of a series taken to show Maori use of seafood. **LEFT** The woman standing at the bench lived in Wellington's Dixon Street flats, built by the government in the early 1940s and equipped with carefully laid-out kitchens. The bowls and bottles of milk arrayed on the bench suggest that this photograph was posed to show the style of kitchen that state housing could provide.

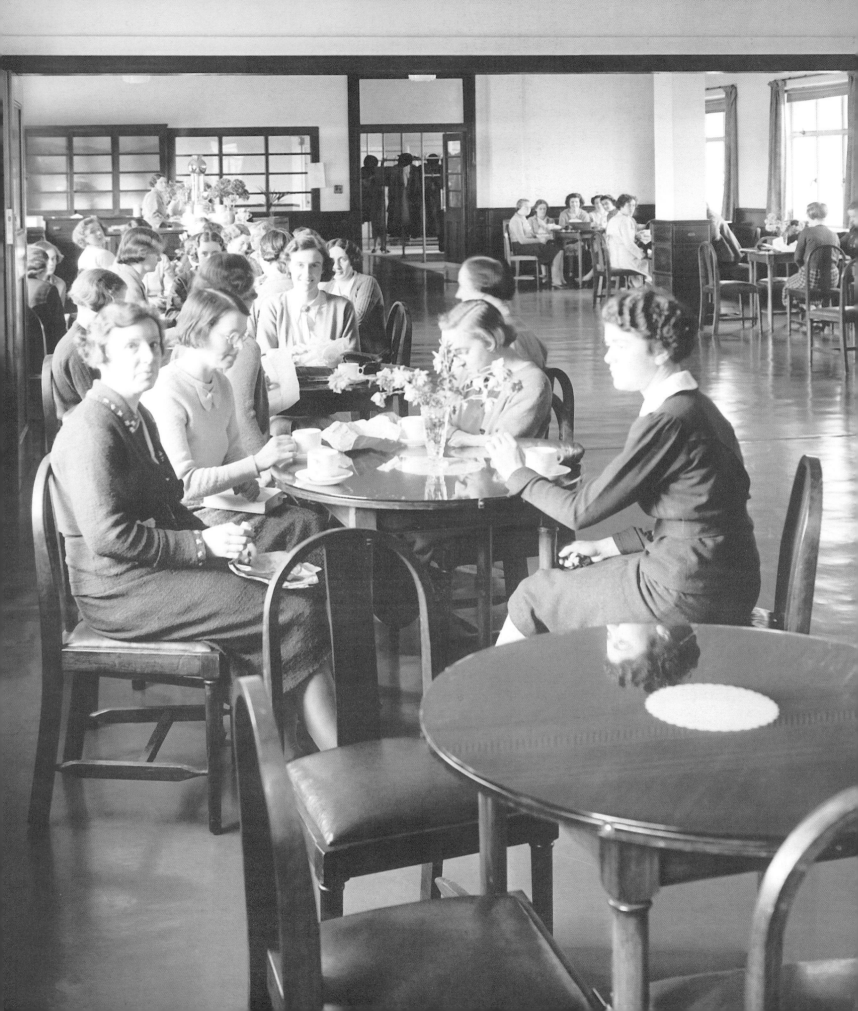

Nurses at tea, 1916

Smoko in the field, 1950s

TAKING A BREAK Tea and coffee breaks have been important markers in a working day: a chance to sit down, chat with fellow workers, do a bit of shopping, or simply get away from the workplace. **LEFT, FAR LEFT** The breaks taken by the nurses in 1916, and the women working at the Railways office in Wellington between the wars were genteel affairs, with china pots of tea, vases of flowers on the tables, lace doilies and highly polished floors and woodwork. The office staff would have been members of the different sections of the Railways Department — accounts, typing and other administrative units — and it is likely that each group congregated at its own table, chatting among themselves.

OPPOSITE Railways staff cafeteria, Wellington, 1920s–30s

The group of fruitpickers in the middle of the century are enjoying a more informal 'smoko'. The matching cups that several hold suggest that the farmer's wife may have been responsible for providing the tea and the thick slabs of cake.

For manual labourers, smoko rooms mostly offered little in the way of comfort, being places for a quick smoke or a cup of tea. An electric jug, jars of instant coffee, a couple of ashtrays, table and chairs and a radio were the only facilities in the hut of this group of railway workers in the mid-1970s.

LEFT Smoko room, Auckland, 1976

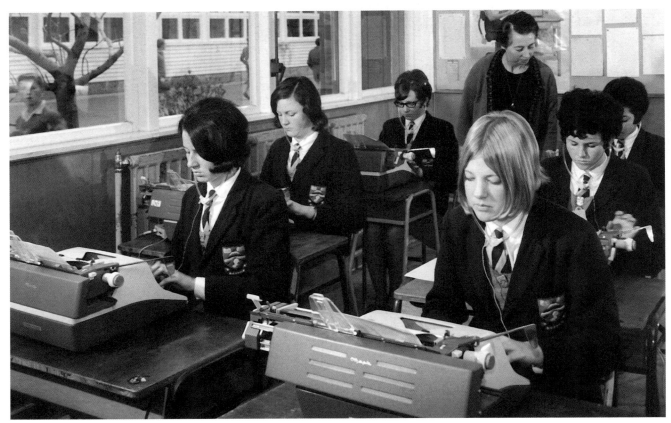

Dictaphone class, Taita College, 1968

EDUCATION FOR WORK Vocational training was an integral part of New Zealand's education system. Throughout the century, schools provided different forms of practical training for girls and boys. Boys and young men received instruction in suitable masculine tasks — metalwork, applied sciences, agriculture or woodwork. Girls and young women were taught domestic skills or trained for women's occupations such as typing. **ABOVE** The girls typing from dictaphones at Taita College in 1968 were destined for secretarial work.

Hunter training school, Golden Downs, 1958

Post and Telegraph training, Burnham, 1948

EDUCATION FOR WORK Apprenticeships and training on the job enabled people to enter the workforce and those already employed to improve their skills. **ABOVE** The group of men at a training school for postal and telegraph workers in 1948 learned skills in circuitry, the mechanics of telegraph insulators and, judging by the strategic placement of ladders and telegraph poles, the art of pole climbing and fixing insulators. **LEFT** The hunter training school operated by the Forest Service at Golden Downs, Nelson, trained young forestry workers to fend for themselves in the bush, and to hunt. The instructor's sketch of 'target and bush' may have been for the benefit of the camera, or perhaps training began at this most basic level, although hunting was supposedly a part of the way of life for the young New Zealand male.

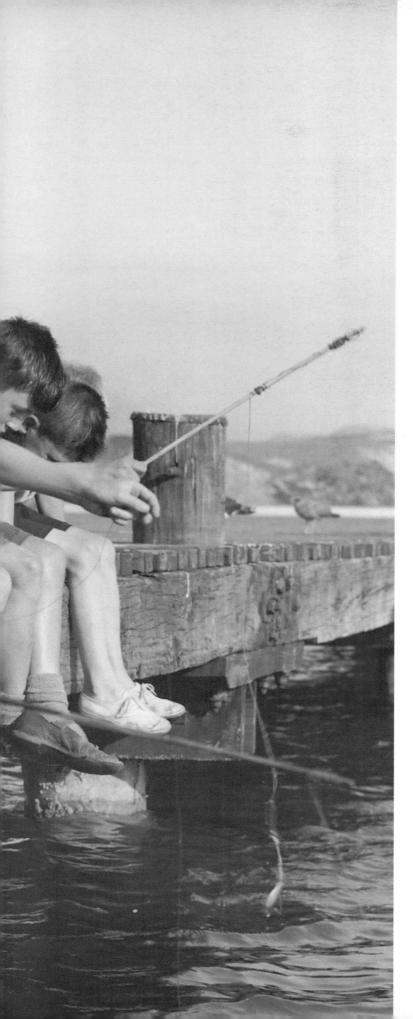

Generations of New Zealand children (especially boys) have enjoyed fishing — from the wharf, off the rocks, or from dinghies. Here boys dangle baited lines off a wharf in the 1940s.

Fishing, 1940s

Time Out
Recreation and Leisure

As a modern society began to evolve in New Zealand in the early twentieth century, a new concept of 'leisure time' began to emerge. A more settled and urbanised society, the greater regulation of hours of school and work, improved transport and communication systems and smaller families combined to make the time 'ripe for leisure to take on a new importance'.[1] In periods of economic prosperity such as the 1920s and the two decades after the Second World War, leisure activities blossomed further. By the second half of the century, leisure and recreation were embedded as part of contemporary society.

Earlier in the century, community-based activities were popular.[2] School, work and club picnics, for example, were regular community events before the Second World War at places such as Wellington's Days Bay and Auckland's Domain.[3] Social evenings and dances were run by women's organisations and local clubs in community halls throughout the country. Many churches provided recreational activities for their congregations or local communities: picnics, dances, sports teams, reading and study groups were part of the services that religious groups offered. These events, focused in the local community (whether urban or rural), played a large part in the social calendar of many New Zealanders early in the century, but faded from the 1960s onwards.

Many community-based activities in both urban and rural areas centred on clubs. New Zealanders have been great joiners. Clubs and associations dedicated to a wide range of causes, hobbies, fellowships, skills and interests proliferated in the first two decades of the century and again from the 1970s. The First World War generated many organisations, often formed by women's or patriotic groups, devoted to aiding the war effort, providing for the comfort of soldiers or sending relief packages to refugees. In rural areas, groups such as the Farmers' Union (founded in 1899 and later known as Federated Farmers) and the Women's Division of Federated Farmers (founded in 1925) provided important local networks. Musical and performing arts

clubs flourished from the first years of the century, and most major (and several provincial) towns had an orchestra or choir. Local choral and operatic societies, chamber music groups and amateur dramatic societies were active throughout the century, many organising national tours in the years before the Second World War.

Leisure based on the home, family and friends was simpler than more organised activities: visiting friends and relatives, sharing a cup of tea or a glass of beer, knitting, playing with the local kids, watching TV, reading, walking in the park, riding horses, playing computer games. Many of these activities required virtually no preparation and demanded little effort. Many were also 'free', and open to people regardless of where they lived or how much money they had. Some of them — watching TV, reading and gardening — were among the most popular forms of recreation at the end of the century.[4]

The introduction of the 40-hour week in 1936 made Saturdays and Sundays special days. Saturday morning was often spent pottering around the house — mowing the lawns, digging the vegetable garden or watching children's sport — while the afternoon, for men especially, might be devoted to team sports, the races or the pub. In this context, Sunday developed a special status as a day for family leisure.[5] The automobile gave families more mobility, and by the 1930s the Sunday drive had developed its widespread and enduring popularity.[6] The weekend was the time for exploring the great outdoors — one of the great New Zealand pastimes — and the growing number of private motor cars in the 1920s, and again from the later 1950s, gave more people access to the beach, the bush and the mountains. Tramping, fishing and hunting have been popular (particularly among men) throughout the century, but private cars brought the bush and the rivers much closer to those who lived in urban areas.

In the late nineteenth and early twentieth centuries commercially organised leisure expanded. Dance halls and picture theatres, for example, offered new forms of entertainment; for those with money, they were an alternative to church-run dances and picnics. Some commercial activities were highly organised and cost a lot to host or attend. Patriotic gatherings and one-off events such as the openings of venues, hot-air balloon displays and the landing of aeroplanes attracted crowds.

Economic prosperity encouraged the growth of commercial leisure in the early part of century, but other factors were also involved. More young women, for example, were entering the paid workforce as factory hands, shop assistants and clerical workers; their regular working hours gave them more time for recreation than domestic service had allowed. These young women probably still visited friends, sewed and knitted for recreation as their mothers had done, but the 'new women' of the 1910s and 1920s demanded — and took — their leisure in more diverse ways, and they had more money to spend.[7]

New Zealand's urbanisation from the 1910s both fostered commercial leisure opportunities and enabled the growth of new community-based forms of recreation, particularly clubs and associations. Towns and cities could sustain leisure enterprises, and provided a critical mass of members for organisations of various sorts. Larger centres were more likely to support art galleries and museums and be visited by touring shows. By the end of the century Wellington was hosting a biennial International Festival of the Arts, and in 1998 the national museum was transformed from the Dominion Museum into a major and controversial new institution, the Museum of New Zealand Te Papa Tongarewa. Most major centres also had significant art collections in their own galleries and hosted film and arts festivals of various kinds.

In the last quarter of the century there was an explosion in the most commercial form of recreation: shopping. Shopping for pleasure has always been a part of affluent life: department stores, for example, went out of their way in the 1920s and 1930s to encourage browsing and purchasing, providing lavish mail-order catalogues for rural customers or afternoon tea in their own tea-rooms.[8] Greater availability of cheap goods, the development of large shopping complexes and

Sole Brothers and Wirths Circus, 1956

malls from the late 1960s and the easing of restrictions on Saturday shopping all helped turn shopping into recreation for more New Zealanders. With more women in the paid workforce from the 1960s, shoppers often had more disposable income. At the same time, skills such as sewing and knitting began to be seen more as recreation rather than as a contribution to the household economy; cheaper clothing reduced the need for women to sew and knit garments for the family. By the 1990s, the retail areas of most main towns and cities were busy every day of the week.

Sports have been among the most organised forms of recreation. Some major sports were well established by the beginning of the twentieth century, including rugby and cricket. The inter-provincial competitions in these and other sports have been significant to regional identity in New Zealand. More regular working hours allowed people to participate in team activities, and the reduced physical demands of work released people's energies for sport.[9]

This was noticeably the case for women in the years following the First World War. Long hours of domestic service (until the 1920s the major form of paid work for women) would have affected women's ability to take part in the sports that were then starting to become fashionable. The demise of domestic service corresponded with a period of growth in women's team sports and female participation in a wide range of outdoor pursuits, including cycling, golf, basketball and swimming.

In the first two decades of the century, a national interest in physical health and fitness boosted the popularity of sports and physical activity. Personal health and fitness was considered by many to be the basis of a healthy society and nation. Swimming, tramping, mountaineering, lifesaving, tennis and golf all flourished in this period, and New Zealanders pursued the 'body beautiful' through activities from body-building to health and beauty clubs.[10] By the late 1930s, the government had also begun to promote sports and physical education. The Physical Welfare Branch of the Department of Internal Affairs sent out physical fitness instructors to community groups,

Performing animals featured in the travelling circuses that toured New Zealand during the 1950s. Here children and adults cross the railway lines for a free view of the elephants from the Sole Brothers and Wirths Circus before they are unloaded.

Tennis match, Te Horo School, 1950s

Sporting facilities in rural areas have always been simpler than those in towns. Small sports clubs share their facilities with other groups, or borrow grounds at public facilities. Here local people play tennis at Te Horo School on the East Coast in the 1950s. Spectators sit against fences and buildings to watch the games. Cows graze in the paddock next to the courts, and a stack of firewood has been assembled for collection or a bonfire. The players themselves have dispensed with the dress code of urban clubs. Long skirts, shorts, long pants and checked shirts are as much in evidence as tennis whites.

and in the 1940s a standardised physical education programme was incorporated into the secondary school curriculum.

Sport kept youngsters busy, made women healthy, and men masculine. Keeping young people physically active in and after school was one way to keep them off the streets and out of mischief. From the late nineteenth century, and particularly from the First World War, physical education was a feature of the primary school curriculum, while in the playground the more unruly games were discouraged.[11] Organisations such as the Young Men's and Women's Christian Associations provided thorough sports and fitness programmes; involvement in sport was widely considered to be a way of taming unruly juvenile behaviour and providing an outlet for adolescent sexual urges.[12] Women's sports grew as attitudes to physically active women and girls changed in the 1920s. From being considered detrimental to women's mental and bodily health (and their child-bearing potential), sport became a way for women to demonstrate their well-being.[13] Sports like boxing and rugby were also thought to show manliness. Rugby in particular has been tightly entwined with notions of national identity and success. It has also been the focus of considerable controversy, particularly surrounding issues of anti-apartheid and sporting contact with South Africa.[14]

The major shift in sporting activity in the second half of the twentieth century has been towards individual rather than team activity.[15] Gym culture epitomises the contemporary sporting ethos: a gym workout can be done alone and at any time of the day or the year, and it supports the end-of-the-century obsession with physical appearance. It is also intensely commercialised. Like its outdoor counterpart, mountain biking, gym culture sustains an entire clothing and equipment industry, with special drinks and dietary supplements reinforcing the connection between appearance, sport and consumption.

Professionalisation and commercialisation have moved sport more clearly into the realm of entertainment. Watching sport has always been as popular as playing it. With the communications revolution of the 1980s and 1990s, 'spectator sport' became an event in itself.[16] Rugby matches such as those in the Super 12 series provide pre-match and half-time entertainment aimed at the whole family, and the televising of games means that the spectacle is shared throughout the country. While this repackaging has been a deliberate move to woo back support for the game lost in the 1980s, it is also part of a broader trend of blurring sports, consumption, commerce and entertainment.

New Zealanders' experiences of leisure have been influenced by many things: the availability of time off, access to facilities, financial resources, social status and region. Women and men, however, have largely inhabited separate worlds of leisure.[17] Women have often favoured domestic activities such as visiting friends, gardening or handcrafts (which sometimes blur into work).[18] Married women's leisure has been defined by their domestic role, with the demands of housekeeping and childminding taking precedence over recreation outside the home. Men tended to spend their time off in both the domestic and public realms — playing rugby, drinking at the pub, gardening, and spending time with the family. For much of the century, men were the primary income-earners in the family and the community, and could more easily pay for commercial leisure activities. These patterns changed from the 1970s as family size decreased and more women entered paid work. Greater earning power increased the range of activities available to women; since the 1980s, for example, women have been keen participants in the gym culture and its surrounding consumption. The rise of individual physical activity has also helped to break down some of the traditional boundaries between women's and men's activities.

Leisure pursuits in country areas had their own character. A scattered rural population made large commercial enterprises unprofitable. The specialised sports facilities found in cities were rarely developed in the country, where racecourses, community halls and sports fields often hosted many different activities. While towns had picture theatres in the 1920s and 1930s, smaller communities screened films in local halls or even from the vans of touring cinemas.[19] Especially popular in rural areas (although they were also held in cities) were the annual Agricultural and Pastoral Shows, which combined opportunities for trade with recreation and entertainment; they attracted people from surrounding districts, and, like country dances, were special events in rural communities for much of the century. Country people also had good access to New Zealand's bush, mountains and waterways, and activities such as tramping, hunting and fishing have been popular rural pursuits. Most rural New Zealanders, however, like their urban counterparts, spent much of their leisure time at home or on the farm, reading, spending time with the family, riding horses, hunting, tending the house and property, and, by the end of the century, watching TV and surfing the Internet.

Official photographers were often employed to depict the country's scenic attractions, so there is an emphasis in these photographs on public forms of leisure. People are shown at the beach, enjoying mountains and bush, fishing, or playing 'national' sports such as rugby or netball. More domestic recreation, such as handcrafts, gardening, TV-watching or reading, features little amongst the photographs in the Archives New Zealand collection. Likewise cultural activities — attending the theatre, playing musical instruments, listening to concerts, watching films — are largely absent. Despite this focus, the photographs collected here show New Zealanders at leisure in a wide range of activities, across the country and throughout the century.

Boxing match, France, 1914–18

THE MATCH AND THE MEET Soldiers who served in the century's many conflicts enjoyed a packet of cigarettes and a pack of cards in snatches of leisure on duty, or longer breaks. **RIGHT** This card game took place on the Noumea docks in 1943 as New Zealand soldiers waited to leave for the Solomon Islands in the Second World War. **ABOVE** Soldiers and officers also organised events such as rugby matches or this well-attended boxing bout in France during the First World War.

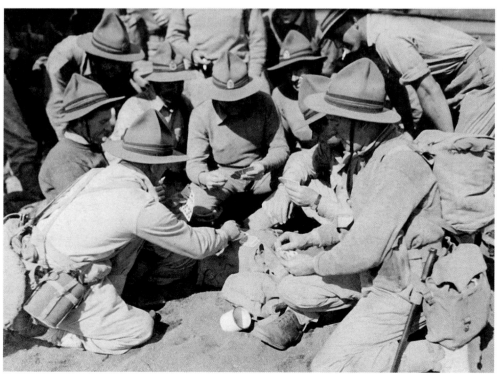

Card game, Noumea, 1943

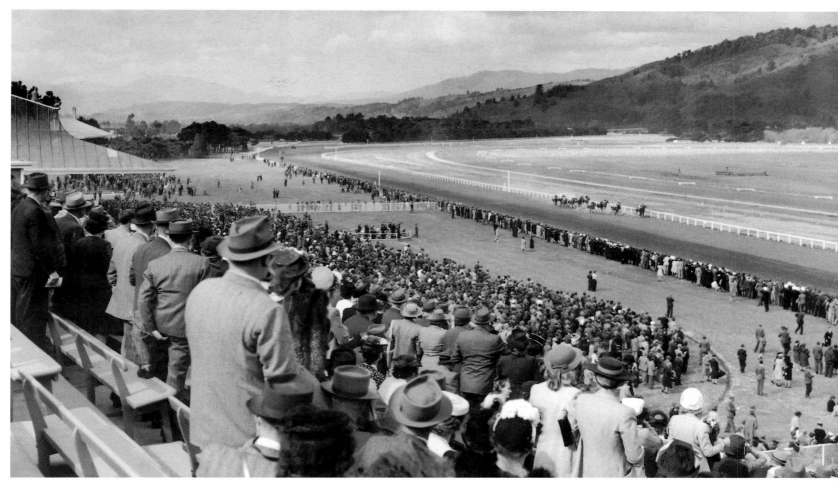

Trentham races, 1940s–50s

Auckland v Taranaki, 1960s

THE MATCH AND THE MEET Rugby and racing occupied hallowed ground in New Zealand culture for much of the century. **LEFT** This Ranfurly Shield rugby match between Auckland and Taranaki in the early 1960s would have drawn a good crowd, with many thousands of men around the country also listening to the live commentary on radio. Challenge matches for the Ranfurly Shield were played from 1904, and winning the Shield was a matter of provincial pride. The intensity of Shield matches is reflected on the faces of the players as a try is scored. **ABOVE** Horse racing was popular from the later nineteenth century, especially among working-class New Zealanders. The drama of the racing and the lure of easy money attracted large crowds to racecourses such as Trentham, near Wellington. In this photograph, probably from the 1940s or 1950s, spectators have followed the tradition of dressing up for race day, with suits, jackets and hats worn by the men, and suits, hats, and (in the foreground) furs by women.

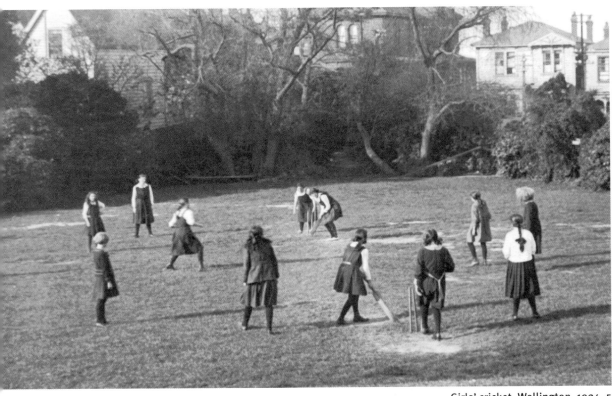

Girls' cricket, Wellington, 1924–5

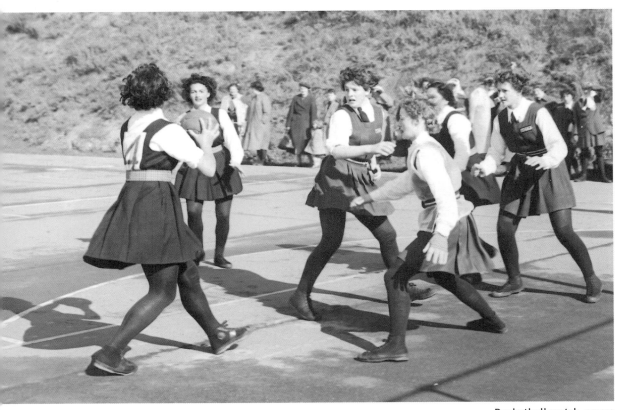

Basketball match, 1950s

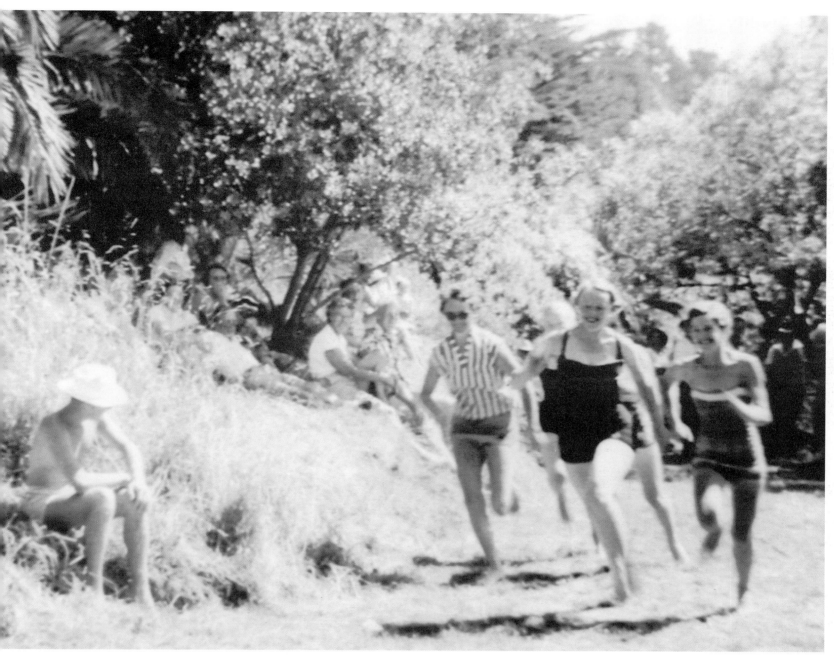

Picnic races, Hawke's Bay, 1961

THE MATCH AND THE MEET At the beginning of the century competitive sport was considered unhealthy for women (and believed to be particularly detrimental to their capacity to bear children), but after the First World War it was promoted as a way to improve female health and well-being. Sports such as cricket and basketball (renamed netball in 1970) became more popular during the 1920s and 1930s. **TOP LEFT** The pupils of Wellington Girls' College playing cricket in the mid-1920s are probably practising in the school grounds, although pitches in such poor condition were common enough features of women's sport. Women's teams tended to be assigned the least desirable playing fields and the boggiest paddocks. Basketballers escaped this problem, partly because the game was played on hard courts, and partly because men were not competing for the facilities. Yet basketball had its own restrictions. **BOTTOM LEFT** Until 1958, players had to wear the black stockings worn by the teams in this photograph, and it was not until 1970 that the pleated gym frock was replaced by a skirt and top. Here the game had nine players on each side, three of whom were allowed in the shooting circle; during 1958–9, the game moved to seven a side. Away from the sportsground, women could often be freer. **ABOVE** The women racing through the bush at a school picnic in Hawke's Bay in 1961 were continuing a tradition of informal competition at social events — three-legged races, sack races, pram racing and the married women's sprint.

Cricket, Upper Moutere, 1979

THE MATCH AND THE MEET Owning a boat — even a P-class yacht or a dinghy equipped with an outboard motor — may be beyond the reach of most New Zealanders, but boating is part of summer in many parts of the country. For some it is a sport, for others a pastime. In Auckland the annual Anniversary Day regatta on the Waitemata Harbour is a major event; these yachts are rounding a mark during a race in the 1974 regatta. **RIGHT** By 2000, the regatta had been held for more than a century, and sailing had become almost a passion with Aucklanders as the city cemented its reputation as the 'city of sails'.

Auckland Anniversary Regatta, 1974

Bowls, Wellington, 1975

THE MATCH AND THE MEET New Zealanders have been more active as sports spectators than as participants, especially since the 1920s. The crowds that flock to Carisbrook, or who turned on their radios to listen to the rugby, or later their TVs to watch the netball, have far outweighed the number of people playing these sports. These two photographs capture some of the more leisurely forms of sport and their spectators. **ABOVE** Lawn bowls has traditionally been the sport of an older generation, and is often played in park-like grounds. Far from the razzmatazz of the huge crowds at a rugby match, the people watching a bowls tournament at Wellington's Mt Victoria Club in 1975 enjoy the game from seats dotted around the green. **TOP LEFT** Cricket can also be played in a relaxed environment, as this family picnic in Upper Moutere in 1979 suggests. Day- or afternoon-long matches were perfect opportunities for lying in the sun. Here spectators could drive their cars to the edge of the paddock, giving the game an intimacy lacking at some large venues.

Manawatu A & P Show, pre-1920

SHOWTIME From the late nineteenth century, the local Agricultural and Pastoral Show was an annual highlight for rural, provincial and urban New Zealanders alike. Held in rural centres, and cities such as Christchurch, Palmerston North and Wanganui, the A & P show was a chance for farmers to display their stock, compete in dog trials and learn about the latest farm equipment and products; women could also display their household skills. The shows brought together rural and town folk; in places such as Christchurch, they were a chance for the town to visit the country without leaving the urban centre. **ABOVE** The photograph of the Manawatu show held in Palmerston North early in the century captures some of the excitement of watching the events, especially the popular Grand Parade, one of the final events of any show. The line of Clydesdales and carts would be followed by groups of animals waiting in the background; well-kept horses circle in the middle of the ring. The popularity of shows waned over the century, and by the 1980s, those in many larger urban centres had ceased.

Calf club day, 1968

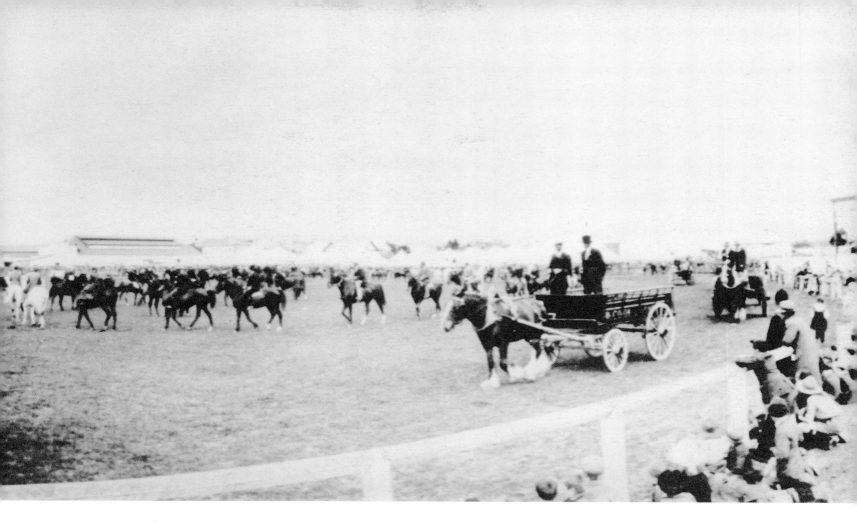

SHOWTIME Rural fairs and A & P shows included many competitive events. One of the most popular events for children throughout the century was the calf club day. **FAR LEFT** Here the pupils of one country school in 1968 prepare their animals (lambs as well as calves) for judging. Farm children were often given lambs or calves to hand-rear; as grown animals these would probably be despatched to the meatworks along with other livestock from the farm. **LEFT** While there was a national woodchopping competition, the sport was most frequently held as part of an A & P or other agricultural show. At Hikurangi, Northland, in 1967, a sizeable crowd gathers to watch the chopping and sawing competition, sitting close by despite the flying chips of wood.

Woodchopping, Hikurangi, 1967

Light the cigarette race, Tolaga Bay School Christmas party, 1953

SHOWTIME Community-based fairs were occasions for local people to gather and socialise. Compared with the larger A & P shows, school galas and rural fairs were usually modest affairs featuring book stalls, second-hand clothing sales and raffles. **LEFT** The Tolaga Bay Primary School's 1953 Christmas party is held on rugby fields on which stock still grazes. A merry-go-round and a local band sitting on the back of a truck offer entertainment. **ABOVE** One of the many games was the 'light the cigarette race': under the watchful eye of an older judge, young couples huddle closely together to light up. Presumably, only one cigarette was lit by a match; the other was lit by the couple standing closely together, cigarettes in mouths, and lighting one cigarette with the other. 'Adult' games like this had long formed a part of local picnics, where constraints were loosened, and people escaped from their usual roles or patterns of behaviour. Many picnic and party games reversed gender roles or included a courtship ritual, such as cigarette-lighting or a three-legged race.

Tolaga Bay School Christmas party, 1953

79

Musicians, Ruatiti, 1908

SONG AND DANCE Playing a musical instrument was a valued skill before the days of radio and mass entertainment, especially in isolated bush areas. **ABOVE** This group of surveyors at Ruatiti in the Wanganui back-country in 1908 posed for the camera with their instruments; the fiddle and mandolin would often be accompanied by a mouth organ. The two men thumping out a melody on piano and banjo at a rowdy function in the middle of the century were part of a 'do-it-yourself' entertainment heritage. **RIGHT** Playing the piano or a stringed instrument is not today associated with Pakeha masculinity, but the men in these photographs obviously combine work and boisterous mateship with a pleasure in music. A more common musical stereotype is the image of women at the piano, a feature of both urban and country life throughout the century.

Office function, 1950s

Dance, Auckland Community Centre, 1960s

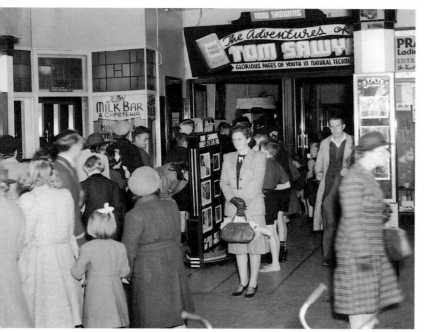

State Theatre, Palmerston North, 1940s

SONG AND DANCE Youth culture quickly adopted rock'n'roll music and all the dance forms that grew from it in the 1950s and 1960s. **ABOVE** These young people at the Auckland Community Centre display the slick foot and hip action known as the twist.

Until the advent of television in the 1960s, going to the movies was one of the most popular forms of mass entertainment. **LEFT** There were more than 500 picture theatres in the late 1940s, around the time this photograph was taken at the State Theatre in Palmerston North. The cluster of women and children queuing to see *The Adventures of Tom Sawyer* suggest that this may be a school holiday screening. Going to the movies was still an occasion requiring hats and gloves for the women.

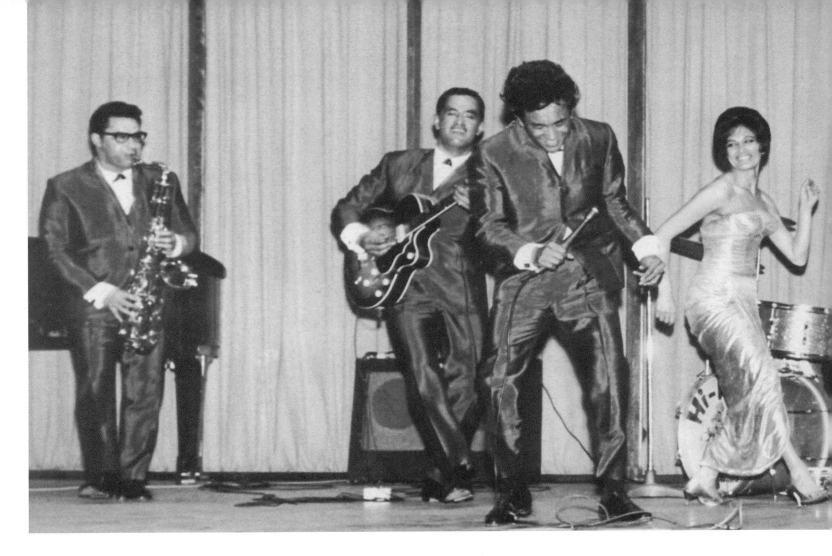

SONG AND DANCE Maori musicians enjoyed many different opportunities early in the century, from touring groups to performers in tourist centres such as Rotorua. Maori bands were particularly popular. **RIGHT** The band posed in the bush in the 1900s has not been identified, but they may have been members of one whanau (family), as many Maori bands were. In the second half of the century, Maori show bands and entertainers were much in demand. Groups such as the Howard Morrison Quartet sang, danced and played their instruments, sometimes with a comic panache immortalised in numbers such as 'Puha and Pakeha'. The combination of rock'n'roll, show bands and swing led to high-energy bands such as the Hi Fives, photographed in the 1960s. **ABOVE**

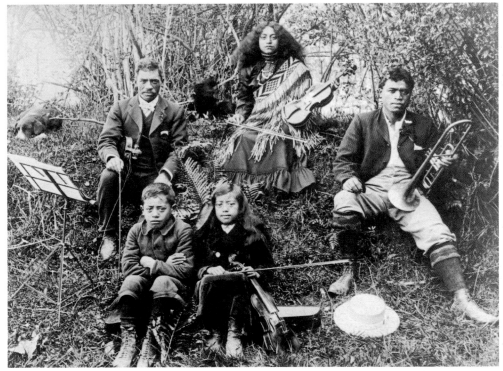

Musicians, pre-1910

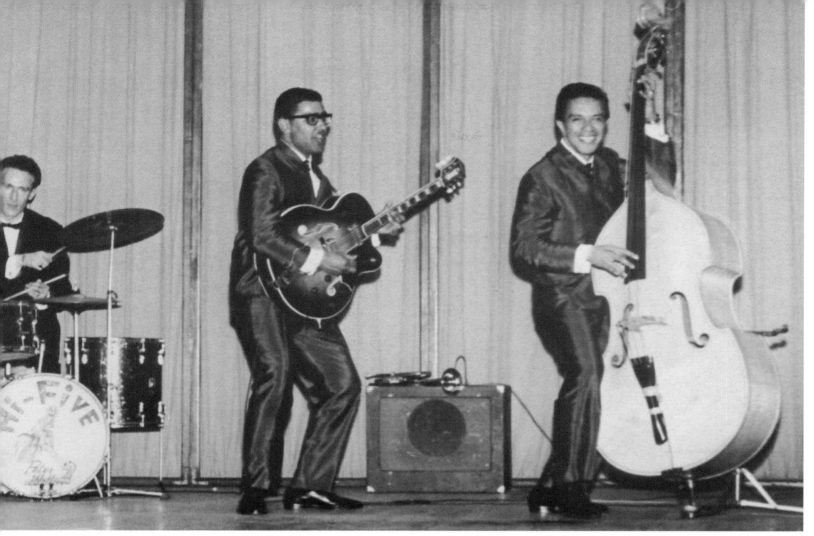

Hi Fives, 1950s

Symphony Orchestra, Wellington, 1972

SONG AND DANCE Early in the century, public concerts of classical music were performed primarily by international artists and a few short-lived orchestras and choral societies; radio played a wider range of music to a larger audience from the 1920s. European immigrants before and after the Second World War encouraged concerts, and local groups such as the Wellington Chamber Music Society (founded in 1945) initiated tours by international performers. New Zealanders were able to listen to a state-funded orchestra when the National Centennial Symphony Orchestra played at the 1939–40 Centennial Exhibition and later toured the country. The orchestra was disbanded during the war, but in 1947 the National Orchestra (later the New Zealand Symphony Orchestra) played its first concert. Here the orchestra plays in a packed Town Hall in Wellington in 1972. **LEFT**

THE GREAT OUTDOORS The rich experiences offered by the country's bush, mountains, lakes and rivers have been enjoyed by many New Zealanders throughout the century. There is untamed country close to most urban areas in which people can walk, boat, tramp, hunt and fish. **ABOVE** Some are drawn to more remote areas precisely because of their inaccessibility and isolation, captured in this photograph of Lake Rotoroa in the Nelson Lakes, perhaps in the 1920s. Shot through a wide-angled lens, it conveys the magnitude of the scenery; such photographs were taken by government photographers to market the scenic beauty and solitude of the country.

Hare drive, Hanmer, 1912–14

Boating on Lake Rotoroa, Nelson Lakes, 1920s

Tramping, Tararua Range, 1975

THE GREAT OUTDOORS Hunting, fishing and tramping form part of New Zealand's heritage, particularly for men. From the middle of the century, more women tramped (rather more than hunted or fished), and tramping sometimes became a family activity. But earlier in the century few women joined these vigorous outdoor pursuits, prevented by both convention and domestic responsibilities. **FAR LEFT** Not a woman can be seen among the hunters standing by their kill after a hare shoot near Hanmer in the 1910s. **LEFT** The hunters crossing a stream in the Tararua Range in the 1970s are probably on a weekend away in the bush; located close to Wellington, the Tararuas were a popular tramping area from the 1920s, and the proliferation of deer gave plenty of opportunity to both recreational hunters and the deer cullers employed by the Forest Service.

Fiordland expedition, 1949

THE GREAT OUTDOORS This skier on the Tasman Glacier appears almost to be part of the dramatic mountain landscape that New Zealanders and international visitors travel to every winter. **RIGHT** The wildlife photographer perched on a clifftop in Fiordland was part of a joint New Zealand and American expedition to photograph and explore the area in 1949. **ABOVE** Like many trampers in Fiordland before and since, this man has the company of two kea, or mountain parrots, birds known for their size and beauty as well as less endearing habits: they are raucous, inquisitive and prone to destroy expensive tramping equipment.

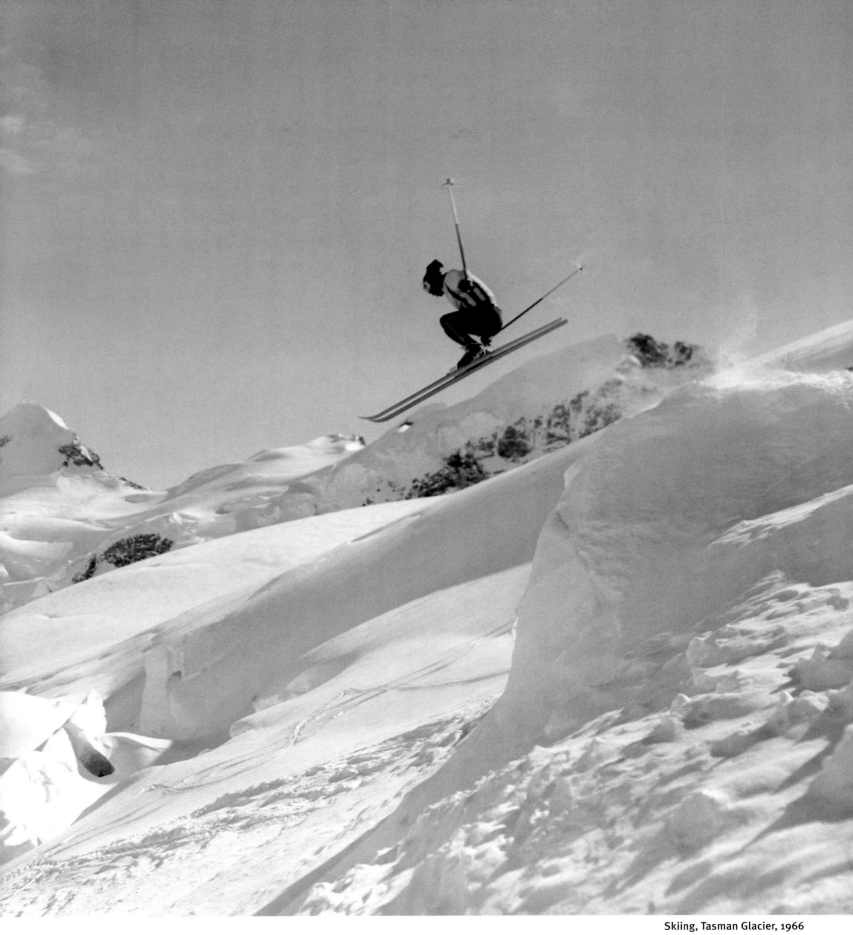

Skiing, Tasman Glacier, 1966

Descending the Franz Josef Glacier, 1920s

BEAUTIFUL NEW ZEALAND The Southern Alps and the North Island mountains featured on the tourist map, appealing to mountaineers and climbers as well as people keen to walk in the snow and ice. **ABOVE** The group picking their way down the Franz Josef Glacier from the Pinnacles in the 1920s were amongst the growing numbers of wealthy New Zealanders and international visitors who toured the country in the 1920s and 1930s. Their style of clothing — everyday wear rather than clothes designed for a mountain climate — and lack of climbing equipment shows that walking up the glacier was considered a quick jaunt rather than a serious climb.

The central North Island with its spectacular thermal and volcanic features has long been a mecca for local and international tourists. They also visited Rotorua to see the 'model Maori village' at Whakarewarewa. Ngati Whakaue and Tuhourangi people lived in the village, where some also worked as guides. Visitors came to watch Maori going about their daily lives — washing, cooking, making clothes — and performing haka and dance. Many of these guides and performers were celebrated in both the Maori and Pakeha worlds, but the exploitative side to tourism is seen here in a 1935 photograph of a tour party with young Maori at Whakarewarewa. **BOTTOM RIGHT** Until well into the century, tourists encouraged boys to cavort naked, dive for pennies in the pools, and perform 'penny haka'. Such images appeared in films shown to local and overseas audiences. **TOP RIGHT** Filmcraft, a forerunner of the government's National Film Unit, shoots scenes for *New Zealand Scenic Charms* at Whakarewarewa in the 1930s. To create appropriate images of 'Maoriland', Maori dressed in traditional costume are posed in 'daily activities' around the hot pools. Away from the cameras, Maori in European dress observe proceedings from the verandah. Greater Maori control of the local tourism industry in the last quarter of the century reduced some of the worst forms of cultural exploitation.

Film shoot, Whakarewarewa, 1930s

Children and tourists, Whakarewarewa, 1935

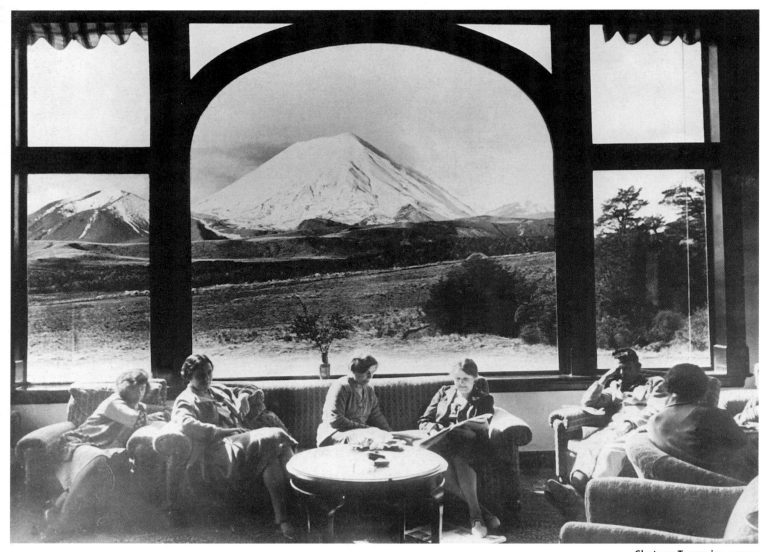

Chateau Tongariro, 1930s

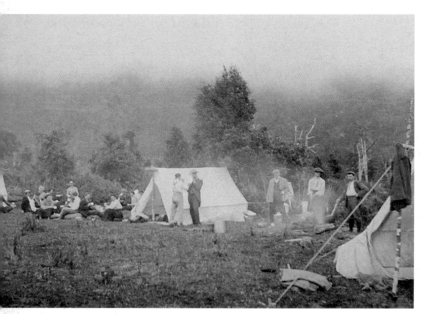

West Coast camping trip, pre-1910

BEAUTIFUL NEW ZEALAND Accommodation for travellers was relatively sparse early in the century. **LEFT** The tourists photographed outside their tents traversed the West Coast of the South Island in the 1900s by bicycle and carriage. More upmarket comforts were available in popular tourist resorts such as Mount Cook and Waitomo Caves. **ABOVE AND OPPOSITE** The Chateau Tongariro, opened in 1929, provided luxury accommodation for skiers and others wanting to enjoy the mountain scenery of the central North Island. Photographs of the Chateau with the mountains Ruapehu, Tongariro or Ngauruhoe were common in government promotional brochures from the 1930s, and these examples were probably taken to sell New Zealand as a holiday destination locally and overseas. The facilities suggest ease and pleasure: there are comfortable chairs and sofas, reading matter and side tables in the 1930s (above), and stylish outdoor furniture and cocktails for the 'young people' of the 1960s (opposite). With the boom in tourism in the last quarter of the century, luxury accommodation was built in major tourist destinations such as Queenstown.

OPPOSITE **Chateau Tongariro, 1960**

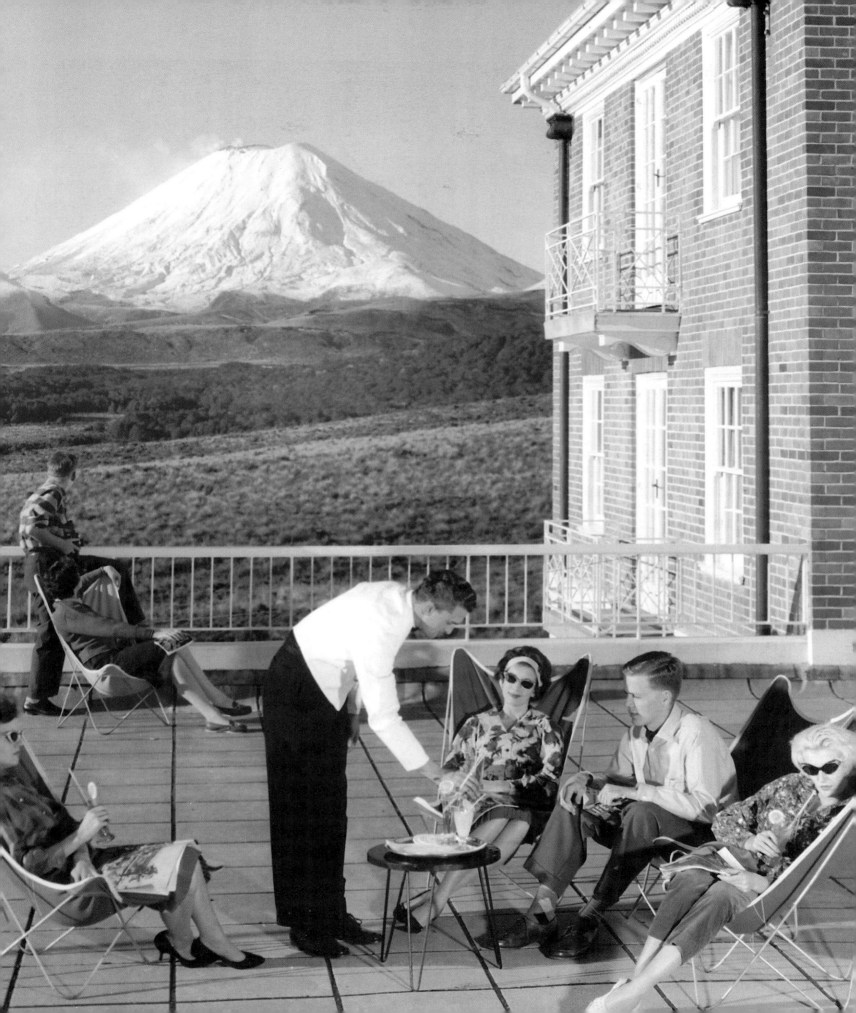

Clifton Beach, Hawke's Bay, 1961

Totaranui Beach, Nelson, 1961

Sumner Beach, Christchurch, 1900

AT THE BEACH Christchurch's Sumner Beach was a popular holiday spot in 1900, when this photograph was taken. **LEFT** A day at the beach in Victorian New Zealand was a more formal affair than it became in the twentieth century; here adults shield themselves from the sun with parasols — sunbathing would not come into vogue for another 20 years — while children play in the water. The horse-drawn bathing sheds parked on the beach preserved the modesty that mixed bathing required at this period: women and men donned their bathing suits in the sheds, and walked into the water once the shed had been backed out to a suitable depth.

Later in the century, the beach came to suggest relaxation and informality, and different social rules from 'normal life'. 'Doing nothing' is acceptable — even expected — at the beach. Getting a tan, like these men on a Hawke's Bay beach in 1961, became part of beach culture from the 1920s. **TOP** By the 1980s, anxieties about skin cancer had diminished New Zealanders' passion for sunbathing, but here no sunhats or sunscreen lotions can be seen.

New Zealand's long coastline has always offered beaches where people can 'get away from it all', such as this lonely beach at Totaranui in Golden Bay in the 1960s, where the children are dwarfed by the expanse of sea. **ABOVE**

AT THE BEACH The camping ground at Mount Maunganui, shown here in 1958, quickly filled up during the summer months, with tents, awnings and caravans all jostling for space. **ABOVE** This may have been the great Kiwi summer holiday, but the essentials of life were unchanged — there were still nappies (in the foreground) to wash and dry.

Bathing suit contest, 1960s

94

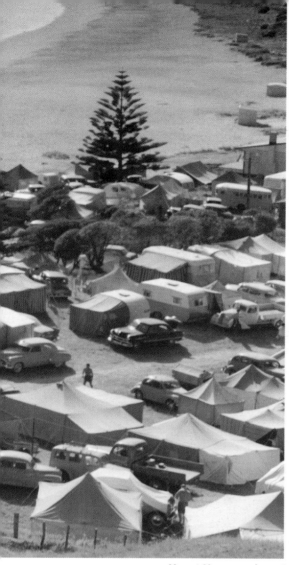

Mount Maunganui, 1958

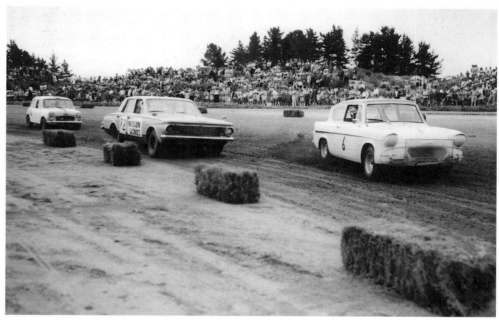

Car races, Tahunanui Beach, 1967

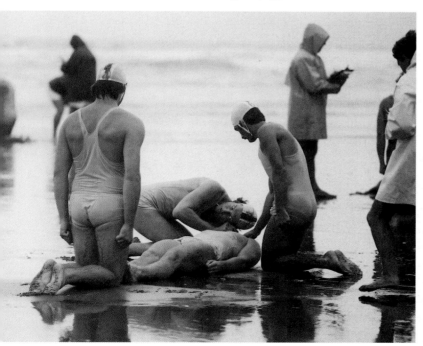

Surf Lifesaving Championships, South Brighton, 1979

AT THE BEACH New Zealanders put beaches to many uses. **ABOVE** In the summer of 1967, cars race each other on Nelson's popular Tahunanui Beach: barely modified vehicles speed around a makeshift sand track marked out by hay bales. **FAR LEFT** Bathing suit competitions came into vogue in the 1930s, and reached a peak of popularity in the 1950s and 1960s. Girls and women of all ages paraded across a stage in their bathing suits vying for local titles such as Miss Tiny Tot, Junior Miss, Miss, and Mother and Daughter. In the wake of feminist criticism, such competitions had virtually died out by the end of the century. **LEFT** The more serious side of beach culture is conveyed in the photograph of the national Surf Lifesaving Championships held at South Brighton in miserable conditions in March 1979. Lifesaving began in New Zealand in the 1910s, when the first clubs were established at New Brighton, near Christchurch, and Lyall Bay in Wellington. As this photograph suggests, the sport has a ritualistic element; here competitors kneel in rigid poses while teammates give textbook demonstrations of mouth-to-mouth resuscitation.

Strand Arcade, Auckland, 1970

SHOPPING People have always shopped for pleasure as well as for the basic necessities of life. Throughout the century window-shopping, and shopping for luxury items, have been leisure activities in towns and cities — for women perhaps more often than men, and for wealthier people. Early in the century, some department stores kept their goods in drawers or on shelves behind the counter; customers had to ask to see them. After the First World War shops became more inviting, and shoppers could browse amongst the wares. **RIGHT** Hawkers and their barrows, as seen here in Wellington in the 1940s, disappeared from city streets after the Second World War. The woman and two small girls pausing by the barrow are dressed for a day 'in town' shopping or perhaps for a social visit. **ABOVE** Later in the century, malls like Auckland's Strand Arcade (photographed in 1970) presented shopping as an experience to be enjoyed; customers could linger indoors, and look through the greater range of consumer goods that were coming onto the market. As the century progressed, the lower prices of many imported products made shopping a leisure activity for lower-income as well as wealthy New Zealanders.

Hawker's barrow, Wellington, 1940s

Recorder class, Clifton Terrace School, 1979

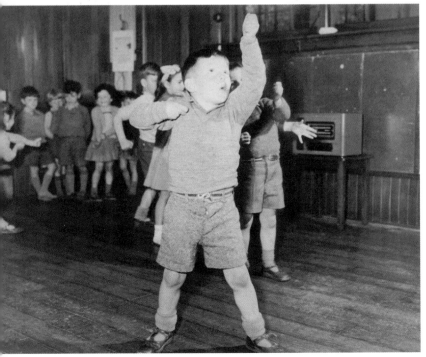

Radio dance class, Roseneath Primary School, 1952

PLAYTIME Within the structured world of school, children's play and learning are often combined. **ABOVE** These young boys are in a swimming class, but they also express the sheer fun of being in the water. **TOP LEFT** Generations of New Zealand children have also learnt their first dance steps, plucked the ukelele or played the recorder at school. Sitting cross-legged on the floor, like these pupils at Wellington's Clifton Terrace School in 1979, children worked their way through simple pieces such as 'Mary Had a Little Lamb' and 'Frère Jacques'; carols such as 'Silent Night' were practised for the end-of-year Christmas function. **BOTTOM LEFT** During the 1940s and 1950s, radio educational broadcasts sometimes featured dance lessons. This small Wellington boy is picking out the steps to an action song playing on the radio in the background. The school or town library could provide hours of pleasure for children. **RIGHT** From the 1930s, mobile library services were available in various parts of the country, as well as in many towns and cities. Here two youngsters clutch the precious books they have chosen from the shelves of the mobile van.

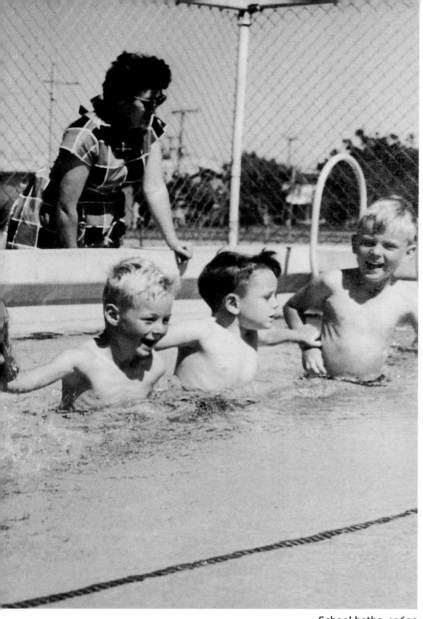

School baths, 1960s

Dressing up, 1960s

PLAYTIME Rough and tumble games have usually been the domain of boys — girls were often called 'tomboys' if they climbed trees, participated in rugged games or did other 'boy things' such as going fishing. **ABOVE** For little girls, dressing up is an age-old pleasure; this one has found an old over-sized pair of gloves and what appears to be an evening or wedding dress to wear.

Mobile library, 1960s

Display of toys, Te Aro School, 1920

PLAYTIME The toys in a 1920s classroom in Wellington show typical gender differences: building blocks for the boys, dolls and thread for the girls. **ABOVE** Organised playground games have also been divided into separate activities for boys and girls. **RIGHT** At Invercargill's Middle School between the wars, the boys lined up in military precision to perform drills, while the girls partnered each other in folk dancing, which was probably regarded as 'sissy' by the boys.

Folk dancing and drill, Invercargill, 1920s

Soccer match, Takapuna, 1975

4 Square, Parikino, 1960s

Skateboarding, 1979

PLAYTIME The distinctions between boys' and girls' games began to blur later in the century (and probably children had always shared some games). **TOP LEFT** These youngsters playing for a Takapuna soccer team in 1975 would split into separate girls' and boys' teams as they got older, but mixed teams were a useful way of getting girls involved in sports traditionally dominated by boys.

Games organised by children themselves sometimes broke gender boundaries. Both boys and girls played court games such as 4 Square. **MIDDLE LEFT** The girls at Parikino on the Whanganui River play this game in the 1960s; a lone boy looks on while the girl in Square 3 displays her skill at spinning the ball to outwit the player in Square 4.

Young New Zealanders have always taken their pastimes to the streets. In the late twentieth century, skateboarding was one of the most popular forms of street recreation, especially among adolescent boys. Skateboarding first appeared in the 1960s, and became most popular in the 1970s, and again in the 1990s. **BOTTOM LEFT** This photograph was taken in 1979 at one of the skateboarding bowls constructed in an effort to keep skateboarders away from other public spaces. Most skateboarding still took place on footpaths, down steps, and anywhere else with sufficient concrete and an obstacle to make the boarding more exciting.

Physical movement class, Wellington, 1940s

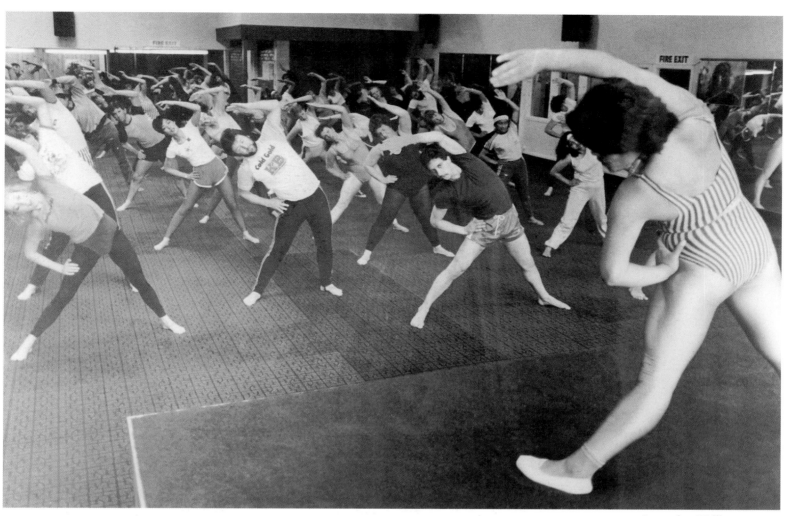

Jazzercise, Wellington, 1983

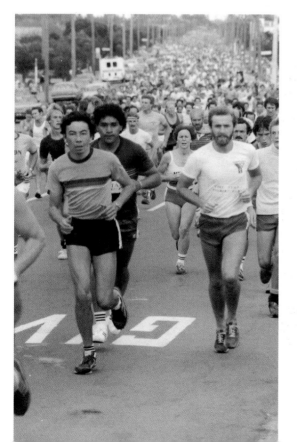

THE FITNESS CRAZE The late twentieth-century emphasis on health and fitness is the most recent in a long line of fitness movements. **FAR LEFT** Physical drills and dumbbell exercises were introduced to New Zealand schools in the first decade of the century; from the 1940s, as this photograph taken on the roof of a Wellington building shows, women's movement classes were popular. Such classes emphasised smooth, graceful actions that were designed to tone the body rather than push it to the limits as in later fitness crazes. **LEFT** After the international success of New Zealand runners in the 1960s and 1970s, more New Zealanders took to pounding the streets. Auckland held its first Round the Bays run in 1973. Within a decade, it attracted thousands of runners, and other centres had established running events. The photograph shows an enormous line of runners taking part in Christchurch's 1983 City to Surf run.

ABOVE The gym craze of the 1980s and 1990s brought with it a new trend in sports clothes. Brief, figure-hugging tops, shorts, tights and leotards displayed the toned, fit body. At the beginning of the 1980s, as in this 1983 jazzercise class, few had adopted this clothing, but within a decade shorts and t-shirts were the exception in the gym, and a merchandising industry and culture had sprung up around lycra wear. Lycra was comfortable and easy to care for, but tight lycra clothes accentuated body shape — ideally, muscular for men and toned or waif-like for women — and could be unforgiving to the great majority of New Zealanders who bulged in the 'wrong' places.

City to Surf run, Christchurch, 1983

War veterans' home, 1960s

TIME OUT From 1960, the New Zealand Broadcasting Service beamed television shows into homes. TV offered a major new form of entertainment, and also became the primary way of receiving news and information about current events. Television brought other cultures — British and North American especially — into New Zealand homes, with all the positive and negative effects that entailed. Televisions were sometimes babysitters, or occupied the kids after school, or could be watched while doing the ironing. They affected personal communication. TV sets took pride of place in lounges such as this one in 1974, when transmission in colour had begun. **RIGHT** Images of the family staring at 'the tube' in the corner of the lounge, with little communication between its members, may well characterise the 'TV generations' of the later twentieth century.

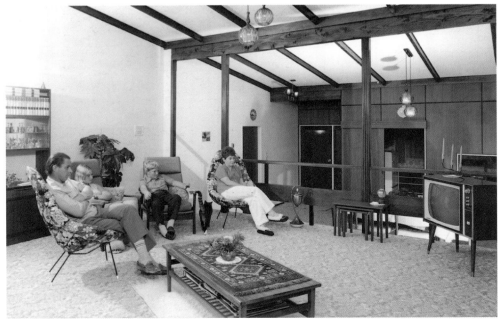

Watching TV, Upper Hutt, 1974

Oriental Parade, Wellington, 1960s

TIME OUT Wellington's Oriental Parade has long been a place where locals sit and gaze out to sea. **ABOVE** With his feet up, a cup of tea and a smoke, the man in this photograph appears content and oblivious to the young women chatting nearby. New Zealanders are also said to be a nation of readers, with young and old alike enjoying this reflective pursuit. While most books available in the early part of the century were imported from Britain, Europe or North America, the local publishing industry produced a much larger and richer range of titles from the 1960s. **TOP LEFT** The men reading newspapers and books here were photographed in a war veterans' home in the 1960s.

Bridging the Gaps
Communications

The 'transformation of space' through new communication and transport systems was a preoccupation in nineteenth-century New Zealand;[1] twentieth-century society was no less intent on bridging gaps between people and places. Whether 'communication' meant travelling from place to place, transporting products or stringing telephone lines the length of the country, the evolution of communication systems across two long thin islands has been a dramatic feature of life in twentieth-century New Zealand.[2]

A traveller going from Invercargill to Auckland in 1900 faced a journey of almost four days by rail and steamer, and considerably longer if his or her conveyances were horse-drawn.[3] The huge public works schemes of the late nineteenth century had criss-crossed the country with railway lines that connected major cities, towns and large settlements. Goods could be moved relatively quickly and cheaply, and passengers could travel in some comfort and style. Railways expanded considerably in the first two decades of the twentieth century, and so did settlements that depended on getting their manufactured goods and produce to other centres or overseas. Once the last spike of the North Island Main Trunk Line had been hammered in with much ceremony in 1908, passengers could travel most of the length of the island by rail. Steamers also transported people and goods, although the railways provided stiff competition for freight in all but isolated areas. They plied their way between coastal settlements, and between major ports, as well as serving provincial areas such as Nelson, New Plymouth and Napier.

Urban streets of places such as Invercargill and Auckland bustled with many modes of transport in 1900. People got around by foot, on bicycle, on steam-powered trams, and, in the case of one person at least in Auckland, in an automobile

On harbours such as the Hokianga, on lakes in the South Island, and on major rivers like the Whanganui, boat transport was used for much of the century, although steam boats were phased out from the late 1910s. At Rawene, for example, farmers and others relied on ferries in the middle of the century to send their produce to distant markets or local dairy co-operatives. Shipping goods by sea declined with the massive expansion of motorised transport in the second half of the century. Trucks, milk tankers (from the late 1940s) and other large lorries could quickly carry goods from one place to another, and once the major highways were sealed in the late 1950s, roads took the place of waterways for transport.

Rawene, 1952

The Eglinton family at the Rimutaka summit, 1916

The motor car opened up new worlds for travellers, offering a freedom not afforded by public transport time-tables, or by horses, with their need to rest and refuel. By the mid-1920s the Sunday drive had become fashionable, with families and friends loading blankets and picnic gear into cars and driving off in search of resting spots. This well-dressed trio stopped at the summit of the Rimutaka Hill between Wellington and Wairarapa in 1916. Making it to the 555 metre summit would have taken some time in this vehicle on the unsealed roads that were common until the 1950s.

imported in 1899 (the first two automobiles had been imported into Wellington the previous year). Horses dominated the roads, pulling carriages, cabs, trams and buggies, or carrying riders. The variety of transport in New Zealand's towns and cities increased over the next 20 years. The two hilly cities, Dunedin and Wellington, introduced cable cars (in 1881 and 1902 respectively), but the major new development in public transport was the electric tram. Thousands of people turned out in Auckland in 1902 for the opening of the city's electric tram service, and some 70,000 had used it by the end of the first week. Similar scenes were enacted in other places, including Invercargill, within a decade.[4] The clean and efficient electric trams replaced the older steam trams, and signalled the end of horse-drawn traffic. By the 1920s horses were relatively rare in the streets of major towns and cities, although they continued to be used in rural and remote areas until the 1950s.

Urban street life became brisker as well as cleaner with the advent of trams, but it was the motor vehicle that transformed both urban and rural society in the first two decades of the century.

Automobiles first appeared in New Zealand in 1898, and more than 70,000 were registered in 1925 when this became mandatory.[5] Along with motor cars came buses and trucks, providing new forms of public and goods transport in both city and country. The use of motor vehicles also had an impact on other modes of transport; hauling goods by road, for instance, significantly diminished the coastal shipping industry, and provided an alternative to the goods train.

The motor vehicle gave people a sense of freedom; in their own cars, they could travel when and where they wanted.[6] The social effects of a car-owning population were vast. Towns and industries could spread outwards; new forms of recreation became possible — park-like golf courses were established on the edges of towns; country people could travel easily to town, for shopping, pleasure or education; tourism, holidays and resorts all flourished.

Telegraph and telephone lines also crossed the landscape, enabling quick communication over a distance. The number of people taking advantage of these technologies — for work, to keep the machinery of government rolling, or simply to keep in touch — increased dramatically around the beginning of the century. Between 1890 and 1910, the number of telegrams sent annually increased from 1.96 to 8.56 million, while the number of telephones jumped from around 3,000 to more than 30,000.[7]

By 1950, the trip between Invercargill and Auckland took two days and one night. Travellers could journey by rail from Invercargill to Picton — the South Island Main Trunk Line was finally finished in 1945 — but the overnight ferry from Lyttelton to Wellington was the quickest surface route between the islands. Well-off travellers could save time and catch a plane, the fastest and newest mode of transport between main centres. The air equivalent of a national trunk line between Auckland and Dunedin was established by 1936, with stops in Palmerston North, Blenheim and Christchurch. The state-run National Airways Corporation took over the major internal routes in 1947 and these were soon expanded to provide reasonably quick, if comparatively comfortless, travel from one end of the country to the other. Like the train and motor car before it, travel by air opened up new parts of the country for tourism. For the first time, also, New Zealanders (at least affluent ones) could see the rest of the world without enduring a long sea voyage.

Nonetheless, road and rail remained the main forms of long-distance travel within New Zealand at mid-century. The number of registered cars was more than 500,000 by the end of the 1950s; motor vehicles, like other consumer goods, had become essential items in the immediate postwar years.[8] Motorists could drive almost the length of the North and South Islands, but unsealed road surfaces made the going tough and long; the main highway between Auckland and Wellington was not completely tarsealed until 1954. Although the railway system had to compete with road haulage, the railway network reached its greatest extent in the early 1950s. Government protection for rail encouraged farmers and manufacturers to use it. Subsidies for moving goods by rail, and regulations prohibiting long-distance road haulage if rail were available, underpinned the rail system between the 1920s and the 1950s. The volume of goods and livestock transported by rail increased by 50 per cent over this period, and the length of railway line continued to expand until 1952.[9]

The streets of Invercargill and Auckland in 1950 had lost some of the diversity they showed in 1900. Motor vehicles predominated, as they would for the rest of the century. Auckland, especially, began to depend on the motor vehicle as it sprawled in all directions from the 1950s onwards. New suburbs sprang up well away from city-centre workplaces; in 1954, an estimated 40 per cent of commuters travelled into central Auckland by car each morning.[10] The use of public transport declined as Auckland constructed a network of motorways facilitating access from suburbs to the central business district.[11] Traffic lights were introduced in Auckland in 1947 and car-parking buildings in 1955, but the problems of more and more cars entering the city daily were to prove insoluble for the rest of the century.

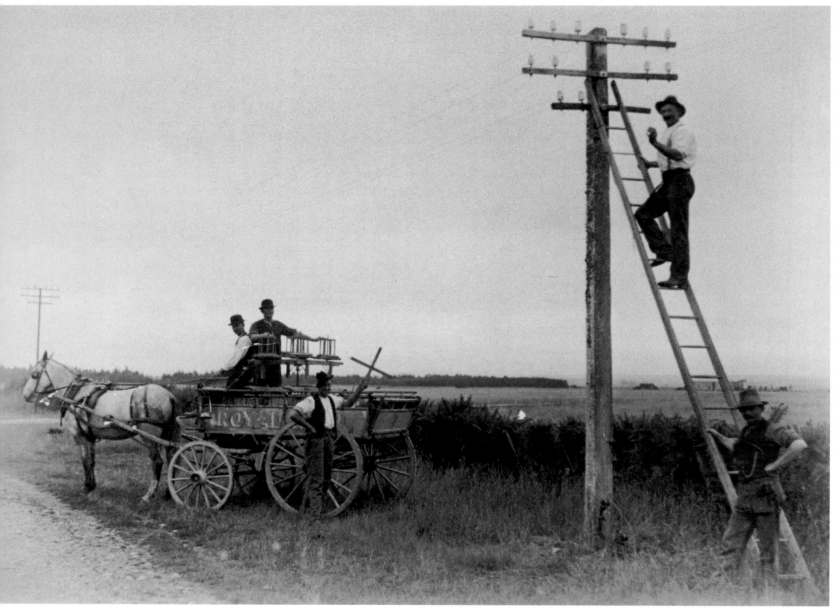

Linesmen at work, Gore, 1918

The swift development of telecommunications in the late nineteenth and early twentieth centuries was visible in the spread of cables and pylons across the New Zealand landscape. Urban and suburban streets were strung with telephone lines, and telegraph poles marched alongside railway lines and roads, cut across paddocks and dotted hillsides. Linesmen carted poles and lengths of cable around the countryside to enable the telecommunications industry to expand. Here linesmen install insulators on a telegraph pole near Gore in 1918.

Commuters and shoppers in other centres continued to rely more on public transport. By the 1950s, both Invercargill and Auckland had abandoned their electric trams in favour of buses, and other cities quickly followed suit. Wellington retained its tram system until 1964, when trolleybuses were introduced; Christchurch reintroduced trams in the 1990s as a tourist attraction. The running of Wellington's last electric tram was a major event: a band played 'Auld Lang Syne' at a public 'farewell ceremony'.[12] Wellington also had an extensive urban and suburban rail system that brought thousands of commuters into the city each morning from the Hutt Valley and Porirua. Of all the main cities, Wellington's public transport system remained the most comprehensive at the end of the century, although Wellingtonians' use of private cars has been steadily increasing.

Most homes and businesses had telephones by the middle of the century, and callers soon had no need to place phone calls through operators. New services based on the telephone became available: from 1958, for example, the '111' emergency service. Radio broadcasting also flourished; more than 75 per cent of households had a radio in the 1950s. Like the car, it had become an

essential consumer item. The broadcasting system catered for many interests and groups. Children's educational and entertainment programmes, live sports broadcasts, music, talent quests, serials, quiz shows, religious programmes, parliamentary broadcasts and a very limited Maori content could all be heard.[13] Women's programmes often featured a larger-than-life host – Aunt Daisy was the best-known broadcaster in this period – who dispensed cooking and homemaking advice. Such shows and the 'romantic' drama serials such as *Doctor Paul* which were broadcast during the day reinforced the domestic ideology for women that prevailed during the 1950s. These shows also offered valuable companionship and entertainment for women spending much of the day at home.[14]

At the end of the century, a traveller could breakfast in Invercargill and arrive in Auckland by plane in time for lunch. Theoretically, it was possible also to breakfast in Invercargill on one day and in Auckland the next by driving on the tarsealed motorways that ran the length of the country. Rail travel in the 1980s and 1990s was more limited than it had been 40 or even 20 years earlier. Branch railway lines steadily closed between the 1960s and the 1980s as businesses sent more goods by road, and as passengers chose to travel long distances by air or car. The deregulation of the transport industry in the 1980s also reduced rail services.

Air travel grew considerably between the 1950s and 1980s. Changes in aircraft design and engine efficiency made air travel within New Zealand cheaper. More flights between main centres and the opening of routes to provincial and tourist towns also allowed people to move quickly around the country. Scenic flights over places such as Fiordland or the Southern Alps became popular and business people could fly between centres for meetings. International flights put the country on the itinerary of more overseas tourists, and opened the world to New Zealanders. Air travel made the great Kiwi 'OE' (overseas experience) available to many more young New Zealanders.

New Zealanders of the later twentieth century thus travelled, sent goods, and communicated long-distance by very different methods from those of the early twentieth century. But while changes in traditional forms of transport were significant, they were, by and large, an acceleration of earlier trends: more private cars, more road traffic, fewer railways and greater air travel. In telecommunications, the replacement of operators with direct dialling and the introduction of cordless and mobile phones can also be seen as part of patterns begun 50 or more years ago. More dramatic has been the impact on communication of new forms of technology. Together and separately, the television and the computer have transformed New Zealand life in the last third of the century.

Television was first broadcast in 1960 and soon occupied a substantial part of New Zealanders' leisure time. It also represented a new form of communication. News and current affairs programmes gave people up-to-the minute information about events at home and abroad. Colour was introduced in 1973, and increasingly New Zealanders could choose between a number of channels. Business and home computers, the Internet and e-mail also altered the way that New Zealanders worked, spent their leisure, did business, shopped, received the news, listened to music and communicated with each other from the late 1980s. Personal and business communication has shifted rapidly under the impact of e-mail, which is rendering paper-based methods of communication cumbersome.

It is too soon to gauge the impact of these technological developments on communication between people and on daily life. The new systems may have more effect than the other significant changes in communication that occurred over the century. In the middle of the century, the automobile greatly affected the games people played, the places they lived in and visited, and how they did their shopping. The Internet and e-mail have done as much and more at the end of the twentieth century – and without people having to leave the comfort of their chairs.

Little River, Banks Peninsula, 1906

PEOPLE TO PLACES Horse-drawn transport was the only way to cross the South Island before the Otira Tunnel opened for rail traffic in 1923. High passes – precipitous and winding routes over the Southern Alps – connected the coasts, while lower but still challenging passes gave access to Central Otago. From the 1870s railway lines advanced into the interior. In Central Otago, the line ran eventually to Kingston and Cromwell, but further travel was on horseback, or by cart or carriage. **LEFT** As the photograph of Skippers Canyon in Central Otago early in the century suggests, the sheer scale of the landscape impeded rail travel in what was, in any case, a sparsely populated area. Passengers travelling through the canyon negotiated their way along spectacular tracks carved out of the hillside. Open coaches – and indeed some of the roads – were suitable for travel only in the warmer months. In winter, snow made some roads in Central Otago difficult to negotiate, and travellers huddled under coats and blankets inside closed coaches. For a while, horse-drawn coaches also provided feeder services for the railways. **ABOVE** In this 1906 photograph, a convoy of coaches lines up in front of the station at Little River. This was the end of the line, and passengers travelling further towards Akaroa on Banks Peninsula went by coach. Until the 1960s, this small station was the transport hub of a busy farming district, and it remained so until more efficient road transport and better roads led to its closure.

Rural society welcomed the automobile. **RIGHT** This 1917 photograph of the stock saleyards at Waingaro in the Waikato hints at the massive transformation of transport that began in the first two decades of the century. Horses were, and would remain for some time, the main means for rural people to travel around, and to and from, their properties. But cars made a huge difference to country people, and, in the 1920s and 1930s, they had a higher rate of automobile ownership than urban dwellers, perhaps also reflecting greater prosperity in some parts of rural society at that time. The roads may have been poor – potholes are clearly visible on the track into the saleyards – but motorised transport gave rural people far more mobility, expanding their social, educational and farming opportunities.

Waingaro saleyards, 1917

OPPOSITE **Skippers Canyon, pre-1910**

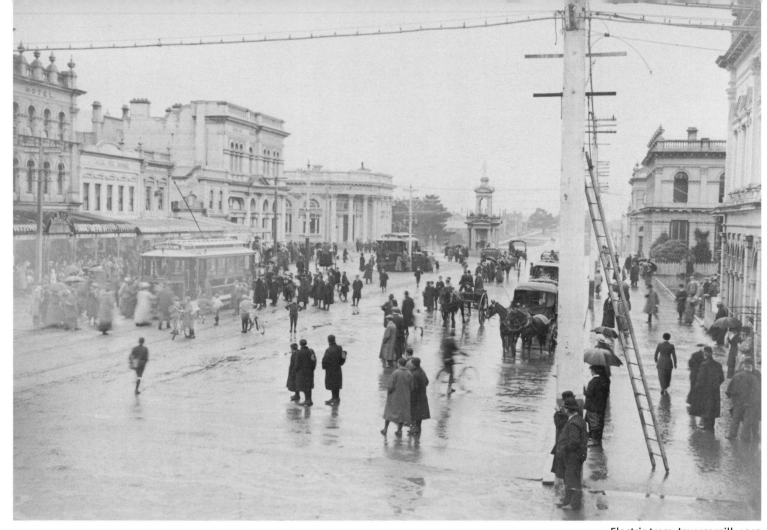

Electric tram, Invercargill, 1912

Bus stop, New Plymouth, 1979

PEOPLE TO PLACES Electric trams introduced a new, efficient form of public transport to New Zealand cities in the first two decades of the century, replacing the steam-powered or horse-drawn trams that had been in service since the 1880s. **ABOVE** Inclement weather did not deter the people of Invercargill from turning out in March 1912 to watch the inaugural trip of their electric tram. Henry McKesch's photograph evokes the town's excitement: well-dressed pedestrians, delivery boys, cyclists, schoolchildren and coach-drivers gather to watch passengers board the tram and proceed down the main street. The photograph also captures the great changes occurring in towns and cities with the spread of electricity: power lines, electric street lights and the ladder propped against the lamp post in the foreground suggest the impact of this new source of energy on New Zealand's streetscapes.

Diesel buses began to replace trams in the 1930s, and, as suburbs spread further from city centres, bus routes wound through them. Bus links were essential for commuting, shopping, going to school and social activities. For women maintaining the household and caring for children, buses were a lifeline; they were cheap and regular, and allowed women to shop in town or the suburbs. **LEFT** These New Plymouth women are waiting for their bus in 1979. Rapidly rising levels of car ownership from the 1960s reduced people's reliance on bus services, but in major commuter cities such as Wellington and Auckland, bus travel remained important at the end of the century.

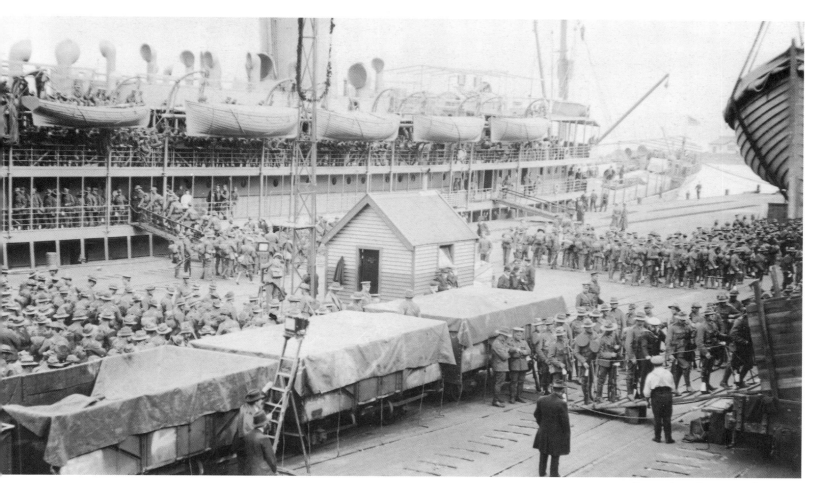

Troops boarding at Lyttelton, 1915

PEOPLE TO PLACES Passenger and cargo ships linked the North and South Islands throughout the century. Steamer services between Lyttelton and Wellington (and, for a time, Napier, New Plymouth and Auckland), and between Wellington and Nelson or Picton, provided relatively fast travel between the islands. In the latter part of the century, the ferry between Wellington and Picton was New Zealand's main passenger shipping service. **RIGHT** The introduction of 'roll-on, roll-off' ferries that carried passengers as well as freight allowed people to take their cars on board, as in this photograph of the *Aramoana* in 1963, the year after the introduction of the service. Ships were the only means by which New Zealanders travelled to the rest of the world until the 1950s, and it was by ship that thousands of soldiers, doctors and nurses went off to wars on the other side of the world. **ABOVE** In this photograph taken by George Cook, an officer in the Expeditionary Force, New Zealand troops file on board a steamship bound from Lyttelton to Egypt in 1915. These coal-powered vessels accommodated hundreds of men in somewhat cramped, uncomfortable conditions during a trip that lasted about six weeks. The departure of troops was always an emotional and newsworthy event, and a number of photographers can be seen.

Aramoana, 1963

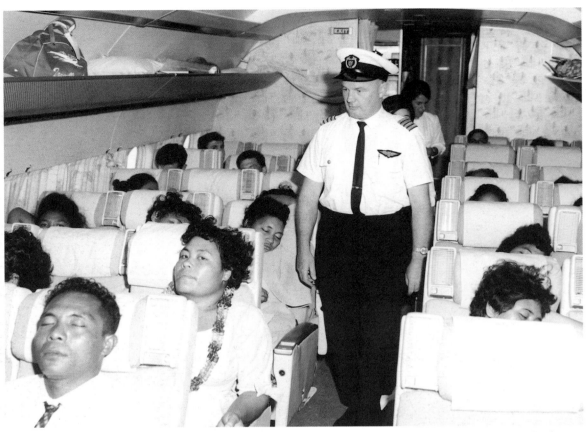

Aircraft, Tokelau Islands to New Zealand, 1966

PEOPLE TO PLACES Air travel revolutionised transport in the middle of the century, particularly for an island country like New Zealand. RIGHT These passengers are boarding a National Airways Corporation Lockheed Lodestar in the 1940s; a decade earlier, Union Airways of New Zealand had inaugurated a service between Auckland and Wellington. Air travel may have been quick, but compared with rail travel, it was relatively comfortless, with noisy and cramped conditions, comparatively high fares, and sparse food and drink services. ABOVE By the 1960s, when these plane passengers were photographed, aircraft travel had become considerably more comfortable. These Tokelauan people were travelling to New Zealand to work in the forest plantations of the central North Island. They were among the thousands of Pacific Islands immigrants who arrived from the late 1960s in search of employment.

Boarding aircraft, 1940s

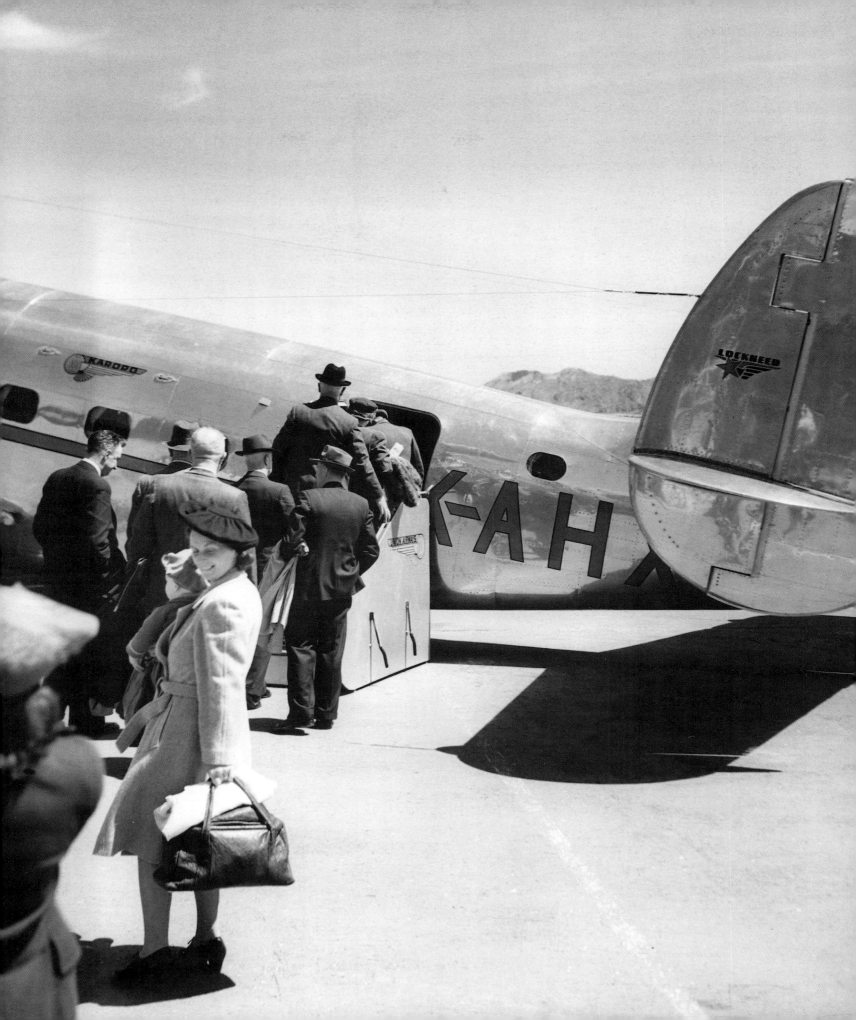

School buses, Otorohanga, 1940s–50s

LEFT Cycling to school is a memory shared by grandparents, parents and today's children. Throughout the century, schools up and down the country featured a twice-daily bicycle rush that is captured in this photograph at a boys' school. Pupils stream from classes to the cycle park, where they disentangle their machines from the general crush. Most of the bikes are of the solid, old-fashioned type; a few are the latest in 1970s style, with 'ape-hangers' and a banana seat.

Bicycle park, 1970s

Horse paddock, Ruatoria, 1950s

FROM HOME TO SCHOOL AND BACK AGAIN In country districts, small towns and even the outer suburbs of a few larger centres in the first half of the century, children came to school on horseback. **ABOVE** Schools such as the Native School at Ruatoria, photographed here in the middle of the century, provided a paddock for the horses. Horses rather than bicycles or motor vehicles were used in Ruatoria partly because of the settlement's isolation, but rural Maori communities were often more impoverished than their Pakeha counterparts and in some areas relied heavily on horse travel.

State-funded school buses served rural and urban New Zealand from the 1920s, and were especially important in rural districts. **LEFT** This convoy of buses has picked up children from around rural King Country to take them to a secondary school in Otorohanga, perhaps in the 1940s or 1950s. Such bus services provided better access to school, and encouraged parents to send their children to local high schools rather than boarding schools. For the pupils, the bus trip had its own pleasures and perils: jockeying for the best seat at the back of the bus, smoking while the driver was not looking, surviving the bullying of fellow pupils.

Shortland Street post office, Auckland, 1920s

CAR CULTURE Of the great changes that occurred in the twentieth century, the arrival of the car on New Zealand roads was one of the most dramatic. Introduced in 1898, cars were sweeping along rural roads and crowding city streets within two decades. Road rules were slow to catch up with the number of cars. Drivers simply left their cars standing in the street outside Auckland's Shortland Street post office while they nipped into the building.

Motorway rest area, Auckland–Hamilton Highway, 1960s

Changing the tyre, 1950s

CAR CULTURE By the middle of the century, motorists could stop at any of a number of rest areas that had been established on the roadside and usually managed by the Automobile Association. **ABOVE** These travellers with their caravan have stopped on the highway between Hamilton and Auckland. The facilities are basic — a few wooden picnic tables and benches — but allow the driver to park safely while passengers stretch their legs or have a meal.

Female as well as male drivers may be familiar with the rudiments of car maintenance, but that there is a special relationship between 'blokes' and their cars is something of a New Zealand cliché. Checking the spark plugs, filling the radiator and changing a tyre were skills which all good Kiwi men were expected to have. **LEFT** These young men driving public service cars in the 1950s seem relaxed about their journey and the job in hand (which may well be posed): changing the inevitable flat tyre.

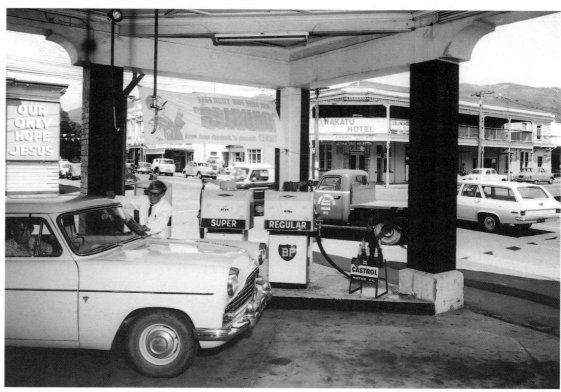

Petrol station, Nelson, 1967

CAR CULTURE Garages were dotted around the country by the 1930s. In small towns and rural settlements especially, they were likely to be general stores, selling petrol and oil along with groceries, stamps and all manner of goods. **LEFT** One such store in the Hokianga settlement of Rawene, photographed in 1952, was a one-stop shop, advertising and selling a range of products: insurance, whiteware, cigarettes, farm machinery, seeds, petrol, and tickets for the ferry that took people and vehicles across the harbour. The kerbside petrol pumps enabled drivers to pull up and refuel on the street corner. Garages such as the one in Rawene were becoming rare in urban centres by the 1960s. **ABOVE** Instead, drive-through petrol stations catered for busy motorists. Nelson's aptly named 'Four Spirits Corner' boasted two pubs, a petrol station and a church in the 1960s.

Petrol station and general store, Rawene, 1952

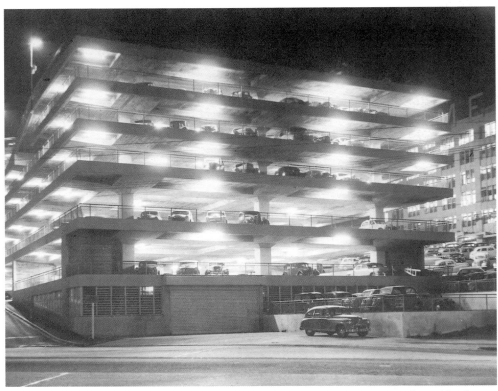

Farmers' Trading Company car park, Auckland, 1955

CAR CULTURE As the century wore on, the problems of the modern, motorised city — traffic jams and insufficient parking — began to surface. Traffic jams were worst in Wellington and Auckland, where thousands of commuters travelled in and out of the city each working day, but provincial towns had their share. **RIGHT** This is Napier on a busy evening (perhaps a Friday night) in 1970. Cars crawl bumper to bumper along the street, and fill all the available parking spaces. **ABOVE** New Zealand's first multi-storey parking building opened in Auckland in 1955, accommodating 500 cars on six levels. Constructed and maintained by the Farmers' Trading Company, it was designed specifically to attract shoppers into the inner city.

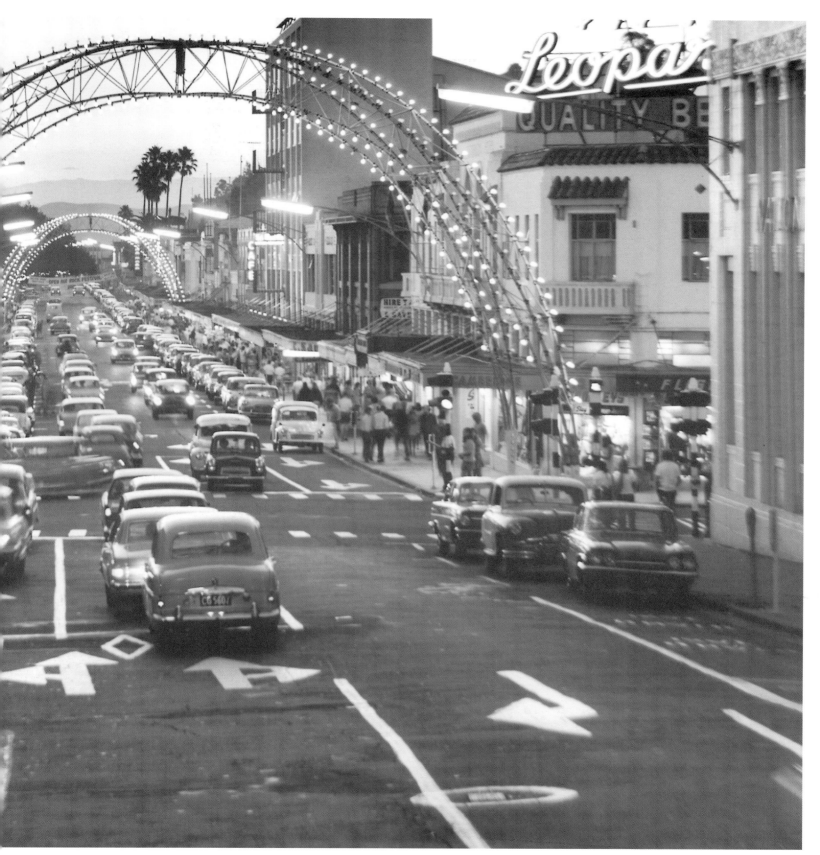

Napier, 1970

White Cragg siding, 1966

TRANSPORTING GOODS A network of railway lines was pivotal to the development of industry and manufacturing, and to the country's agricultural and horticultural sectors. The government's building of major lines began in earnest in the 1870s and continued until 1952, after which smaller lines began to close; by 1990, almost all the branch lines in the South Island had disappeared. The North Island Main Trunk Line was completed in 1908, and its South Island counterpart in 1945. Smaller lines snaked into the interior of both islands, along the West Coast of the South Island, and up both coasts of the North Island. So important were rail lines for the growth of a region that private lines were built as well, although few proved to be long-lasting or successful. **ABOVE** The line cutting across this landscape allowed the previously isolated horticulturalists around the White Cragg siding in Canterbury to get their celery and other crops to market quite quickly. A railway line through a town or settlement could boost an area economically, and it is not surprising that early in the century local political interests campaigned strongly for railway connections. Subsidised freight charges for agricultural produce, and the comparatively poor condition of most road networks, ensured that rail remained the main form of long-distance haulage until the 1960s. In some areas and for some goods, rail transport continued to be important. **RIGHT** These coal trucks in the Westport railyard in 1968 have been hauled out from coal mines dotted along the coast.

Coal trucks, Westport, 1968

Queenstown, pre-1910

Packhorses, Dart Valley, 1950s

TRANSPORTING GOODS Other ways of moving goods existed alongside the rail system. **ABOVE** Carts like this outside the Queenstown Tourist Inquiry Office, for example, took goods into the more remote parts of Central Otago until the 1930s, when cars became more popular. Difficult tracks made some parts of the country inaccessible to all but foot traffic and packhorse. **LEFT** In particularly remote areas, such as the Dart Valley, packhorse teams carried supplies until the 1960s.

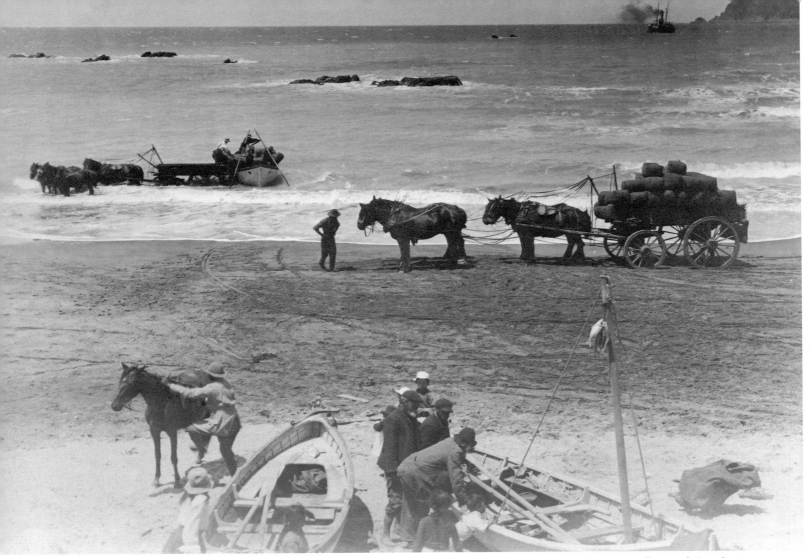

Loading wool, East Coast, 1910s–20s

TRANSPORTING GOODS Horses were also used in conjunction with shipping services in isolated coastal areas. **ABOVE** The steamer waiting beyond the breakers is somewhere on the east coast of the North Island early in the century. Farmers from the surrounding district have brought their wool to the beach in horse-drawn carts; the bales would then be towed out to the steamer. Farmers in coastal areas continued to transport their goods in this way until the demise of steamships – and the rise of motorised traffic – in the 1930s.

In the early part of the century, steamers and scows plied up and down the coastline, collecting and delivering goods (and passengers) in areas where sea transport was cheaper and quicker than rail. **RIGHT** Here the *Wanderer* unloads its cargo at Wellington in 1909. In the background, ships of all sizes are visible in the busy port, suggesting the importance of sea travel to the country.

Scow, Wellington, 1909

Trucks, Wellington wharf, 1925

TRANSPORTING GOODS From the wharves and ports, railway wagons and trucks carried goods inland. From the 1920s, as road surfaces improved, trucks pushed aside horse-drawn carts and buggies. The trucks parked at the Wellington wharf in 1925 are loaded with all manner of trunks, suitcases and carry-bags, topped off by a bicycle or two and with prams strapped on either side of the bonnet. They clearly provided a valuable service to the passenger ships arriving regularly in the city in this period.

Railway station, Temuka, 1900

Railway platform, Dunedin, 1940s

TRAIN CULTURE Railway stations had a culture of their own. For much of the century, the number of people travelling by rail made the local station — however large or small — an ideal place for advertising. **ABOVE** Temuka station, outside which station staff and linesmen stand in 1900, displays hoardings advertising products ranging from tea to bottled soft drinks. **LEFT** Walls and pillars in the larger Dunedin railway station in the 1940s were covered in posters promoting everything from salt to socks, petrol to trucks. The two stations clearly served different needs in different communities. The small, plain station at the mid-Canterbury township of Temuka was a working station, a quick stop for passengers on the route between Timaru and Christchurch. The much grander building in Dunedin, designed by George Troup and completed in 1907, features ornate friezes and stained-glass windows decorated with railway motifs. This was a big, busy station, catering for travellers and goods going north, south and inland. Like other public buildings erected in the city in the same decade, the station was designed on a scale that belied Dunedin's decline from national prominence over the preceding 20 years.

Subway, Wellington Station, 1973

Woburn Station, Hutt Valley, 1953

TRAIN CULTURE Wellington's regional train system brought thousands of commuters to the central city railway station every day. **ABOVE** Passenger numbers soared after the introduction of quicker and more efficient electric services in 1938. By the early 1960s, more than 350 suburban trains arrived and departed daily, transporting over 40,000 people. Many of these commuters had a 'double commute' to get to and from stations which were mostly on the outskirts of suburbs. **LEFT** From this photograph of Woburn Station in 1953, bicycles have clearly provided an answer for those living 'on the flat' in Lower Hutt. Theft does not seem to be a concern; none of the bikes appears locked or secured.

Wellington booking office, 1930s

TRAIN CULTURE With rail the main form of transport in the first half of the century, the Railways Department provided a range of passenger services. These people are queuing at the elaborate booking office in the Wellington Station around 1930. By this time, Railways offered sleeping compartments on the overnight trains between Auckland and Wellington. This station also offered bookings to the major tourist destinations that the Railways Department promoted from the 1920s; the ticketing booth for the Government Tourist Bureau is behind the queue.

TRAIN CULTURE All the benefits of rail were promoted vigorously in advertising and transport pageants such as this one in Wellington in 1928. The floats that paraded through the city's main streets were constructed imaginatively to extol the speed, comfort and efficiency of rail transport. On one float, young women perch inside containers decorated to resemble fruit, vegetables and eggs and sporting puns such as 'I Can't Be Beat'. The promotion may appear corny to modern eyes, but rail links allowed the fruit and vegetable growers of the 1920s to prosper.

Transport pageant, Wellington, 1928

Rail transformed some small centres. By the 1910s, Frankton Junction near Hamilton had become an important Main Trunk Line station for passengers travelling to or from Auckland. The Junction, photographed here in the 1930s, had also gained an unsavoury reputation as a place where young girls and women were unsafe. One women's group even claimed in the late 1910s that it was a centre of a 'white slave' traffic, alleging that young women travellers were kidnapped, spirited away to other towns and forced to work as prostitutes.

Frankton Junction, 1930s

TRAVEL PROBLEMS Before most roads were sealed in the 1950s, travellers found that the country expanded in the summer and shrank in the winter. Tracks that were easily navigable in the dry heat of one season became impassable in the other. **TOP RIGHT** Mud, deep ruts and floods made horse-drawn travel difficult in the winter — as this photograph of a coach traversing a bleak landscape early in the century shows.

Horse travel remained common in rural areas into the 1950s, and, despite the introduction of farm bikes in the 1970s, many farmers continued to use horses until the end of the century. Rural Maori living in Northland and the central North Island often rode about their daily business, and high-country farmers usually mustered their stock on horseback. But in the 1920s and 1930s it was not only musterers and country people who relied on horses. Government officials — district nurses, doctors, police, agricultural advisors — also patrolled their region by horse. **MIDDLE RIGHT** In this photograph, the nation's Director of Forestry is on a tour of the South Island in 1923; wearing suits, ties and hats, the party fords the Turnbull River on its way to inspect forests in Fiordland.

New Zealand's agricultural industry creates particular challenges for drivers. **BELOW** This flock of sheep is travelling along the highway to Te Anau in 1970. Negotiating a way past a mob of sheep or herd of cattle may demand patience from the traveller, but, as early as the 1930s, farmers commented on the extra labour involved in moving stock along roads shared with motor vehicles: 'Prior to the advent of the motor vehicle, sheep would, on an 8-mile stage, only travel about that distance, but since the road became congested with motor traffic the distance has been increased to double … This extra travelling and knocking about soon takes the bloom off sheep, also makes them tired, dull and stupid, with the result that men and dogs have to work harder.'

Stuck in the mud, pre-1910

Fording the Turnbull River, 1923

Paekakariki coast, Wellington, pre-1910

TRAVEL PROBLEMS Some parts of the country were served only by rudimentary roads carved from hillsides, or ending on one riverbank and starting on the other. Fording rivers was a familiar feature of horse-drawn travel, and in places where the road hugged the coastline, horses and coach simply took to the surf. **ABOVE** Coach travel into Wellington from the north followed some of the coast near Paekakariki, where the track periodically disappeared under water. Inside the coach, the passengers were crammed together, while those up front were jolted about and exposed to the elements. The travelling was hard on coaches and horses too: broken axles, lost horseshoes and injuries to the horses were common.

Road safety became an issue as soon as motor vehicles appeared. Speed limits (30 miles per hour in built-up areas from 1936) and road rules (first published in 1937) were introduced as the authorities attempted to reduce the number of accidents. **LEFT** Two hundred people were killed on the roads in 1930; by the early 1960s, around the time of this fatal crash in Hawke's Bay, there were more than 400 fatalities each year. The rising number of deaths from the 1960s (the road toll leapt to over 800 in 1973) led to more stringent regulations. Front seat belts had to be fitted from 1965, and breath-testing was introduced in 1969 in an attempt to stem the rise of alcohol-related accidents.

Accident in Hawke's Bay, 1960s

OPPOSITE **Te Anau, 1970**

135

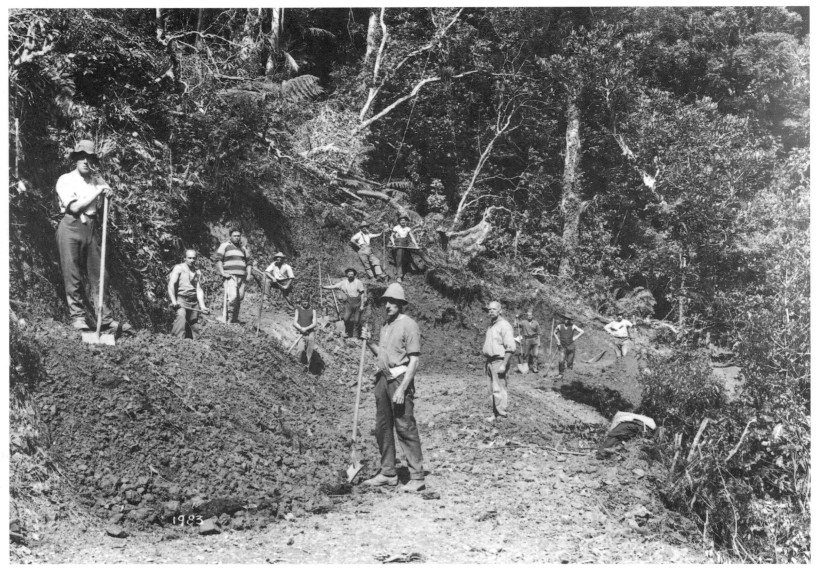

Road building, North Auckland, 1930s

MAINTAINING THE SYSTEM The vast infrastructure of a communications system spanning two long narrow islands was initially built mainly by hand. Roads, bridges, tunnels and rail lines were constructed from the mid-nineteenth century, although many were not completed until well into the twentieth, and the Main Trunk Railway Line only in 1945. The expansion of urban centres, and the huge growth in motorised transport from the 1950s, generated a road-building boom, and many new motorways were constructed from the 1960s. **ABOVE** The men making a road through the North Auckland bush may well be engaged in relief work during the depression of the 1930s. **TOP RIGHT** The rail maintenance gang is working at Ngaurukehu, near Taihape, in 1956, when the national system was at its greatest extent. The team is adding a deviation to the line, a task requiring precision and care, as is suggested by the abundance of workers, three of whom appear to be supervising.

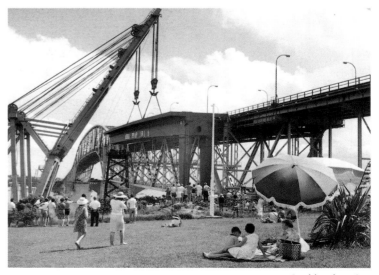

Auckland, 1960s

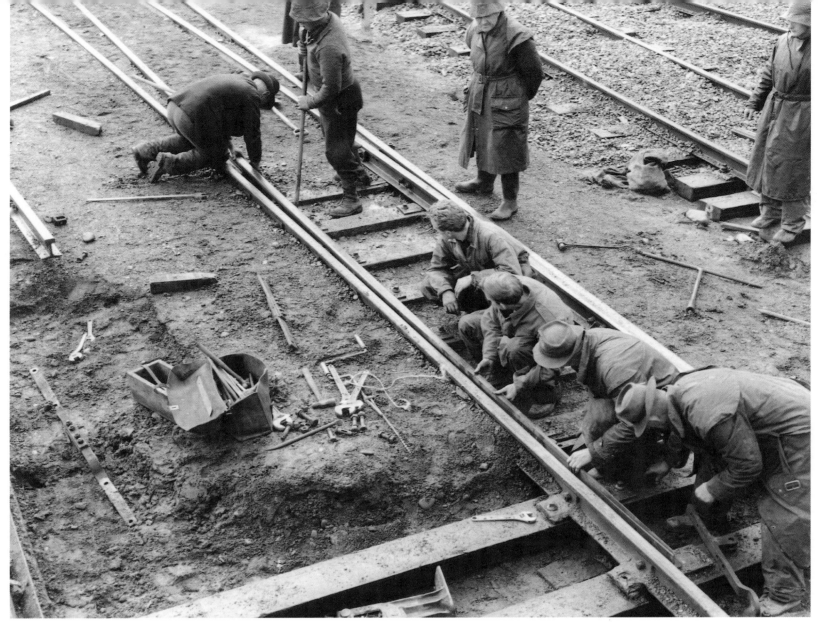

Track maintenance, Ngaurukehu, 1956

Auckland Harbour Bridge, 1981

MAINTAINING THE SYSTEM In the first decades of the century Auckland became a large, sprawling city. From the 1950s a network of motorways was constructed to link centre and suburb, and the Auckland Harbour Bridge was completed in 1959. **FAR LEFT** Connecting the North Shore suburbs and business districts with the city centre, the bridge cut travelling times in half. Within a decade, the bridge had to be enlarged; more lanes (dubbed the 'Nippon Clip-ons' because they were made in Japan) were added to each side. **LEFT** As the photograph from 1981 shows, the clip-ons gave greater flexibility to traffic controllers as the middle lanes could be used for traffic going either way. Auckland has continued to grow as a centre for both population and industry, and traffic congestion still puts unremitting pressure on the city's motorway system.

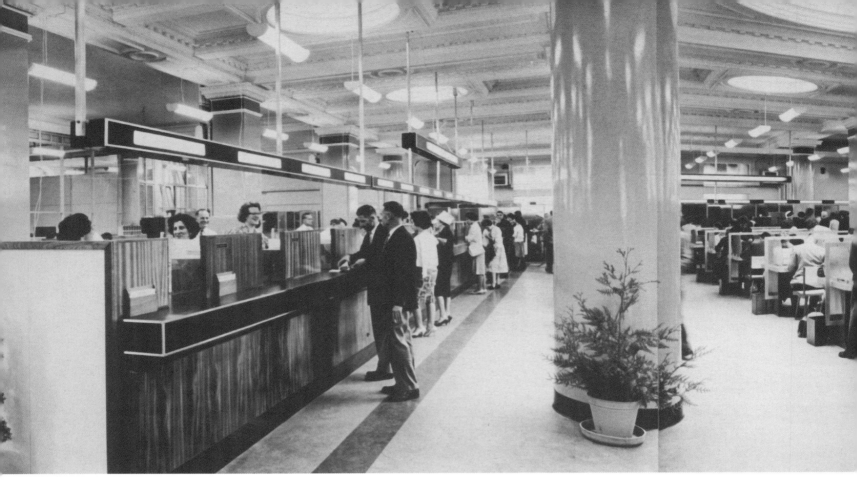

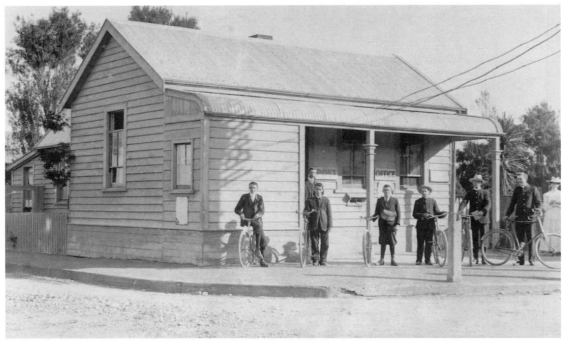

Post office, Lower Hutt, 1904

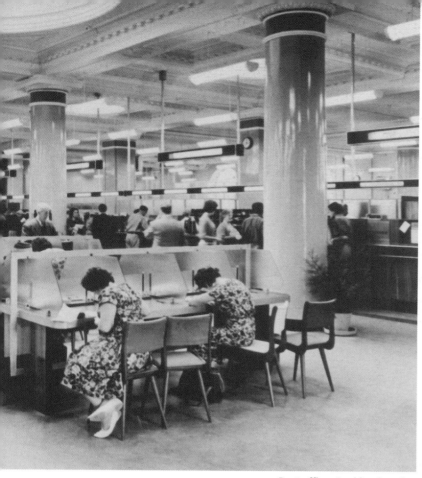

KEEPING IN TOUCH The post office has been one of the country's most important public institutions, offering a range of communication and banking services until the 1980s. **BOTTOM LEFT** Lower Hutt's small post office (photographed in 1904) was the centre for mail and telecommunications services in the area. Telegraphs were sent from and to the post office, and delivered to homes and businesses by uniformed 'telegraph boys' on bicycles. The office also connected telephone calls and provided postal and banking services. More than 3,000 people worked in the Post and Telegraph Department in 1904 as postmen, telegraphists, delivery boys, telephone exchange operators, postmasters and postmistresses. Some of these employees travelled the country by train, sorting mail as they went. **BELOW** Mail was sent between the main centres by rail and delivered to towns by vans such as the one photographed here in 1933; airmail services did not begin until 1935. **LEFT** The post office played a central role in cities, suburbs and country districts for most of the century: in the main Auckland post office in the 1960s more than 30 counters are available, with several marked off for special purposes — telegrams, banking, stamps, international mail. Post offices continued to offer this range of services until 1987, when the Post Office was split into three state-owned enterprises: New Zealand Post, Postbank and Telecom.

Post office, Auckland, 1960s

Postal van, 1933

KEEPING IN TOUCH Telegraph, and later telephone, operators were a central part of the telecommunications system until the 1970s. Early in the century, calls were logged through operators: subscribers rang in to the exchange, gave the number to which they wished to be connected, and an operator made the connection. Manually operated telephone exchanges remained in many rural areas until the 1960s; here 'party lines' (telephone lines shared by several households) created additional work, not to mention occasional excitement, embarrassment or annoyance for phone users. **FAR RIGHT** As in this photograph of an exchange in the 1950s or 1960s, telephonists were mostly women, although they sometimes worked under the eye of a male supervisor. This had not always been the case. Women were first employed as telephonists in 1892, but until the Second World War they struggled for acceptance. As in some other occupations, women were taken on and laid off according to the needs of the male workforce. **TOP RIGHT** In the photograph of the Instrument Room at the General Post Office in Wellington in late 1918 only a few women are visible. At this time, soldiers returning from the war were resuming jobs that women had held for its duration.

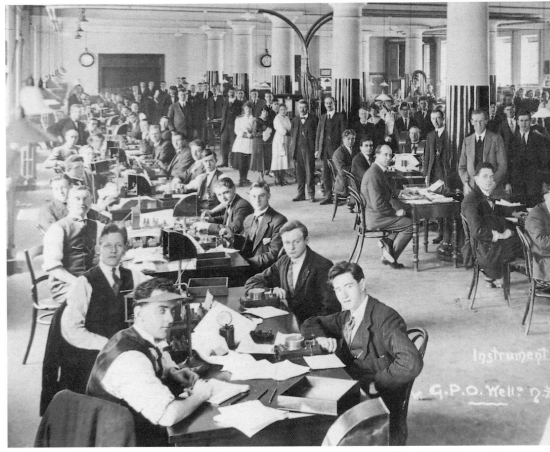

Telegraph Department, General Post Office, Wellington, 1918

Radio played a prominent role in New Zealand from its introduction in the 1920s. It provided listeners in towns and remote areas alike with news, entertainment, sports commentaries, current affairs documentaries, women's sessions, quiz shows, household hints and political broadcasts; it gave children living in isolated areas an education through correspondence school programmes. Children's sessions were broadcast from the beginning; in the 1950s, schools received 2 ¾ hours of broadcasts weekly, most of them aimed at primary schoolchildren. In the 1950s, the majority of New Zealand households had a radio, giving them an immediate access to news and current events that would not be surpassed until television arrived in the 1960s. At the height of radio's popularity, a huge range of shows and commentaries was broadcast. When the Mayor of Upper Hutt talked to reporter David Kohn in 1955 at the official opening of the Rimutaka rail tunnel, journalists used the latest tape-recording equipment to pre-record the interview. **BOTTOM RIGHT**

Opening of Rimutaka Tunnel, 1955

OPPOSITE **Toll operators, 1950s–60s**

A Home of One's Own
Accommodation and Shelter

Owning a house and a small plot of land was a 'New Zealand dream' of the twentieth century. In the city, this became the 'quarter-acre pavlova paradise'; in the country, the lifestyle block or (decreasingly) the farm. A separate patch of ground was part of the dream; multi-storey apartments or rows of joined houses were considered inferior. In a land of plenty, carving out space for a house was a way to claim a place, especially for British and European settlers and their descendants.

New Zealanders have called many structures home. Some have been solid and permanent: kauri villas set in lawns and gardens, row houses on cramped Dunedin sections, sprawling state house communities in Otara, mock-Tudor mansions with three-car garages in Remuera, penthouse apartments in inner-city Wellington. Many homes were wrought from the bush, especially in the early part of the century when raupo whare, canvas huts and rough-hewn timber cottages dotted the landscape in remote or rural areas. For some, home was a room in an institution, a boarding house or an old people's home. Later in the century, retirement villages or rest homes catered for New Zealand's growing elderly population; the extreme bleakness of earlier institutions had, by and large, disappeared. Temporary shelter has also housed large numbers of New Zealanders at different times: tents in wartime, huts on tramping tracks, caravans in camping grounds, motels and hotels, transit camps, night shelters, time-share apartments.

House styles adapted to technological changes such as the introduction of electricity, as well as to social changes such as the disappearance of domestic servants. Government policy seriously affected the supply of houses and people's ability to obtain accommodation. Between the 1930s and the 1980s, the New Zealand state played a key role in housing, fostering the building industry, making housing loans available.[1]

Urban housing in the first half of the century had four main styles: cottages, row (or terrace) houses, villas and bungalows.

Mr and Mrs McGregor, the original tenants of the first state rental house (built in the Wellington suburb of Miramar in 1937), were the ultimate success story of the first Labour government's state housing scheme. They were photographed outside the house, which they had purchased in 1953 and continued to live in until the 1980s. In 1983, it was registered as an historic place.

First state house, Wellington, 1960s

Small, squat cottages contained only a living room and one or two bedrooms off a central hall. Strips of land in front and behind provided space for gardens and sheds. Terrace houses (often two-storeyed) were joined together along the street frontage. Cottages and row houses often had a lean-to kitchen at the back, containing the coal range that was in common use by the turn of the century.[2] By 1900, major centres had piped water for domestic use, but only some areas of Christchurch and Wellington had sewerage facilities.[3] The collection of 'night soil' or (less commonly) the use of public cesspits continued until the 1930s and 1940s; in one or two small towns, such as Palmerston in the south, 'night soil' was collected until the 1970s.[4]

Conditions in small inner-city cottages and terrace houses were often overcrowded and sub-standard. Terrace houses in Auckland, Wellington and Dunedin came to represent urban slums during the recession of the late nineteenth century. Concern about the effect of poor housing on health increased when bubonic plague was discovered in Auckland in 1900. Municipal authorities set about demolishing the slums, and some of the worst terrace houses had been torn down by the 1920s. Although legislation empowered the government to build houses to rent to poor families, few were provided, and housing in towns and cities remained in short supply in the first 40 years of the century.[5]

Better-off families lived in the detached villas that were popular from the mid-1890s. Better ventilated than a cottage, with an internal kitchen and sometimes a bathroom at the back, the villa was the 'archetypal Victorian house' in New Zealand. It was private, roomy, designed for family living, and expressed the status and (comparative) wealth of the rising middle class.[6] Sited away from the workplace, villas contributed to suburbanisation. As tramways and roads spread out from town centres, so too did suburbs full of villas, taking advantage of the greater space in the newly-developed 'hinterlands' of urban areas.

The bungalow, built in large numbers from the 1910s to the 1930s, was less formal than the villa. Instead of separate rooms with specific uses, bungalow rooms often combined some functions, reflecting a more relaxed lifestyle. Small 'kitchenettes' began to appear, linked to living or dining rooms; cooking, eating and socialising might now be shared by the household in one space. Bungalows usually had internal bathrooms and toilets, and laundries with space for washing tubs and (sometimes) washing machines. The spread of electricity from the 1920s meant that good lighting and (in some cases) electric cooking facilities were installed. Bungalows were also constructed for labour-saving devices rather than domestic servants, who had dwindled in number by the 1930s.[7]

Maori in rural or remote areas were still building, and living in, traditional houses at the end of the nineteenth century. Individual whanau (family groups) slept in whare mehana, and larger groups in wharepuni. These were usually one-room earth-floored structures, built of raupo or reeds and thatched with nikau or flax. Cooking was done outside or in a communal cookhouse, and washing in nearby rivers, lakes or creeks. As Maori and Europeans mixed more, European housing features were included. Some whare were extended to include cooking facilities, some had chimneys or iron roofs, some were made of sawn timber rather than traditional materials. Iwi such as Tuhoe, in the Urewera, lived in traditional dwellings into the 1930s, but more and more Maori lived in European houses or added European elements to whare-style buildings.[8]

Maori housing was noticeably worse than that occupied by Pakeha throughout the century. Overcrowding, a lack of indoor sanitary facilities and disrepair characterised Maori housing in both urban and rural areas until the 1940s. Maori health suffered as a consequence, and illnesses such as typhoid, dysentery and respiratory problems were more common among Maori than Pakeha. Maori health officers and Maori Councils attempted to improve housing conditions — pulling down the worst structures, installing water tanks and privies, and building some new houses — but the lack of government funding or commitment seriously hindered the provision of better housing in Maori communities.[9]

OPPOSITE Trampers and hunters used huts in the back of beyond. The deer-shooters' hut in which two hunters were photographed in the 1960s eating their breakfast was made out of timber from the surrounding bush. The supports and all the furniture, including the bunks, were made from timber poles; a glass louvre window, a dirt floor and probably a tin roof completed the hut. While this building is typical of the tramping huts that were built (often by tramping clubs) throughout the bush-clad and mountainous regions of New Zealand, from the 1920s and again after the Second World War, these men were not enjoying recreation but working: deer culling was a government-paid occupation from the 1930s. They would have been based in the hut while they culled deer by day, and perhaps possum by night.

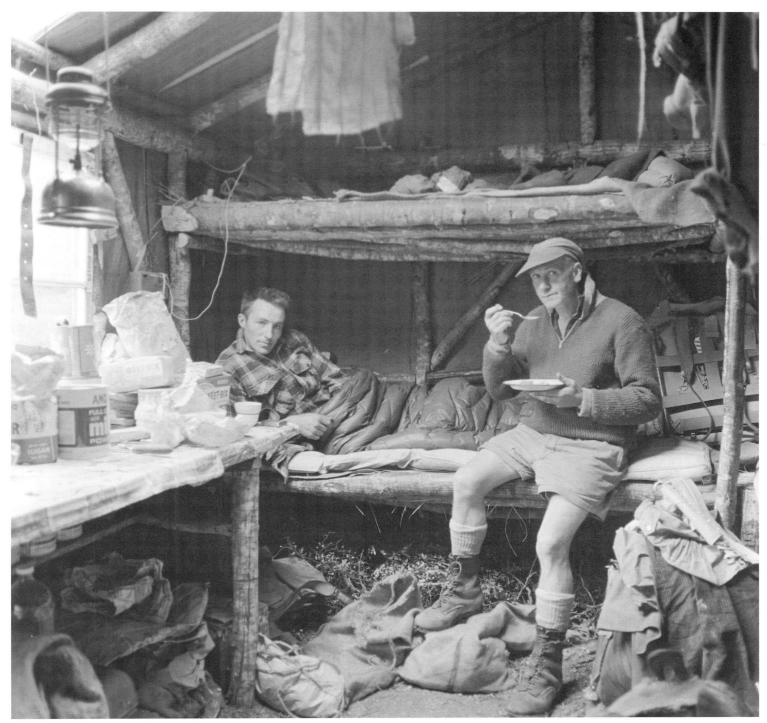

Deer-shooters' hut, 1964

The first Labour government is synonymous with the expansion of the welfare state.[10] The provision of housing formed a substantial part of this expansion, and by 1949 Labour had built and rented out at low rates 32,000 state houses. Some new suburbs on the outskirts of Auckland, Wellington and Christchurch were designated as state housing areas, and housed the young families who were the main beneficiaries of Labour's scheme.[11] John A. Lee, who oversaw Labour's early housing programme, abhorred the uniform, high-rise dwellings usually associated with mass housing. He wanted streets and suburbs of houses that differed from each other and were not

Pole house, Titirangi, 1980

New Zealand architects, influenced by both local and international architectural movements, experimented with a range of house styles throughout the century. A desire to blend in with the surrounding landscape and local environment prompted designs such as this pole house at Titirangi on the outskirts of Auckland, photographed in 1980. The house seems part of the bush, with heavy supporting beams resembling tree trunks and large windows minimising the barriers between occupants and the outside world.

tucked away in urban backwaters. Some state housing suburbs had spectacular views — Orakei in Auckland or Strathmore in Wellington, for example — but although there were more than 400 different designs for state houses, there was an inevitable uniformity in their mass construction. The buildings in street after street of the state house suburbs could be very much alike.

State houses promoted a particular view of family life.[12] Houses of two or three bedrooms were designed for young nuclear families, and they were built to include modern cooking and washing facilities. By the mid-1950s more than half of New Zealand families had washing machines and electric ranges. A family dining space was provided off the kitchen or living room; the latter was at the heart of the house. A backyard provided space for both children and gardens, while the absence of fences in some state housing areas suggested a community spirit.

Maori migrating to urban centres after the Second World War benefited from Labour's housing policy and were able to obtain decent housing at reasonable rents. Some houses built specifically for Maori were concentrated in areas such as Tamaki in Auckland and Waiwhetu in Lower Hutt, for example, although government policy favoured 'pepper-potting' Maori tenants among Pakeha families. The design of state houses did not take into account the fact that Maori families tended to be larger than Pakeha, and some Maori houses continued to be overcrowded.

The postwar marriage boom created unprecedented demand for housing, and in 1950 there was a waiting list of more than 45,000 applications for state houses.[13] The National government in power from 1949 saw home ownership (rather than renting) as the solution to this problem, and from 1950 state house tenants could buy their homes, or use their family benefit to obtain a deposit on a property. The notion that all New Zealanders could be homeowners – and that the state should not be their landlord – led to generous loan schemes (advances of up to 90 per cent of the value of the house, with interest fixed at 3 per cent) and considerable support for the building industry.

House construction boomed from the 1950s to the 1970s as New Zealanders took advantage of cheap home finance. One company, Beazley Homes, had built 20,000 houses by the late 1960s; vast new suburbs appeared in Auckland and Wellington.[14] Many of these houses were influenced by new architectural trends, such as 'Scandinavian' design with exposed beams and open-plan areas for family living and family pastimes. A plethora of household appliances eased some of the burdens of running a home, especially as more married women entered the paid workforce. Sections now tended to be smaller, and carports or garages provided for vehicle-owning commuters. Construction materials had changed too, from the indigenous kauri and rimu used in villas and bungalows to the treated pine that became available when the country's large pine plantations began to be milled.

By the early 1970s, more than two-thirds of householders owned their own homes, compared with around half 40 years earlier. Home-ownership stayed at this level to the end of the century. But Maori ownership levels declined from the late 1970s, and by the early 1990s they were 20 per cent lower than those for Pakeha. Maori also made up a disproportionately large percentage of state-house tenants, as state housing had become the refuge of low-income and socially disadvantaged groups.[15]

Postwar housing design burst forth with a wide range of styles. Architects from Europe brought fresh perspectives. Young New Zealand architects, some of whom were trained in New Zealand rather than overseas, looked to the local environment for challenges and ideas. Some styles evolved from the traditional villa or bungalow, others developed ideas from colonial architecture, and some were imported. Architects such as Ian Athfield, Miles Warren and Roger Walker departed from past styles in highly original ways, sometimes absorbing and responding to the New Zealand environment, sometimes reacting against it.[16]

The gap between rich and poor that dramatically widened from the mid-1980s was reflected in housing, especially as government withdrew from the housing market. Homelessness was finally acknowledged as a social problem, and urban poverty became all too visible in large areas of New Zealand's cities. These were also the areas offering the only accommodation that many Maori and Pacific Islanders could afford. Even though the number of people per dwelling had declined during the century (from about 5 at its beginning to 2.8 in 1996), people at the lower end of the socioeconomic scale still crowded into cramped accommodation.[17] Daily life in these suburbs could be tough, as families coped with straitened financial circumstances and inadequate housing; the extent of the differences between 1900 and 2000 could be questionable indeed.

Owning a home was still an ideal at the end of the twentieth century, but 'home' had come to have many meanings. Urbanisation created larger, more crowded cities. As factories moved out to industrial estates on the urban fringe, inner-city warehouses and offices were rented to the transient young or refurbished for affluent owners. In the suburbs, groups of townhouses almost filled their sections. Late twentieth-century New Zealanders did not necessarily want the quarter-acre paradise that their parents or grandparents had acquired.

Whare, Te Kaha, 1920s

THE BACK OF BEYOND This Maori whare at Te Kaha in the eastern Bay of Plenty, photographed in the 1920s, was built of punga logs and thatched, probably with nikau. **ABOVE** As no ventilation hole is visible in the roof, cooking was probably done outside. This was one of several styles of traditional Maori construction that continued in some areas into the early decades of the century despite the growing European influence on Maori housing.

Clearing the land in the late nineteenth and early twentieth centuries took thousands of Pakeha into the bush. **TOP RIGHT** Often they lived rough in huts and cabins like those photographed in the midst of felled trees early in the century. These temporary shelters were made from materials at hand – in this case, roughly hewn logs roofed with canvas. Cooking was done inside the hut over an open fireplace; in this photograph the sloped roof of the chimney area billows smoke. A bench supporting cooking utensils sits outside the hut, as does a large water can with a tap. A white cat perches on a bench, and a child is passing through the doorway: families, as well as single men, lived in these isolated milling settlements.

Makeshift bush camps were also home to agricultural workers. **BOTTOM RIGHT** This is a drover's family's camp on Wairongomai Station in Wairarapa in 1928. Sleeping in a tent, cooking under a shelter, hanging washing on the fence – none of this suggests easy living. But this camp lacks the desolation of some other bush dwellings; the small boy tending to the saddle and the woman sitting writing seem relaxed in their outdoor 'home'.

Bush-clearing settlement, pre-1920

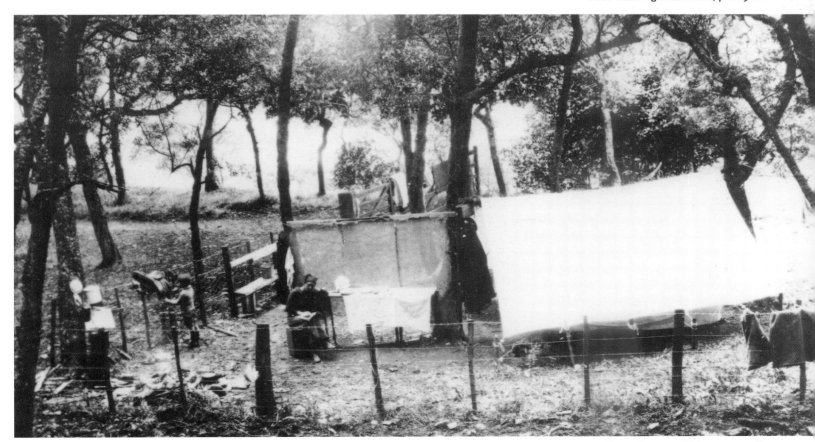

Drover's camp, Wairarapa, 1928

THE BACK OF BEYOND After the clearing came the farms, and in time the established homesteads of country districts. Otago and Canterbury, Hawke's Bay and Wairarapa were sprinkled with the residences of wealthy landowners. Some, like Otekaike in North Otago and Glenmark in North Canterbury, were ornate three- or four-storeyed mansions with many rooms. Others were more modest, such as Crookston in West Otago (photographed in 1915). RIGHT Many of the large estates were sheep runs spread over large tracts of land. Government policy in the late nineteenth century led to the breaking up of many of these estates, but the houses remained, often with substantial farms attached. (Few, however, survived to the end of the twentieth century.) Spacious, well-kept gardens usually surrounded the house, and Crookston probably had servants to look after the interior and grounds.

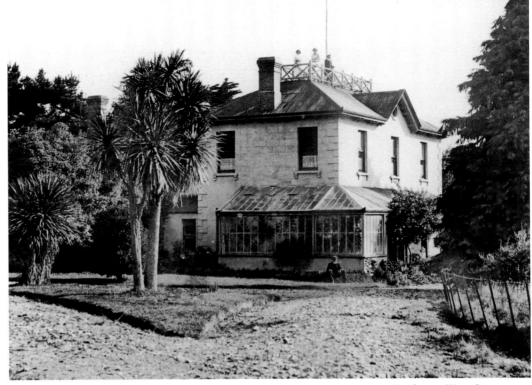

Crookston, West Otago, 1915

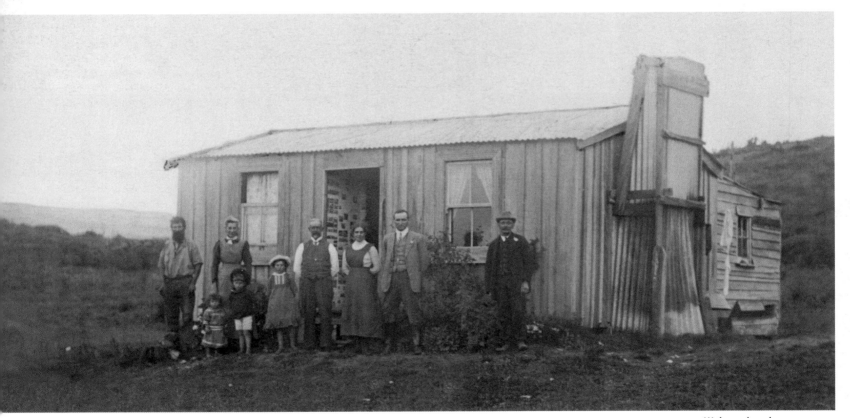

Waipapakauri, 1910s

Roughly sawn timber and a corrugated iron chimney were typical of many hastily erected houses that became home to Pakeha clearing the land. ABOVE The Gleeson house at Waipapakauri in the Far North (photographed early in the century) included features of a more permanent and domestic dwelling — glass windows, lace curtains and lean-to kitchen at the back.

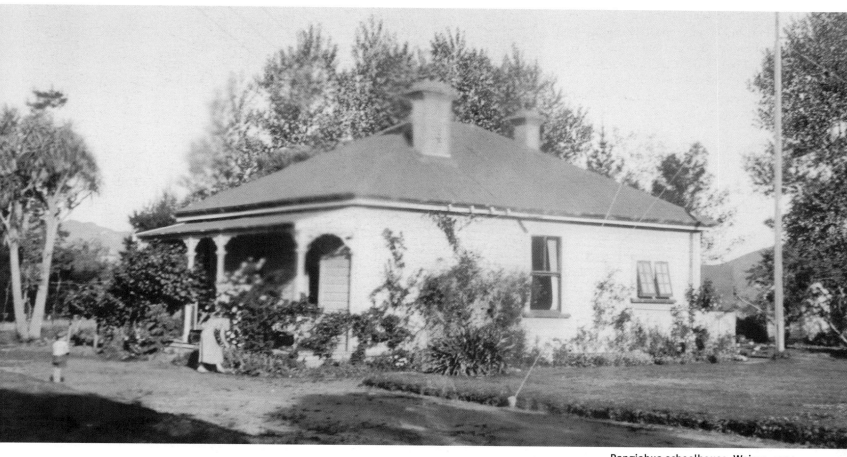

Rangiahua schoolhouse, Wairoa, 1934

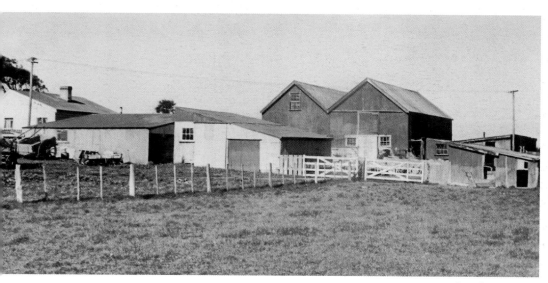

Farmhouse, 1946

THE BACK OF BEYOND Government officials who worked in rural areas often had more permanent accommodation. **ABOVE** The teacher at the Rangiahua Native School (near Wairoa) in 1934, for example, lived with his family in this neat house attached to the school (with a flagpole in the backyard). The garden of roses, hollyhocks and other flowers was a common sight in rural New Zealand as Pakeha became more settled on the land.

Large farmhouses were the exception rather than the rule, and most farming families lived in relatively simple accommodation, such as this farmhouse photographed in the mid-1940s. **LEFT** The small cottage is dwarfed by the scale and number of the outbuildings: sheds for farm vehicles and cars, a barn, a shearing shed, and a host of smaller implement sheds. There is little separation between farm and house; here the business of the farm, rather than the appearance of the house, has priority.

Sawmiller's house, Ruru, 1960

Woodcutters' hut, Haast Pass, 1950s

Stone hut, Upper Shotover Valley, 1957

THE BACK OF BEYOND More permanent structures were built for back-country accommodation by the middle of the century. **TOP LEFT** The Forest Service woodcutters sitting outside their hut in the Haast Pass, perhaps in the 1950s, enjoyed the comparative luxury of four solid walls, a sturdy roof and windows that could be opened. The hut probably had no running water, as large kerosene cans for collecting water stand on a bench outside the door. **FAR LEFT** The house in the West Coast settlement of Ruru was occupied permanently by the sawmilling family photographed outside it in 1960. Like the canvas-roofed huts in the bush, this house is hemmed in by its surroundings. Shelter trees are planted close to the back, and the front door is separated from the railway line only by a large pile of sawn timber. The washing on the line and the timber planks laid over muddy ground suggest the hard work involved in maintaining this home, and perhaps the straitened financial circumstances in which some rural families lived. **BOTTOM LEFT** Mr Cox's stone hut in the Upper Shotover Valley in 1957 was once typical of dwellings in the remote parts of Central Otago. Schist was the perfect building material in the harsh climate of freezing winters and scorching summers. Built to last, the stone huts of nineteenth-century gold-miners can still be seen in the Central Otago landscape.

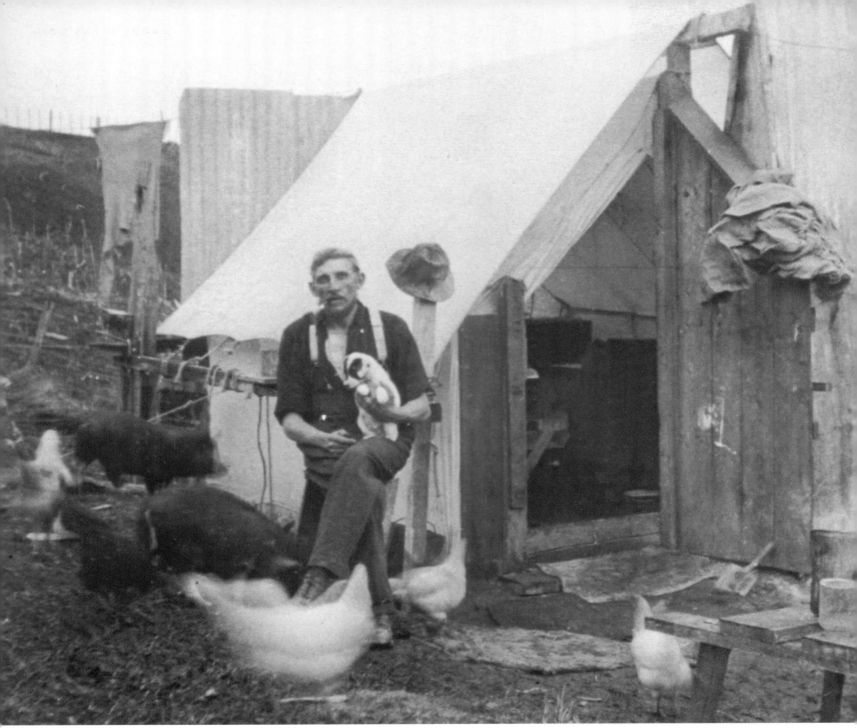

Te Uhi cutting camp, 1921

THE BACK OF BEYOND Large public works schemes generated temporary and semi-permanent camps up and down the country, and sometimes in cities as well. The Railways Department provided a range of accommodation for its construction workers while tracks, bridges and tunnels were built. **ABOVE** 'Gibson's camp' in 1921 near the Te Uhi cutting on the Wairoa–Waikokopu line was a temporary settlement built from bits of wood and tin, with a few tents with wooden doors. Food was probably prepared outdoors, and cooked over an open fire inside the hut. The chickens and pigs may well have been part of the camp economy, kept as food or for sale or barter. Housing like this was easy to dismantle and remove once the work in the area was completed.

TOP RIGHT The huts in 'Sulphur City: Population 7' at Tangiwai Bridge in the central North Island in 1957 would have been transported there by train, to be taken somewhere else once the work was done; their resemblance to train carriages is marked. These single men's huts were fairly basic, as the photograph inside a similar Wellington hut shows. **BOTTOM RIGHT** Electricity was provided for lighting, appliances such as radios, and heat (although the Sulphur City huts have a chimney for a stove or fire), but there was scant room for relaxation beyond lying or sitting on the narrow bed. Meals would have been taken in a communal hut, and clothes washed in a shared ablution block.

Tangiwai Bridge camp, 1957

Workman's hut, Wellington, 1959

Sir John Roberts' house, Dunedin, pre-1910

Cottages, Lyttelton, 1980

HOUSING THE PEOPLE Urban New Zealand displayed extremes of housing at the beginning of the century. **TOP** At one end of the scale were large mansions such as the Roberts family's impressive Dunedin house, complete with tower and pseudo-minarets and set in landscaped grounds. At the other extreme were cramped terrace houses, and small cottages such as some of these in a Lyttelton street (photographed in 1980). **ABOVE** The design of the cottages was simple: a central hallway to a kitchen/dining area was flanked by a bedroom or two and a sitting room. Bathrooms and toilets, and sometimes kitchens, occupied a lean-to behind the house. **RIGHT** The terrace houses with narrow backyards set in tiny streets are in the Wellington suburb of Newtown early in the century. To reform-minded citizens, scenes such as this suggested squalor that many hoped had been left behind in Britain. In the years following the First World War, local councils set about demolishing such housing.

Wellington terrace houses, pre-1920

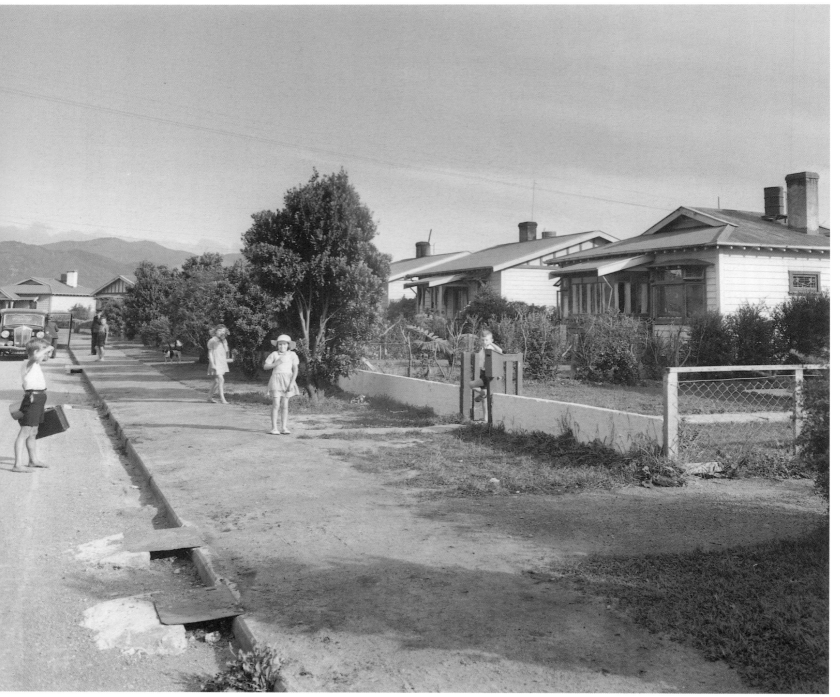

Railways housing, Lower Hutt, 1930s–40s

Lower Hutt, 1940s–50s

HOUSING THE PEOPLE Houses provided by the state were built to several designs. The Railways Department had supplied housing for its staff since the 1880s, and in the 1920s it began erecting prefabricated homes. **LEFT** More than 2,000 houses – many of them bungalows – were provided by the Railways in the 1920s; these bungalows are probably in Lower Hutt where more than 300 were built. By the time this photograph was taken in the 1930s or 1940s, some of the house-holders had cars and set up low ramps onto the footpath for off-street parking. Newer housing styles superseded the bungalow from the 1930s. **ABOVE** This house on the Johnson Rumgay 'estate' in Lower Hutt in the 1940s or 1950s followed modernist concepts with its flat roof and mix of sharp angles and curves.

Blenheim, 1950s

Tamaki, 1960

HOUSING THE PEOPLE Between 1937 and 1949 the state housing schemes of the first Labour government provided more than 32,000 new houses. Nearly all houses until then had been erected by private builders, but now the state dominated the market in a concerted effort to house New Zealanders in better facilities. **RIGHT** The Auckland suburb of Orakei was one of the first state housing areas. In the late 1940s it shows much of the mid-century state planners' vision: curving streets and an absence of fences suggest 'community'; rows of nappies drying in the breeze are evidence of the family life promoted by politicians. These state houses were typical of their time: solid buildings with two or three bedrooms, high tiled roofs, windows a good distance above the ground. **TOP** Generous backyards allowed householders to cultivate gardens such as the one photographed in Blenheim in the 1950s. By then, however, New Zealand's population had grown considerably and cities sprawled outwards. **ABOVE** New state housing developments such as these multi-unit dwellings in Tamaki photographed in 1960 were relatively cheap to build and their small sections helped control 'urban sprawl'.

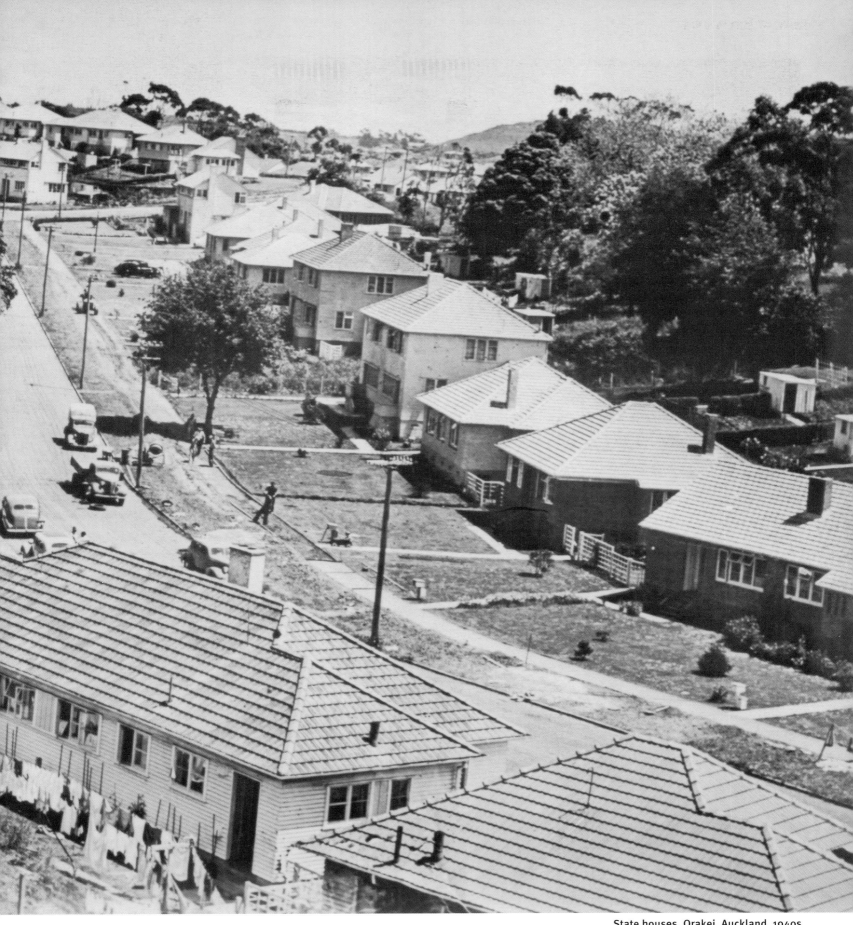

State houses, Orakei, Auckland, 1940s

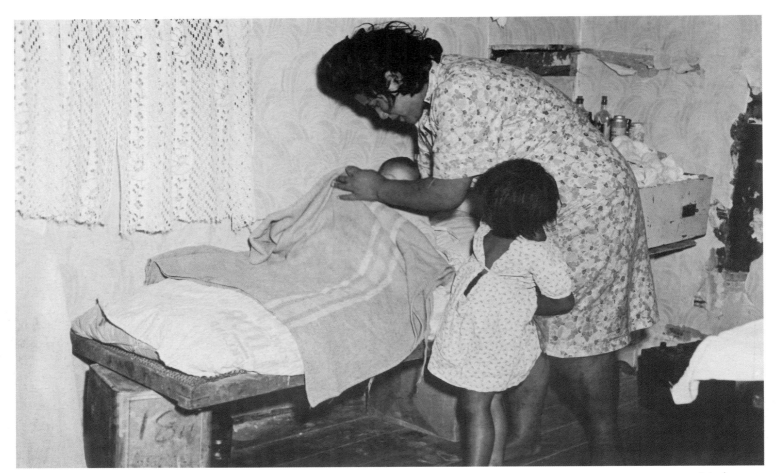

Interior, 1950

HOUSING THE PEOPLE The early state housing schemes were primarily targeted at urban centres and Pakeha families. Rural areas and Maori families gained comparatively few of the housing benefits initiated by the first Labour government and continued by its successors. The government removed some substandard rural Maori accommodation from the 1930s by tearing down some dwellings and repairing others. **RIGHT** By the end of the 1940s, 10 per cent of Maori had been rehoused under land development schemes that renovated properties and built new houses, such as this homestead at Opotiki. Even so, the living conditions of most Maori were of a lower standard than those of Pakeha. **TOP RIGHT** This Far North dwelling in the 1950s had more in common with the makeshift shelters of the early twentieth century than with the new homes being built in towns and cities. **ABOVE** Many rural Maori may have lived in material poverty, but the warmth and care of their homes is suggested in this photograph of a woman putting her small child to bed.

New housing, Opotiki, 1940s

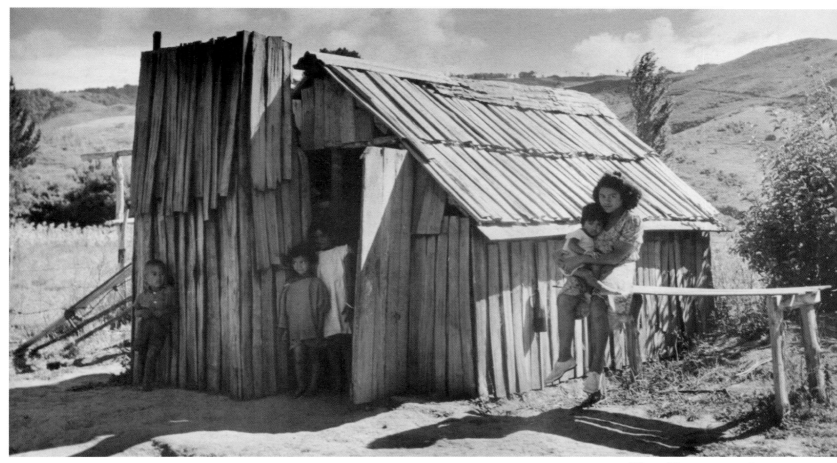

Whare, Whangaroa county, 1950

Wharenui, Mangere, 1966

HOUSING THE PEOPLE Wharenui on marae had long sheltered Maori attending hui, and in the immediate postwar years a number of urban marae were established. Sleeping overnight in the meeting-house or wharenui was a time-honoured part of gathering together, or meeting to settle business or politics at hui, or spending time grieving after a death. Some marae also offered hospitality to travellers. **LEFT** This South Auckland marae provided overnight accommodation for a group who left the Tokelau Islands in 1966 to take up employment at a forestry camp at Rotoehu in the Bay of Plenty.

Housing boom, North Shore, Auckland, 1973

CHANGING STYLES The opening of the Harbour Bridge in 1959 signalled the start of a building boom as Auckland's North Shore became a series of commuting suburbs. Here, as in many other suburbs from the 1950s, private builders erected new houses, sometimes with government support. These Forrest Hill houses are being built for the new suburban middle class, seeking space and privacy within driving distance of the city centre. Most are two-car homes of urban commuters, with double garages as well as room for the car in front of the house. Most are also large, leaving little room for gardens, lawns or play areas. These 1970s properties demonstrate the demise of the quarter-acre dream that had been such a strong theme in New Zealand housing. The hillside seems to be occupied by busy, double-income families with no time to mow the lawn or tend a vegetable garden.

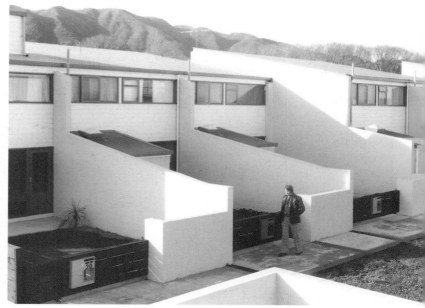

Suburban flats, Wellington, 1970s

Park Mews, Hataitai, 1970s

CHANGING STYLES Postwar suburban sprawl created several types of new suburb. Not all improved on the rows of tenement houses in turn-of-the-century Dunedin or Wellington. **TOP** These flats, perhaps in the Wellington suburb of Karori, look bleak, with tiny sections hemmed in by concrete. Dense housing of this rather functional kind appeared increasingly from the 1960s, as more and more people moved to the major centres in search of employment, and from city centres out to the suburbs.

Some local architects were strongly influenced by the design of New Zealand's colonial houses. **ABOVE** The Park Mews apartments at Hataitai in Wellington, photographed here in the later 1970s, were based on features common in colonial homesteads, such as high gables and verandahs. Designed by the architect Roger Walker in 1974, the apartments also set out to challenge the sameness of New Zealand's suburbs by creating a dizzying array of windows, roof styles and levels.

Dixon Street flats, Wellington, 1940s

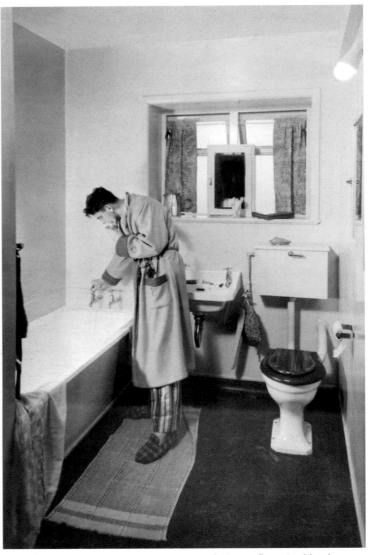

Bathroom, Symonds Street flats, Auckland, 1940s

BEYOND NUCLEAR FAMILIES Many New Zealanders have not lived in either nuclear or extended families: the young, single people, couples, the elderly. The state housing system catered for some of these households by building blocks of flats from the late 1930s. **ABOVE** Two of the largest complexes were the Dixon Street flats in Wellington (left), and the Symonds Street flats in Auckland, the bathroom of which is shown here (right). The multi-storey Dixon Street flats, designed along modernist lines by the Austrian architect Ernst Plischke, opened in 1943. Most had one bedroom, with a living room, kitchen and balcony. Washing was done in a communal washing area on the roof of the flats, where washing lines were installed.

The private sector provided most of the flats that were rented or owned by single people and couples. **RIGHT** Prime sites such as Wellington's Oriental Parade attracted developers from the 1950s, and high-rise buildings increasingly blocked the harbour views from the older homes further up the slopes. The location of these apartments put them out of reach of the people who lived in buildings such as the Dixon Street flats. By the 1980s, multi-storey apartment blocks dominated parts of Wellington's foreshore as more people chose (or could afford) to live near the centre of town.

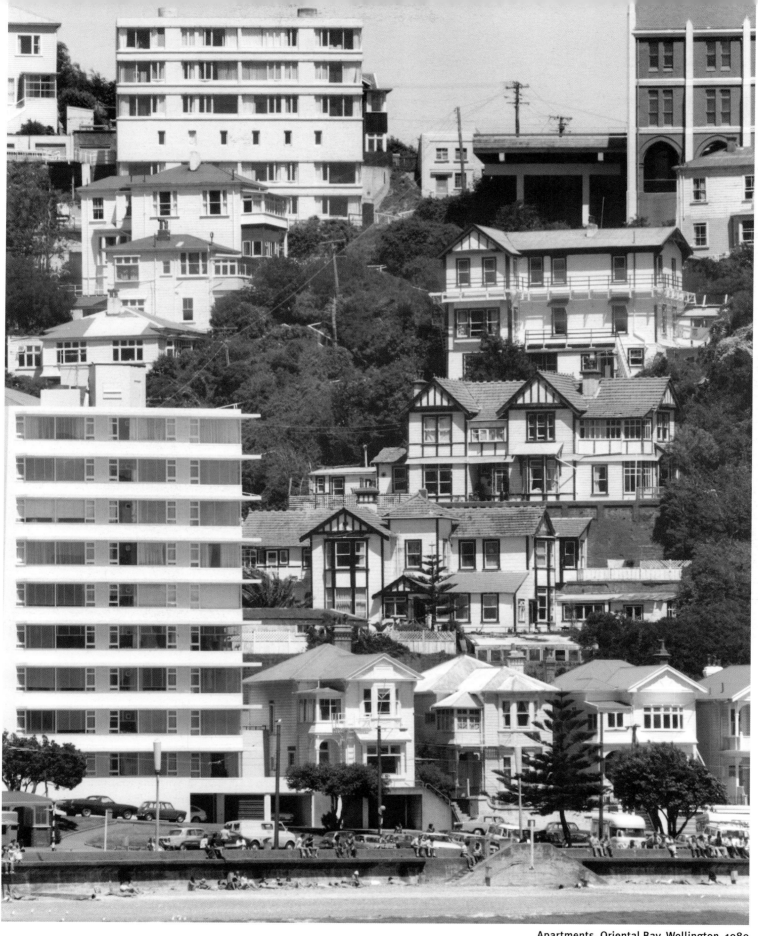

Apartments, Oriental Bay, Wellington, 1980

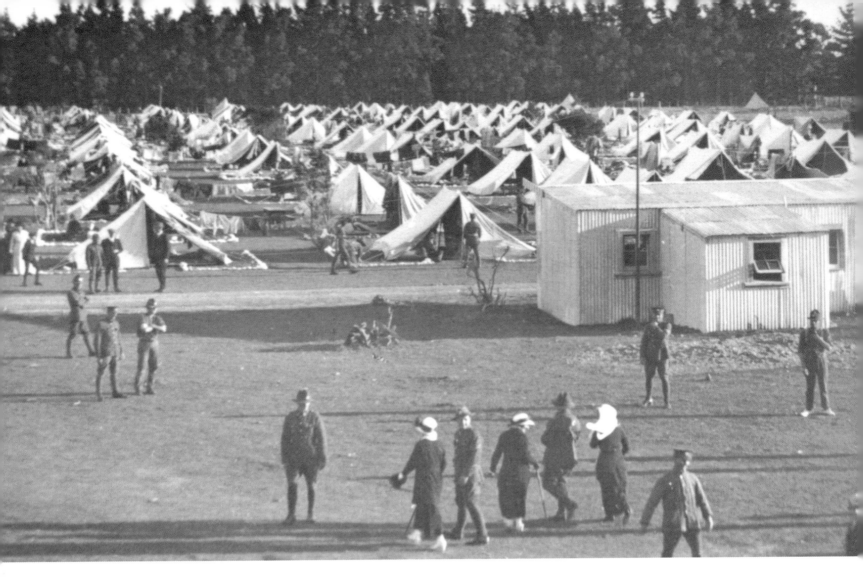

AWAY FROM HOME Soldiers on leave took any available accommodation to rest and relax. **RIGHT** Some of the men in the dormitory run by the YMCA in Britain during the Second World War are New Zealanders. The accommodation is rudimentary, with only a wooden chair separating each bed from the next, but despite the crowded conditions most are sleeping soundly.

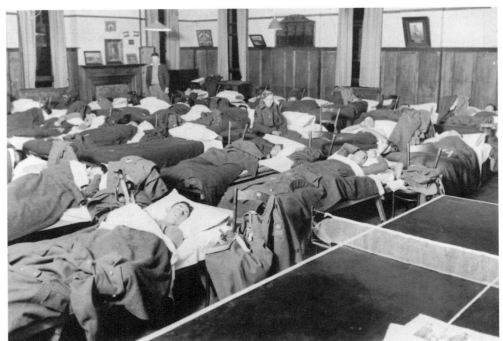

YMCA dormitory, 1940s

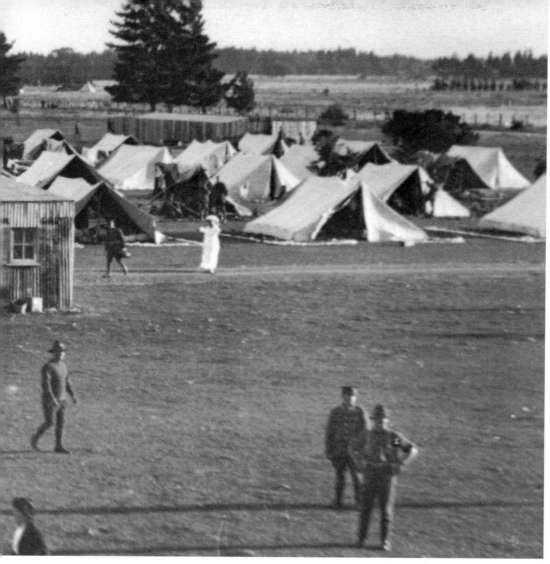

AWAY FROM HOME Soldiers lived away from their families and homes for extended periods. This photograph shows the aptly-named 'Canvastown' section of the First World War training camp at Featherston, Wairarapa. Only two solid structures can be seen among a sea of tents. Immediately in front of a clump of tall trees on the right is the ablution block and toilet area; too small for a mess-hall, the corrugated iron building in the foreground may be an administration block or quarters for officers. The men living in Canvastown did their best to make these tents home. Some are entertaining friends or family; others have hung their washing out to dry in the walkways between the tents.

'Canvastown', Featherston, 1915

New Zealand troops stationed in the Pacific Islands from 1942 sometimes lived in wooden huts that could be opened up in the heat of the summer but were liable to be blown down during the cyclone season. These members of the Women's Auxiliary Army Corps were photographed resting between shifts in their barracks on New Caledonia in 1944. Above their beds hang mosquito nets, essential for living in the Pacific at that time.

WAAC quarters, New Caledonia, 1944

Wellington Hospital, 1900s

AWAY FROM HOME A variety of institutions housed people who required or were 'committed to' particular forms of care. Two very different types of medical care were provided in the two hospitals pictured here. **ABOVE** Wellington Hospital, sited in spacious grounds in the suburb of Newtown, was a large, ornate wooden structure when this photograph was taken in the first decade of the century. Patients can be seen in the garden, and one is being wheeled around the grounds by a nurse. **RIGHT** Tokanui Hospital in Waikato provided mental health care for women and men; this photograph shows the female admission ward in the 1960s. Despite the plants on the shelves, this is clearly an institution rather than a private home.

Tokanui Hospital, 1967

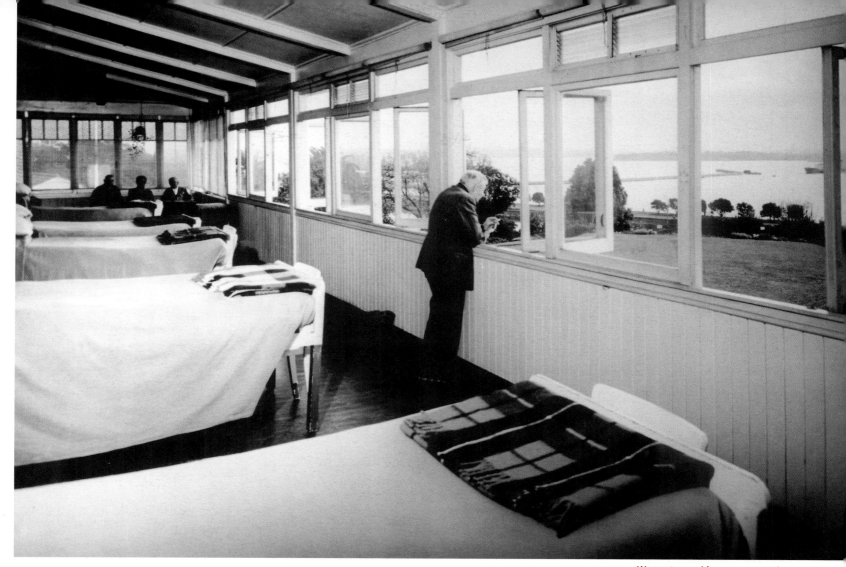

War veterans' home, 1950s–60s

AWAY FROM HOME Some elderly slept in dormitories and ate in communal dining rooms. **ABOVE** The spare simplicity of the verandah dormitory of this war veterans' home in the 1950s or 1960s offers little that seems homely: a row of high, hard beds, wooden floors, and tartan blankets.

Some city councils erected housing for the elderly after the Second World War. **LEFT** These Christchurch flats, photographed in mid-century, were typical of the one-bedroom flats built for pensioners. The residents did their best to personalise them: lace curtains, ornaments and well-kept gardens add touches of individuality to the regimented line of buildings.

Pensioner housing, Christchurch, 1950s

Appearances
Hair and Clothing

The way we dress is the 'most immediate way we present ourselves materially to the world'.[1] Whether we have carefully selected from a full wardrobe or simply grabbed the first thing at hand, our clothing is indicative of our lifestyles, our choices, the times and places in which we live. Utilitarian as clothes may be in offering warmth and protection, they inevitably express personal identity. In all societies, social status or wealth, ethnic difference and even region are indicated by dress. Group identity can be strengthened by uniforms (formal or informal); occupations are revealed by particular forms of clothing; rites of passage are usually accompanied by special clothes, in contemporary urban communities as well as traditional ones. Styles of dress also underscore current ideas of masculinity and femininity, and they may confirm, or challenge, popular gender stereotypes.[2]

Changes in how we look have coincided with, and been influenced by, periods of significant change in New Zealand society. The First World War signalled the end of nineteenth-century clothing styles in the Western world. At the beginning of the century, women wore long trailing skirts with tightly corseted waists, and had elaborate hairstyles and headwear. Waists, busts and hips were emphasised in fashions that manipulated bodies into an S-shape through corsets and extra fabric around the hips and buttocks. Late nineteenth-century feminists and dress reformers criticised such styles, demanding an end to corsets and the adoption of less bulky clothing, but it was the exigencies of wartime that led to the demise of these fashions.[3] The range of new opportunities for women that opened up — extensive fund-raising and paid employment in teaching and the public service, for example — demanded a looser, shorter style of dress for more active and public lives. Hemlines, which had begun to rise in 1910, went up further

Participants in a nursing conference in 1949 retained some of the military look that had influenced women's fashion during the 1940s. For these busy working women, hats and other accessories were simple: little jewellery, virtually no gloves, and spectacles which imparted an air of authority. These women also carried large handbags, both as a fashion item and as a vital accessory for the working woman. Capacious bags held spectacles, keys, handkerchiefs, purses, notebooks, make-up, writing materials, diaries and address books.

Delegates to New Zealand Registered Nurses' Association Conference, 1949

during the war, and the constricting corset fell from favour. Practical considerations accounted for other changes in women's appearance. Elaborate dress, hair and hats depended on dressmakers, milliners and (for the more wealthy) servants to care for clothes and hair; the workforce and materials which supported such styles were in short supply during the war years.

The relief and ebullience that greeted the end of the war was reflected in clothing styles. Brighter colours and looser clothes suggested a society that had shrugged off gloom in pursuit of better times. The 'flapper look' embodied this shift: hems around or above the knee, bare arms and short hair. The war had given impetus to an interest in health and fitness that intensified in the 1920s. Healthy, tanned, athletic bodies were the ideal, and symbolised the efficient, vigorous nation that New Zealand wished itself to be.[4] Clothing reflected the interest in healthy bodies. For women, straight dresses that drew attention to the legs rather than the bust, waist or hips imparted an athletic, boyish look accentuated further with bobbed haircuts. Clean-shaven faces, baggy pants and loose blazers suggested fit, active men. The clothes of an expanding public service and business sector often reinforced the concept of an efficient, orderly workforce: sensible blouses and skirts for women worn with trim hairstyles, and tailored suits with crisp collars and ties for men.

The financial and social stringencies of economic depression and war in the 1930s and 1940s were also visible in clothing. Sartorial practicality was important: making do with a limited supply of clothing and materials, going without items such as hats, wearing old clothes and uniforms for work or as a statement of wartime patriotism.[5] Even more than in the First World War, the new employment opportunities for women demanded different types of clothing. Women who found themselves working in areas such as transport, on farms or in munitions factories discovered that long trousers were more practical than skirts and dresses.

The Second World War also stimulated the development of synthetic fibres. Products such as nylon had been developed during the 1930s, and used for underwear and other garments after the war. Like terylene (developed in 1941), nylon was simple to care for and launder, and needed no ironing. Although synthetic material could be hot to wear, it was convenient and remained popular. Synthetic fibres were developed with increasing sophistication over the rest of the century and used widely, especially for sporting and leisure wear.

Peacetime, the end of rationing, a renewed emphasis on home and family, and a more settled, prosperous economy made an impact on fashion from the late 1940s. Women's clothing became less utilitarian again as they left wartime employment. The focus on home and family brought a 'return of femininity' in women's clothes. Softer fabrics and styles that enhanced rather than hid the female shape were part of the 'New Look' introduced by French fashion house Dior in 1947, and picked up later by New Zealand women.[6] For men, the tidy, unadorned business suit with a short back and sides haircut signified the importance of finance and business in the postwar world.[7]

In the 1950s, for the first time, a distinctive form of youth dress appeared.[8] Young people, and teenagers especially, were influenced by American culture in music and films, and modelled their look on American film stars: short, tight pants and sweaters for young women; stovepipe trousers, slicked-back hair and drape coats or leather jackets for men. Experimentation and the questioning of social conventions among younger people in the 1950s escalated during the next decade. The miniskirt represented one of the more extreme challenges, but for both women and men, personal appearance changed more dramatically, and more frequently, from the 1960s onwards. Some clothes first adopted widely in the 1960s, such as denim jeans, remained common for the rest of the century. Other fashions, such as the colourful flower-power and long-haired hippie look of the 1970s, the power dressing of the 1980s and the grunge style of the 1990s, were more short-lived. The importation of cheap clothing and New Zealand's participation in a global marketplace contributed to more eclectic ways of dressing and to a rapid turnover in fashions. From the 1980s, Pakeha began to adopt Maori and Pacific motifs, sometimes wearing bone or greenstone carvings or

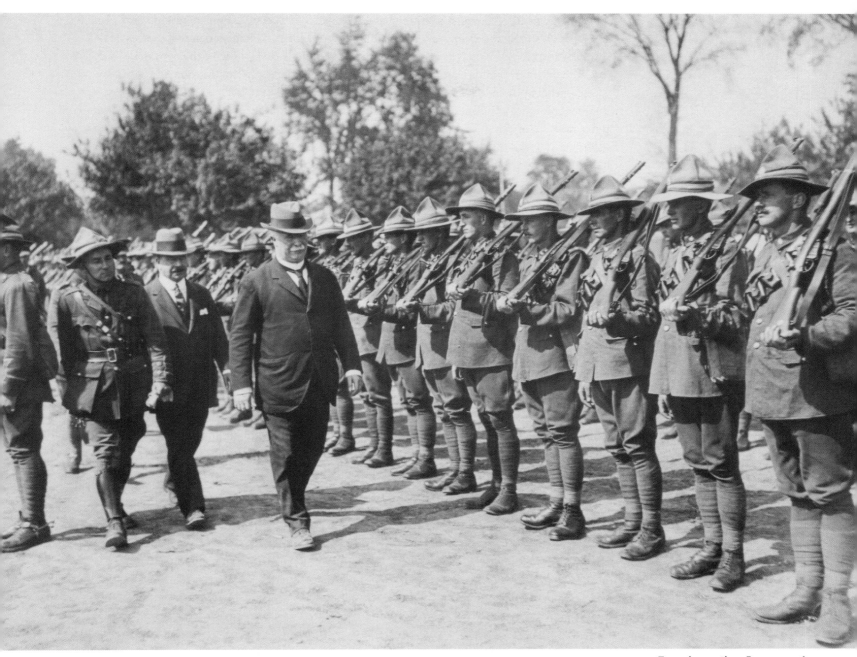

Troop inspection, France, 1916

incorporating koru designs on fabrics. The mix of styles at the end of the twentieth century also represented a more diverse society offering wider choices in work, leisure, education and lifestyle.

Over the twentieth century, the appearance of both women and men has generally become less formal. Social justice and egalitarianism have long been touted as defining features of New Zealand society, but before the First World War, social class, occupation and wealth were indicated by differences in clothing. Elaborate garments and hairstyles took money to buy and time to arrange; styles for poorer women were often freer than those of more wealthy and leisured women. Open-necked shirts and beards indicated a man who laboured for others or farmed land in the backblocks. The levelling effect of the First World War, and the opportunities it created in work and leisure, disrupted both the fashions and the social patterns of early twentieth-century New Zealand.[9]

Armed conflicts during the century saw up to a quarter of a million New Zealanders, mainly men, spend several years in military uniforms. In this photograph, William Massey and Joseph Ward, who headed the wartime coalition government, inspect troops in France in 1916. The New Zealand soldiers wear the distinctive 'lemon-squeezer' hats that had been developed earlier in the decade by soldiers who modelled its shape on that of Mt Taranaki.

The boundaries between different types of clothes have also begun to blur. The clear demarcation between evening and day wear, for example, began to break down from the 1960s, although people still 'dressed up' for events such as weddings or school balls. Everyday wear in the second half of the century was increasingly made up of a variety of styles, and there was often little difference between clothes worn for work, sport or leisure. Before the Second World War, sports clothes were largely confined to sports fields, although knitted pullovers, jerseys and cardigans – all items worn for sports such as golf – became everyday attire from the 1930s.[10] Gradually from the 1950s, and more rapidly during the 1980s, sports clothes have become everyday items: shorts, sports shoes, tracksuits, sweatshirts and sweatpants, lycra wear, cycling shorts, caps, jackets, team jerseys and clothing with the logos of sporting manufacturers. Designer Karen Walker has suggested that such clothes impart a 'Saturday morning feel' to New Zealand dress.[11] Intensive marketing of the sports industry and sportspeople has encouraged the widespread use of sports clothes; consumers have been invited to wear the same brand, cap or football jersey as their current hero or team as a sign of support. The late twentieth-century emphasis on sports, recreation and physical appearance has also encouraged the wearing of sports clothes.

The differences between men's and women's clothing have also become less distinct. The androgynous, unisex look that appeared in the 1970s was a radical departure from styles readily identifiable as men's or women's. Long hair, brightly coloured clothes, jewellery and denim jeans upset long-established traditions in men's and women's appearance, just as the impetus of 1970s sexual politics re-examined the relations between women and men.[12] While men's fashions reverted to a more clearly male style after the 1970s, women's dress remained more ambiguous. Women of all ages, for example, now regularly wear trousers, in almost any situation. As more women entered the worlds of business, management and finance in the 1980s, 'power dressing' became common: shoulder pads worn in tailored suits, jackets, blouses and tee shirts epitomised this look. Power dressing was a sartorial statement of the gains that women had made towards social equality with men; that the clothing style had more in common with men's dressing than women's suggests the ambiguity of those gains.

The significant changes in appearance during the century hide important continuities. Rural and urban New Zealanders have consistently dressed differently, as have Pakeha and Maori people, especially before the Second World War when most Maori lived in rural communities. Specific styles – women's hats and scarves, for example – have persisted in country areas after their demise in more populous centres. Some items of clothing are also immediately identifiable with rural New Zealand. Black singlets, bush shirts or Swanndris may have become a clichéd image of the man on the land or the 'real' New Zealand, but they are still seen more frequently in Piopio and Tuatapere than on Auckland's Queen Street.

Despite differences in clothing style, lifestyle and opportunity, a uniformity of dress remained strong at the end of the twentieth century. For casual wear, businessmen, bureaucrats and blue-collar workers, the unemployed, young and old, male and female, Maori and Pakeha are all likely to don some type of sports-as-leisure wear. This style of dressing may look more relaxed than corsets and long dresses, or suits and hats, but it also suggests a society in which conformity and blending with the crowd remains important.

OPPOSITE Older people retained semi-formal hats for special occasions and everyday wear in the second half of the century. The elderly woman consulting her racebook at Trentham in 1976 is wearing the only hat in sight. People of her generation still dressed up for a special event such as the races. In the 1980s and 1990s, more formality became fashionable again for some racegoers. At major meetings in the main centres, prizes could be awarded for the best hats (for women), and the best outfit.

Trentham Races, 1976

Family group, Poro-o-tarao, 1900s

ALL DRESSED UP Incongruous as the contrast between good clothes and a rough shelter may seem, this family living in the bush at Poro-o-tarao in the King Country early in the twentieth century has clearly dressed with pride for a carefully composed photograph. **ABOVE** With a white shirt for the man, a corseted jacket and long skirt for the woman, a loose shirt and short pants for the boy, and matching pinafores for the two girls, this family presents itself as respectable, upright and neat, even in the back of beyond.

Events such as debutante balls were also opportunities for formal photographs. Some families spared no expense for their daughter's 'coming out'. **RIGHT** In this photograph of a 1953 debutante and her mother, both women are immaculately dressed, the daughter décolleté in white, her mother regal and protective. The heavy velvet of the mother's gown, and the lace and brocade of the daughter's, are set off by elaborately coiffed hair, flower arrangements and jewellery.

Debutante and mother, 1953

Joseph Ward, 1910s

Wartime entertainers, 1940s

ALL DRESSED UP For many men during the century the tailored suit was the height of dressing up. Some men — farmers and labourers, for example — reserved their only suit for special occasions such as weddings or funerals. Businessmen, public servants and politicians wore them as regular working attire. The twentieth-century suit has undergone minor design changes: variations in the number of jacket buttons, the width of cuffs or lapels, or colour. Suits became plainer as men divested themselves of accessories. Until the 1920s, fob chains, gloves, sticks, tiepins, waistcoats and hats completed the outfit of fashionable men like Joseph Ward (1856–1930), who cut a debonair figure on the political scene. **ABOVE** Some of these accessories disappeared after the First World War as men's clothing became more sober, although men continued to wear hats and waistcoats into the 1960s, and ties were worn into the twenty-first century.

Men who dressed as women, either for entertainment or as cross-dressers and transvestites, sometimes took the glamour of the ball gown to extremes. **ABOVE** The two men photographed in the 1940s entertained soldiers at home and overseas by dressing as femmes fatales, with magnificent gowns and make-up to match. Men like these would have played the part of exotic temptresses in opposition to the stereotype of the women left at home — the quiet domestic, the wife, sister or mother. These performances were exaggerated masquerades that did not threaten the masculine culture of the army. Men who dressed or lived as women later in the century were able to be more explicit in creating a sexualised and womanly look.

Receiving corsages, Majestic Cabaret, Wellington, 1947

Performers, Wellington Maori Arts Festival, 1950s

ALL DRESSED UP Women's skirts became shorter during the twentieth century, but floor-length dresses remained fashionable for special occasions — dances and balls, festivals and ceremonial events — until the 1970s. They were ideal for dances such as the waltz, and the graceful hip action of Pacific Island dance. **LEFT** The women outside the Wellington Town Hall are dancing in the Wellington Maori Arts Festival in the 1950s. Their long dresses combine Pacific designs and European style; in the 1980s and 1990s, some Pakeha would adopt elements of Maori and Pacific design into their clothes. **ABOVE** The young women collecting their corsages are dental school graduates at their annual ball. The photograph was taken in 1947 as New Zealand emerged from wartime austerity. The gowns reflect the changing mood of the period: some shimmer with the glamour of ball gowns, but others are more prosaic, with checked prints and floral patterns.

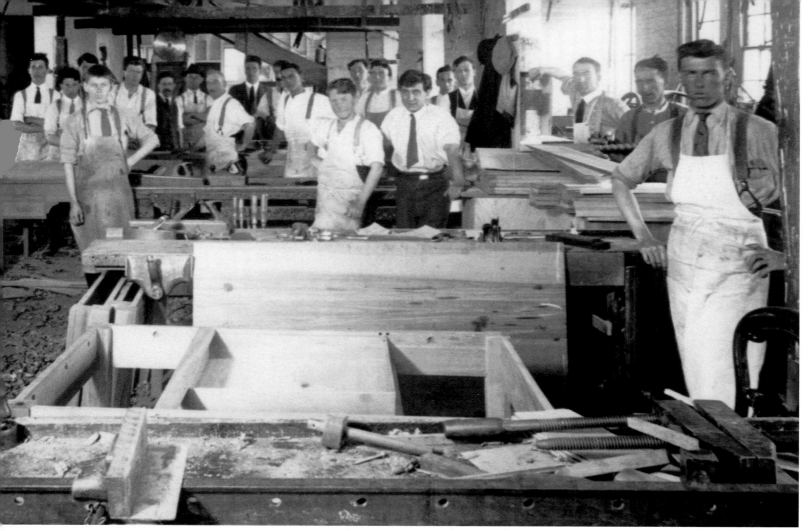

Staff of Scoullars' factory, Wellington, 1921

WORKING CLOTHES Until the Second World War, collars and ties were commonly worn by men at work — by staff and bosses in the office, and sometimes on the factory floor — but they indicated a certain formality and position. **ABOVE** Most of the men at Scoullars' Wellington furniture factory in 1921, for example, wear collars and ties, usually under a protective apron. Many workers in this small factory would have been skilled tradesmen, for whom a collar and tie denoted a status above that of unskilled labourers.

The black singlet and the bush shirt are New Zealand icons: rugged, practical, hard-wearing clothes suitable to all forms of tough physical labour. The singlet came into its own after the Second World War, worn mainly by farmers and shearers. **RIGHT** The shearer photographed here in the 1970s wore a more modern version of the black singlet, traditionally a bulky woollen garment that could reach part-way down the thigh.

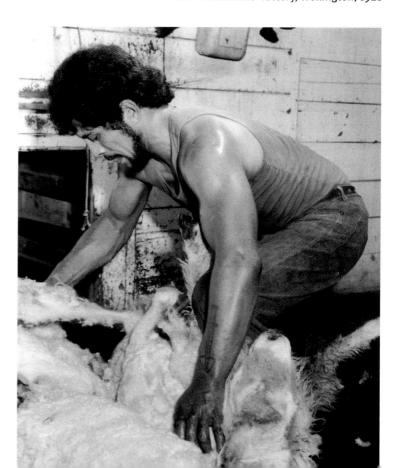

Shearing, White Rock Station, Wairarapa, 1973

182

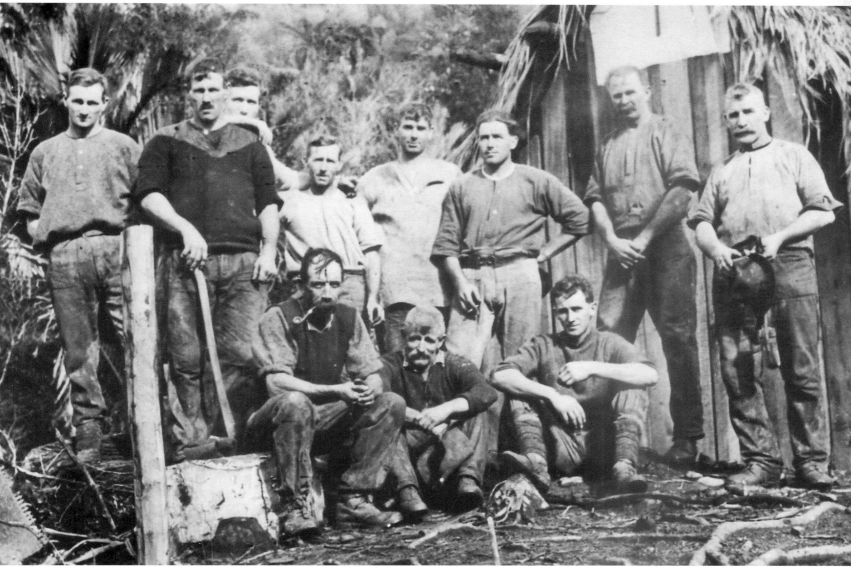

Loggers, Hamilton and Jones' logging camp, Mercury Bay, 1924

WORKING CLOTHES Outdoor manual labourers favoured hard-wearing shirts and jerseys, sometimes made of wool. Lace-up or button-up woollen shirts, such as these sawyers wore in the 1920s, offered protection from the elements, and showed little of the sweat and grime of physical work. In contrast to the relatively formal conditions of the urban factory, the relaxed, masculine atmosphere of the outdoor labourer is reflected in the casual, open-necked shirts.

WORKING CLOTHES The elderly fisherman photographed here is protected from the cold, wind and wet by his woollen jersey and pants; the younger man next to him wears only a short-sleeved shirt. **RIGHT**

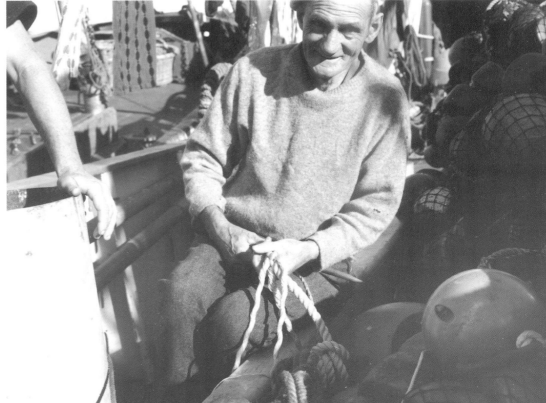

Fisherman, 1950s

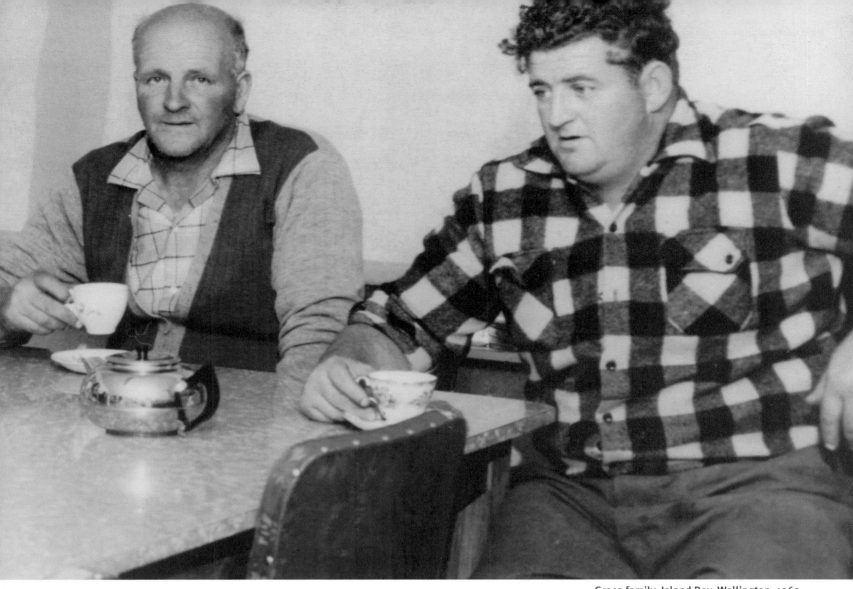

Greco family, Island Bay, Wellington, 1962

WORKING CLOTHES Woollen bush shirts, often made in a checked pattern, were first developed in the nineteenth century. **ABOVE** They provided much-needed warmth for men who worked in all kinds of weather, such as the men of the Greco family – here enjoying a cup of tea – who fished out of Wellington's Island Bay in the 1960s.

Smocks had largely disappeared from the wardrobe by the late twentieth century, but working women regularly wore them in all kinds of office and retail positions until the 1970s. **LEFT** Flowery short smocks, such as these typists wore in the early 1950s, protected their clothes from ink stains and grease. The smock was a pragmatic alternative to the neat skirt and blouse otherwise worn by typists and female clerical staff during this period.

Shorthand typists, Wellington, 1954

185

SHORTS AND LONGS Before the Second World War, trousers were long, and mainly worn by men. **BELOW** Sportsmen wore shorts that hovered around the knees, as in this photograph of Wellington harriers in the first decade of the century. **RIGHT** Shorts were popularised during the Second World War as soldiers found them comfortable in the warm climates of the Middle East, the Pacific and southern European countries such as Italy, where these soldiers were photographed. **FAR RIGHT** More women also began to wear trousers during the war years; these women are harvesting cabbages in 1945 with the assistance of American soldiers. For many of the occupations women entered during the war, trousers were more practical than skirts.

New Zealand soldiers in Italy, 1940s

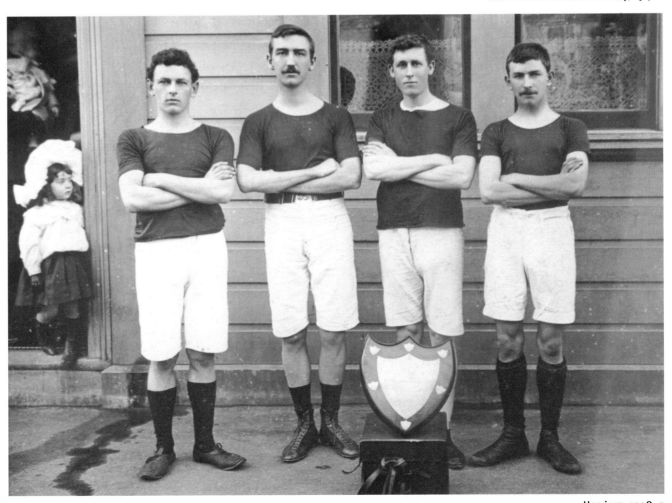

Harriers, 1908–9

OPPOSITE **Harvesting cabbages, 1945**

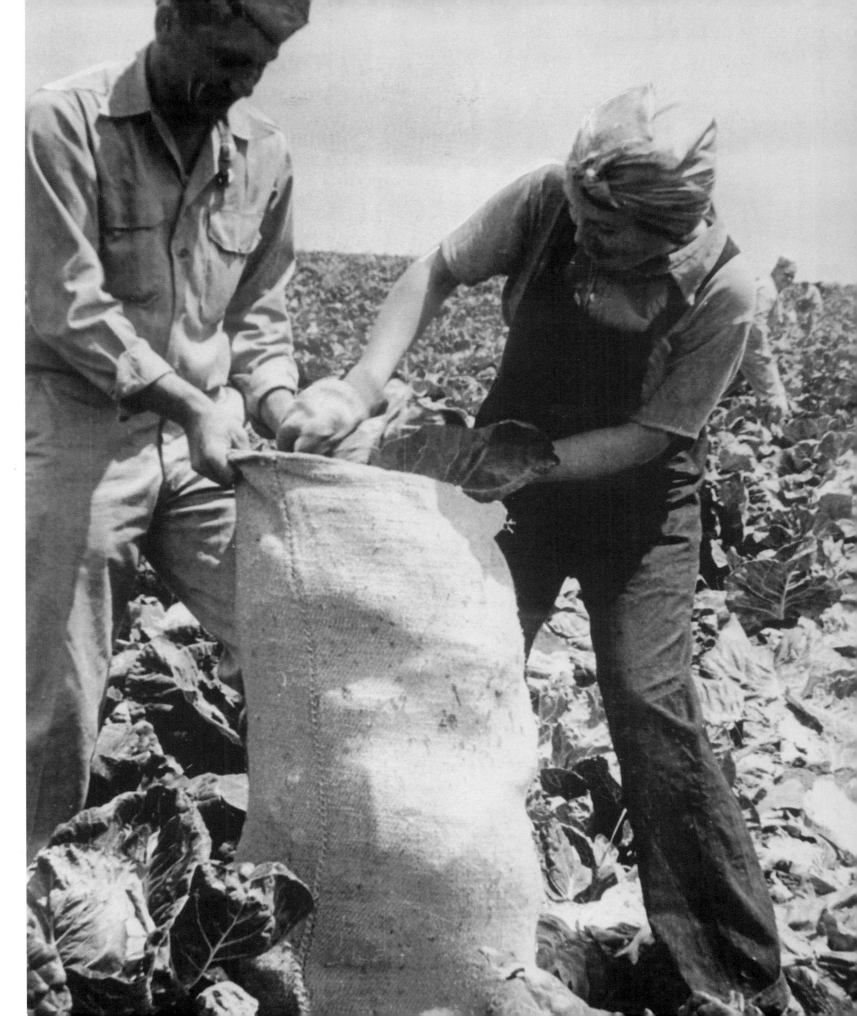

Walk shorts, Radar Station, Auckland, 1966

SHORTS AND LONGS As clothing became more casual in the second half of the century, men wore shorts for both work and leisure. **RIGHT** Worn with loose shirts and jandals — made locally from the late 1950s — shorts became almost a summer uniform in parts of the country. **ABOVE** From the 1960s, men working indoors also took to shorts: the walk short, frequently worn with long socks and a short-sleeved shirt over a white singlet, was acceptable attire in some offices. New Zealand men now had an alternative to the business suit for the heat of a Pacific summer. Affordable, cool and easy to launder, the walk short was a quiet reaction to an older era.

Shorts and jandals, 1970s

Jeans and slacks, 1975

SHORTS AND LONGS Long trousers were every-day wear for both sexes in the second half of the century. Jeans were virtually a uniform for young people from the 1960s. Denim jeans and a denim jacket, often worn with running shoes, gave a casual, sometimes scruffy look to fashion. **ABOVE** The young man in this photograph from 1975 sports the flared legs of 1970s jeans; the width of these trousers is modest, as some could be as much as 50 centimetres wide. The older women sitting beside him would have worn skirts and stockings in their youth; now they have the comfort and warmth of 'slacks'. **LEFT** Tracksuits and looser sweatpants, such as those worn to play golf in 1986, were regularly worn by both men and women from the late 1970s and they contributed to the relaxed look of New Zealand clothing in the latter part of the century.

Golf, Queenstown, 1986

UNIFORMS New Zealanders spent a lot of time in uniform, at work and at play, especially before the 1960s. Many occupations adopted a clinical white uniform suggesting hygiene and cleanliness. In this photograph of a training clinic in 1925, dental nurses are instructing students in the gentle art of tooth-pulling. While the trainees wear a white smock over their ordinary clothes, the qualified dental nurses have the full outfit: white veil and uniforms, and in one case, white stockings and shoes.

Dental nurses and trainees, Wellington, 1925

The greater organisation of sports such as rugby at the beginning of the century was reflected in uniforms. Irregular team clothing had largely disappeared and the rugby jersey was formalised. The round-necked pullover-type jerseys of the 1890s were replaced by lace-up tops with a V-neck insert giving extra protection around the shoulders. This 'New Zealand Football Team' — probably the one that beat Australia 9–3 in August 1904 when this photograph was taken — wears the black jersey and silver fern adopted 12 years earlier as the official uniform of the national team. Apart from the player with white shoes, the team presents a smooth front, with silver ferns prominently displayed.

'New Zealand Football Team', 1904

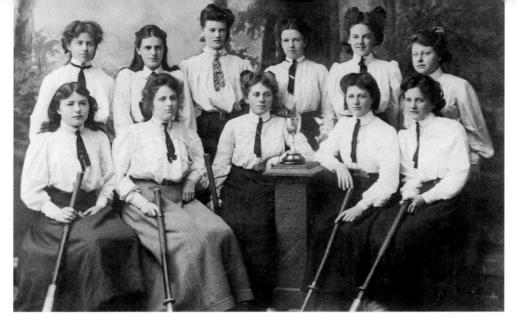

Wellington Girls' College hockey team, 1900s

UNIFORMS Over the century, some sports uniforms became more informal as part of wider changes in clothing styles, especially for women. The nineteenth-century campaigners for women's dress reform had argued that women's clothing needed to be looser for reasons of health and to enable women to be more active. By the beginning of the twentieth century, a few schools allowed girls to wear bloomers for sport, but most played in the same style of clothing that they wore every day. **TOP LEFT** The Wellington Girls' College hockey team, photographed before 1910, played in uniforms indistinguishable from their normal clothes: thick stockings, heavy skirts sweeping the ground, crisp, white long-sleeved shirts and buttoned collars with ties. But women's dress was changing, and the shapeless dresses of the 1920s offered considerable freedom for sportswomen. **MIDDLE LEFT** For athletes such as the Hutt Valley Lady Harriers, photographed in 1931, short, loose-fitting, sleeveless dresses worn with flat shoes and ankle socks allowed them to participate more actively. Most sportswomen continued to wear skirts or dresses until the 1950s; there was considerable opposition to women wearing shorts, which were thought to make them look masculine.

Sports that relied on precision and regularity reflected this in their uniforms. **BOTTOM LEFT** The young women in this Wellington marching team in 1969 stand very still as judges scrutinise their posture, tidiness, length of skirt and the distance between team members. Competitive marching developed during the 1920s and 1930s when women's sports clothes were becoming less restrictive; the skirts of marching teams have always been short to allow freedom of movement and highlight the precision of marching. The clean white tops and spotless boots indicate the importance of appearance in this sport. Neatness, good posture and control of the body — attributes considered particularly necessary for women and girls — are paramount.

Hutt Valley Lady Harriers, 1931

Team inspection, Wellington, 1969

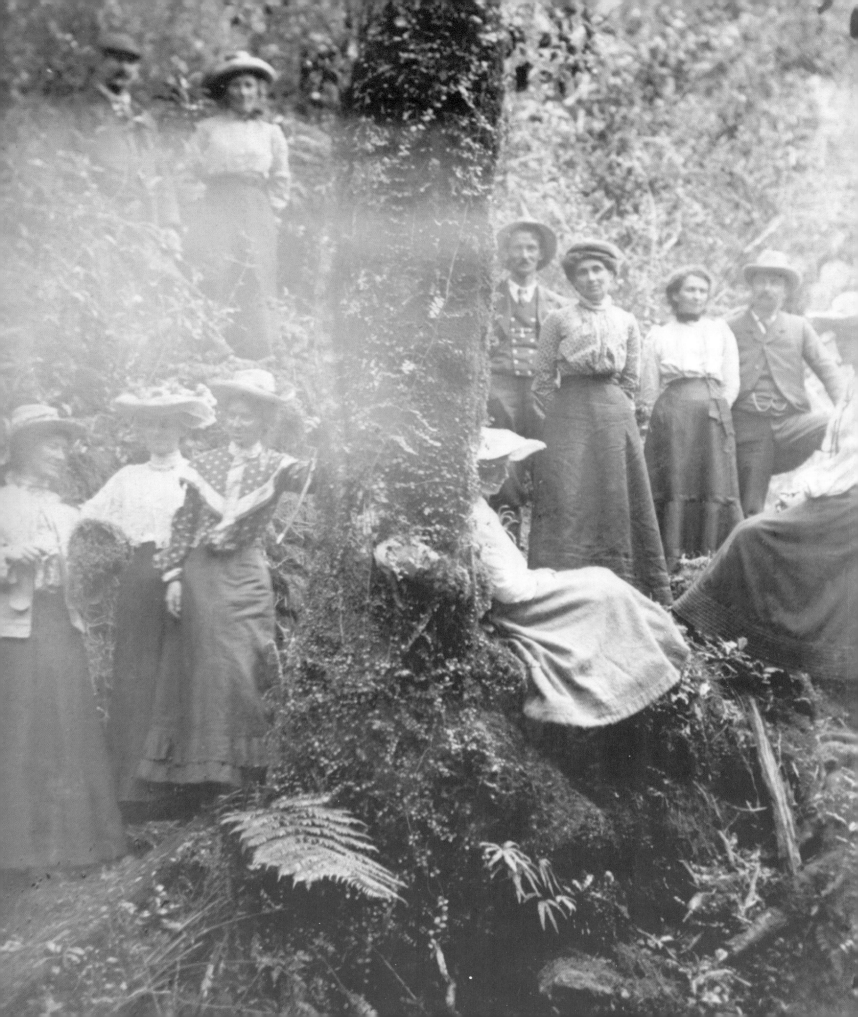

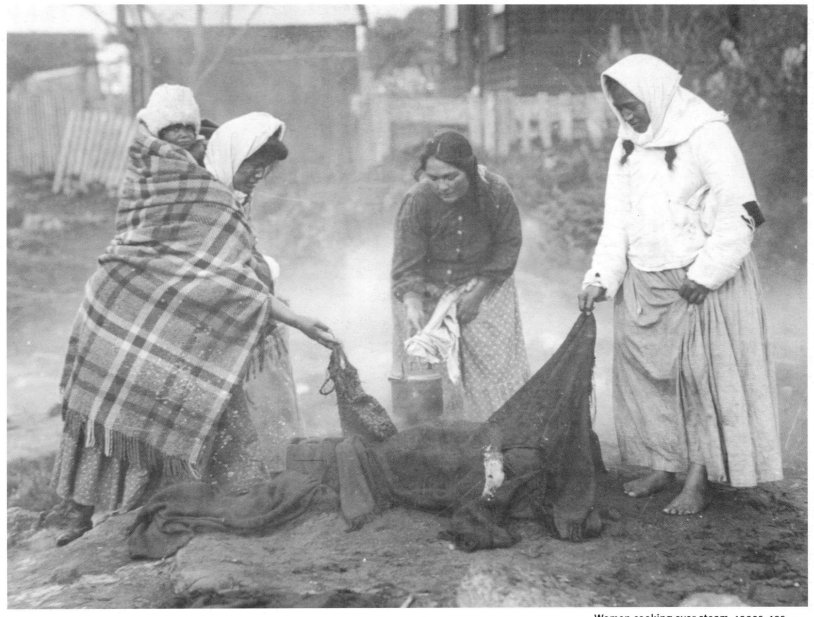

Women cooking over steam, 1900s–10s

HEMLINES At the beginning of the twentieth century, New Zealand women wore their dresses long, with skirts that swept the ground. Nonetheless, these women photographed in the bush seem comfortable enough. **LEFT** They are dressed as they would have in town, in ways that express both social status and contemporary fashion. Even on the remote West Coast, these women wear stylish hats, dark skirts and elaborate blouses; corsets are evident, and the woman at far right sits upright, perhaps constrained by her stiff undergarments.

Maori and Pakeha women living in rural areas usually wore less elaborate garments, but their dresses also trailed on the ground in the first decades of the century. This is likely to have made women's domestic work more difficult, as this photograph suggests. **ABOVE** These women cooking over natural steam outlets are dressed in European clothes, worn in their own style. Blankets were often worn as cloaks by Maori; they offered warmth, protection and, in the case of the woman cooking, a means of carrying a young child.

OPPOSITE **In the West Coast bush, 1900s**

Swimming club and spectators, Thorndon Pool, Wellington, 1926

HEMLINES Hemlines began to rise about 1910, and some women divested themselves of tight corsets and undergarments as well. By the mid-1920s, hems at the knee or slightly above characterised the 'flapper look' that gave women an androgynous or boyish appearance. Legs feature prominently at this meeting of St Apallonia's Swimming Club in 1926. Along with the swimmers are spectators in the height of 1920s' fashion, with cloche hats (rather like the bathing caps of the swimmers), knee-length hems, loose garments, ties and strappy shoes. 'Flappers' were criticised for exposing their bodies and suppressing some visible signs of femininity — the bust, hips and waists. The freedom of movement allowed by such garments reflected new employment and leisure opportunities for women in the 1920s. Short dresses suggested women more interested in dancing and good times than family, home and hearth; legs, rather than the maternal bosom, were the focus of fashion. The short hems of the flappers lasted only a few years, and by the early 1930s hems were tracking downwards again towards the mid-calf.

Train hostesses, Auckland, 1954

HEMLINES With the exception of the short skirts of the mid-1960s and early 1990s, hems hovered at knee length or below for the rest of the century. In the years after the Second World War, this hemline stood for sensible, conservative dressing. **ABOVE** These train hostesses photographed in Auckland in 1954 all wear their skirts at mid-calf, with the clearly defined waists fashionable from the late 1940s. **FAR RIGHT** A softer, more 'feminine' look re-emerged at party time in the 1950s and 1960s: the full skirt of this woman dancing at the Ngati Poneke club in Wellington swung to the rock'n'roll beat. Both fashions, however, focused attention on the waist and bust; the female shape was back in favour, along with the domestic role for women.

RIGHT The controversy caused by the flapper look in the 1920s paled beside the reaction to the miniskirt in the 1960s. Moralists denounced the mini as provocative; it would, some argued, unleash a wave of sexual disorder among men rendered unable to control themselves by the sight of so much female leg. Boots or platform shoes, such as those worn by this miniskirted woman in the late 1960s, further accentuated the legs. These were either left bare or encased in pantyhose, one of the major developments in women's clothing in the latter part of the twentieth century. Pantyhose were essential to the miniskirt, which often barely covered the buttocks; suspender belts or the cumbersome apparatus sometimes required by stockings were impractical with miniskirts.

Miniskirt and platform shoes, 1960s

OPPOSITE Dancers, Wellington, 1950s

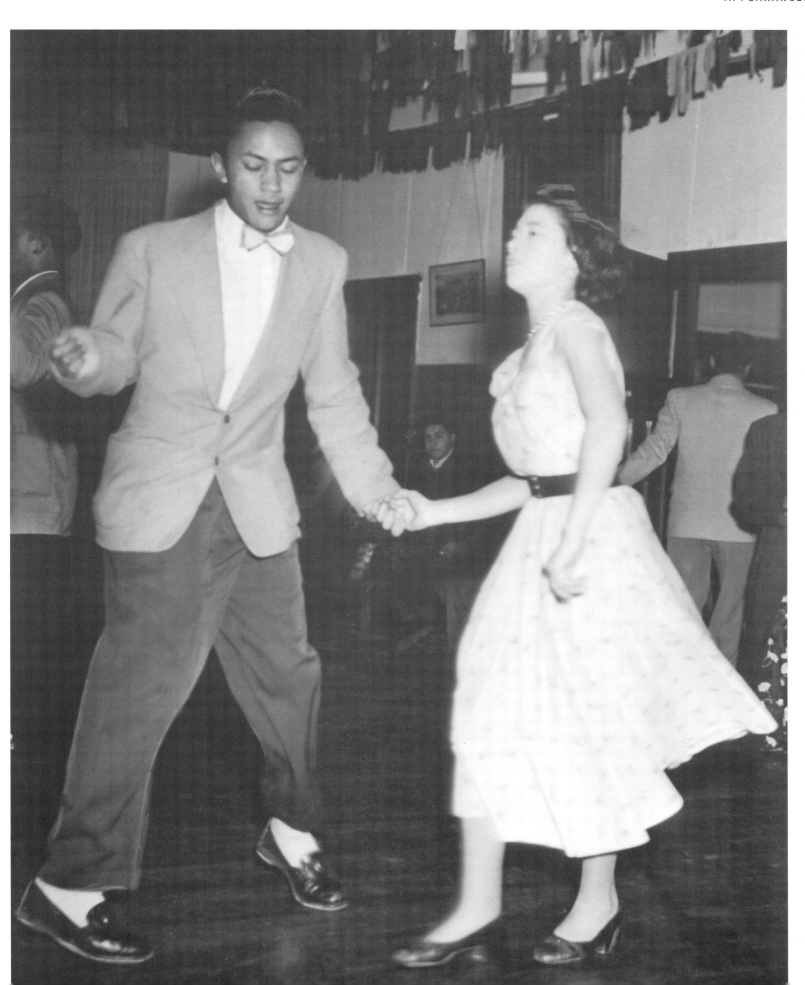

HAIR AND WHISKERS Hair was a focal point in women's fashion in the early twentieth century, and women spent a lot of time arranging fashionable styles. Plaiting, crimping with hot tongs or securing hair tightly with rags gave long, straight hair a frizzy effect, as in this photograph from 1900. **BELOW** Such an effect was indispensable for constructing the large, fluffy, rolled styles that were in vogue before the First World War. **RIGHT** Pakeha women, such as the staff of the Oamaru telephone exchange photographed in 1910, preferred these elaborate styles, and almost never appeared in public with their hair loose. Maori women were more frequently seen with long hair flowing freely or secured by simple hats or scarves.

Oamaru telephone exchange staff, 1910

Crimped hair, Wellington, 1900

Wellington Dental School students, 1925–6

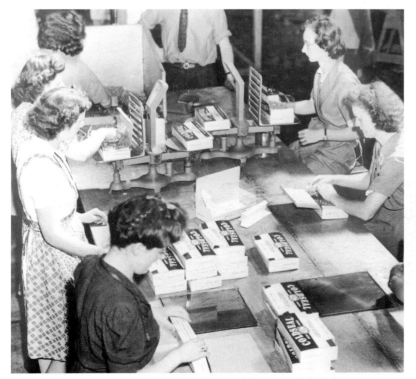

Packing peas, Pukekohe, 1940s–50s

HAIR AND WHISKERS Women took to the short bob or shingle cut as part of the boyish look of the 1920s. **ABOVE** Several of these trainee dental nurses photographed in the mid-1920s have hair that has been crimped and permed as well as bobbed or shingled. Introduced in New Zealand in 1906, the permanent wave became more popular, and more affordable, after the First World War. Such hairstyles also signalled a new type of woman with opportunities not open to her mother's generation: one too busy with paid work to fuss about having an elaborate hairstyle, or too intent on dancing to worry about her hair becoming unstuck. These women were among the earliest dental nurses – the first trainees were accepted in 1921 – and their simple hairstyles fitted them for life in the 1920s.

LEFT New Zealand women such as these employed in a pea dehydration plant at Pukekohe in the 1940s or 1950s were influenced by the wartime spread of Hollywood glamour; waved hair pulled back from the face and tucked in soft folds around the neck or shoulders became popular. Such styles were practical for the women who entered new industries during and after the Second World War. Reasonably simple to maintain, they kept the hair away from the face, and from machinery for women working in factories or production lines, often without headwear.

199

Kingston Railway Station staff, 1900

HAIR AND WHISKERS Most photographs of nineteenth-century New Zealand men show them to be heavily whiskered. By the beginning of the twentieth century, fashions in men's facial hair were changing, and the full beard was disappearing. Amongst the staff of the Kingston Railway Station (photographed at Christmas 1900) little remains of the bearded pioneer look. The only long beard is worn by an older man, who is probably an outdoor manual labourer — he wears a collarless, soiled shirt and open waistcoat. Two other men (probably guards on the trains) have trimmed beards and display the ties and collars of non-manual workers. The smooth, moustached faces of the younger men seated on the ground have a more urbane appearance, and their neckwear (exposed completely in the absence of beards) is more elaborate and colourful. Such changes in whiskers and neckwear mark wider shifts in New Zealand society and masculinity. The whiskers that were practical in the bush were out of place on men living in more settled circumstances. A carefully shaved face and a crisp white shirt with collar and tie were the mark of a respectable man who had left the bush as well as his beard behind.

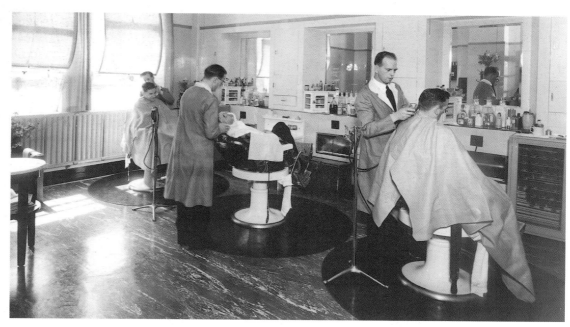

Wellington Railway Station barber's shop

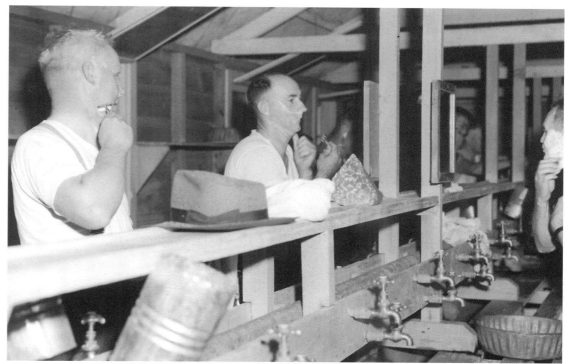

The morning shave, Linton, 1949

HAIR AND WHISKERS A shaven face and short hair remained the most popular look for men for much of the century. TOP Barber's shops, such as this one in the Wellington Railway Station in the 1940s, obliged their customers with a shave or the short back and sides style fashionable during and after the Second World War. ABOVE Safety razors like the ones being used by men at Linton, near Palmerston North, in 1949, made shaving quicker. A smooth face and cropped hair demanded constant attention. Shaving became a daily ritual, and for young men, the first shave was a step into manhood. The men in camp use the bare essentials of soap and water to obtain a lather, but the barber's shop offered a range of products for both shaving and hair care. Creams, after-shave lotions and hair oils were indispensable to men's sleek hairstyles in the 1950s, when men as well as women emulated the Hollywood look.

HAIR AND WHISKERS Hair worn straight and long with a central parting was fashionable for both women and men in the 1970s. The unisex look captured the hippie atmosphere of the period. For men, long hair could be a rebellion against the clipped styles of the 1950s and 1960s; for women, unadorned and simple long hair was a reaction against the fussy styles of an earlier period. The 'natural look' was the order of the day for the counter-culture, with its connotations of freedom from restraint. The man and woman with their Afghan hounds were photographed in 1978, at the end of the unisex period. While some men and women continued to wear their hair long, male and female hair-styles were again sharply differentiated in the 1980s and 1990s.

Horowhenua A & P Show, 1978

The 'alternative' looks of the 1970s also included hairstyles such as 'Afros'. Worn here by a worker at the General Motors factory at Upper Hutt in 1974, the Afro was a large frizzy style popularised by a generation of black American activists, performers and artists. For some New Zealanders, obtaining the look was simply a matter of letting naturally curly hair grow in abundance, but for those with straight hair, perming and back-combing were necessary to achieve the bushy effect.

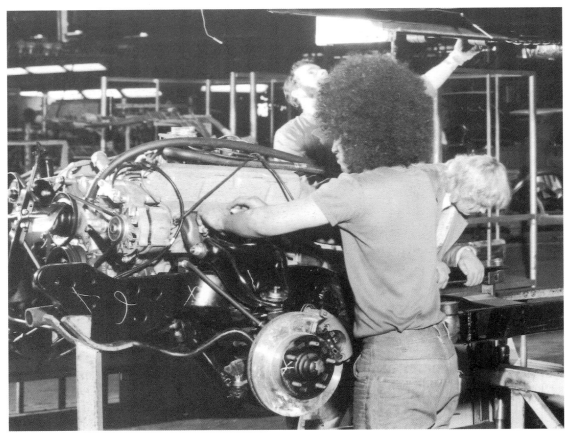

Afro, Upper Hutt, 1974

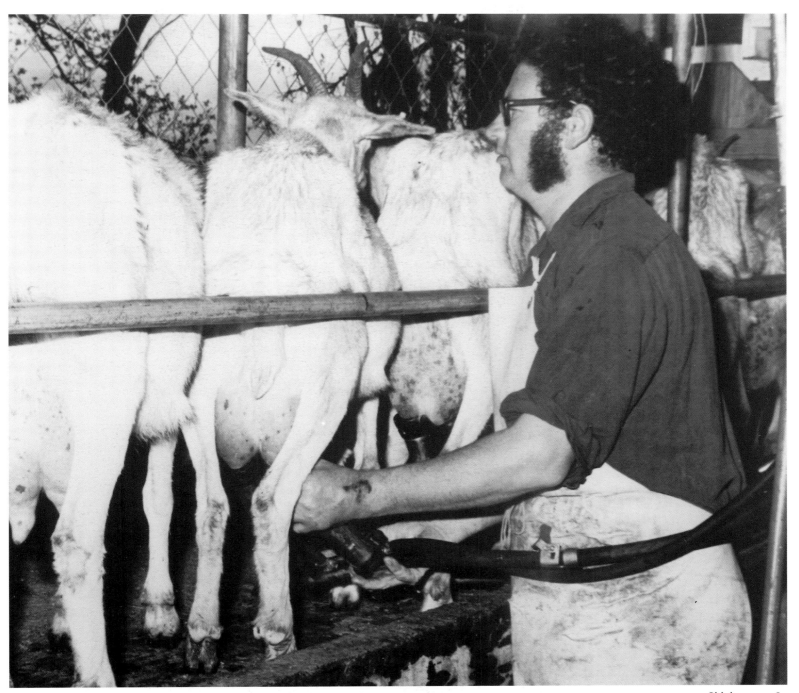

Sideburns, 1983

HAIR AND WHISKERS Sideburns disappeared when the shaved look came into fashion in the 1910s, but returned to favour along with beards in the 1970s. Large sideburns (such as those worn by this farmer milking his goats in 1983) suggested a man who was slightly rugged, rural rather than urban, less constrained than the shaven, short-haired men, but more acceptable than those with long hair or shaggy beards; in short, a late twentieth-century version of the male pioneer. By the mid-1990s, however, the trim sideburns often worn by young urban men presented an image of a different kind of masculinity: confident, sophisticated and cosmopolitan.

HAIR AND WHISKERS Fashionable 1960s hairstyles for women, such as the 'beehive' (towers of curls piled on the head), shared some characteristics with the coiffure of the early twentieth century. Realising them was an elaborate and time-consuming process. The young woman in the hair salon has had her hair set in rollers, frizzed, back-combed and sprayed to achieve the desired look. The early twentieth-century practice of wearing false hair, in the form of switches or hairpieces, also returned, as 1960s women enhanced their natural appearance with a range of attachable items that included false eyelashes and false fingernails – precursors of the synthetic body implants of the 1980s and 1990s.

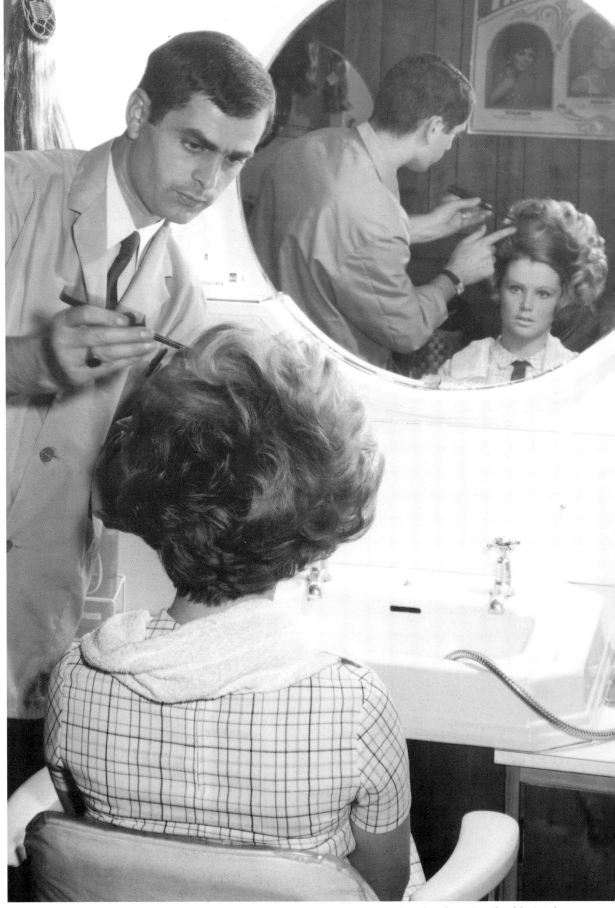

Creating the 1960s 'beehive' style

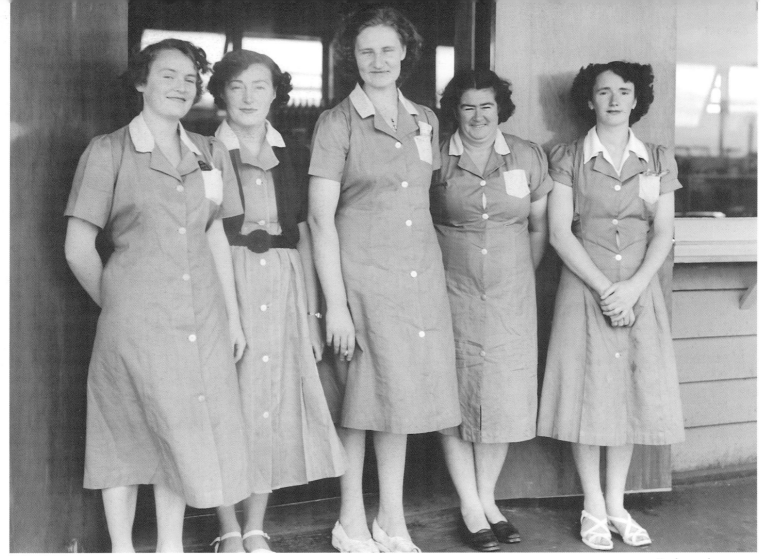

Unshaven legs, 1952

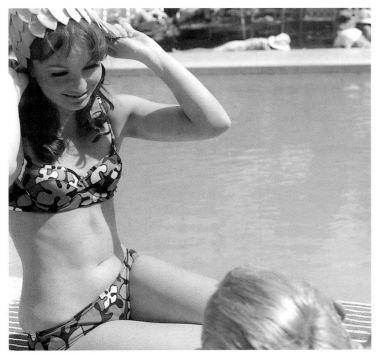

The bikini line, 1969

HAIR AND WHISKERS Hair anywhere but on their heads has, for much of the century, been unacceptable to many women. When sleeveless dresses with short hems exposed arms and legs in the 1920s, the twentieth-century ideal of the tanned and hairless woman began to emerge. Middle-class women of British descent, especially, found body hair 'unsightly'. Initially this distaste extended only to underarm hair, and the group of women canteen workers in this photograph from the 1950s have hair visible on their legs. **ABOVE** In the 1960s the miniskirt and the disappearance of stockings turned attention to women's legs, and briefer swimming costumes exposed new areas from which hair should be removed. **LEFT** The model posing at the Wairakei Tourist Hotel in 1969 is the epitome of the hairless female: her leg, underarm and pubic hair near the bikini line are all smooth. By the 1970s, the pendulum had swung again: retaining body hair became a political statement for some feminists who rejected the child-like sexuality of the slim, hairless woman. For some women in the 1980s and 1990s (feminist and non-feminist) keeping their body hair made a statement about the female 'beauty myth' and the industries that had developed around it.

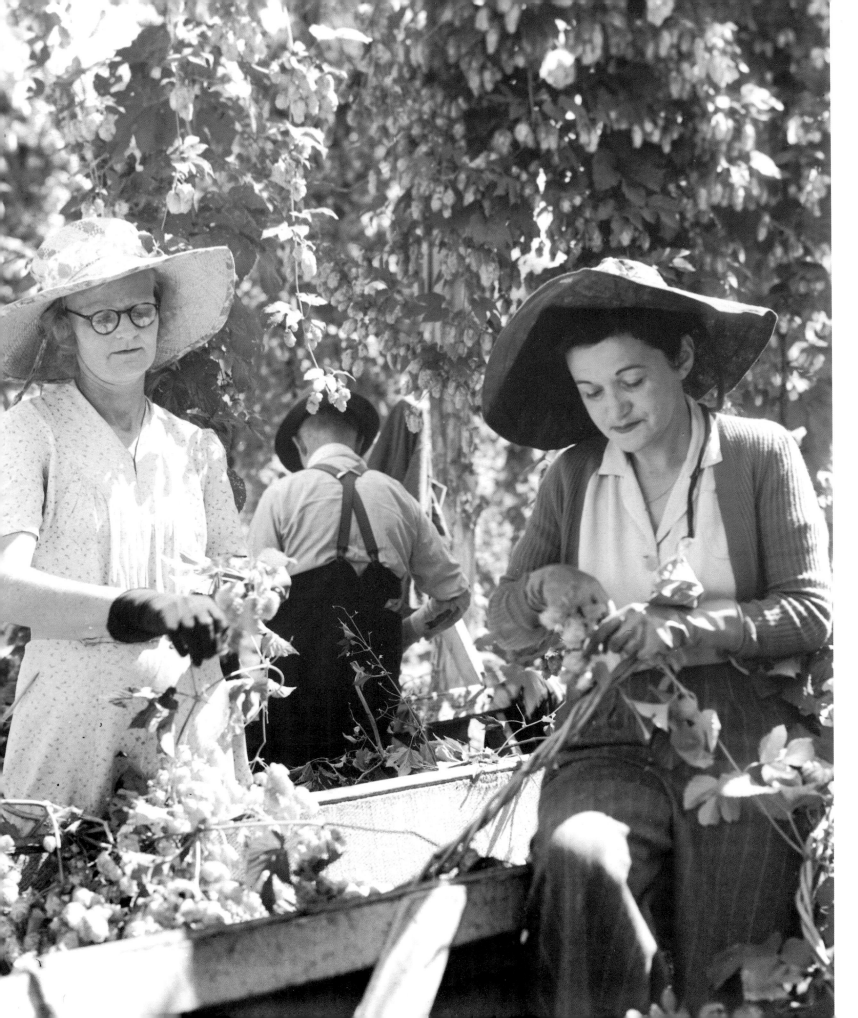

Opening of Ohiro Home, Wellington, 1904

ACCESSORIES Hats were essential accessories during the first half of the century. **ABOVE** The opening of the Ohiro Home for the elderly in Wellington in 1904 was a formal local occasion attended by men of authority — businessmen perhaps, local notables, a clergyman. Several of the men wear top hats and carry canes. Some have bowlers, and one a cloth cap of the kind commonly worn by labourers (although he too wears a three-piece suit). The women's hats also show a mixture of social positions. The two older women seated in the front row wear elaborate hats in keeping with their heavily tailored clothes. The simple hat in the back row is suitable for a younger woman, but suggests also a 'New Woman' who spurns the heavy garb and restricted life of the previous generation. The white cap of the matron in the front row symbolises the efficiency and order appropriate for someone in her position; her cap and dress show none of the adornment that distinguishes the clothes of the older ladies, and her hands are bare.

LEFT Hats were worn less by both men and women during and after the Second World War. Rationing and shortages, the demands of new work opportunities, and the general upheaval of the war all had an impact on clothing. Older women still wore hats for work or formal occasions, but these had become plainer. Practical straw or cloth hats offered protection from the hot sun for women picking hops near Motueka in the 1940s.

OPPOSITE **Picking hops, Motueka, 1940s**

Addington saleyards, Christchurch, 1950s

Waipukurau saleyards, Hawke's Bay, 1981

The Stormtroopers, 1970s

ACCESSORIES Formal hats may have been less common after the Second World War, but hats of different kinds were worn to the end of the century. In the 1940s and 1950s, hats were part of ordinary dress for older men. **TOP LEFT** The farmers and stock merchants gathered around the pens at the Addington saleyards in the 1950s wore suits for the occasion, but they would have worn their hats every day. **BOTTOM LEFT** Floppy towelling or cloth hats became popular from the 1970s. Cheap to purchase, easy to clean and offering protection from the sun, they were worn at work and on the beach, around the home and on the street, in the last decades of the century. They were even worn with shirts and ties, as these stock agents at the Waipukurau sales in 1981 show.

ABOVE Young people seeking to define themselves also wore hats. 'Delinquent' youths in the 1950s sometimes wore peaked leather caps; members of gangs and bikies donned German army helmets; some gangs in the 1970s sported peaked military hats, such as the Stormtroopers photographed admiring a motorbike with 'ape-hangers'. American-inspired baseball caps worn backwards and beanies appeared in the 1980s and 1990s. Each of these styles was used to subvert its original purpose, often representing a flagrant anti-authoritarianism. The wearing of military hats and the adoption of other military insignia and items of clothing was ironically appropriate in gangs that had ordered hierarchies, complex sets of rules and initiation rituals, and sometimes referred to their members as soldiers.

Family group, 1900s

CHILDREN Before the First World War especially, children's dress often marked off childhood as a time when distinctive clothes were worn. **TOP RIGHT** The short pants, loose shirts and sailor suits worn by the young boys in this early twentieth-century family portrait were typical of the period. **BOTTOM RIGHT** Young girls, such as the pupils of Wellington's Te Aro School, wore ankle-length dresses, pinafores and their hair loose. The transition from child to adult was displayed in clothing and hairstyles. The older boy in the family portrait is dressed as a young man in a heavy three-piece suit with fob chain and pocket handkerchief; older girls would dispense with the pinafores, wear skirts that trailed on the ground and have their hair pinned up.

Girls' class, Te Aro School, Wellington, 1903–4

Girls on a jungle gym, 1960s

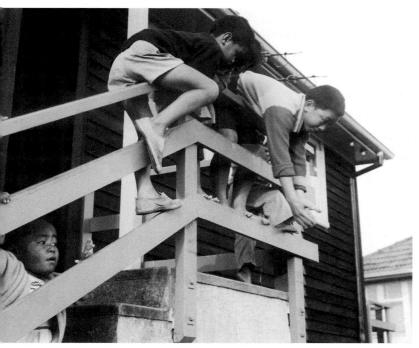

Orakei, 1960s

CHILDREN Children's clothing grew less formal as the century wore on. After the Second World War, shorter hemlines for girls and shorts for boys allowed a greater freedom of movement, especially in play. Even so, girls' fashions did not always enable them to play comfortably or without embarrassment. **LEFT** Young boys in shorts and sneakers could scramble easily over objects such as the banisters outside a house at Orakei, but girls swinging on jungle gyms had to tuck their skirts into their knickers for the sake of propriety. **ABOVE**

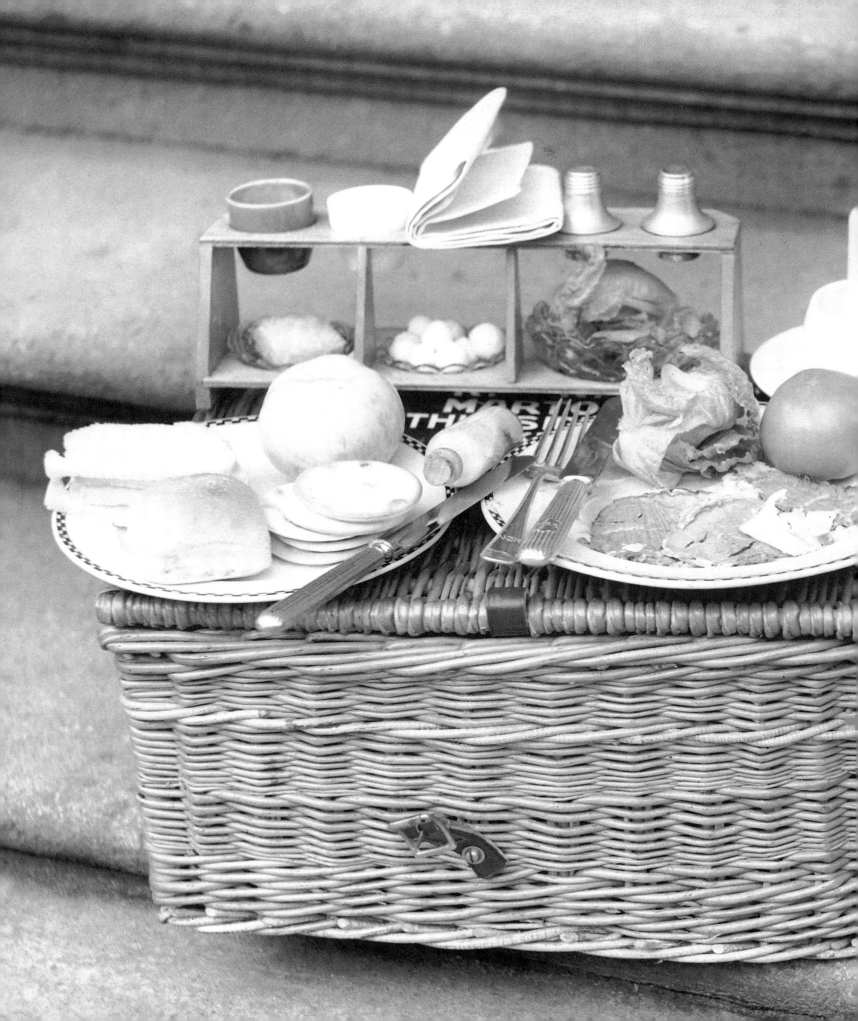

A Land of Plenty
Food and Drink

Judith Miller sometimes stayed with her grandparents in rural Taranaki during the 1940s. She recalls the meals she ate:

> At 7.30 you were ... faced with a ... huge plate of porridge ... and then nana would go and do the dishes ... and then she was back in the kitchen preparing scones for morning tea. And straight after ... the roast was put into the oven, and the vegetables like potatoes and carrots were prepared, and all sort of left there to cook. The greens were put on later. Jellies made the night before, and custard ... you ate your way through all sorts of vegetables, greasy fatty meat ... and greasy gravy ... the plate was handed around, you helped yourself to vegetables ... In the morning, depending on the day of the week, [nana] would make fruit cakes and so forth. Come three o'clock my uncle and grandfather would appear, didn't have to be called, and there'd be this enormous afternoon tea which actually went on for about half an hour, and then grandfather would be ... sitting down to tea at six o'clock, and that was how the day went.[1]

Such meals were typical New Zealand fare (particularly in the country) until at least the 1970s.[2] Hearty morning and afternoon teas featured homemade scones, biscuits and cakes; rich dinners of fatty roast meat, gravy and vegetables were followed by pudding. The food was solidly English in origin, reflecting the country's nineteenth-century colonisation. This fare was plain beside the culinary multiculturalism of the last quarter of the century. The preparation of these meals, however, was far from simple. The skills of the traditional New Zealand cook are not reflected in that other late twentieth-century phenomenon – the instant meal. Yet the key features of New Zealand cuisine have remained throughout the century: the predominance of meat, a generous helping of dairy products, and a passion for baking.

Nineteenth-century British settlers saw New Zealand as a land of plenty, and they adapted their mundane, meagre and largely starch-based diet to match the new culinary opportunities.[3]

A food hamper available on special trains in the 1930s included the meat and vegetables common in New Zealand meals for much of the century.

Railways food hamper, 1930

The expanding agricultural industry soon put butter, cheese, eggs and milk onto the tables of rich and poor alike, and all aspired to the daily (or thrice-daily) consumption of meat. Fish and other seafood, which formed part of working-class British diets and were found in abundance in New Zealand waters, were largely ignored in favour of red meat.

Fondness for meat and dairy products continued throughout the twentieth century, although a lack of money during the 1930s and rationing during the Second World War put such products out of reach of many New Zealanders for a time. The types and amount of meat eaten changed from the middle of the century. Before the 1920s, the average New Zealand adult consumed up to 120 kg of meat annually; the amount fell sharply from the 1950s, levelling off at about 80 kg in the late 1980s. Mutton and lamb seemed ubiquitous: as a 1940s immigrant recalled, 'I got so tired of ... all the horrid things done with a forequarter of hogget when it was roasted on Sunday and spread over the week.'[4] But beef was, in fact, the meat most commonly eaten. Medical and nutritional concern about heart disease and the level of fat in diets contributed to a decline in the consumption of meat (especially red meat) from the 1970s. Once reserved for special occasions (a birthday tea or Christmas dinner), chicken became an important part of New Zealand diets; between 1960 and the 1980s, the consumption of chicken increased five- or six-fold.[5] Similar worries about cholesterol, fat and heart disease lay behind a decline in the consumption of full-fat dairy products in the last quarter of the century. Until then, New Zealand had the highest level of butter consumption in the developed world, and among the highest levels of milk and egg consumption.[6]

Tea and cakes formed part of the nation's 'hospitality culture'.[7] For much of the century, the cake tins were opened and the kettle put on as soon as visitors called. This was the mark of a good host and housekeeper, and so the cake tins always had to be full. The rationing of butter and sugar during the Second World War forced home bakers to substitute other products: adding lemon juice and baking soda to dripping turned it into an acceptable butter substitute in cake-making.[8]

Commercial establishments had produced a range of biscuits and cakes since the late nineteenth century, but homemade varieties remained in favour — and were cheaper — until the 1960s. Locally produced recipe books contained extensive sections on cakes and biscuits before the 1970s: 44 of the 95 recipes in the first (1908) edition of the *Edmonds' Cookery Book* were for cakes or biscuits, and the proportion remained about the same until the late 1960s. Women's entry into the paid workforce in the 1960s spelled an end to the baking culture, as busy workers often had neither time nor inclination to make cakes and biscuits; besides, improved packaging and greater variety now made commercially manufactured products more attractive. Between the early 1960s and the early 1980s, home baking declined dramatically.[9]

The Second World War brought changes to the eating and drinking habits of New Zealanders. Soldiers returning from overseas, the stationing of American servicemen in the country from 1942, and the arrival of groups of European refugees from the late 1930s had lasting effects on local cuisine. A taste for coffee was introduced, and with it, the beginning of a cafe culture: coffee consumption grew in the postwar years and equalled that of tea by the 1980s. The European migrants also brought with them a preference for drinking wine rather than beer, and their presence helped boost the local wine industry. The wartime and postwar migrants gradually shifted New Zealand cuisine towards a more Mediterranean style and away from the earlier English and northern European traditions. Foods such as olive oil, yoghurt, garlic, salami, wholegrain breads and pasta gradually appeared on New Zealand plates. The local production of dried pasta, for example, trebled between the 1940s and the 1970s, and not all of it went into macaroni cheese and puddings: Edmonds issued a special pasta recipe book in 1964, detailing various ways of serving pasta in savoury dishes.[10]

With the exception of the kumara and some seafood delicacies, however, Pakeha adopted little of Maori cuisine and barely incorporated indigenous flora or fauna into their diets. Maori had

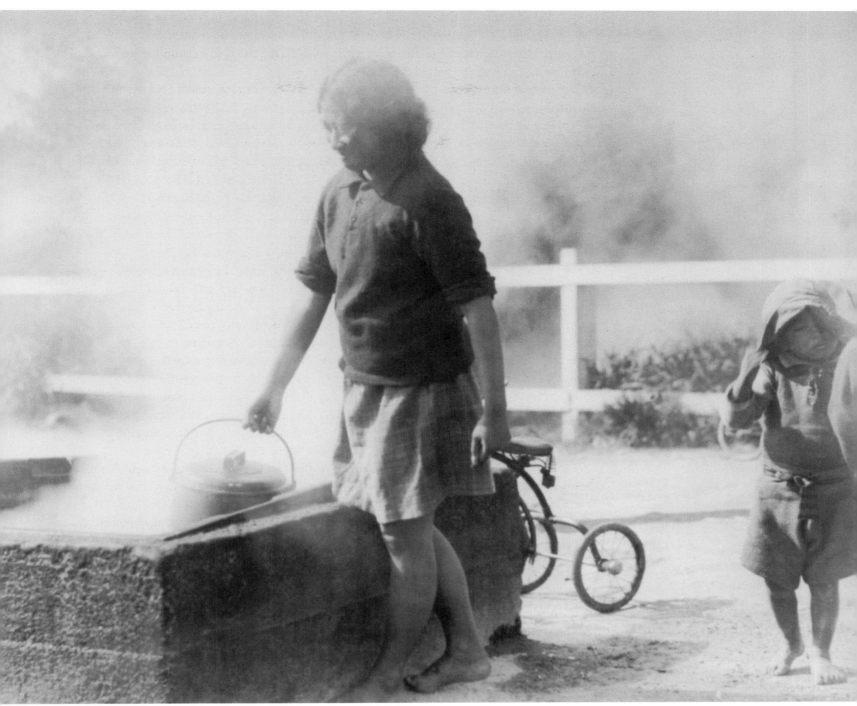

Cooking pool, Central North Island, 1920s

adopted many Pakeha foods by the beginning of the twentieth century, and continued to do so. Throughout the century, hui might feature hangi, rewena ('Maori bread'), kai moana (seafood), a boil-up of puha and pork bones, and on special occasions, native birds, but they also included tea, soft drinks, cakes and processed foods.[11] Maori migration to urban centres from the Second World War further altered the balance between Maori and Pakeha foods and cooking methods. While Maori households in both urban and rural areas cooked Maori food, there remained important differences in Maori and Pakeha diets. The lower standard of living of most Maori households was reflected in diets that featured higher levels of fat and calories, and fewer green vegetables. The

People living in the volcanic region around Taupo and Rotorua sometimes used the natural supply of hot water for steaming food, as in this 1920s photograph of a cooking pool.

combination of economic and social disadvantage with fat-heavy diets has contributed to Maori people's greater risk of dying younger and from illnesses such as heart disease.[12]

New types of food and new cooking styles were evident from the 1950s. The food historian David Burton recounted the experience of his father, who catered for the annual dinners of his local RSA: when in the 1950s the regular fare of pigs' trotters, saveloys and pies was replaced by a 'Continental spread', all the platters were 'swept clean'.[13] New cuisine also involved the consumption of different vegetables. The earlier staples — potato, cabbage, cauliflower, Brussels sprouts — were eaten less as vegetables such as courgettes and peppers were introduced, and as light salads came into favour.[14]

A further wave of migrants, mostly from Asia, in the 1970s and 1980s introduced more new foods and styles: woks and soy sauce were to be found alongside electric frying pans and tomato sauce; rice or noodles were preferred to potatoes. By the 1990s, New Zealand chefs, along with their counterparts in Australia and California, had brought together the various influences on local food to form 'fusion cuisine' — a mix of Asian, European and Mediterranean cooking styles that could be found in many restaurants.

The other major boon to local cuisine in the immediate postwar years was the expansion in the range of kitchen appliances. Refrigerators and ranges (electric, coal and gas) had been available for some time, but fell in price around the time of the Second World War. About half of New Zealand homes had a refrigerator and a stove in the early 1950s; a decade later, it was claimed that the country had one of the highest levels of ownership of major electrical appliances.[15] These appliances made the tasks of obtaining, storing and cooking food considerably easier, but they may have also raised expectations of what came out of the kitchen. The postwar emphasis on women's domestic skills, especially competence in the kitchen, was reflected in a wide range of cookery books that advised women on how to please family, husband and friends. The popular series of books by the newspaper columnist Elizabeth Messenger, for example, contained vast amounts of useful advice on the types of meal a working man would expect on his arrival home.[16]

The growth of a leisure, lifestyle and health culture in the last quarter of the century also had an impact on diets and cooking methods. The type of food that Judith Miller enjoyed on her grand-parents' Taranaki property in the 1940s became anathema to health-conscious New Zealanders; food in such abundance also became unnecessary to people whose work did not involve arduous physical labour. Medical studies showing high levels of obesity in New Zealand emphasised the need for dietary change. Using oil instead of fat or butter, grilling rather than frying, eating vegetables raw or lightly steamed rather than boiled, lean meat instead of fatty, wholegrain bread in preference to white, fruit instead of prepared puddings, trim milk as opposed to whole — the list of changes was long. An increase in vegetarianism and the consumption of whole foods also contributed to changes in diet. New foods such as yoghurt, bean sprouts and tofu appeared in both restaurants and households. In the 1990s, concern about food additives, pesticides and genetically modified food altered once more the way some New Zealanders thought about food.

Busier lifestyles and the expansion of the leisure industry took dietary changes further. The traditional Sunday roast had become a thing of the past by the early 1980s.[17] Convenience eating flourished in the 1980s as takeaway food outlets opened in greater numbers. The microwave joined the list of home appliances that made cooking quicker and left more time for work or leisure. Ironically, in a society where food and health had become intimately linked, the production of less healthy packaged and prepared foods expanded greatly in the last quarter of the century.

For urban and well-off New Zealanders, the proliferation of cafes, bistros and restaurants in the 1980s and 1990s turned the experience of drinking and dining out into a regular event. An interest in food became part of urban sophistication. Magazines such as *Cuisine* informed New Zealanders of the latest trends in food and wine, offering recipes, details of local wines, restaurant reviews, and classified sections telling readers where to obtain gourmet foods. Overseas travel, as well as the

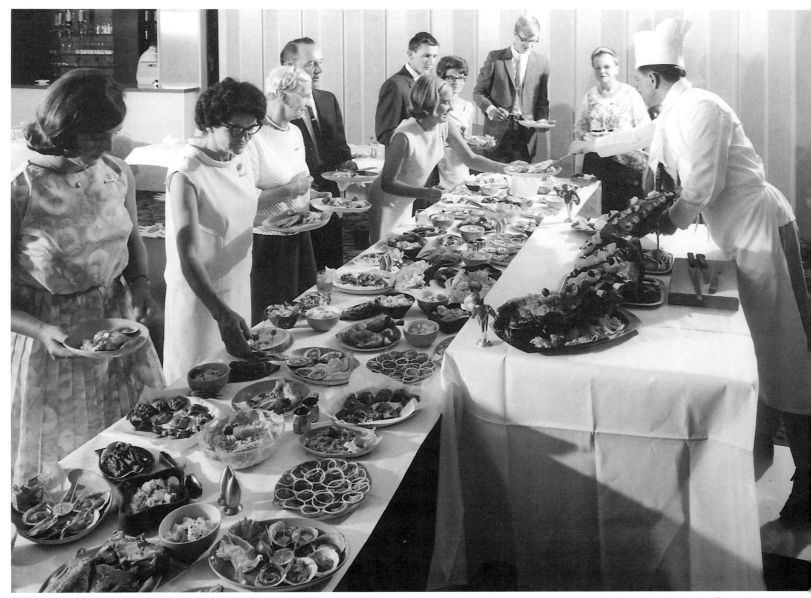

Hastings Travelodge buffet, 1967

impact of immigrant groups, had exposed New Zealanders to a variety of food traditions. As food historian David Burton wrote: 'without the democratisation of air travel, you can bet all our modern wineries, farmhouse cheese factories, charcuteries and bakeries would not have become ingrained so suddenly in our culture.'[18]

The photographs in this chapter provide a glimpse of some of the changes in food and drink during the century. The nature of the Archives New Zealand collection reveals more of the public settings for eating and drinking than the domestic. Photographs of some of the 'icons' of New Zealand cuisine are absent (pavlovas, fish and chips, sponge cakes, whitebait fritters) but in their place are foods that have formed part of New Zealand life in the last century: meat pies, sliced white bread, the meal of meat and potatoes, school milk, kina and bread and butter.

Migrants from Europe and Asia who arrived after the Second World War opened restaurants introducing New Zealanders to new cuisines. Hotels and other accommodation houses such as motor lodges that opened in the 1960s also offered different kinds of food. Here guests at the Hastings Travelodge in 1967 have a wide choice at the buffet. The dishes show the increasing sophistication of the 1960s: they include an array of cold salads, an elaborately dressed ham, and hot meats which are carved by the chef.

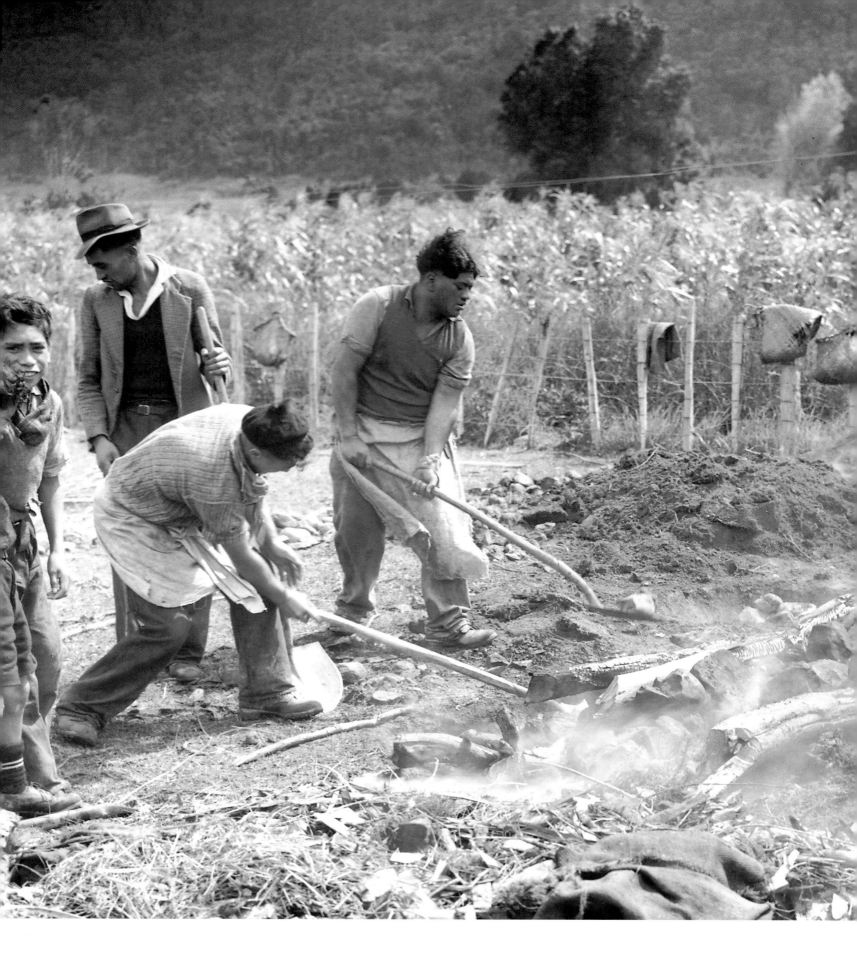

Hangi, 1950s

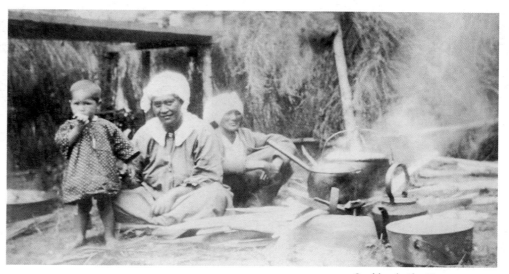

Cooking in the Urewera, 1924

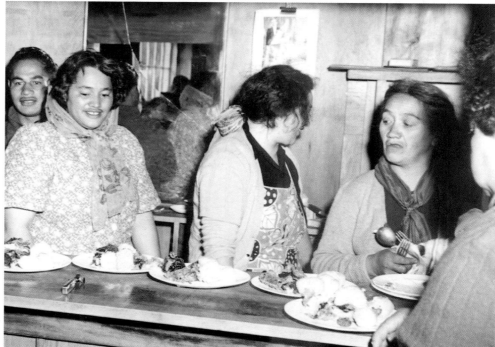

Meal at a hui, Central North Island, 1950s

DINNER-TIME Some households in the first half of the twentieth century cooked meals over coal- or wood-fired stoves. **TOP** The Maori group cooking outside was photographed in 1924, possibly in the Urewera area, where the European presence made relatively little impact before the middle of the century. For more special gatherings throughout the century, traditional hangi were prepared. **LEFT** This group of men is putting down a hangi: heated stones are placed over baskets of food before the mound is sealed with flax and sacks. The food is then steamed for as long as four hours. Hangi fed the large crowds that met in hui, supplying them with meat, potatoes, kumara, greens or seafood. **ABOVE** Later in the century, marae kitchens provided most of the meals required by marae meetings or tangi; hangi were reserved for special occasions. The food at this gathering in the King Country in the 1950s may have been prepared in the traditional way.

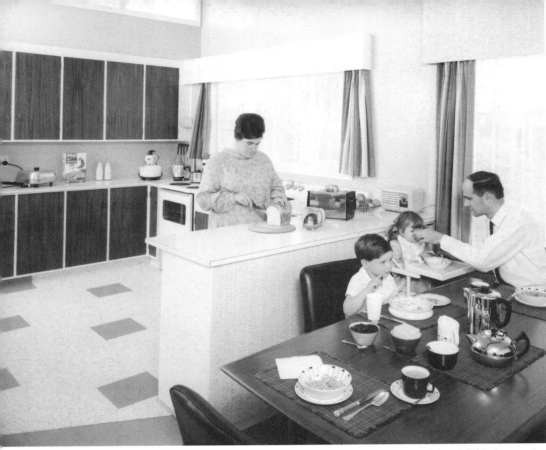

A 'model' kitchen, 1960s

DINNER-TIME Kitchen gadgets designed to make cooking easier proliferated in the prosperous postwar years, as this carefully staged photograph of a domestic kitchen in the 1960s shows. **ABOVE** A line-up of appliances is visible: the electric frying pan, a sturdy cake-mixer, the white electric stove, a blender, a pop-up toaster, a radio; an electric jug sits on the table. A box of cornflakes, two bottles of milk and a loaf of bread complete the 'well-stocked kitchen'.

From the 1870s coal ranges were manufactured in New Zealand, and by the mid-1940s were found in almost 40 per cent of New Zealand households. Their use declined rapidly in the 1950s as electric ranges became available. By the mid-1960s, when the last coal ranges were produced in New Zealand, fewer than 8 per cent of households still had them. Many of these were in isolated areas, such as the dwelling attached to the Cape Reinga lighthouse, photographed here in 1967.

Cape Reinga lighthouse kitchen, 1967

Kitchen, Sunnyside Hospital, 1962

DINNER-TIME Communal kitchens could be very different. **LEFT** The bakery at the Wellington Railway Station in 1963 shows the effects of hard usage with its peeling paint and stained floors and walls. The pastry is probably being prepared for use in the meat pies and sausage rolls (synonymous with railway food) that were baked in the rows of oven drawers on the right of the photograph. **ABOVE** The kitchen at Sunnyside Hospital in Christchurch was photographed in 1962 at a quiet time of day between the rush of preparing meals for patients. It is spacious and designed for ease of movement around the gleaming stove on which sit shiny pots.

Bakery, Wellington Railway Station, 1963

Washing up, especially before the arrival of the automatic dishwasher in New Zealand homes in the 1960s and 1970s, was often a shared task. The people in this photograph, perhaps from the 1960s, may have been doing the dishes in a restaurant or community centre. The stack of plates and glasses, the industrial-size 'Zip', and the large toaster or deep fryer suggest that this is not a family household.

Washing up, 1960s

Eating kina, 1960s

KAI MOANA Rivers and the sea provided food for Maori living in rural areas. **ABOVE** The kina or sea urchin shown in this photograph were reasonably plentiful for much of the twentieth century. Like many other varieties of fish and shellfish that had been abundant around New Zealand's coasts, kina was in short supply by the end of the century. By the 1980s, much traditional Maori seafood (kai moana) was subject to restrictions limiting the size or number taken and the length of the harvesting season. Delicacies such as toheroa, a shellfish prized by Maori and Pakeha alike, fell into this category. **RIGHT** This photograph was taken on Muriwai Beach in 1962 during the toheroa season, the period when people were allowed to take limited amounts of the shellfish.

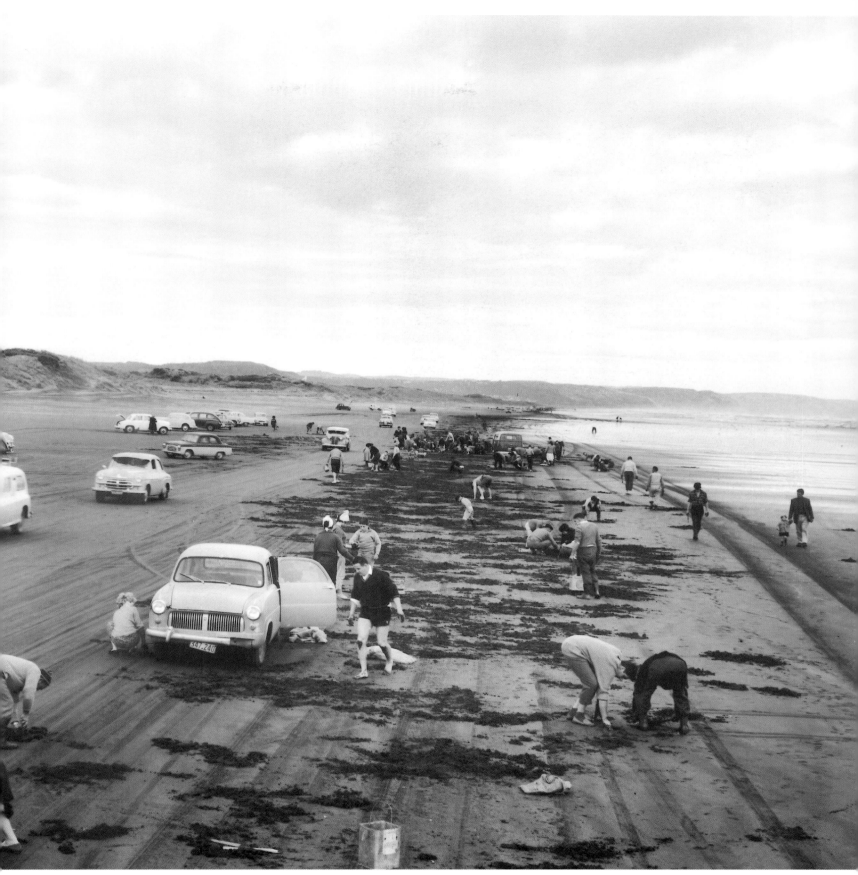

Gathering toheroa, Muriwai Beach, 1962

Home vegetable garden, 1949

FRESH, FROZEN AND CANNED Home vegetable gardens were popular from the nineteenth century, providing cheap produce for preserving as well as a steady supply of vegetables during both summer and winter. Men have usually taken care of the vegetable garden, but where women worked full-time in the household (for example, in country areas or during the immediate postwar years) they frequently took on this responsibility in addition to tending the flower garden. **ABOVE** Large vegetable gardens like the one photographed here in 1949 contributed to the household economy: in popular memory at least, mid-century urban and rural households grew most of their own fruit and vegetables. Many households, however, also bought produce from greengrocers. **RIGHT** New Zealand's Chinese community played an important part in the produce industry, owning greengrocer's shops in the cities and large market gardens in the surrounding districts. The latter supplied produce markets; at the Auckland market photographed here in the late 1950s or 1960s, greengrocers are collecting supplies for shops in the city.

Auckland City Markets, 1950s–60s

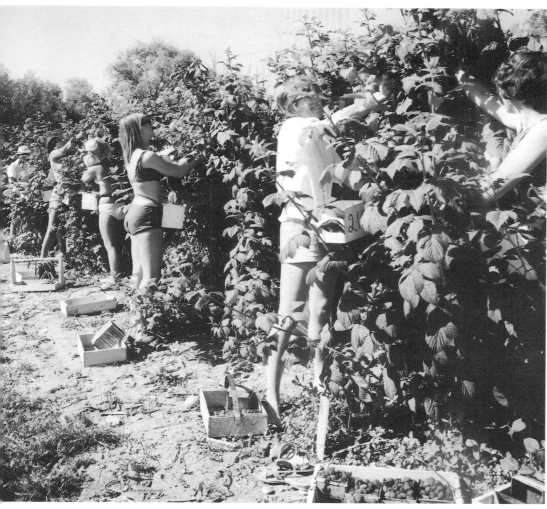

FRESH, FROZEN AND CANNED New Zealand's main berry crop in the first quarter of the century, raspberries, were later joined by a variety of other fruits — blackberries, boysenberries and several berry crosses. Local people and students earning money over the summer worked as seasonal pickers; these raspberry pickers are working outside Tapawera in the Nelson district in the 1960s. Apples, peaches, apricots, tomatoes and berries were all central ingredients in the mid-century enthusiasm for preserving fruit. The cooking skills of New Zealand women included bottling and the making of jams, jellies and chutneys. Some fruits grown for preserving were different from the forms available later in the century: berries were less sweet, for example, and apples softer and more floury — ideal as fillings for pies, but less satisfying to eat raw. From the 1960s the ready availability of cheap jams and canned and frozen fruit meant that the economies of home bottling diminished, and women entering the paid workforce now had less time for this sometimes onerous summer ritual.

Picking raspberries, Tapawera, 1967

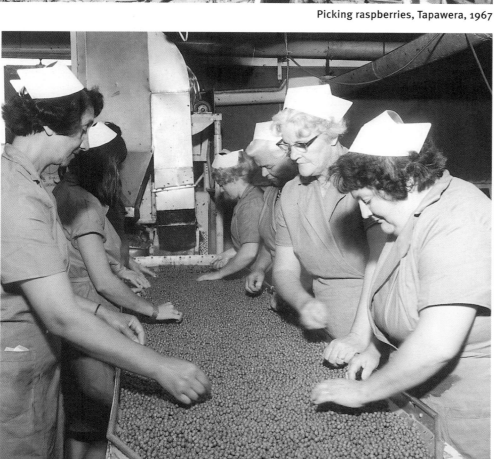

Deep-frozen vegetables were produced commercially from the late 1940s, but their household use was dependent on the availability of home freezers. Most New Zealanders relied on ice boxes or safes to store perishable food until the 1950s, when cheaper prices and the enthusiasm for consumer goods brought refrigerators, and then freezers, into many homes. The frozen food industry grew from the 1960s as new products such as frozen fish fingers appeared. Large firms such as Watties and Lever Brothers expanded their production, and the popularity and convenience of frozen foods, particularly vegetables such as the ubiquitous pea, allowed smaller companies too to flourish for a time. The Marlborough processing factory of Dobson's Frozen Foods, photographed in 1968, provided a source of seasonal employment for the local community.

Processing peas, Marlborough, 1968

Hutt Valley Consumers' Co-operative, 1940s

FRESH, FROZEN AND CANNED Until the 1950s, New Zealanders in towns and cities bought their food from small grocery stores or had it delivered. Groceries displayed their goods behind a counter, and customers asked for what they wanted. **ABOVE** The photograph of the Hutt Valley Consumers' Co-operative Society store at Naenae in the late 1940s illustrates this mode of shopping, to which friendly, personalised service was central. The white-coated attendants dealt individually with each customer, dispensing goods across the counter after weighing items such as the biscuits stored loose in boxes on the right. Grocery shopping at 'the Co-op' contrasted with that in supermarkets. New Zealand's first supermarket – Foodtown – opened in Otahuhu in 1958. With its self-opening doors, 65 shopping trundlers and 150 car parks, this supermarket began a new era in food and grocery shopping. Supermarkets were one-stop shops selling all forms of dry and fresh goods; this Wellington supermarket, photographed in 1971, shows the large aisles and well-stocked shelves common to supermarkets. **RIGHT** They became a feature of the sprawling suburbs that spread outwards from the major towns and cities in the 1950s.

Woolworths supermarket, 1964

Wardells supermarket, Wellington, 1971

FRESH, FROZEN AND CANNED Shoppers could buy canned fruit and vegetables from the beginning of the century. The Second World War boosted the canning industry, which became a major one after the war. Companies such as Watties (in business from 1934) were important producers. **ABOVE** By the 1960s, when these shoppers were photographed in a Woolworths supermarket, canned products containing all manner of preserved food were on the shelves. In households where both men and women were out all day, processed foods were convenient to use.

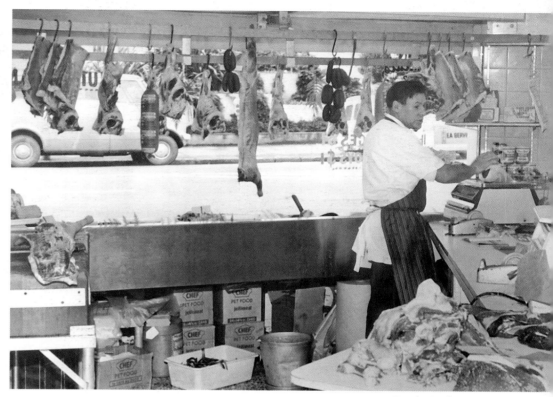

Butcher's shop, 1970s

Dairy, Arrowtown, 1970s

BUYING FOOD In the suburbs of large towns and cities, and especially in provincial and rural settlements, small grocery stores and corner dairies continued to provide a valuable service. **LEFT** Shops such as this one in Arrowtown photographed in the early 1970s combined an element of self-service with the personal service of the older-style grocer's; the hand-written prices added a further personal touch. Even though the goods might be pricier than in large stores, a familiar face in a local shop was important to a small community.

Specialist food stores continued to operate alongside supermarkets in the last quarter of the century. Fish shops, butchers' shops, bakeries and greengrocers were the most common. **ABOVE** In shops such as this butcher's photographed in the 1970s, customers could choose particular cuts of meat rather than buying pieces already wrapped in plastic and vacuum-sealed packs.

Railways meal, 1974

NEW ZEALAND CUISINE While rail travel in New Zealand has never been known for haute cuisine, the two meals displayed here capture some of the shifts in twentieth-century eating habits. **RIGHT** The stylish 1930s food hamper was probably reserved for special trains carrying distinguished guests; regular travellers scrummed for their food (meat pie, sandwiches, cup of strong tea) in the euphemistically named 'refreshment rooms'. The hamper includes the kind of food common in the first decades of the century: hot meat and potato, sandwiches, cake and fresh fruit, served with a flask containing a hot drink and milk in bottles. **ABOVE** The 1974 meal displays the greater range of food available some decades later: there is fancy cheese and wine, the food is lighter, and some of it processed. A large salad of ham, chopped lettuce, grated cheese, tinned beetroot, boiled egg and canned asparagus will be followed by a dessert of jelly and tinned fruit. The presentation is more utilitarian: plates have been replaced by small dishes in which the food is packed rather than arranged, and the cloth serviette has given way to a heavy paper mat. Tea, milk and condiments are not included, but presumably are available by self-service. The bottles of spirits and sparkling wine suggest that this is an evening meal on an overnight train.

Railways food hamper, 1930

Carving the meat, 1981

NEW ZEALAND CUISINE A European refugee who arrived in New Zealand in the middle of the century described learning to cook 'the New Zealand way': 'just put everything into the roasting tin and put potatoes and pumpkin right around.' The Saturday or Sunday roast that was for so long a fixture of New Zealand life began to disappear from the 1970s. Other cuts and types of meat became more popular, and less red meat was consumed. **LEFT** Roast meals involved many rituals. Women spent hours in the kitchen ensuring that meat, gravy, sauces, baked and roast vegetables, and steamed or boiled vegetables all reached the peak of perfection at the same moment. To men fell the tasks of carving the joint and presiding over the table, as this photograph from the 1980s illustrates.

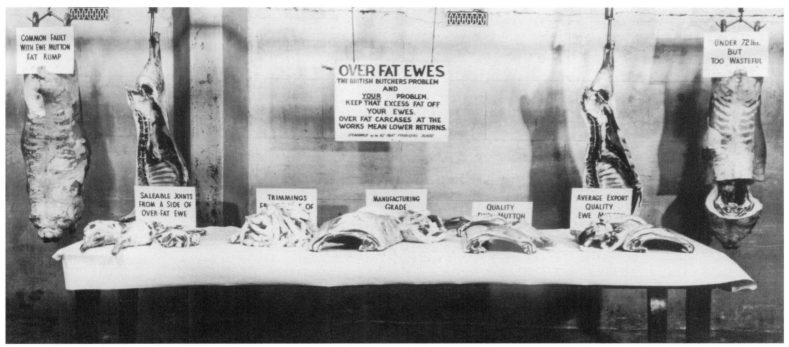

Meat display, Borthwicks, Feilding, 1953

New Zealand has a reputation for roast lamb dinners, but in fact beef was consumed in greater amounts than other forms of meat. Sheep meat — hogget, mutton and less frequently lamb — was the second most popular meat. New Zealanders liked their meat on the fatty side, perhaps because this roasted better, but consumers in the country's major export market, Britain, demanded less fat. In the middle of the century, the Department of Agriculture and individual freezing works encouraged farmers to be more rigorous in ensuring that stock sent to the works was lean. **ABOVE** Displays such as the one at Borthwicks Freezing Works in Feilding in 1953 illustrated the economic disadvantages of sending over-fat sheep to the works. The few saleable joints and small mountain of fat trimmings on the left of the table are contrasted with the export quality carcass and cuts on the right.

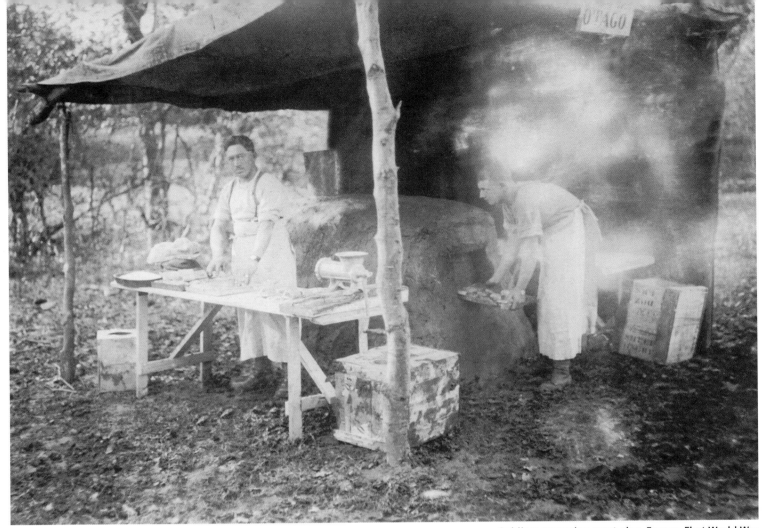

Soldiers preparing meat pies, France, First World War

NEW ZEALAND CUISINE The meat pie has had a dubious reputation. Successive generations of schoolchildren have lampooned it in rhymes such as 'Podges' pies are full of flies. Problem: find the meat.' Ditties like these can be heard wherever pies are sold around the country. The meat pies eaten by soldiers in the trenches during the First World War were both hot food and a taste of home. **ABOVE** These cooks photographed in France have just pulled a batch of pies from their brick oven. They would have prepared them from scratch, mincing the tinned bully beef (or more rarely fresh meat) and rolling out the pastry.

'The barbie' became synonymous with summer for many New Zealanders towards the end of the century. At home as well as on holiday, people took to cooking on a barbecue. **RIGHT** An earlier picnic tradition of cooking meat directly over an open fire was adapted to the portable barbecue using charcoal (as in this 1970s photograph of campers at Thames) and later to the substantial gas-fired barbecues used in the gardens of more affluent suburbs. A barbecue meal was originally simple (sausages, chunks of steak or lamb chops, with sliced bread and perhaps a salad), but more complex dishes (kebabs, salmon steaks) began to creep onto the menu in the 1980s and 1990s. Wine in glasses became as common as beer in cans. But one ritual remained intact, despite all other social changes: 'firing up the barbie' and cooking the meat was, and is, men's work. Women rarely take on this role, which perhaps preserves something of the male pioneering spirit.

Barbecue, Thames, 1977

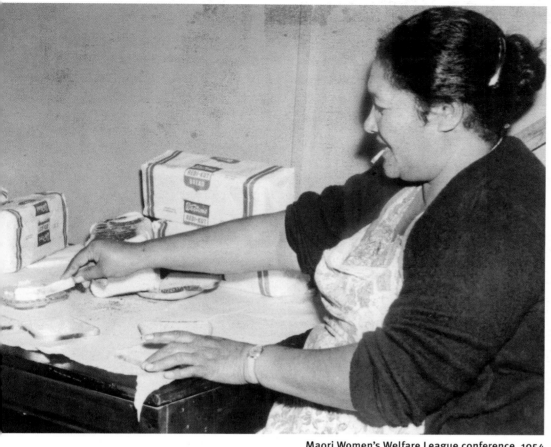

Maori Women's Welfare League conference, 1954

NEW ZEALAND CUISINE White bread, sliced or unsliced, was the bread of choice for New Zealanders for most of the century. Pakeha inherited the British disdain for wholemeal or wholegrain bread, which they considered to be 'foreign' and inferior. For many years, soft white bread coated in butter and topped with various spreads was a staple in lunch boxes and on the dinner table. **LEFT** Generations of New Zealand women buttered piles of white bread for social functions and meetings; this woman is buttering mounds of Weston's Redi-Kut bread for lunch at the Maori Women's Welfare League conference in 1954. Few knew of the health benefits of brown bread before the postwar arrival of European migrants used to wholegrain and rye bread. A greater appreciation of nutritional values, as well as an interest in vegetarianism and 'alternative' healthy lifestyles, led to a much greater enthusiasm for wholegrain breads. The variety of breads — white, brown, French, Italian, Maori, rye, and multi-grain — available in the late twentieth century would have astonished New Zealanders of the 1930s.

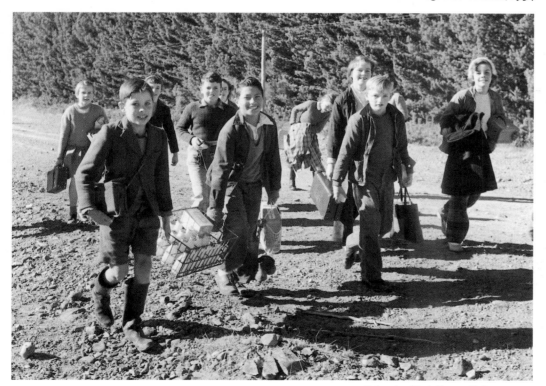

School milk delivery, Nelson, 1959

Between 1937 and 1967, all schoolchildren were issued with a half-pint of milk each day. Small bottles of milk and a box of straws were delivered in crates, like the one carried by two Nelson schoolboys in 1959. **LEFT** The scheme was first mooted in the early 1930s to utilise surplus produce and provide much-needed income to farmers hit by the depression, but it was also designed to boost the health of the country's children, many of whom were believed to be undernourished. Considerable government and public attention had been paid to children's health and welfare in the first decades of the century as part of wider efforts to ensure the good health of the population. Milk, butter and cheese were considered vital parts of a growing child's diet. Although cost was probably the reason for the scheme ending in 1967, some health professionals were by then questioning the emphasis on dairy products in the New Zealand diet.

Paekakariki Railway Station cafeteria, 1940s–50s

Hot-dog stand, 1950s

FOOD ON THE GO The New Zealand hot dog or 'battered sav' — a sausage or saveloy coated in batter, deep-fried, dipped in tomato sauce and served on a stick — has been a culinary staple at sports fixtures, A & P shows, fairs and galas. When the Sole Brothers and Wirths Circus travelled around the country in the 1950s and 1960s, its hot-dog stand was a favourite with its patrons. **TOP LEFT**

Railway station cafeterias offered fast, simple food. One traveller recalled that in the 'refreshment rooms': 'a gentleman lost all trace of quality, femininity disappeared, as men and women clawed to reach the counter, there to be served tea or coffee in cups which felt and looked like lumps of lard, and to be served sandwiches, rock cakes and hot pies.' **FAR LEFT** The Paekakariki Railway Station cafeteria at mid-century is bustling with passengers hurrying to buy and consume sandwiches, slices of fruitcake and tea. A notice reminds customers not to carry crockery onto the train, but to 'kindly leave cups, saucers, and spoons on platform'.

Pie-carts and fish and chip shops traditionally provided most of the takeaway meals eaten in New Zealand. Pie-carts began to disappear from city streets in the 1960s, and while fish and chips have continued to be popular, they now complement a wide range of other foods, including hamburgers from the 1950s and American fast-food outlets from the 1970s (Kentucky Fried Chicken opened in New Zealand in 1970, Pizza Hut in 1975, McDonald's in 1976). By the end of the century, there were almost 150 McDonald's outlets around the country. These Rotorua picnickers are enjoying a meal of Kentucky Fried Chicken in 1975. **BOTTOM LEFT**

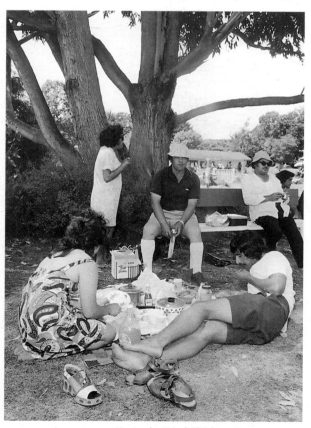

Kentucky Fried Chicken, Rotorua, 1975

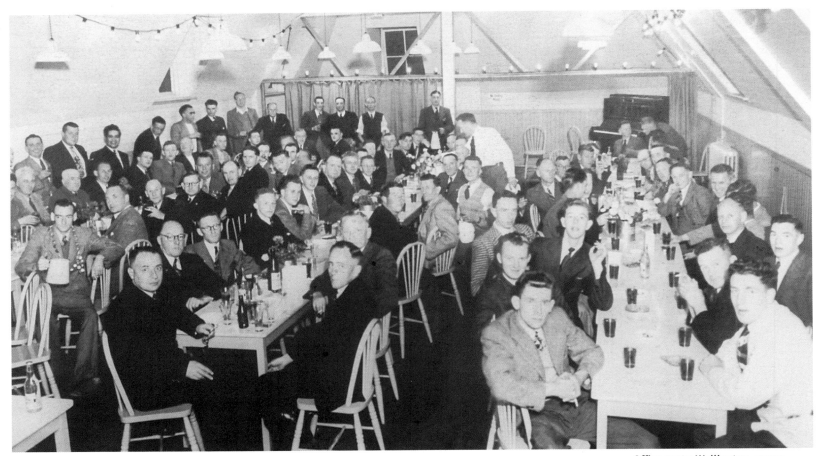

Office party, Wellington, 1950s

Mon Desir Beer Garden, Auckland, 1968

Beer tanker, Auckland, 1964

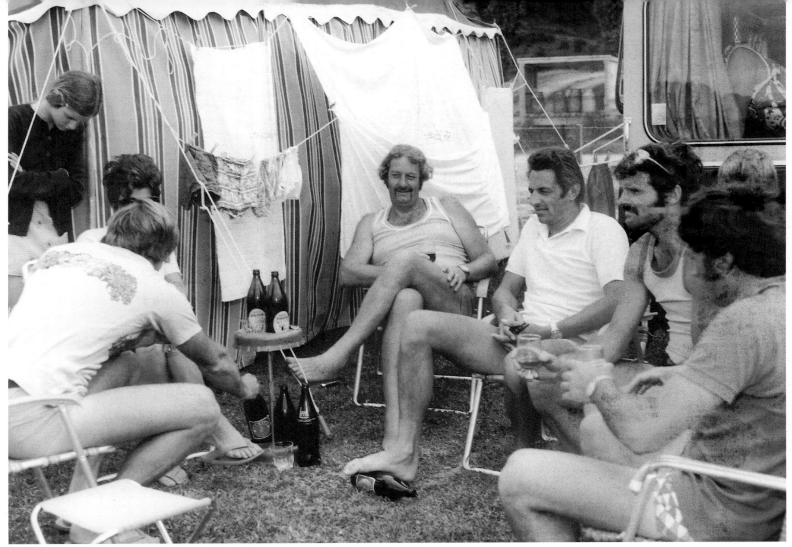

Drinks with mates, Waipu Cove, 1976

A BEER New Zealand women drank beer and (from the 1980s) wine, but drinking beer was part of the stereo-type of New Zealand men. A world of masculine bravado and excess often accompanied beer drinking; 'getting pissed' was a mark of manhood, while a man who knew how to handle his beer could 'hold his piss'. **TOP LEFT** The bindery staff of the Government Printing Office seem to be enjoying their beer (with little food) at this social function in the 1950s. The surroundings are as bleak as the public bars of the time, and many of the men have ignored the 'No Smoking Please' sign at the back of the room; the scene is set for an evening of drinking and masculine companionship. The pub was a man's world until the 1970s: a place of frosted glass, bare walls, high tables with ashtrays and stools. There men could exchange stories and share a joke over a beer after work before the closing time of 6 p.m. Spending convivial time with mates has been part of male beer-drinking culture, as it is here at a Northland motor camp in the 1970s. **ABOVE**

New Zealand liberalised its licensing laws in the 1960s. From 1961, wine could be served in restaurants, although only 10 establishments were initially granted liquor licences. Six o'clock closing ended in 1967, and pubs could stay open until 10 p.m. during the week. Such changes affected the nature of drinking establish-ments. **FAR LEFT** Places such as the North Shore's Mon Desir Beer Garden, photographed here in the summer of 1968, offered food, drink and entertainment outdoors. Unlike pubs, this environment welcomed women.

The consumption of alcohol, especially beer, has figured large in New Zealand social life, in different ways in different parts of the community. Nineteenth-century New Zealand had a reputation for hard drinking, yet the per capita consumption of beer was less than half that in Britain, and declined in the twentieth century. Concern about the effects of alcohol inspired the temperance movement of the late nineteenth and early twentieth centuries, as well as later campaigns against drinking and driving. A tanker refuelling a pub — as this one is doing in the 1960s — was a common sight in New Zealand until the 1980s. **LEFT**

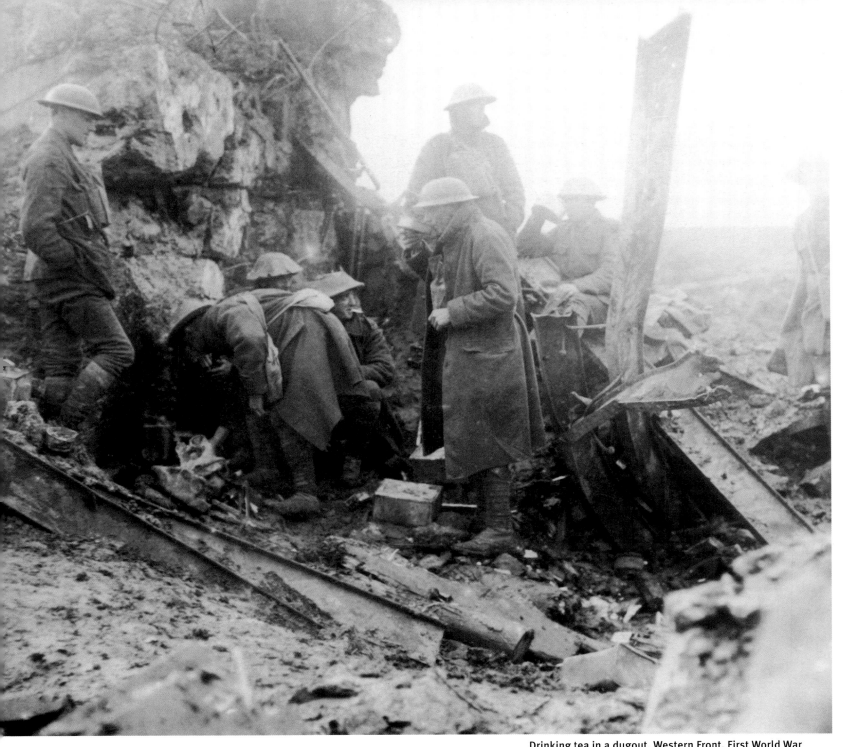

Drinking tea in a dugout, Western Front, First World War

A CUPPA For soldiers in wartime, a cup of tea offered warmth and a brief respite from battle. Drinking a can of tea was among the first ways that these New Zealand soldiers relaxed after entering a German dugout during the First World War. Norman Gray, who fought on the Western Front in 1916–17 and took part in the actions around the Somme and Ypres, recorded the welcome relief that warm tea gave: 'It had been raining for two and a half days and was still pouring. The walk up the hill was just about the finish for most of us. We were drenched to the bone, utterly fagged after sixty hours of almost continuous work, and it required a series of supreme efforts to keep from flopping into the mud – anywhere – and letting things rip. Just on the ridge, before we reached our site, we were greeted by the Y.M.C.A. canteen, a cup of tea and two packets of biscuits ready for every man.'

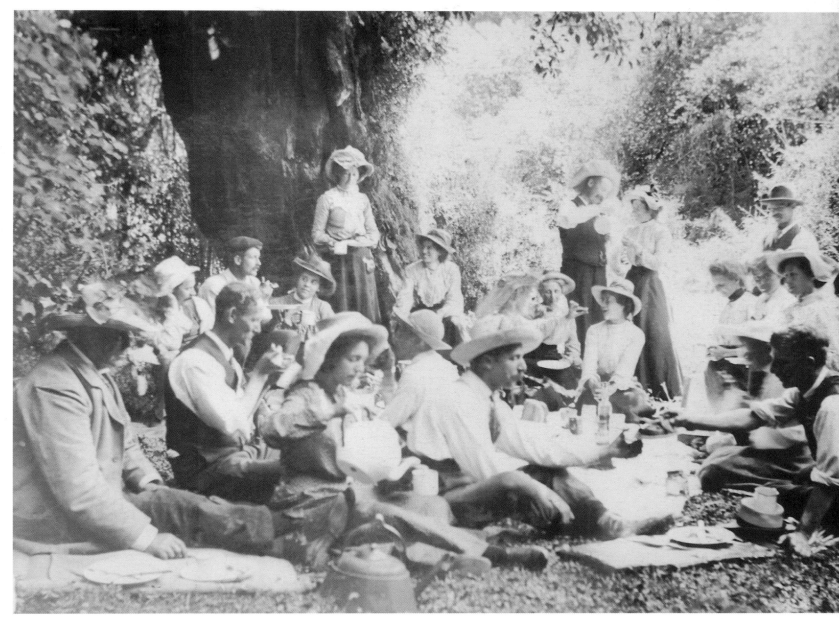

Picnic, pre-1910

A CUPPA New Zealand is a nation of tea-drinkers. Tea is the preferred hot drink for both Maori and Pakeha, and the country has one of the highest rates of tea consumption in the world. The rationing of tea during the Second World War was considered to be a major deprivation for New Zealanders. Brewing the billy for tea has been a central part of life outdoors — working on the farm or in the bush, tramping or picnicking. In this photograph of a party touring the West Coast of the South Island in the first decade of the century, several teapots are visible, along with cups, mugs and an elaborate set of plates and cutlery.

Supper, 1950s

A CUPPA Afternoon tea or supper formed part of most social gatherings. Dances and meetings frequently ended with cups of tea. **ABOVE** At this mid-century function, the cups have been laid out on the tables beforehand, and the tea poured from large pots will wash down hot savouries or sandwiches and biscuits.

Coffee was drunk in New Zealand from the mid-nineteenth century, but it was not fully appreciated before the arrival of European refugees and the stationing of American servicemen in the country in the 1940s. One of the country's first European-style cafes serving espresso and filter coffee opened on Wellington's Lambton Quay in the 1940s after operating as a stall at the 1939/40 Centennial Exhibition. **BELOW** Cafes became popular meeting spots and coffee-drinking a mark of sophistication among the young in the 1950s and 1960s, as this photograph taken in the University of Auckland student cafeteria in the mid-1960s suggests. The development of 'instant coffee' in the early 1960s simplified its preparation. Between the early 1960s and the 1990s, coffee consumption increased more than ten-fold, most of it instant coffee.

Cafeteria, University of Auckland, 1966

Picnic, Warrington, 1917

A CUPPA A cup of tea outdoors could be easily prepared. At an informal picnic at Warrington near Dunedin in 1917, the women and young boy have just a billy for boiling water, and some small cups.

Framing the Century
A Public View

The daily activities charted in this book occurred within a wider context. Other chapters have shown how changes in the material things of life influenced, and were affected by, developments on a national or international scale. The First World War marked the end of nineteenth-century fashions in dress and hairstyle; the arrival of migrant groups from the 1940s brought about changes in food culture; extensive state welfare schemes from the 1930s shaped the pattern of cities, transport and the design of houses. This chapter examines some of these international, national and local milestones, and looks at the way these were expressed in ceremonies, celebrations and conflicts throughout the century.

The photographic sequence begins (on p.248) with a photograph from 1901, when New Zealand was at war with another country, and closes with one from 1981, when the challenges came from within. In 1900 New Zealand was a rural nation with a population of less than a million people evenly divided between the North and South Islands. Pakeha New Zealanders were greatly in the majority; the Maori population was just beginning to recover from its lowest level of about 45,000. The country was losing its 'frontier' aspects as the sex ratio became balanced and the population aged.[1] Natural increase, and some immigration, accounted for steady population growth over the next half century, and the population reached two million in 1952.

Overall growth in the population masked significant differences between Maori and Pakeha. While Maori fertility and mortality levels both remained high well into the century, those for Pakeha declined. Pakeha families fell from an average

The 1960s and 1970s saw radical Maori politics emerge. The massive Land March from Te Hapua in the Far North to the steps of Parliament in 1975 brought the alienation of Maori land to the forefront of national and Maori politics. It was followed two years later by the occupation of Bastion Point in Auckland. Local Maori and the government had been in dispute over the land for over half a century by the time the state ejected Ngati Whatua from the area in 1950. The government's decision to sell the land in 1977 prompted a group of Ngati Whatua and supporters to occupy the Point. For more than 500 days Maori lived at the site, erecting buildings and displaying placards such as this one. The occupation ended abruptly when the government ordered a massive police and army operation to remove the people and buildings. The wider issue of returning land that had been taken unfairly, however, continued to be a focus for both Maori and government into the next century.

Bastion Point, May 1978

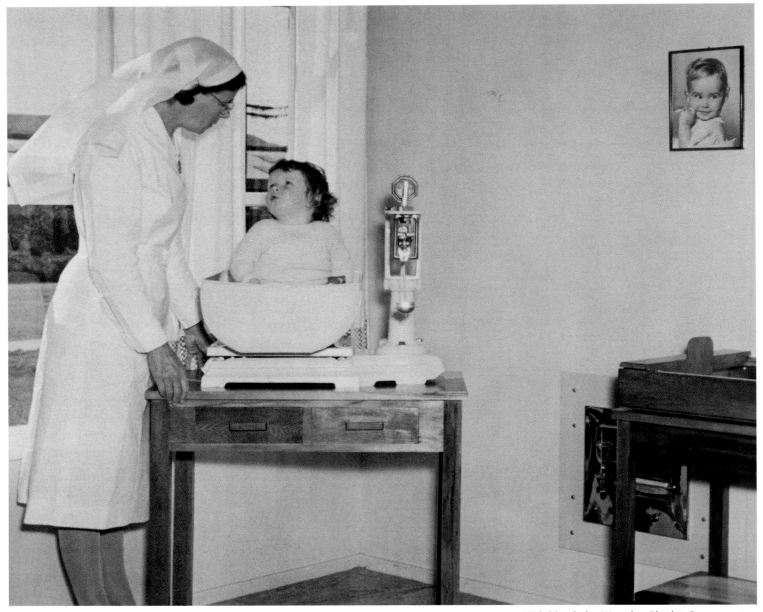

Weighing baby, Waterloo Plunket Rooms, 1950s

Despite the significant differences between Maori and Pakeha, and urban and rural society, most children (and their parents, especially their mothers) received the benefits of extensive social services. Most would meet a Plunket nurse, either in their own homes or in purpose-built Plunket Rooms such as this one in the Hutt Valley suburb of Waterloo. The weighing of babies and toddlers was part of a Plunket ritual: the society's founder, Frederic Truby King, saw weight gain in babies as a measure of the success of the organisation.

of around 4 children in the 1880s to 2.2 in the 1930s. The population's rural majority disappeared within the first decade of the century. By the 1920s, a third of the population lived in the major centres of Auckland, Wellington, Christchurch and Dunedin, and more than half lived in towns of more than 8,000 people.

The Second World War caused a major shift in the patterns of both settlement and population growth. Rural Maori moved to towns and cities in search of work in a process of urbanisation that continued for almost the rest of the century. Maori fertility and mortality rates declined, but both remained higher than those for Pakeha. The period from the end of the Second World War to the early 1960s was marked by higher Pakeha fertility, as the postwar marriage boom created the 'baby-boomer generation' — more than a million babies were born between the mid-1940s and 1960. This birth spurt was temporary, and since the later 1960s New Zealand's population (especially Pakeha) has aged, fertility levels have declined, and population growth has flattened out. By the end of the century, the population of nearly 4 million was concentrated in the major towns and cities of the North Island.

The baby-boomers were born into a world very different from that of their parents and grandparents, many of whom lived through two world wars and a major economic depression. The first Labour government, elected in 1935, had introduced a raft of provisions designed to enhance family life and provide for the social security of New Zealanders. To a welfare system in which the main benefits were for the elderly, widows and some children, Labour added sickness, family and emergency benefits, and superannuation for those aged over 60. Medical and hospital benefits and a state housing scheme completed the welfare package. The system was by no means universal, and some poor New Zealanders fell through its cracks, but it was more comprehensive than that overseen by earlier governments such as the Liberals (1891–1912) and Reform (1912–25).

Postwar governments enlarged the welfare system, introducing payments for single parents from 1973, expanding superannuation, and offering cheap housing loans. The system was increasingly expensive and, some argued, fostered 'welfare dependency' as 'bludgers' relied on state handouts rather than working or taking care of themselves. The welfare system was gradually dismantled from the early 1990s as part of the 'revolution' in social policy following the rise during the previous decade of political ideologies that emphasised the withdrawal of the state from a central role in favour of the free market.

For much of the century, New Zealand's most significant international relationship was with Britain. The country went where Britain went, and looked to it for advice or example in many areas.[2] In 1907 New Zealand became a British Dominion in recognition of self-government; the representative of the monarch was the head of state, though only from 1939 did governors-general represent the Crown alone rather than the British government. The century opened with New Zealand troops fighting alongside British forces in South Africa; twice more before the middle of the century New Zealand sent its soldiers across the world to fight Britain's enemies. Serving the Empire in international conflicts exacted a heavy toll on the country: around 250 men died in the South African conflict, 17,000 in the First World War, and 11,500 in the Second. British systems long provided the models for the country's political and judicial structures, and at the end of the century the Privy Council, based in London, was still the highest 'New Zealand' court. Britain was the major market for New Zealand goods until the last third of the century, receiving the bulk of local dairy, wool and meat production as well as supplying most of the country's imports.[3]

At the beginning of the century, more than half of the Pakeha population had been born in New Zealand, but their roots in the British Isles remained strong. The great majority of nineteenth-century settlers had come from England, Scotland, Ireland or Wales. Periodic injections of migrants from Britain in particular – in the 1920s, and for 20 years after the Second World War – continued these ties, and by the 1960s New Zealanders born in the British Isles outnumbered Maori. Some other Pakeha also considered Britain to be 'home'. The point at which New Zealand began to earn this label for Pakeha has been much debated; it is viewed as a significant marker of national identity and nationalism, even if the meaning of such terms is slippery and the search for their origins fraught.[4]

New Zealand's place in the world began to shift in the second half of the century. Signs of a more independent foreign policy had been evident since the 1930s, and these accelerated after the Second World War.[5] The signing of the ANZUS alliance with Australia and the United States in 1951 signalled that New Zealand was looking closer to home for security and support. The country's participation in the Vietnam War alongside the United States and Australia was a sign of the shifting position. Despite New Zealand's nuclear-free stance, which substantially altered the relationship with the United States from the mid-1980s, the local rather than the European world had become the focus. The entrance of Britain into the European Economic Community in 1973 forced New Zealand to find new markets for both imports and exports. By the end of the century, Britain was a minor market in comparison with Asia, Australia, North America and continental Europe.

Awaiting the arrival of the Duke and Duchess of Cornwall and York, Auckland, 1901

Ceremony marked royal visits as New Zealand demonstrated its relationship to the British Empire, or from the late 1940s the British Commonwealth. Domestic servant Mary Leary captured the guard of honour and welcome party in a relaxed moment before the Duke and Duchess of Cornwall and York disembarked from the royal yacht *Ophir* at Auckland's Queen Street wharf on 11 June 1901. Shortly after this photograph was taken, the guard sprang to attention as the couple walked down the gangway, and the Duchess pressed a button in the 'electrical arrangement' erected on the table at the foot of the gangway. The button sent a signal for immediate action: ships' cannons boomed and shore batteries replied, bells rang, bands played 'God Save the King' and the Guard of Honour presented arms.

Cultural links between New Zealand and the rest of the world also altered. Enormous changes in communications after the Second World War opened New Zealand to new cultures and broke down some of the connections with Britain. During the war, American servicemen stationed in New Zealand had introduced a new formality into relations between women and men: New Zealand women commented on the politeness of the 'American boys', and their rituals of bringing gifts to women they dated.[6] Popular culture was derived increasingly from North America as the advent of television reinforced the influence of music, fashion and films.

The visit of Queen Elizabeth II in 1990 as part of the country's sesquicentennial captured the shifts in New Zealanders' world views. This royal tour followed the customary pattern: as during previous royal tours, people lined the streets, children paraded, and the Queen opened events and was welcomed onto marae. But the tone of this visit was different from earlier royal tours. More voices were raised in protest against the place of the monarchy in modern New Zealand. Maori drew attention to grievances related to the Treaty of Waitangi. The Queen's visit to Waitangi was marked by vigorous discussions about the problems faced by Maori, the place of the Treaty and the government's willingness to honour it. The Queen herself was not necessarily a welcome guest at Waitangi; a young Maori woman hurled a black t-shirt at her in protest.[7] The 1990 visit was a pale shadow of the 'Royal Summer' of 1953/54, an exuberant, country-wide celebration of monarchy and loyalty to the Crown.

The New Zealand of the second half of the century was increasingly a nation of many cultures. Groups from the Middle East and southern and eastern Europe had entered the country in greater

numbers from the 1940s; the Pacific Islands and Asia provided most of the immigrants in the 1970s and 1980s. Signs of ethnic diversity were to be seen everywhere from restaurants to grocery shops, street signs to fashions.

Despite the cultural diversity of the later twentieth century, biculturalism — an awareness of and commitment to the principles of the Treaty of Waitangi — has been emphasised and hotly debated. For Maori, the consequences of land loss, a lower standard of living than that of Pakeha, the challenge of nurturing language and culture, and the effects of discrimination were constant realities. Pakeha New Zealand had always had the opportunity to contemplate these issues, but it was an opportunity seldom taken until late in the century. Until the 1960s, Pakeha could easily remain ignorant of the Maori culture that existed around them. Maori and Pakeha certainly related to each other — in sport, war and work, for example — and Maori rituals were harnessed to Pakeha causes as occasion demanded, such as international events. But interaction was limited, and Pakeha understanding of Maori culture was circumscribed.

The postwar urban migration of Maori in search of work changed all this. As the historian Michael King has noted: 'Maoris ... are almost all, of necessity, bicultural people; most Pakehas are not.'[8] Many Pakeha were surprised to discover that New Zealand society was more complex than 'one nation, one people', and that its race relations were not 'the best in the world'. Urban centres were not easy environments for Maori separated from whanau and support systems. The fact that young Maori appeared disproportionately in crime statistics underlined some of the difficulties they faced in relating to Pakeha society and urban culture.

The urban experience, however, also enabled Maori to challenge their position in society more effectively. The vigour of the Maori cultural renaissance of the late 1970s, and the determination with which Maori sought compensation for past injustices, was particularly unwelcome to some Pakeha. A new relationship between Maori and Pakeha was signalled in 1975 with the establishment of the Waitangi Tribunal to hear Maori claims under the Treaty of Waitangi. The extension of its jurisdiction in 1985 to hear historical claims took that relationship a step further, although a Pakeha backlash against the 'grievance industry' in the 1990s showed that there was still work to be done in race relations.

The Maori cultural and political renaissance was also part of a general questioning of the New Zealand 'establishment' from the 1970s. Environmental issues, women's rights, the anti-apartheid movement, opposition to New Zealand's involvement in the Vietnam War and (in the 1980s) homosexual law reform became major political issues. In some cases, such as the demonstrations against the tour by the South African rugby team (the Springboks) in 1981, protests were violent and left lasting marks on the social fabric. The last two decades of the century were characterised by challenge and conflict as well as by major economic, social and political changes.

The photographs in this chapter focus on the public activities that form a large part of the Archives New Zealand collection. Some of the events shown in these photographs capture New Zealand's relationship with the rest of the world or ways in which the country presented itself to outside observers. Others depict watersheds in relationships within New Zealand, such as those between Maori and Pakeha, workers and bosses, ordinary New Zealanders and the state, or between regions. Some of the photographs juxtapose progress with uncertainty, celebration with tragedy, confidence with challenge. Such events and activities provide a structure in which daily life took place. Taken together, these photographs frame some of the changes in life during the twentieth century; they open a window on the diverse ways and relationships of New Zealanders.

EMPIRE AND REGION, 1900s–10s The twentieth century opened with New Zealand soldiers fighting in a war on the other side of the world. More than 6,000 New Zealanders heeded the imperial call to arms and volunteered to fight alongside the British in their war against the Afrikaners in South Africa between 1899 and 1902 (known as the Boer War). **LEFT** Here a group of returned soldiers stand behind a plaque laid in Wellington by the Duke of Cornwall and York, the future King George V, whose visit during 1901 expressed British gratitude for New Zealand's war effort.

Maori often participated in the ceremonies associated with royal visits, although their role could be ambiguous. A warm Maori–Pakeha welcome signalled a harmony in race relations that belied the reality of Maori life. In recent decades Maori have sometimes chosen the occasion of royal visits to protest about the Crown's failure to redress or acknowledge breaches of the Treaty of Waitangi signed in 1840. Early in the century, however, New Zealand society at large expressed support for the Crown by marking royal occasions, and in this 1911 photograph, Hokianga Maori have turned out to honour the coronation of George V. **TOP RIGHT**

The public sector and the machinery of government expanded considerably early in the century. Regions vied with each other for new public facilities that promised labour and commerce. New post offices, for example, were opened in both Auckland and Wellington in November 1912. Unruly crowds marked the Auckland ceremony, but the opening of the Wellington building was a more orderly affair, as this photograph suggests. **BOTTOM RIGHT** A small, well-behaved crowd huddles beneath umbrellas as dignitaries gather in the arched entrance to the building. Public buildings erected in this period were sometimes grand and highly stylised; the ornate figures along the balcony of this post office were removed after an earthquake in 1942, and taken to the rubbish dump when the building was demolished later in the century.

Unveiling of plaque, Wellington, 1901

OPPOSITE Opening of the Wellington post office, 1912

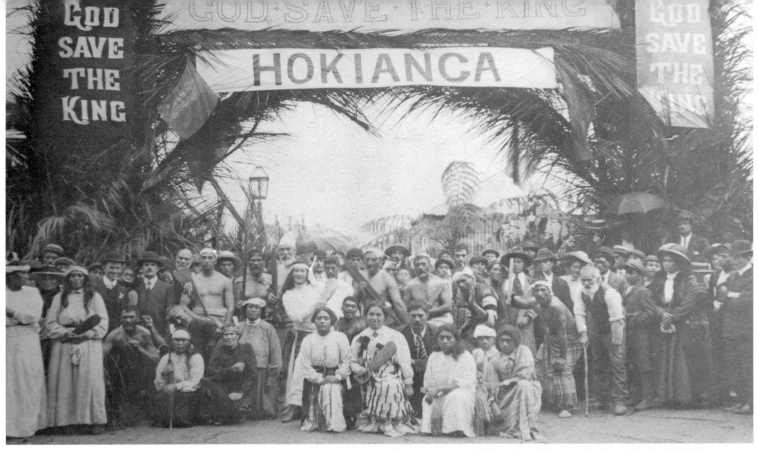

Celebration of the coronation of George V, Hokianga, 1911

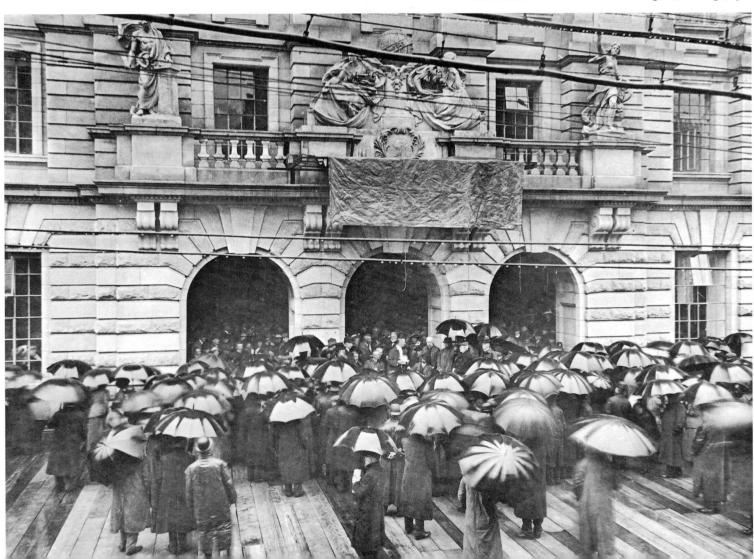

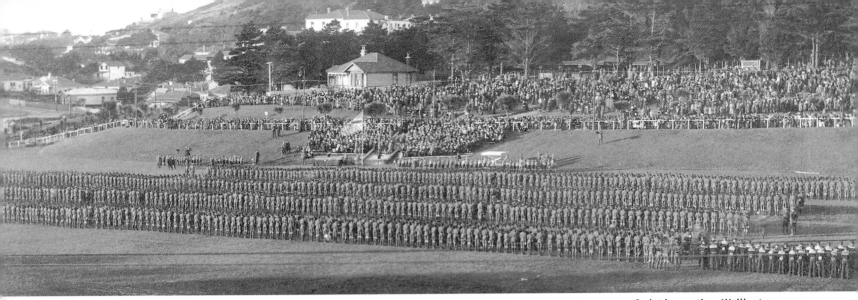

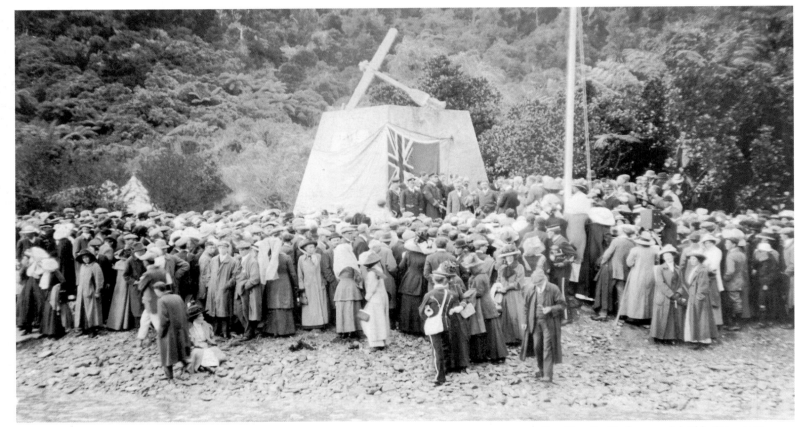

EMPIRE AND REGION, 1900s–10s National efficiency was a New Zealand ideal in the first two decades of the century, when this country like many others fostered a society ready to meet threats from within and without. Organisations such as the Boy Scouts and schoolboy cadet corps were formed during the 1900s to instil discipline and military skills in young men. **TOP** Here young military cadets parade at Wellington's Newtown Park in May 1914 for inspection by Sir Ian Hamilton, who would command the British forces at Gallipoli in the following year. The test for New Zealand, and many of these young men, came when war broke out between Britain and Germany in August 1914.

Their British heritage helped many white New Zealanders to define their place in the world. **ABOVE** In 1913 a group of local people and officials gathered at Ship Cove in Queen Charlotte Sound to unveil a memorial to Captain James Cook. The large anchor on top of the memorial represented his two-week sojourn in the area in 1770. Cook anchored in the harbour to repair the *Endeavour* and explore the surrounding area; on 31 January 1770 he hoisted the Union Jack on the highest point of land which he claimed, along with adjacent land, for the British Crown. For later generations, Ship Cove became symbolic of the European naming and claiming of the country.

PRIDE AND PROTEST, 1910s–20s Socialism and the rights of workers were major political issues in the first years of the century. One of the most turbulent episodes in the struggle between workers and employers occurred at the country's largest gold mine during the Waihi strike of 1912, when striking miner Fred Evans was felled by a police baton and later died from his injuries. Evans was a member of the Waihi Workers' Union, an affiliate of the Federation of Labour. Ardent 'revolutionary socialists' who were disenchanted with the progress being made under the arbitration system to improve wages and conditions had formed the Federation in 1909 to engage in direct industrial conflict. **TOP RIGHT** In 1912 John Carless took this photograph of his fellow breakaway unionists (firemen and engine drivers) who had formed a separate organisation in order to return to the arbitration system. The photograph carefully depicts the Engine Drivers' Union as moderate and loyal. The men are all well dressed, and proudly display a Union Jack. Members of the Waihi Workers' Union, in contrast, had trampled the flag in the mud the previous year on the occasion of the coronation of George V.

The right of workers to an eight-hour working day was enshrined in Labour Day, first marked in New Zealand on 28 October 1890; the day was a public holiday from 1899. The occasion was initially marked by a strong show of trade union support. Workers took to the streets bearing union and workplace placards. Some, such as staff from the Government Printing Office in Wellington in 1916, marched behind floats specially decorated: 'Ye Old Order Changeth Yielding Place to the New' is written at the top of the cart. **BOTTOM RIGHT** The industrial unrest and defeat of unions in the early 1910s had reduced the emphasis on labour solidarity that had once characterised the floats and processions. By the mid-1910s, the focus had moved towards patriotism and militarism; the Printing Office float carries a mixture of labour slogans and patriotic flags.

Ohinemuri Engine Drivers' Union and Firemen's Industrial Union of Workers, Waihi, 1912

Labour Day float, Wellington, 1916

251

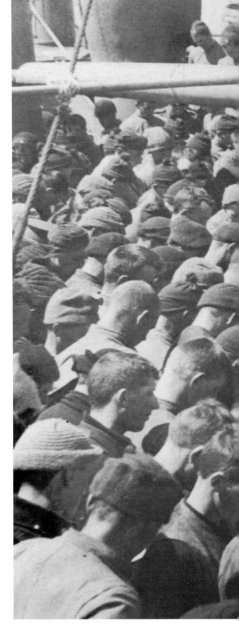

Front-line trench, the Somme, 1916

NEW ZEALAND AT WAR, 1914–18 More than 120,000 New Zealanders served in the First World War, out of a population of around a million people. One in seven soldiers did not return, one of the highest casualty rates among 'colonial' forces. Seventeen thousand New Zealanders died during the conflict, many in the mud and trenches of Flanders and northern France. In the Battle of the Somme, which began in July 1916, the Allies suffered enormous casualties. **ABOVE** The New Zealand Division suffered almost 7,500 casualties, including 1,500 killed; with casualty rates of more than 40 per cent, three of these New Zealanders in a front-line trench stood a good chance of being injured or killed. **RIGHT** The words of the chaplain on this troopship may well have been very comforting, although when this photograph was taken in 1915 some New Zealanders still thought of the war as a great adventure from which they would return. While the majority of New Zealanders professed some religious adherence in this period, the number actually attending religious services was declining. Among the many reasons given for the waning influence of organised religion were alcohol, the breaking of the Sabbath and a lack of religious instruction. Near the chaplain's feet, a draughtboard has been set up.

Religious service on a troopship, 1915

NEW ZEALAND AT WAR, 1914–18 All New Zealand moved onto a war footing for the duration of the conflict, and society became highly regulated. Fund-raising for the war effort was intensive, organised and often creative. A flurry of schemes, many organised by women's groups, gathered funds for Belgian widows and orphans, sick and injured soldiers, wounded horses, and every conceivable type of cause associated with the war and its impact. The Red Jersey Appeal raised money for Salvation Army officers (whose war uniform included a red jersey), who provided support and services to soldiers and civilians. **LEFT** In June 1918 the staff of the Government Printing Office dressed as animals and formed themselves into a 'zoo' that joined other groups and tableaux processing through Wellington to join a military tattoo in Newtown to raise money for the appeal. A Lower Hutt group dressed as fruit and paraded as a 'perambulating horn of plenty', while the musical zoo climbed into the wooden cage pulled by a horse bedecked with bells and sashes, and growled and cavorted while the spectators threw coins at them.

OPPOSITE **Fund-raising, Wellington, 1918**

Railways Publicity Studio, Hutt Valley, 1920s

RICH AND POOR, 1920s–30s As in the South African War, the Crown sent a royal visitor (Edward, Prince of Wales) to New Zealand in 1920 to express its appreciation of the country's war effort and cement ties with Britain. More royals visited the country in 1927, and once again New Zealand seized the opportunity to present itself as a loyal outpost of empire. These huge posters of the Duke and Duchess of York, prepared in the publicity section of the Hutt railway workshops, were characteristic of the ostentatious displays of patriotism during this visit. They presented an image of a secure place in the world that was largely unquestioned until the last third of the century.

Protest at pay cuts, Wellington, 1931

Gordon Coates, Auckland Railway Station, 1930

RICH AND POOR, 1920s–30s In the 1920s New Zealand set about rebuilding after the losses of the war and the influenza epidemic of 1918; relief, optimism and jubilation were captured in many photographs of those years. By the end of the decade, however, the economy was in a state of collapse like others in the industrialised world. Widespread unemployment across many occupational sectors (perhaps 12 per cent of the workforce in 1933) caused many New Zealanders to take to the streets in public protests. The riots that occurred in major centres during 1932 were the most notable, but alongside such street activity, workers and unemployed pressured government officials less dramatically. **TOP LEFT** This peaceful demonstration gathered on the steps of Parliament in March 1931 to protest at the recent government decision to cut the wages of public servants. The deputation had little effect; later in the year, a further 10 per cent wage cut was imposed.

Depression or no, social and official occasions went on. **BOTTOM LEFT** Here the Reform Party leader Gordon Coates (back to camera), known as the 'jazz Premier' for his dress and demeanour, greets the Minister of Railways and another well-attired dignitary at a ceremony in the Auckland Railway Station in November 1930. Coates was on the comeback trail after losing the 1928 election; Reform joined the United Party to form a coalition government the following year.

Sampling school milk, Mangapapa School, 1938

BETTER TIMES, 1935–40 Labour swept to power in the 1935 election. **RIGHT** Prime Minister Michael Joseph Savage, the diminutive figure in the pinstripe suit at the centre of this 1937 photograph, became a secular saint for many New Zealanders. The extensive welfare package introduced by Labour promised to achieve the society that many wished for after the ravages of war and depression. The milk in schools scheme introduced in 1937 was one of Labour's policies to assist family welfare. **ABOVE** A sample of the milk is tried here by Deputy Prime Minister Peter Fraser at Mangapapa School, Gisborne, in 1938.

Michael Joseph Savage's prime ministerial rail tour, 1937

Men from the Ratana movement, 1950s

BETTER TIMES, 1935–40 The Labour victory also appealed to Maori. Since the early 1930s, Labour had been allied with the strong Ratana movement. Founded in 1918 by Tahupotiki Wiremu Ratana – known as the Mangai or mouthpiece of God – the Ratana faith quickly gathered followers and by the mid-1930s had the allegiance of almost 20 per cent of Maori. Ratana chose as the spiritual emblem of the faith the five-pointed star and crescent moon that is worn by the oldest man in this unidentified photograph, possibly taken in the 1950s. The emblem took from earlier Maori prophetic movements, notably that of Te Kooti in the 1860s and 1870s, traditional Christian faith, notably the Trinity, and the spiritual legacy of Ratana himself. The alliance between Ratana and Labour was advantageous for both parties, assuring Labour of Maori support (until the 1990s) and giving Maori and the Ratana movement a voice in national politics.

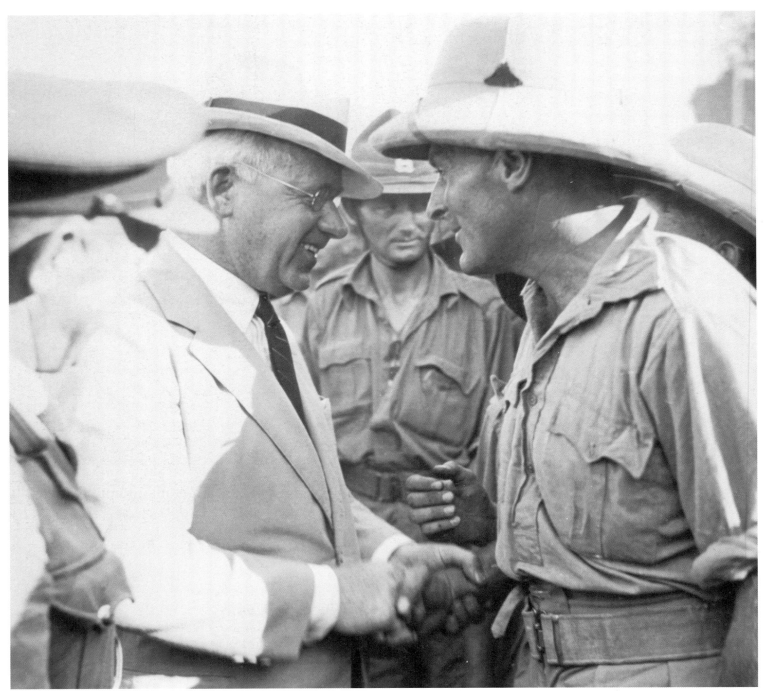

Peter Fraser visiting soldiers in Egypt, 1940s

NEW ZEALAND AT WAR, 1939–45 New Zealand declared war on Germany in September 1939, and once again thousands of men and women crossed the world to fight on the battlefields of Europe. Prime Minister Michael Savage confirmed the country's support for Britain in the famous words, 'Where she goes, we go, where she stands, we stand.' More than 140,000 New Zealand soldiers served with the Allied forces in the Second World War; 11,500 died, and another 17,000 were injured. During the First World War New Zealand's politicians had travelled overseas to visit the troops, and now they did so again. **ABOVE** The wartime leader Peter Fraser, who assumed the leadership of the country after the untimely death of Savage in 1940, is photographed here visiting New Zealand soldiers stationed in North Africa, perhaps in 1941. The Second World War also saw women play a role that went beyond nursing and volunteer work. **BOTTOM RIGHT** These WAACs – members of the Women's Auxiliary Army Corps – stationed in New Caledonia worked in communications and other key support areas. The outbreak of war in the Pacific brought this conflict much closer to home than the First World War; feelings of unease were heightened after the fall of Singapore to Japanese forces in 1942.

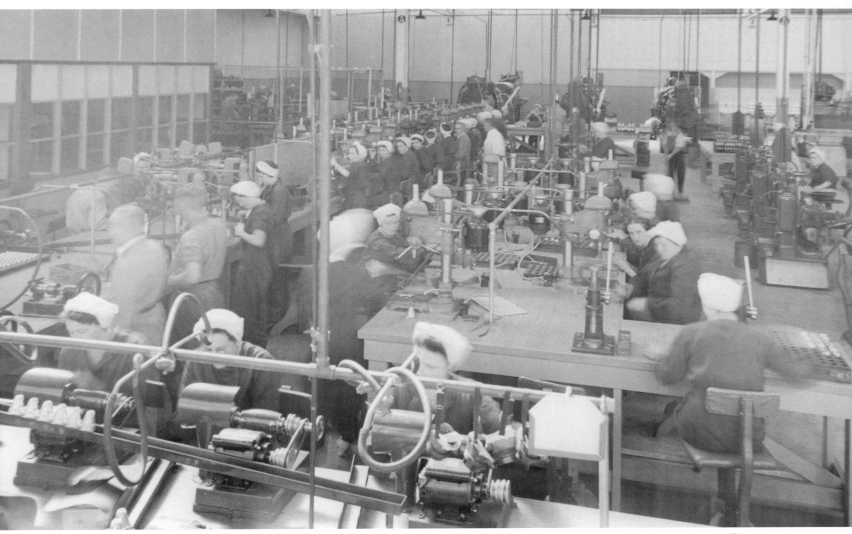

Pallo Engineering, Wellington, 1940s

NEW ZEALAND AT WAR, 1939–45 As in the First World War, there were massive changes for women on the home front. **ABOVE** The workforce of this factory was predominantly female because of the industrial conscription, or 'manpowering' of women, which directed them to work in essential industries from 1942. These women in a Wellington munitions factory were among the 6 per cent of women directed to engineering works. In terms of employment opportunities, the war brought no lasting gains for women. The late 1940s and 1950s were characterised by an emphasis on women's domesticity and role as homemakers.

WAAC Kiwi Company, New Caledonia, 1944

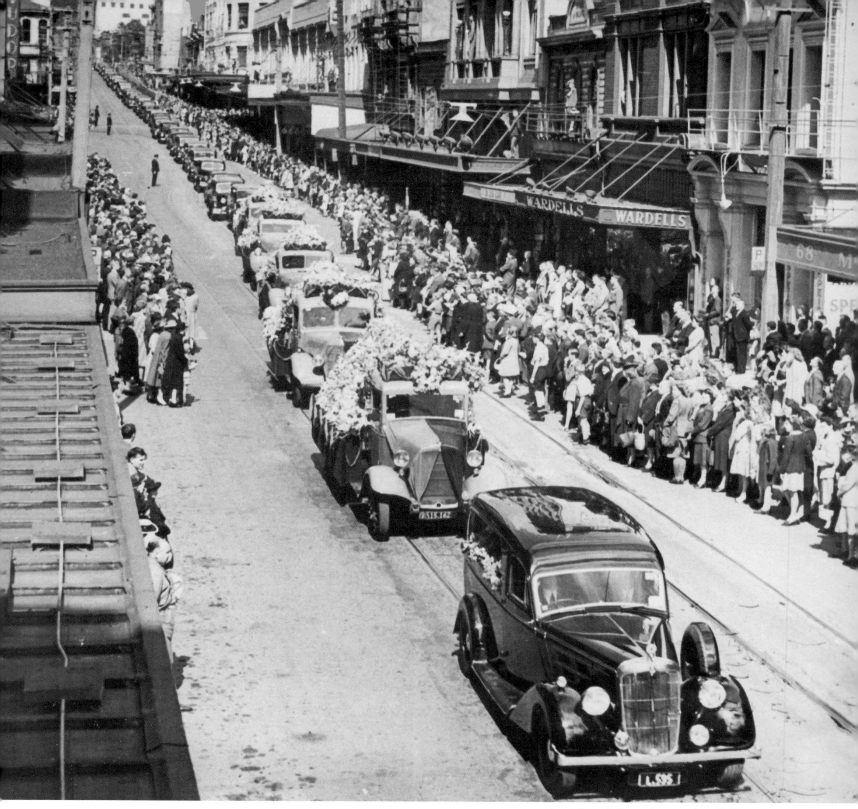

Janet Fraser's funeral procession, Wellington, 1945

PAYING RESPECTS, 1945–54 The country was still at war in March 1945; this state funeral accorded to Janet Fraser, wife of Prime Minister Peter Fraser, was a public occasion for the expression of the grief and loss many had experienced since 1939. Crowds line Wellington's Willis Street as the long funeral cortege makes its way from St John's Church to the Karori cemetery. Janet Fraser was a popular figure who campaigned for health and welfare services for women and children: women are prominent among the mourners.

Princess Te Puea's funeral, 1952

PAYING RESPECTS, 1945–54 Crowds also mourned the death of Te Puea Herangi, who died in 1952. ABOVE Based in the Waikato, where she spearheaded the campaign against the conscription of local Maori in the First World War, Te Puea was also a national Maori figure, and has been described as possibly the most influential woman in New Zealand history. She built a model community, Turangawaewae, in Ngaruawahia from 1921, worked tirelessly to improve the health, education and welfare of her people, and was passionately committed to Maori culture and te reo (language). Te Puea also organised regular meetings of the Kingitanga during the 1920s and 1930s, and brought much focus back into Maori political life.

By the 1950s New Zealand had cemented new relationships in the world, particularly with the United States and Australia, as the links with Britain began to loosen. Even so, New Zealanders flocked to cheer Queen Elizabeth II and Prince Philip when they toured the country in the summer of 1953/54. The visit was the first by a reigning monarch, and thousands turned out to view the couple during their five-week tour. RIGHT This photograph shows the eager crowds that gathered in Greymouth in January 1954; a line of returned soldiers strains to keep back people keen to catch a closer glimpse of the royal couple.

Royal visitors, Greymouth, 1954

Unveiling of Tangiwai Memorial, Wellington, 1957

REMEMBERING THE DEAD, 1950s The royal visit coincided with New Zealand's worst railway disaster, at Tangiwai on Christmas Eve 1953. One hundred and fifty-one people lost their lives when the northbound Auckland express plunged into the Whangaehu River from a bridge damaged by a lahar only moments before the train arrived. It was one of New Zealand's worst transport disasters in the twentieth century: in 1968, 51 people died when the *Wahine* ran aground at the entrance to Wellington Harbour, and 11 years later, over 250 people died when a DC-10 crashed into the slopes of Mt Erebus in Antarctica. A state funeral for 21 unidentified victims from the Tangiwai disaster was held in Wellington's Karori cemetery on 31 December 1953 and attended by Prince Philip. **ABOVE** In March 1957 the Tangiwai National Memorial, designed by government architect F. Gordon Wilson, was unveiled at the cemetery. The occasion was a major public event: friends and relatives of the deceased gathered to watch the ceremony and lay flowers and wreaths.

The loss of life New Zealand had suffered during the Second World War rejuvenated the spirit of Anzac Day, which had been first marked in 1916. **RIGHT, TOP AND BOTTOM** In 1955, when these photographs were taken during the centennial celebrations of the Te Aro and Mitchelltown schools of inner-city Wellington, long, sombre columns of men and women marched to memorials where services were held and wreaths laid to mark the 40th anniversary of the Gallipoli landings. This column is proceeding along the flat Aro Valley — tramlines are clearly visible on the narrow road — to the memorial at the corner of Aro Street and Holloway Road where the service was held. The returned soldiers — some of whom appear old enough to be First World War veterans — wear their medals as they remember fallen comrades.

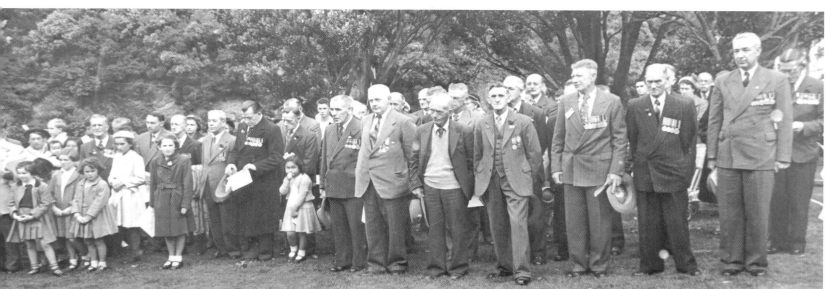

Anzac Day march and memorial service, Wellington, 1955

THE BABY BOOM, 1950s–60s The 1950s has been seen as a period of stability. The political and social emphasis was on family life and nurturing the young, who became a much larger proportion of the population following the post-war marriage and baby boom. Children growing up in the two decades following the Second World War were born into a society where there was considerable social spending on their health and welfare: free education, free health care and a universal family benefit. New schools opened throughout the country, including in small towns and rural areas which experienced a period of growth after the Second World War. **RIGHT** The opening of Motu School in the Gisborne high country in 1955, for example, was a significant event for local people.

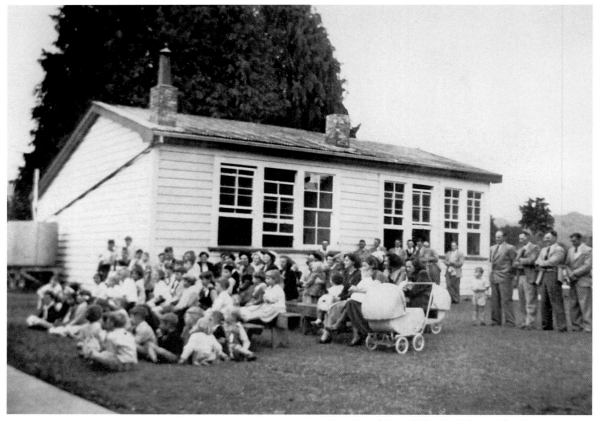

Opening of Motu School, Gisborne district, 1955

Woodleigh School, Taranaki, 1967

The baby boom of the immediate postwar years continued into the early 1960s. While fertility levels fell among Pakeha (although not Maori) in the 1960s, the maturing of those born just after the war initially masked the decline. Marriage occurred at a young age, suburbs spread, and schools and the welfare system expanded to cope as the first baby-boomers began to produce their own families. **ABOVE** This photograph is from the tail end of the postwar baby boom: 'crocodile lines' of primary schoolchildren cross a playing field on their way into class in Taranaki in 1967.

Teenage party, Christchurch, 1960s

THE BABY BOOM, 1950s–60s The 1950s and 1960s were also notable for intense public concern over the behaviour of the country's youth. An inquiry into 'juvenile delinquency' in the Hutt Valley in 1954 and the resulting Mazengarb Report, a copy of which was sent to every home, were defining moments in postwar New Zealand. Adults asked how the nation had gone so wrong as to corrupt the morals of its young, and 'juvenile delinquency' was discovered in many places and guises. The willingness to define youthful activity as delinquency was more a reflection of adult concerns about social change than of actual behaviour. Yet these decades were times of significant change for New Zealand's young people. **ABOVE** As suggested in this posed photograph of a 'teenage dance party' in Christchurch in the mid-1960s, independence, participating in popular culture, and enjoying the latest in fashionable clothing, hairstyles and music (these young people are playing Beatles records) were important for the nation's youth. Perhaps for the first time in New Zealand history, higher levels of prosperity put these things within reach of many young people.

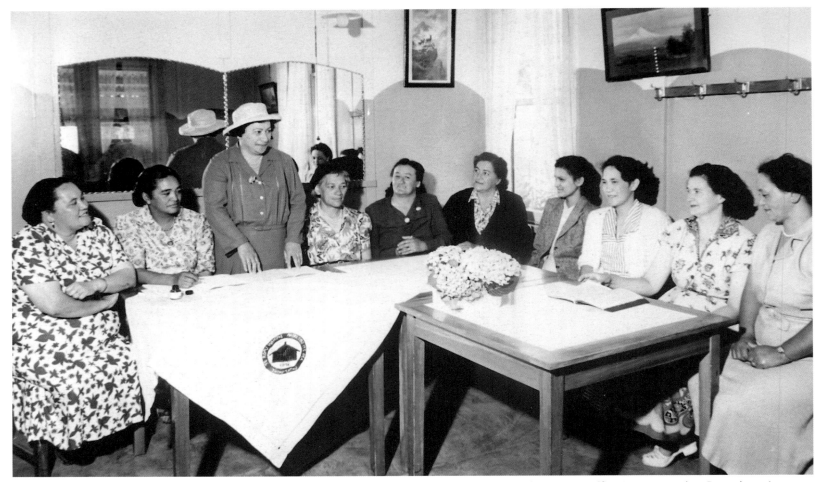

Maori Women's Welfare League meeting, Ruatoria, 1960s

MAORI AND PAKEHA, 1950s–60s New Zealand may have been more prosperous in the 1950s and 1960s, but major discrepancies remained. Maori continued to have a lower standard of living than Pakeha. With more Maori living in urban areas than previously — 19 per cent in 1951, twice the proportion in 1926 — inequalities were more visible. One of the most significant groups helping Maori adjust to urban life was the Maori Women's Welfare League (Te Ropu Wahine Maori Toko i te Ora), founded in 1951. The League drew attention to the state of Maori housing, education, health and welfare, influencing government policy in these areas, and fostered Maori cultural and social activities. The League was also a vital meeting place for women who had few other opportunities to play a public role. Here the Ruatoria Branch meets in the 1960s. **ABOVE** While structures such as the League gave Maori a political voice nationally, much organisation and activity occurred at the 'flaxroots' level on rural and urban marae, in tribal or Maori committees. **TOP RIGHT** These men were photographed during a hui on an East Coast marae, probably in the 1960s. Gatherings such as this where Maori cultural life and language dominated gave the lie to the official policy of assimilating or integrating Maori and Pakeha into one people.

Pakeha liked to think that the 1950s also marked a period of stable relations with Maori. This 'stability' was reflected officially in national celebrations and on days such as Waitangi Day. From its first official commemoration in 1934, Waitangi Day meant different things to Maori and Pakeha. For over 40 years, the official celebrations presented the Pakeha view: the day was a symbol of nationhood in which two races were brought together as one people. **BOTTOM RIGHT** This photograph taken at Waitangi in 1959 shows some of the dignitaries who attended the events, including Prime Minister Walter Nash (seated second from left). In the last three decades of the century, some alternative Maori interpretations have emphasised injustice, discrimination and a failure to honour the Treaty of Waitangi. These challenges and protests have altered the forms of commemorating Waitangi Day, and raised questions about nationhood and national identity.

Hui, Te Tairawhiti, 1960

Waitangi Day, Waitangi, 1959

CHALLENGE AND CONSENSUS, 1960s–80s The 1960s and 1970s brought challenges to the establishment in many areas. In 1966 the long state monopoly on commercial radio was broken with the founding of Radio Hauraki, which broadcast from the ship *Tiri* outside the country's territorial waters until 1970. With its lively announcers playing contemporary music, the station soon became popular. Its ongoing dispute with the government undoubtedly helped. **TOP RIGHT** In this photograph of Radio Hauraki's 1967 'Awakathon', announcer John Courts tries to break the world record for non-stop announcing.

Not everyone challenged government policies or joined protest movements. Support for the status quo was strong in country areas especially. Groups such as the Women's Division Federated Farmers (founded in 1925) focused more on issues directly affecting rural women, such as the improvement of rural services. **BOTTOM RIGHT** In this photograph members of the Ouruhia Branch enjoy their Christmas lunch in Hagley Park, Christchurch, in 1968. But along with other women's groups, this organisation provided members with skills and experience useful for national political campaigns or the women's movement.

During the 1960s the new international relationships that New Zealand had forged since the 1940s were put into practical effect. In 1965, New Zealand sent troops to South Vietnam to support the American and Australian forces fighting the Vietnamese Communists. **FAR RIGHT** New Zealand soldiers had found this man without identity papers near their base in South Vietnam and handed him over to the local authorities for investigation. New Zealand's involvement in the conflict was unpopular with some New Zealanders, who argued vehemently against both the American campaign and the decision to send troops. Opposition to the Vietnam War was part of a more radical protest movement of the 1960s and 1970s, when women's rights, Maori rights, the anti-apartheid struggle and other issues came to the fore in a rejection of the postwar consensus.

Radio Hauraki 'Awakathon', 1967

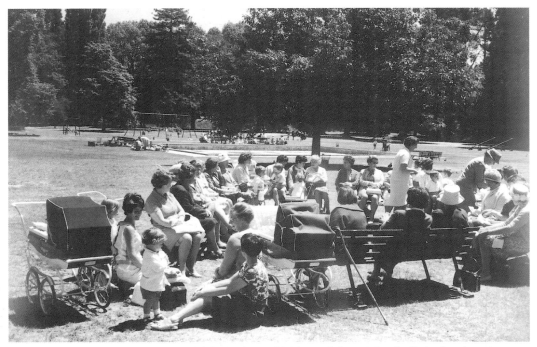

Women's Division Federated Farmers Christmas lunch, Christchurch, 1968

OPPOSITE **Escorting a prisoner into Victor Company Base, South Vietnam, 1969**

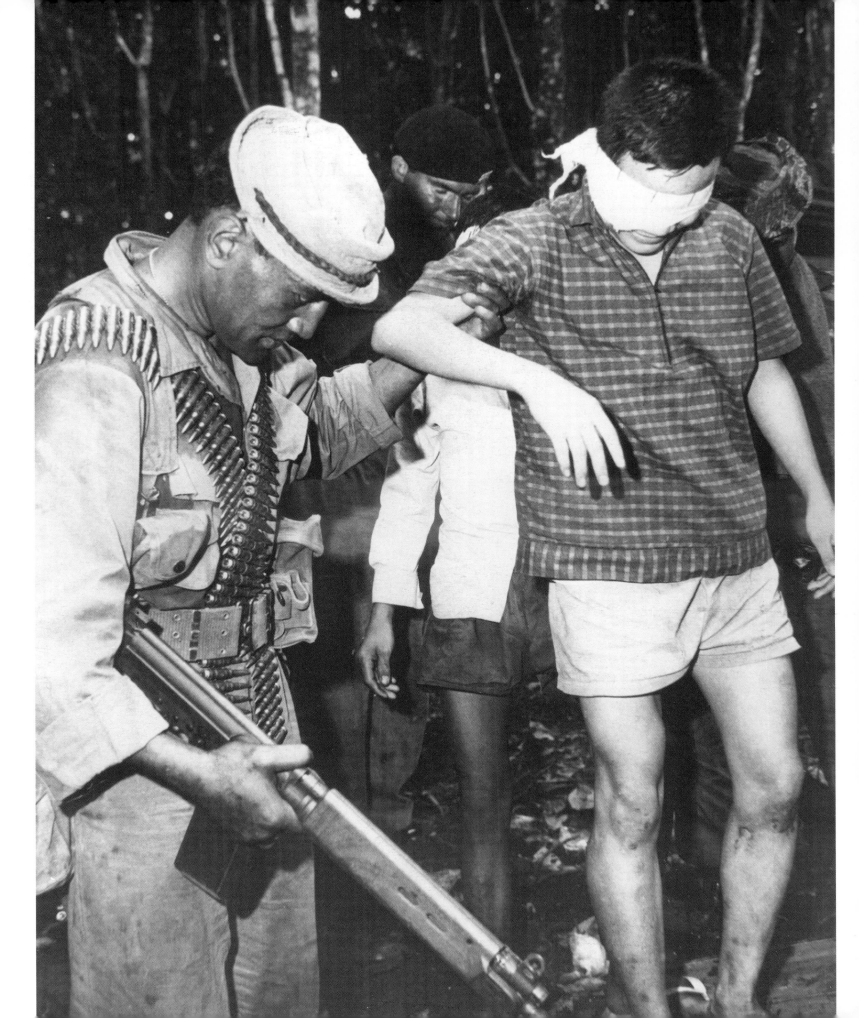

CHALLENGE AND CONSENSUS, 1960s–80s Radio Hauraki was one of many radio stations on which the musician John Hanlon's protest lyrics, 'Damn the dam cried the fantail/as he flew into … the sky', could be heard. Hanlon's song became part of this country's first major environmental protest over the raising of the level of Lake Manapouri for hydro-electric works supplying the aluminium smelter at Bluff. The Save Manapouri Campaign was formed in 1970 and, along with groups such as the Royal Forest and Bird Protection Society, drew attention to the environmental cost of raising the lake; in 1973, the new Labour government decided that the lake should remain at its natural level. **RIGHT** This photograph was taken in the spiral access tunnel to the powerhouse in 1971, when the last three generators began operating. Developments such as that at Lake Manapouri were followed by the 'Think Big' schemes of the late 1970s and early 1980s, when the National government responded to an international oil crisis with natural gas and hydroelectric schemes designed to increase the country's self-sufficiency in energy. The high dam at Clyde and the consequent flooding of the old township of Cromwell was one of the most controversial developments.

Spiral tunnel, Manapouri, 1971

The protests against the 1981 Springbok rugby tour became defining moments in the country's twentieth-century history. The tour generated unprecedented outrage at the decision of the government to allow the New Zealand Rugby Union to continue sporting contact with the apartheid regime of South Africa. Anti-tour demonstrators clashed with both police and rugby supporters in ugly and violent incidents, especially in Auckland, Hamilton and Wellington. **RIGHT** This photograph was taken in Wellington's Rintoul Street, close to Athletic Park where the Springboks were playing. Baton charges by police clothed in riot gear and carrying protective shields against anti-tour demonstrators wearing crash helmets for safety were photographed and filmed, and used as evidence in deciding the complaints against police conduct that were filed. Not all clashes between police and anti-tour protesters ended in baton charges, but protester resistance and police force were evident in many incidents, including this one.

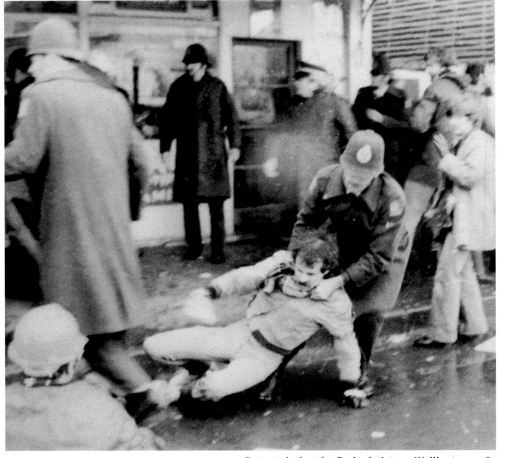

Protest during the Springbok tour, Wellington, 1981

Mr H. Roche, 1960s

Living in the Twentieth Century closes on a note of reflection, as retired forest ranger Mr H. Roche considers a tame seagull from the depths of a comfortable chair. Amongst the many threads of twentieth-century life shown in these pages, no one strand is dominant. Protest is strong in recent memory of the late twentieth century; poverty affected the lives of many in the first and last decades (as well as several decades in between); far-off wars brought death to families and communities; stability is off-set by sudden or long-term change. *Living in the Twentieth Century* offers this last photograph as a comment on the immediacy of daily life, within the rich variety of experience also shown in these pages.

REFERENCES

Introduction

1 The histories of photography I found most useful were Graham Clarke, *The Photograph*, Oxford University Press, New York, 1997, and Naomi Rosenblum, *A World History of Photography*, 3rd edn, Abbeville Press, New York, 1997. For histories of photography in New Zealand, see Hardwicke Knight, *Photography in New Zealand: A Social and Technical History*, John McIndoe, Dunedin, 1971; William Main and John B. Turner, *New Zealand Photography from the 1840s to the Present*, PhotoForum, Auckland, 1993.

2 William Main, *Wellington Album*, Grantham House, Wellington, 1998, p.6, gives the attempt as 1847; Main and Turner, p.3, give 1848 as the date.

3 I took the notions of past, becoming and present with respect to photographs from Michael King, *After the War: New Zealand Since 1945*, Hodder and Stoughton, Auckland, 1988, p.9, and Raphael Samuel, *Theatres of Memory. Volume 1: Past and Present in Contemporary Culture*, Verso, London, 1994, p.322.

4 Keith Sinclair, 'Hard Times (1972–1989)', in Keith Sinclair (ed.), *The Oxford Illustrated History of New Zealand*, Oxford University Press, Auckland, 1990, p.362.

5 Figures in this and the following paragraph are drawn from *New Zealand Official Yearbook, 1998*, Statistics New Zealand/GP Publications, Wellington, 1998, pp.85–104.

6 New Zealand has a rich social history but we know relatively little about the everyday lives of people in the past. For recent additions to our knowledge of everyday activities, see Caroline Daley, *Girls and Women, Men and Boys: Gender in Taradale 1886–1930*, Auckland University Press, Auckland, 1999; several essays in Caroline Daley and Deborah Montgomerie (eds), *The Gendered Kiwi*, Auckland University Press, Auckland, 1999, and in Bronwyn Dalley and Bronwyn Labrum (eds), *Fragments: New Zealand Social and Cultural History*, Auckland University Press, Auckland, 2000.

7 The major historical works relating to the topics under discussion are indicated in each chapter of this book.

8 For example, Erik Olssen, 'A Nation 1914–1918', in Judith Binney, Judith Bassett and Erik Olssen, *The People and the Land/Te Tangata me Te Whenua: An Illustrated History of New Zealand, 1820–1920*, Allen and Unwin/Port Nicholson Press, Wellington, 1990, pp.334–6.

9 A.C. Wilson, *Wire and Wireless: A History of Telecommunications in New Zealand 1890–1987*, Dunmore Press, Palmerston North, 1994, p.191.

10 Recent examples include Frazer Andrewes, 'The Man in the Grey Flannel Suit: White-Collar Masculinity in Post-War New Zealand', in Daley and Montgomerie (eds), pp.191–212; Bronwyn Labrum, 'Persistent Needs and Expanding Desires: Pakeha Families and State Welfare in the Years of Prosperity', pp.188–210, and Fiona McKergow, 'Opening the Wardrobe of History: Dress, Artefacts and Material Life of the 1940s and 1950s', pp.163–87, in Dalley and Labrum (eds).

11 *Yearbook*, 1998, p.304.

12 Prime Minister's Department, Information Section, *Appendix to the Journals of the House of Representatives*, 1949, H–47, pp.2–3, gives an overview of the early history of the National Publicity Studio.

13 Perhaps most famously, Ans Westra's photographs for *Washday at the Pa*, taken for the School Publications Branch in 1964, generated considerable disquiet among some Maori groups, notably the Maori Women's Welfare League, because of the way in which Maori life was portrayed. The League was successful in having the images removed from the publication. For more on this, see Barbara Brookes, 'Nostalgia for "Innocent Homely Pleasures": The Controversy over *Washday at the Pa*', in Barbara Brookes (ed.), *At Home in New Zealand: History Houses People*, Bridget Williams Books, Wellington, 2000, pp.210–25.

14 Main and Turner, pp.45–6.

15 John Pascoe, 'Photography in New Zealand', *Landfall*, vol.1, no.4, 1947, p.302.

16 One reason for the rigidity of many Victorian studio photographs of families was the need to keep the sitters motionless while the photograph was taken. Some photographers resorted to inserting rods and hooks in the backs of clothes to keep their subjects upright.

17 Samuel, pp.365–6.

18 Keith Sinclair, 'Preface', in Sinclair (ed.), p.viii.

19 Samuel, p.328.

20 Samuel argues that this is why social historians especially have utilised historical images, Samuel, pp.315–33.

Chapter One

1 For recent studies on the meanings of work, see Rollo Arnold, *Settler Kaponga 1881–1914: A Frontier Fragment of the Western World*, Victoria University Press, Wellington, 1997; Caroline Daley, *Girls and Women, Men and Boys: Gender in Taradale 1886–1930*, Auckland University Press, Auckland, 1999; Erik Olssen, *Building the New World: Work, Politics and Society in Caversham 1880s–1920s*, Auckland University Press, Auckland, 1995; Claire Toynbee, *Her Work and His: Family, Kin and Community in New Zealand 1900–1930*, Victoria University Press, Wellington, 1995. Stevan Eldred-Grigg, *New Zealand Working People 1890–1990*, Dunmore Press/Trade Union History Project, Palmerston North, 1990, attempts to provide a social history of the work of working-class people.

2 A useful summary of changes in industrial sectors is Lisa Davies with Natalie Jackson, *Women's Labour Force Participation in New Zealand: The Past 100 Years*, Social Policy Agency, Wellington, 1993. The study also covers men's work, and figures in this paragraph are drawn from it and from *New Zealand Official Yearbook, 1998*, Statistics New Zealand/GP Publications, Wellington, 1998, ch.14.

3 Tom Brooking, 'Economic Transformation', in Geoffrey W. Rice (ed.), *The Oxford History of New Zealand*, 2nd edn, Oxford University Press, Auckland, 1992, pp.230–53; Malcolm McKinnon (ed.), *New Zealand Historical Atlas/Ko Papatuanuku e Takoto Nei*, David Bateman/Historical Branch, Department of Internal Affairs, Auckland, 1997, plate 97.

4 McKinnon (ed.), *Historical Atlas*, plate 97.

5 Gary Hawke, 'Economic Trends and Economic Policy, 1938–1992', in Rice (ed.), pp.412–50, gives a good summary of the history of protection for both sectors and the changes in manufacturing.

6 McKinnon (ed.), *Historical Atlas*, plate 96, gives an account of the social effects of changes in large-scale manufacturing.

7 The 1992 figure includes part-time workers, of whom women have been the majority during the century; figures from Davies with Jackson, p.xiii, and *Yearbook*, 1998, p.304.

8 For more on this, see Deborah Montgomerie, 'Manpowering Women: Industrial Conscription during the Second World War', in Barbara Brookes, Charlotte Macdonald and Margaret Tennant (eds), *Women in History 2*, Bridget Williams Books, Wellington, 1992, pp.184–204.

9 See Erik Olssen, 'Women, Work and Family, 1880–1920', in Phillida Bunkle and Beryl Hughes (eds), *Women in New Zealand Society*, Allen and Unwin, Sydney, 1980, pp.159–83.

10 Melanie Nolan, *Breadwinning: New Zealand Women and the State*, Canterbury University Press/Historical Branch, Department of Internal Affairs, Christchurch, 2000, ch.7, notes the contradiction between the 1950s emphasis on home and family, and governments' encouragement of women into the paid workforce.

11 Bronwyn Labrum, 'Persistent Needs and Expanding Desires: Pakeha Families and State Welfare in the Years of Prosperity', in Bronwyn Dalley and Bronwyn Labrum (eds), *Fragments: New Zealand Social and Cultural History*, Auckland University Press, Auckland, 2000, pp.188–210, discusses the consumerism of the 1950s and 1960s.

12 *Yearbook*, 1998, p.312.

13 Two of the many studies that examine aspects of union activity and the fight for fair wages and decent working conditions are Olssen, *Building the New World*, and Bert Roth and Janny Hammond, *Toil and Trouble: The Struggle for a Better Life in New Zealand*, Methuen, Auckland, 1981. See also Gregory Burke and Ann Calhoun (eds), *Art and Organised Labour: Images of Working and Trade Union Life in New Zealand*, Wellington City Art Gallery, Wellington, 1990.

14 Roth and Hammond, p.149.

15 Lloyd Jones and Bruce Foster, *Last Saturday*, Victoria University Press, Wellington, 1994, pp.131–46, provides a useful discussion of legislation surrounding Saturday trading and its effects on work and leisure.

16 Shops that opened on Saturday mornings, and later Saturday afternoons and Sundays, were not permitted to sell all items, or particular quantities of goods. Jones and Foster, pp.142–3, summarise the exempted goods.

17 Studies examining domestic work include Daley, and Helen May, *Minding Children, Managing Men: Conflict and Compromise in the Lives of Postwar Pakeha Women*, Bridget Williams Books, Wellington, 1992, and Toynbee.

18 Daley, chs 3–5.

19 Jean-Marie O'Donnell, '"Electric Servants" and the Science of Housework: Changing Patterns of Domestic Work, 1935–1956', in Brookes et al. (eds), pp.168–83.

Chapter Two

1 Caroline Daley, 'A Gendered Domain: Leisure in Auckland, 1890–1940', in Caroline Daley and Deborah Montgomerie (eds), *The Gendered Kiwi*, Auckland University Press, Auckland, 1999, p.90.

2 Jock Phillips notes that statistical information on leisure activities was not collected in a sustained manner until the 1970s, and suggests that any analysis of leisure before then is 'impressionistic', Jock Phillips, 'Men, Women and Leisure since the Second World War', in Daley and Montgomerie (eds), p.216.

3 A fine study of picnics is Isabella Mitchell, 'Picnics in New Zealand During the Late Nineteenth and Early Twentieth Centuries: An Interpretive Study', MA thesis, Massey University, 1995; see also Caroline Daley, *Girls and Women, Men and Boys: Gender in Taradale 1886–1930*, Auckland University Press, Auckland, 1999, pp.93–5. During the research for this project I found a large number of photographs

of staff of many government departments enjoying annual picnics at Days Bay, especially before the 1940s.

4 Phillips, pp.217–21.

5 Daley, *Girls and Women*, pp.92–9, and Phillips, p.222, discuss this.

6 James Watson, 'The History of Leisure, Recreation and Tourism in New Zealand', in Harvey Perkins and Grant Cushman (eds), *Leisure, Recreation and Tourism*, Longman Paul, Auckland, 1993, p.23.

7 Daley, *Girls and Women*, pp.122–3; I discuss leisure opportunities for women in urban centres in '"Fresh Attractions": White Slavery and Feminism in New Zealand, 1885–1918', *Women's History Review*, vol.9, no.3, 2000, pp.583–604, and 'Lolly Shops "of the Red-light Kind" and "Soldiers of the King": Suppressing One-Woman Brothels in New Zealand, 1908–1916', *New Zealand Journal of History*, vol.30, no.1, 1996, pp.3–23.

8 Danielle Sprecher, 'The Right Appearance: Representations of Fashion, Gender and Modernity in Inter-war New Zealand, 1918–1939', MA thesis, University of Auckland, 1997, pp.20–30; see also Gordon Parry, *D.I.C.: Retailing Century. The First Hundred Years of the D.I.C. Ltd*, DIC, Dunedin, 1984.

9 Charlotte Macdonald, 'The Unbalanced Parallel: Organisations in Sport, Recreation and Leisure', in Anne Else (ed.), *Women Together/Nga Ropu Wahine o te Motu: A History of Women's Organisations in New Zealand*, Daphne Brasell Associates Press/Historical Branch, Department of Internal Affairs, Wellington, 1993, p.408.

10 Sandra Coney, *Standing in the Sunshine: A History of New Zealand Women Since they Won the Vote*, Viking, Auckland, 1993, pp.258–9, discusses the health and beauty movement.

11 Brian Sutton-Smith, *A History of Children's Play: The New Zealand Playground, 1840–1950*, University of Pennsylvania Press, Philadelphia, 1981, pp.170–5, 218.

12 Bronwyn Dalley, *Family Matters: Child Welfare in Twentieth-Century New Zealand*, Auckland University Press/Historical Branch, Department of Internal Affairs, Auckland, 1998, pp.81–2.

13 Macdonald, pp.405–10.

14 Jock Phillips, *A Man's Country? The Image of the Pakeha Male: A History*, Penguin, Auckland, 1987, pp.81–130, 261 passim.

15 For more on this, see Phillips, 'Men, Women', p.226.

16 Allan Laider and Grant Cushman, 'Leisure Participation in New Zealand', in Perkins and Cushman (eds), p.6.

17 Daley, *Girls and Women*, chs 4–6, is the best account of gender and leisure for the first part of the century; for a later period, see Phillips, 'Men, Women'. The ideas in this and the next paragraph are based on the findings of these two studies.

18 The best account of the relationship between women's leisure and handcrafts is Heather Nicholson, *The Loving Stitch: A History of Knitting and Spinning in New Zealand*, Auckland University Press, Auckland, 1998.

19 Nerida Elliott, 'ANZAC, Hollywood and Home: Cinemas and Film-Going in Auckland 1909–1939', MA thesis, University of Auckland, 1987, p.64, gives the example of Ron Mercer's 'Country Cinema' that toured rural Waikato in the 1930s with a 'talking machine' and a screen towed behind a caravan.

Chapter Three

1 Malcolm McKinnon (ed.), *New Zealand Historical Atlas/Ko Papatuanuku e Takota Nei*, David Bateman/Historical Branch, Department of Internal Affairs, Auckland, 1997, plate 52a.

2 The best general account of transport is James Watson, *Links: A History of Transport and New Zealand Society*, GP Publications/Ministry of Transport/

Historical Branch, Department of Internal Affairs, Wellington, 1996. For other forms of communication see Patrick Day, *The Radio Years: A History of Broadcasting in New Zealand*, vol.1, Auckland University Press/Broadcasting History Trust, Auckland, 1994, and A.C. Wilson, *Wire and Wireless: A History of Telecommunications in New Zealand 1890–1987*, Dunmore Press, Palmerston North, 1994.

3 McKinnon (ed.), *Historical Atlas*, plate 52b; Hamish Keith, *New Zealand Yesterdays: A Look at our Recent Past*, Reader's Digest Services, Sydney, 1984, p.226.

4 Graham Stewart, *End of the Penny Section: When Trams Ruled the Streets of New Zealand*, rev. edn, Grantham House, Wellington, 1993, p.65.

5 *New Zealand Official Year-Book 1926*, Government Printer, Wellington, 1925, p.834–5.

6 Watson, p.182.

7 Wilson, p.191.

8 Figures from Watson, p.173.

9 Watson, pp.173–81.

10 Watson, p.195.

11 McKinnon (ed.), *Historical Atlas*, plate 75.

12 Stewart, p.214.

13 Day, pp.314–19.

14 Sue Garmonsway, '"Just a Wife and Mother?" The Domestic Experiences of Frankton Women 1940–1960', MA thesis, University of Waikato, 1995, pp.48ff, discusses the importance of radio for women in this period.

Chapter Four

1 Most of the literature on shelter in New Zealand examines house styles and housing policy. See, for example, Jeremy Ashford, *The Bungalow in New Zealand*, Viking Penguin, Auckland, 1994; Gael Ferguson, *Building the New Zealand Dream*, Dunmore Press/Historical Branch, Department of Internal Affairs, Palmerston North, 1994; Anna Petersen, 'Signs of Higher Life: A Cultural History of Domestic Interiors in New Zealand c.1814–1914', PhD thesis, University of Otago, 1998; Jeremy Salmond, *Old New Zealand Houses 1800–1940*, Heinemann Reed, Auckland, 1986; Ben Schrader, 'A Brave New World? Ideal versus Reality in Postwar Naenae', *New Zealand Journal of History*, vol.30, no.1, 1996, pp.61–79; Peter Shaw, *New Zealand Architecture: From Polynesian Beginnings to 1990*, Hodder and Stoughton, Auckland, 1991; Di Stewart, *The New Zealand Villa: Past and Present*, Viking Pacific Penguin, Auckland, 1992.

2 Ray Bailey with Mary Earle, *Homecooking to Takeaways: A History of New Zealand Food Eating 1880–1990*, 2nd edn, Massey University, Palmerston North, 1999, pp.54–5.

3 Malcolm McKinnon (ed.), *New Zealand Historical Atlas/Ko Papatuanuku e Takoto Nei*, David Bateman/Historical Branch, Department of Internal Affairs, Auckland, 1997, plate 55, summarises the development of water and sewerage systems in the main centres to 1920.

4 Pers. comm., David Green, Sept. 2000.

5 Ferguson, pp.59–70, discusses the schemes to rehouse workers.

6 Salmond, p.89. For more on the villa, see Stewart, passim.

7 For more on the bungalow, its origins and design, see Ashford, passim, and Salmond, pp.185–211.

8 Michael King, *Maori: A Photographic and Social History*, Reed, Auckland, 1983, pp.76–7, 79–107.

9 See Derek A. Dow, *Maori Health and Government Policy 1840–1940*, Victoria University Press/Historical Branch, Department of Internal Affairs, 1999; Ferguson, pp.53–6.

10 The most comprehensive analysis of the state housing scheme is Ferguson, passim.

11 A good account of the establishment of one of these suburbs, Naenae, is Schrader, passim. See also *Historical Atlas*, plates 73, 74, 75.

12 The best account of the family housing design ethos is Schrader, passim. For more on Labour's family policy in the social welfare area, see Bronwyn Dalley, *Family Matters: Child Welfare in Twentieth-Century New Zealand*, Auckland University Press/Historical Branch, Department of Internal Affairs, Auckland, 1998, part 2, and Margaret McClure, *A Civilised Community: A History of Social Security in New Zealand 1898–1998*, Auckland University Press/Historical Branch, Department of Internal Affairs, Auckland, 1998, chs 2, 3.

13 Ferguson, p.177.

14 Ferguson, p.185.

15 Ferguson, pp.234, 266; *New Zealand Official Year-book, 1998*, Statistics New Zealand/GP Publications, Wellington, 1998, pp.457–8.

16 Shaw, pp.158–98, offers a good discussion of the various housing styles after 1970.

17 *New Zealand Official Yearbook, 1990* and *1998*, Department of Statistics, Wellington, 1990, p.164; 1998, p.457.

Chapter Five

1 Fiona McKergow, 'Opening the Wardrobe of History: Dress, Artefacts and Material Life of the 1940s and 1950s', in Bronwyn Dalley and Bronwyn Labrum (eds), *Fragments: New Zealand Social and Cultural History*, Auckland University Press, Auckland, 2000, p.164.

2 There is no history of clothing in New Zealand, but there are a few good studies of specific aspects of twentieth-century dress. See Frazer Andrewes, 'Representations of Masculinity in Post-war New Zealand, 1945–1960', MA thesis, University of Auckland, 1995, and 'The Man in the Grey Flannel Suit: White-collar Masculininity in Post-War New Zealand', in Caroline Daley and Deborah Montgomerie (eds), *The Gendered Kiwi*, Auckland University Press, Auckland, 1999, pp.191–212; Fiona McKergow, 'Fashion and Femininity: The Sartorial Experiences of Elite and Middle Class Women in New Zealand, 1905–1928', MA thesis, University of Auckland, 1991, and 'Opening the Wardrobe', pp.163–87; Danielle Sprecher, 'The Right Appearance: Representations of Fashion, Gender, and Modernity in Inter-war New Zealand, 1918–1939', MA thesis, University of Auckland, 1997, and 'Good Clothes are Good Business: Gender, Consumption and Appearance in the Office, 1918–39', in Daley and Montgomerie (eds), pp.141–62. More general accounts include Sandra Coney, *Standing in the Sunshine: A History of New Zealand Women Since They Won the Vote*, Viking, Auckland, 1993, pp.150–61; Hamish Keith, *New Zealand Yesterdays: A Look at our Recent Past*, Reader's Digest Services, Sydney, 1984, pp.182–97.

3 For a discussion of dress reformers in New Zealand, see Jane Malthus, '"Bifurcated and Not Ashamed": Late Nineteenth Century Dress Reformers in New Zealand', *New Zealand Journal of History*, vol.23, no.1, 1989, pp.32–46.

4 The growth of women's sport in this period is examined in Charlotte Macdonald, 'The Unbalanced Parallel: Organisations in Sport, Recreation and Leisure', in Anne Else (ed.), *Women Together/Nga Ropu Wahine o te Motu: A History of Women's Organisations in New Zealand*, Daphne Brasell Associates Press/Historical Branch, Department of Internal Affairs, Wellington, 1993, pp.408–10.

5 McKergow discusses wartime clothes in 'Opening the Wardrobe', pp.166–76.

6 Coney, p.159; McKergow, 'Opening the Wardrobe', pp.176–7.

7 Andrewes discusses this in 'The Man in the Grey Flannel Suit', passim.

8 Redmer Yska, *All Shook Up: The Flash Bodgie and the Rise of the New Zealand Teenager in the 1950s*, Penguin, Auckland, 1993, discusses teenage clothing in this period.

9 Erik Olssen explores various changes induced by the First World War in 'Waging War: The Home Front, 1914-1918', in Judith Binney, Judith Bassett and Erik Olssen, *The People and the Land/Te Tangata me Te Whenua: An Illustrated History of New Zealand, 1820-1920*, Allen and Unwin/Port Nicholson Press, Wellington, 1990, pp.299-317.

10 Heather Nicholson, *The Loving Stitch: A History of Knitting and Spinning in New Zealand*, Auckland University Press, Auckland, 1998, pp.65ff, discusses the growing popularity of such knitwear as everyday items.

11 Karen Walker, quoted in Pamela Stirling, 'The Way We Wore', *New Zealand Listener*, 18 Dec 1999, p.18.

12 Barbara Brookes, '"When Dad Was a Woman": Gender Relations in the 1970s', in Daley and Montgomerie (eds), pp.235-49, discusses the unisex look and its implications.

Chapter Six

1 Quoted in Tony Simpson, *A Distant Feast: The Origins of New Zealand's Cuisine*, Godwit, Auckland, 1999, pp.78-9.

2 The history of food and drink in New Zealand has received very little attention. The most useful general study is Ray Bailey with Mary Earle, *Homecooking to Takeaways: A History of New Zealand Food Eating 1880-1990*, 2nd edn, Massey University, Palmerston North, 1999. Simpson focuses mainly on the British and European origins of New Zealand food; David Burton, *Two Hundred Years of New Zealand Food and Cookery*, Reed, Wellington, 1982, includes a good summary of the major changes. Historical discussions of alcohol mainly consider the prohibition movement of the late nineteenth and early twentieth centuries. Marten Hutt, *Te Iwi Maori me te Inu Waipiro: He Tuhituhinga Hitori/Maori and Alcohol: A History*, Health Services Research Centre, Wellington, 1999, focuses on Maori and alcohol, with an emphasis on prohibition as well. Useful information concerning the development of the wine industry can be found in the entries for specific wineries in Bob Campbell, *Cuisine 2000 Wine Annual*, Cuisine Publications, Auckland, [2000].

3 Simpson, pp.35-61, examines diets in nineteenth-century Britain, noting the disparities between the abundant and varied diet of the rich, and the inadequate diet of the working-class people who formed the majority of migrants to New Zealand.

4 Quoted in Ann Beaglehole, *A Small Price to Pay: Refugees from Hitler in New Zealand 1936-46*, Allen and Unwin/Port Nicholson Press, Wellington, 1988, p.41.

5 Figures derived from Bailey with Earle, pp.190-205.

6 Bailey with Earle, p.168.

7 Simpson, p.136.

8 Eve Ebbett, *When the Boys Were Away: New Zealand Women in World War II*, Reed, Wellington, 1984, p.109.

9 Bailey with Earle, pp.90-7, 290.

10 Bailey with Earle, p.89.

11 Burton, p.32.

12 Bailey with Earle, pp.111-12.

13 Michael King, *Maori: A Photographic and Social History*, Reed, Auckland, 1983, pp.116-27.

14 Bailey with Earle, passim.

15 Jean-Marie O'Donnell, '"Electric Servants" and the Science of Housework: Changing Patterns of Domestic Work, 1935-1956', in Barbara Brookes, Charlotte Macdonald and Margaret Tennant (eds), *Women in History 2*, Bridget Williams Books, Wellington, 1992, pp.171-9.

16 See *Dine with Elizabeth: A Round-the-year Book of Recipes Written and Compiled by Elizabeth Messenger*, Parts One and Two, Blundell Bros, Wellington, 1957.

17 Bailey with Earle, pp.187-205, discuss changes in meat eating over the century.

18 David Burton, 'Food', *Landfall*, 199, Mar 2000, p.47.

Chapter Seven

1 Erik Olssen, 'Towards a New Society', in Geoffrey W. Rice (ed.), *The Oxford History of New Zealand*, 2nd edn, Oxford University Press, Auckland, 1992, pp.255-9. Useful summaries of population statistics can be found in the *New Zealand Official Yearbook, 1990*, Department of Statistics, Wellington, 1990, ch.5.

2 W. David McIntyre, 'Imperialism and Nationalism', in Rice (ed.), p.346.

3 There are many good accounts of the British connections to local foreign policy and politics. Two useful summaries are McIntyre, pp.337-47, and Malcolm McKinnon, 'New Zealand in the World (1914-1951)', in Keith Sinclair (ed.), *The Oxford Illustrated History of New Zealand*, Oxford University Press, Auckland, 1990, pp.237-66.

4 Many works consider New Zealand identity and nationalism, and in recent years, the search for 'national identity' has intensified. Useful works include Jock Phillips, 'Our History, Our Selves: The Historian and National Identity', *New Zealand Journal of History*, vol.30, no.2, 1996, pp.107-23, and Keith Sinclair, *A Destiny Apart: New Zealand's Search for National Identity*, Allen and Unwin/Port Nicholson Press, Wellington, 1986.

5 The changes in New Zealand's foreign policy have been examined in detail in numerous works. A useful summary is W. David McIntyre, 'From Dual Dependency to Nuclear Free', in Rice (ed.), pp.520-38.

6 For more on this, see Eve Ebbett, *When the Boys Were Away: New Zealand Women in World War II*, Reed, Wellington, 1984, and Jock Phillips with Ellen Ellis, *Brief Encounter: American Forces and the New Zealand People, 1942-1945*, Daphne Brasell Associates Press/Historical Branch, Department of Internal Affairs, Wellington, 1992.

7 Graeme Davison, 'Cities and Ceremonies: Nationalism and Civic Ritual in Three New Lands', *New Zealand Journal of History*, vol.24, no.2, 1990, pp.97, 114-16. A good discussion of the changing meaning of Waitangi Day over the last half century is Claudia Orange, 'Waitangi Day: A History', http://www.nzhistory.net.nz/gallery/treaty

8 'Author's Note', Michael King, *Maori: A Photographic and Social History*, Reed, Auckland, 1983.

PHOTOGRAPHIC CREDITS

Introduction

PP.8–9
Office picnic, Days Bay, Wellington, 1920s, PT 2/8
PP.10–11
Hauhungaroa Workingmen's Club, 1950s–60s
 Photograph by J. Fijn, AAMK W3495, Box 6
Cable-laying ship, 1900s, AAMF W3327, Box 206
P.12
Preparation for a meal, Turangawaewae, 1950s
 Photograph by Photocraft, AAMK W3495, Box 9
PP.14–15
Miss North, Wellington, 1950s, AANB 883/4i
The backyard, 1957, Photograph by P. Blanc
 AAMK W3495, Box 7
PP.16–17
Cubs and scouts, 1967, Photograph by D. Nicholson
 AAQT 6401, A82688
First World War recruits, Wellington, AAVK W3493, E7547
PP.18–19
Dancing on railway platform, Hawke's Bay, 1955
 Photograph by John LeCren, AAVK W3493, D1421
Fishing, Catlins River, 1977, Photograph by Gordon Roberts
 AAQA 6395, M12292
P.21
School picnic, Hawke's Bay, 1937, ABDJ W3568, Box 46

Chapter One

P.22–3
Puketiti Station, Te Puia, 1950s–60s
 AANR 6329, 45/16/181, 63632, Box 66
PP.25–6
Watties canning factory, Hastings, 1960s–70s
 AANR 6329, 9/17/16, DA7876
Railway track gang, Paremata, Wellington, 1930s
 AAVK W3493, E8341
PP.28–9
Mobile banking van, 1950s, AAMF W3327, Box 211
Karitane home, Melrose, Wellington, 1967
 Photograph by B. Neill, AAQT 6401, A82980
PP.30–1
Mustering on the Arawhata River, 1940s–50s
 AAQT 6401, A9110
Whataroa saleyards, 1940s–50s
 AANR 6329, 2/6/9, DA28899
PP.32–3
Auckland cool store, pre-1950, AAEG 624/6
Whakatu freezing works, 1983
 Photograph by J. Waddington, AAQT 6418, R14687
Ngauranga freezing works, 1949
 AANR 6329, 32/2/39, 636.0822
PP.34–5
Riverdale Co-operative Dairy Factory, 1900s–20s
 AANR 6329, 33/8/2, 630.2
Sunbeam Company, Bay of Plenty, 1940s–50s
 AANR 6329, 4/2/28, DA30105
Anchor factory, 1986, AAQT 6421, B23317
PP.36–7
Mt White Station, Canterbury, 1915
 AANR 6329, 45/16/200, 630.24, Box 66
Sharpening the blades, 1940s–50s, AAQT 6401, A3807
Tailing lambs, 1950, AAQT 6401, A9694
Deer farming, 1984, AANR 6337, OT204, Box 1
PP.38–9
Stacking wheat, Canterbury, 1915
 AANR 6329, 9/28/261, 630.24, Box 13
Harvesters, Hawke's Bay, 1978, Photograph by W. Cleal
 AAQT 6421, B15897
Kiwifruit orchard, Bay of Plenty, 1977, AAQT 6401, B16088
PP.40–1
Logging the kauri forest, 1900s–20s, AAQT 6403, 1906
Tree-felling, Kaingaroa, 1969, Photograph by John Johns
 AAQA 6395, M10617
Forestry nursery, Whakarewarewa, 1924, AAQA 6501, F152
Waipa sawmill, 1971, Photograph by John Johns
 AAQA 6395, M11249

PP.42–3
Down the Blackball mine, 1930s, AAQT 6401, A1259
Rotowaro mine, Huntly, 1969 Photograph by G. Riethmaier,
 AAQT 6401, A91261
PP.44–5
Whaling, Tory Channel, 1940s–50s, AAVK W3493, D45623
Fishing, Otago, 1954, Photograph by K. Bigwood
 AAQT 6401, A34340
Loading apples for export, 1940s, AAAD 699/34c
Timber ship, Port of Napier, 1978, Photograph by W. Cleal
 AAQT 6421, B15888
PP.46–7
Wheelwright's workshop, 1903,
 AANR 6329, 17/9/97, DA31338, Box 22
Fiat assembly plant, Auckland, 1966
 Photograph by G. Riethmaier, AAQT 6401, A80772
PP.48–9
James Chapman-Taylor at work, Upper Hutt, 1954
 Photograph by John Johns, AAQA 6395, M1081
Prefabricated state house, Wellington, 1940s–50s
 ABVF 7484, 1.16
Reserve Bank building, Wellington, 1969, ABTW 6983/4
Oamaru stone quarry, 1920s, AAQT 6403, 1565
PP.50–1
Cafeteria, Auckland, 1940s, ABIN W3337, Box 44
Bookstall, Timaru, 1950,
 Photograph by Kingham's Camera Shop, Timaru,
 ABIN W3337, Box 44
Serving beer, Kaiti, 1971, Photograph by D. Hutchinson
 AAQT 6401, A97382
PP.52–3
Refreshment Branch, Railways Department, Wellington, 1932
 AAVK W3493, C373
Chief Accountant's Office, Railways Department, Wellington,
 1959, Photograph by D. Morgan, AAVK W3493, B2469
Pay office, Public Works Department, Taihape, 1906
 AAVK W3493, E4672
State Insurance Office, 1980s, AAXK W3623, Box 24
Government Printing Office, 1966
 Photograph by G. Riethmaier, AAQT 6401, A79533
PP.54–5
Maori nurses, 1920s–30s, SANS 22/142, Box 4
District nurse, Kaipara, 1928, H 11, W2615, 1/1
Dr Williams' visit, Whangaroa, 1950
 Photograph by K. Bigwood, AAQT 6401, A20175
Schoolboy inoculation, 1950s, SANS 22/142, Box 4
Operating theatre, 1970s, H 26, W2386, 731
PP.56–7
Day care, Otematata, North Otago, 1960s,
 Photograph by Helen Buttfield Hartman, AAAD 699/30c
Hillsborough Playcentre, 1968, Photograph by G. Riethmaier
 AAQT 6401, A86960
Hoani Waititi teaching te reo, 1950s, AAMK W3495, Box 5
Kohanga reo, 1980s, AAMK W3495, Box 5
PP.58–9
Symonds Street flats, Auckland, 1940s
 Photograph by Department of Internal Affairs
 AALF 6112, 25/1/1025, Box 2
Pouring concrete, Auckland, 1969
 Photograph by G. Riethmaier, AAQT 6401, A90683
Dixon Street flats, Wellington, 1940s
 Photograph by Department of Internal Affairs
 AALF 6112, 1/2/25, 423
Preparing toheroa, 1950s, Photograph by P. Blanc
 AAMK W3495, Box 9
PP.60–1
Railways staff cafeteria, Wellington, 1920s–30s
 AAVK W3493, C404
Nurses at tea, Wellington, 1916, ABRR 7563, W4990, 10f
Smoko in the field, 1950s, Sparrow Industrial Pictures
 AANR 6329, 31/29/82, DA23851, Box 47
Smoko room, Auckland, 1976, Photograph by John LeCren
 AAVK W3493, D33602
PP.62–3
Dictaphone class, Taita College, Hutt Valley, 1968
 Photograph by R. Silcock, AAQT 6401, A86598
Hunter training school, Golden Downs, 1958
 Photograph by John Johns, AAQA 6395, M3006

Post and Telegraph training, Burnham, 1948
 Photograph by D. Morgan, AAVK W3493, B670

Chapter Two

PP.64–5
Fishing, 1940s, AAQT 6401, A210
PP.67–8
Sole Brothers and Wirths Circus, 1956
 Photograph by W. W. Stewart, AAVK W3493, D4251
Tennis match, Te Horo School, 1950s
 Photograph by John Ashton, AAMK W3495, Box 6
PP.70–1
Boxing match, France, 1914–18, IA 76/13, H721
Card game, Noumea, 1943, WAII 7/10
Trentham races, 1940s–50s, AAQT 6401, A2045
Auckland v Taranaki, 1960s, AAMK W3495, Box 9
PP.72–3
Girls' cricket, Wellington, 1924–5, AANB 885/1g
Basketball match, 1950s, AAQT 6401, A36787
Picnic races, Hawke's Bay, 1961, ABDJ W3568, Box 46
PP.74–5
Cricket, Upper Moutere, 1979, Photograph by R. Anderson
 AAQT 6421, B18557
Auckland Anniversary Regatta, 1974
 Photograph by G. Riethmaier, AAQT 6401, B4086
Bowls, Wellington, 1975, Photograph by R. Anderson
 AAQT 6421, B6440
PP.76–7
Manawatu A & P Show, pre-1920, ABIN W3337, Box 259
Calf club day, 1968, Photograph by G. Riethmaier
 AAQT 6401, A88060
Woodchopping, Hikurangi, 1967, AAQT 6401, A81509
PP.78–9
Tolaga Bay School Christmas party, 1953
 Photographs by John Ashton, AAMK W3495, Box 7
PP.80–1
Musicians, Ruatiti, 1908, Photograph by H. Girdlestone
 AAQT 6401, A3876
Office function, 1950s, AAUR W3549, Box 97
Dance, Auckland Community Centre, 1960s
 Photograph (and print) by Ans Westra, AAMK W3495, Box 9
State Theatre, Palmerston North, 1940s, AAQT 6401, A2093
PP.82–3
Hi Fives, 1950s, Photograph (and print) by Ans Westra
 AAMK W3495, Box 9
Musicians, pre-1910, AAMK W3495, Box 8
Symphony Orchestra, Wellington, 1972
 Photograph by J. Waddington, AAQT 6401, A99918
PP.84–5
Boating on Lake Rotoroa, Nelson Lakes, 1920s
 ABIN W3337, Box 259
Hare drive, Hanmer, 1912–14, AAQA 6395, M12565
Tramping, Tararua Range, 1975
 Photograph by Gordon Roberts, AAQA 6395, M11931
PP.86–7
Fiordland expedition, 1949, Photograph by K. Bigwood
 AAQT 6401, A11371
Skiing, Tasman Glacier, 1966, AAQT 6401, A80052
PP.88–9
Descending the Franz Josef Glacier, 1920s
 ABIN W3337, Box 259
Film shoot, Whakarewarewa, 1930s, ABKB 7711/14W
Children and tourists, Whakarewarewa, 1935
 Photograph by Moore and Thompson, DWYER 2/7
PP.90–1
West Coast camping trip, pre-1910, TO 17/1
Chateau Tongariro, 1930s, ABIN W3337, Box 259
Chateau Tongariro, 1960, Photograph by B. Clark
 AAQT 6401, A66901
PP.92–3
Sumner Beach, Christchurch, 1900, AAAD 6011, No. 5
Clifton Beach, Hawke's Bay, 1961, ABDJ W3568, Box 46
Totaranui Beach, Nelson, 1961, Photograph by R. Fox
 AAQT 6401, A66599
PP.94–5
Mount Maunganui, 1958, Photograph by W. Walker
 AAQT 6401, A53182

Bathing suit contest, 1960s, AAQT 6467, ex 120
Stock car races, Tahunanui Beach, 1967
 Photograph by W. Collins-Bird, AAQT 6401, A80845
Surf Lifesaving Championships, South Brighton, 1979
 Photograph by R. Coad, AAQT 6418, R6824
PP.96-7
Strand Arcade, Auckland, 1970
 Photograph by G. Riethmaier, AAQT 6401, A95436
Hawker's barrow, Wellington, 1940s, AAQT 6401, A537
PP.98-9
Recorder class, Clifton Terrace School, 1979
 AAQT 6401, L6/29/4/94, Box 16
Radio dance class, Roseneath Primary School, 1952
 Photograph by E. Christensen, E W2694, Folder 10
School baths, 1960s, E W2694, Folder 3
Dressing up, 1960s, Photograph (and print) by Ans Westra
 AAAD 699/5a
Mobile library, 1960s, AAMK W3495, Box 5
PP.100-1
Display of toys, Te Aro School, Wellington, 1920
 ABHO W3771, Box 8
Folk dancing and drill, Invercargill, 1920s
 E W2694, Folder 4
Soccer match, Takapuna, 1975, Photograph by G. Riethmaier
 AAQT 6421, B8167
4 Square, Parikino, 1960s
 Photograph (and print) by Ans Westra, AAAD 699/5a
Skateboarding, 1979, AAQT 6401, B17189
PP.102-3
Physical movement class, Wellington, 1940s, ABKI 672/3
Jazzercise, Wellington, 1983, Photograph by S. Raynes
 AAQT 6401, R15858
City to Surf run, Christchurch, 1983, Photograph by S. Raynes
 AAQT 6418, R14742
PP.104-5
War veterans' home, 1960s, AAYO W3120, 513L, Box 2
Watching TV, Upper Hutt, 1974, Photograph by R. Anderson
 AAQT 6421, B5118
Oriental Parade, Wellington, 1960s, ABHJ W3602, Box 11

Chapter Three
PP.106-7
Rawene, 1952, Photograph by John Ashton, AAMK W3495, Box 6
P.108
Eglinton family at the Rimutaka summit, 1916
 AAQA 6395, M12993
P.110
Linesmen at work, Gore, 1918, Photograph by W. Pond
 AAMF W3327, Box 203
PP.112-13
Skippers Canyon, pre-1910, AAFV 6868/1
Little River, Banks Peninsula, 1906, PO 14/2, No. 27
Waingaro saleyards, 1917, Photograph by R.E. Bell
 PC 4, 1917/1606
PP.114-15
Electric tram, Invercargill, 1912
 Photograph by Henry McKesch, PC 4, 1912/8
Bus stop, New Plymouth, 1979, Photograph by R. Coad
 AAQT 6418, R8106
Troops boarding at Lyttelton, 1915
 Photograph by George Cook, PC 4, 1915/1569
Aramoana, 1963, Photograph by John LeCren
 AAVK 6390, B11095
PP.116-17
Aircraft, Tokelau Islands to New Zealand, 1966
 Photograph by D. Nicholson, AAQT 6401, A81264
Boarding aircraft, 1940s, AAQT 6401, A1049
PP.118-19
School buses, Otorohanga, 1940s-50s, E W2694, Folder 4
Bicycle park, 1970s, AAQT 6401, B19195
Horse paddock, Ruatoria, 1950s, E W2694, Folder 4
PP.120-1
Shortland Street post office, Auckland, 1920s
 AAMF W3327, Box 202
Motorway rest area, Auckland-Hamilton Highway, 1960s
 Photograph by Photocraft, ABPT 6781/4
Changing the tyre, 1950s, ABPT 6781/6
PP.122-3
Petrol station and general store, Rawene, 1952
 Photograph by John Ashton, AAMK W3495, Box 6
Petrol station, Nelson, 1967, Photograph by W. Collins-Bird
 AAQT 6401, A81493
PP.124-5
Farmers' Trading Company car park, Auckland, 1955
 AAQT 6540, A54029, Album 4

Napier, 1970, Photograph by R. Coad, AAQT 6401, A92311
PP.126-7
White Cragg siding, 1966, Photograph by John LeCren
 AAVK W3493, B13680
Coal trucks, Westport, 1968, Photograph by John LeCren
 AAVK W3493, B15875
Queenstown, pre-1910, AAMF W3327, Box 202
Packhorses, Dart Valley, 1950s, AANR 6329, DA724, 34/19/18
PP.128-9
Loading wool, East Coast, 1910s-20s
 AANR 6329, DA5017, 630.241, Box 52
Scow, Wellington, 1909, AAVK W3493, E5525
Trucks, Wellington wharf, 1925, AAVK W3493, D7746
PP.130-1
Railway station, Temuka, 1900, AAVK W3493, E353
Railway platform, Dunedin, 1940s, ABIN W3337, Box 258
Subway, Wellington Station, 1973
 Photograph by John LeCren, AAVK W3493, D22982
Woburn Station, Hutt Valley, 1953, AAVK W3493, D836
PP.132-3
Wellington booking office, 1930s, AAVK W3493, E769
Transport pageant, Wellington, 1928, AAVK W3493, B5648
Frankton Junction, 1930s, AAVK W3493, B5292
PP.134-5
Stuck in the mud, pre-1910, PO 14/2, 32
Fording the Turnbull River, 1923, AAQA 6506, 603, Box 29
Te Anau, 1970, Photograph by G. Riethmaier
 AAQT 6401, A93683
Paekakariki coast, Wellington, pre-1910, PO 14/2, 2
Accident in Hawke's Bay, 1960s, Photograph by Russell Orr
 ABPT 6781/1a
PP.136-7
Road building, North Auckland, 1930s, AAQT 6403/1983
Auckland, 1960s, AAQT 6401, A85714
Track maintenance, Ngaurukehu, 1956
 Photograph by John LeCren, AAVK W3493, B7016
Auckland Harbour Bridge, 1981
 Photograph by J. Waddington, AAQT 6541, CR3981, Box 1
PP.138-9
Post office, Auckland, 1960s, AAMF W3327, Folder 40
Post office, Lower Hutt, 1904, PO-LH, W2087, 2/1
Postal van, 1933, AAVK W3493, C1176
PP.140-1
Telegraph Department, General Post Office, Wellington,
 1918, Zak Photograph, AAMF W3327, Box 201
Opening of Rimutaka Tunnel, 1955, AAVK W3493, B4860
Toll operators, 1950s-60s, AAMF W3327, Box 185

Chapter Four
PP.142-3
First state house, Wellington, 1960s, ABVF 7584, 1.18
PP.145-6
Deer-shooters' hut, 1964, Photograph by John Johns
 AAQA 6395, M9756
Pole house, Titirangi, 1980, Photograph by S. Raynes
 AAQT 6421, B19843
PP.148-9
Whare, Te Kaha, 1920s, H 11, W2615, 1/1
Bush-clearing settlement, pre-1920, ABIN W3337, Box 258
Drover's camp, Wairarapa, 1928, AAQA 6506, M12982
PP.150-1
Crookston, West Otago, 1915
 AANR 6329, 3/5/117, DA29493, Box 6
Waipapakauri, 1910s, AAFV 6868/1
Rangiahua schoolhouse, Wairoa, 1934, ABDJ W3568, Box 194
Farmhouse, 1946, AANR 6329, 3/14/15, DA29939
PP.152-3
Sawmiller's house, Ruru, 1960, AAVK W3493, D4669
Woodcutters' hut, Haast Pass, 1950s
 AANR 6329, DA645, 39/4/24, Box 56
Stone hut, Upper Shotover Valley, 1957
 Photograph by John Johns, AAQA 6395, M2594
PP.154-5
Te Uhi cutting camp, 1921, Photograph by J. Christie
 ABKK W4388, Box 84
Tangiwai Bridge camp, 1957, AAVK W3493, B7892
Workman's hut, Wellington, 1959
 Photograph by John LeCren, AAVK W3493, D4208
PP.156-7
Sir John Roberts' house, Dunedin, pre-1910, AAQT 6403/1567
Cottages, Lyttelton, 1980, Photograph by S. Raynes
 AAQT 6421, B19274
Wellington terrace houses, pre-1920, ABRR 7563, 12L
PP.158-9
Railways housing, Lower Hutt, 1930s-40s, AAVK W3493, C1695

Lower Hutt, 1940s-50s, AALF 6112, 12/3/10
PP.160-1
Blenheim, 1950s, AAQT 6401, A65490
Tamaki, 1960, AALF W3300, Box 10
State houses, Orakei, Auckland, 1940s,
 AALF 6112, 15/1/16
PP.162-3
Interior, Whangaroa county, 1950
 Photograph by K. Bigwood, AAQT 6539, A20179
New housing, Opotiki, 1940s
 AANR 6329, 3/14/149, DA29236
Whare, Whangaroa county, 1950, Photograph by K. Bigwood
 AAQT 6401, A20196
Wharenui, Mangere, 1966, Photograph by D. Nicholson
 AAQT 6401, A81271
PP.164-5
Housing boom, North Shore, 1973
 Photograph by J. Waddington, AAQT 6401, B3123
Suburban flats, Wellington, 1970s, AAQT 6401, B9881
Park Mews, Hataitai, Wellington, 1970s
 ABKK W4358, 4627, Box 29
PP.166-7
Dixon Street flats, Wellington, 1940s
 AALF 6112, 17/2/21, 419, Box 1
Bathroom, Symonds Street flats, Auckland, 1940s
 AALF 6112, 17/9/31
Apartments, Oriental Bay, Wellington, 1980
 Photograph by T. Hann, AAQT 6401, B19225
PP.168-9
'Canvastown', Featherston, 1915
 Photograph by B. Murgatroyd, PC 4, 1915/1594
YMCA dormitory, 1940s, AAYO W3120, Box2
WAAC quarters, New Caledonia, 1944, WAII, 7/7
PP.170-1
Wellington Hospital, 1900s, Photograph by L. Daroux
 ABRR 7563, W4990, 9j
Tokanui Hospital, 1967, Photograph by G. Riethmaier
 AAQT 6401, A83632
War veterans' home, 1950s-60s, Photograph by Evelyn Firth
 AAYO W3120
Pensioner housing, Christchurch, 1950s, AAQT 6401, A70878

Chapter Five
PP.172-3
Delegates to New Zealand Registered Nurses' Association
 Conference, 1949, H 11, W2615, 1/1
P.175
Troop inspection, France, 1916, IA 76/13, H700
P.177
Trentham Races, 1976, Photograph by R. Coad and T. Hann
 AAQT 6418, R6003
PP.178-9
Family group, Poro-o-tarao, 1900s, AAVK W3493, E7742
Debutante and mother, 1953, AAMK W3495, Box 7
PP.180-1
Joseph Ward, 1910s, AAQT 6403, 3127
Wartime entertainers, 1940s, Steele Photographers, Auckland
 AAYO W3120, Box 2
Receiving corsages, Majestic Cabaret, Wellington, 1947
 Photograph by W. Hall Raine, ABKI 667/1
Performers at Wellington Maori Arts Festival, 1950s, AAMK
 W3495, Box 5
PP.182-3
Staff of Scoullars' factory, Wellington, 1921
 Photograph by J. Ellis, PC 4, 1921/1707
Shearing, White Rock Station, Wairarapa, 1973
 Photograph by D. Nicholson, AAQT 6421, B3893
Loggers, Hamilton and Jones' logging camp, Mercury Bay,
 1924, Photograph by Tudor Collins
 AAQA 6505, S91, Box 33
PP.184-5
Greco family, Island Bay, Wellington, 1962
 Photograph by D. Nicholson, AAQT 6401, A69523
Fisherman, 1950s, AAQT 6401, A82792
Shorthand typists, Wellington, 1954
 Photograph by John LeCren, AAVK W3493, B4945
PP.186-7
New Zealand soldiers in Italy, 1940s
 NZEF Public Relations Official Photograph
 NASH 2063, 648
Harriers, 1908-9, Muir's Photographic Studio, Wellington
 AAFC 691/2N
Harvesting cabbages, 1945
 Photograph by Sparrow Industrial Pictures
 AANR 6329, 31/5/41, DA22649, Box 46

PP.188–9
Walk shorts, Radar Station, Auckland, 1966
Photograph by G. Riethmaier, AAQT 6401, A80740
Shorts and jandals, 1970s, AAAD 699/30c
Jeans and slacks, 1975, Photograph by John LeCren
AAVK W3493, D31783
Golf, Queenstown, 1986, Photograph by T. Hann
AAQT 6401, R19866, Box 14
PP.190–1
Dental nurses and trainees, Wellington, 1925, ABKI 667/1
'New Zealand Football Team', 1904
Photograph by Francis Tomlinson, PC 4, 04/37
Wellington Girls' College hockey team, 1900s, AANB 885/1g
Hutt Valley Lady Harriers, 1931
Shadlock Photo, Lower Hutt, NASH 362, 0025
Team inspection, Wellington, 1969, Photograph by R. Coad
AAQT 6401, A92485
PP.192–3
In the West Coast bush, 1900s, TO 17/1
Women cooking over steam, 1900s–10s, ABHT, W3920, Box 2
PP.194–5
Swimming club and spectators, Thorndon Pool, Wellington,
1926, ABKI 667/1
PP.196–7
Train hostesses, Auckland, 1954, Photograph by G. Stewart
AAVK W3493, D1176
Miniskirt and platform shoes, 1960s, ABPT 6781/4
Dancers, Wellington, 1950s, AAMK W3495, Box 5
PP.198–9
Crimped hair, Wellington, 1900
Photograph by William Parker, PC 4, 00/41
Oamaru telephone exchange staff, 1910
AAMF W3327, Box 206
Wellington Dental School students, 1925–6, ABKI 667/1
Packing peas, Pukekohe, 1940s–50s
Sparrow Industrial Photographs,
AANR 6329, 31/11/10, DA2274, Box 46
PP.200–1
Kingston Railway Station staff, 1900
Photograph by P. Malaghan, AAVK W3493, E5761
Wellington Railway Station barber's shop
AAVK W3493, C672
The morning shave, Linton, 1949
Photograph by John LeCren, AAVK W3493, B517
PP.202–3
Horowhenua A & P Show, 1978, Photograph by B. Richardson
AAQT 6418, R14742
Afro, Upper Hutt, 1974, Photograph by R. Anderson
AAQT 6421, B5097
Sideburns, 1983, AANR 6337, G88, Box 1
PP.204–5
Creating the 1960s 'beehive' style, AAQT 6467, ex 145
Unshaven legs, 1952, AAVK W3493, B2820
The bikini line, 1969, Photograph by D. Nicholson
AAQT 6401, A91976
PP.206–7
Picking hops, Motueka, 1940s, AAQT 6401, A5930
Opening of Ohiro Home, Wellington, 1904
ABRR 7563, W4990, 12b
PP.208–9
Addington saleyards, 1950s
AANR 6329, 45/15/19, 630.1, Box 66
Waipukurau saleyards, 1981, Photograph by J. Palmer
AAQT 6418, R10400
The Stormtroopers, 1970s, AAMK W3495, Box 9
PP.210–11
Family group, 1900s, Photograph by S. Carnell, Napier
ABHT, W3920, Box 4
Girls' class, Te Aro School, Wellington, 1903–4
ABHO W3771, Box 8
Girls on a jungle gym, 1960s
Photograph by Helen Buttfield Hartman, AAAD 699/30c
Orakei, 1960s, Photograph (and print) by Ans Westra
AAAD 699/5a

Chapter Six
PP.212–13
Railways food hamper, 1930, AAVK W3493, D10277
P.215
Cooking pool, Central North Island, 1920s
ABIN W3337, Box 259
P.217
Hastings Travelodge buffet, 1967, Photograph by D.
Nicholson, AAQT 6401, A81770

PP.218–19
Hangi, 1950s, AAQT 6401, A2460
Cooking in the Urewera, 1924, H 11, W2615, 1/1
Meal at a hui, Central North Island, 1950s
Photograph by J. Fijn, AAMK W3495, Box 6
PP.220–1
A 'model' kitchen, 1960s, AAQT 6467, ex 369
Cape Reinga lighthouse kitchen, 1967
Photograph by R. Anderson, AAQT 6401, A80914
Bakery, Wellington Railway Station, 1963
Photograph by John LeCren, AAVK W3493, D8600
Kitchen, Sunnyside Hospital, 1962
Photograph by Green and Hahn, H 10, W1947, 16/32
Washing up, 1960s, AAMK W3495, Box 8
PP.222–3
Eating kina, 1960s, E W2694, Folder 2
Gathering toheroa, Muriwai Beach, 1962
Photograph by G. Riethmaier, AAQT 6401, A70985
PP.224–5
Home vegetable garden, 1949, Sparrow Industrial Photographs
AANR 6329, DA20192, 23/69/16
Auckland City Markets, 1950s–60s, AAQT 6401, A58277
Picking raspberries, Tapawera, 1967, AAQT 6401, A81433
Processing peas, Marlborough, 1968, Photograph by W. Cleal
AAQT 6401, A85630
PP.226–7
Hutt Valley Consumers' Co-operative, 1940s
AALF 6112, 22/2/1, 782, Box 2
Wardells supermarket, Wellington, 1971
Photograph by J. Waddington, AAQT 6401, A97429
Woolworths supermarket, 1964, Photograph by John LeCren
AAVK W3493, D9431
PP.228–9
Dairy, Arrowtown, 1970s, AAAD 699/30c
Butcher's shop, 1970s, ABHJ W3602, Box 9
PP.230–1
Railways meal, 1974, Photograph by John LeCren
AAVK W3493, B21972
Railways food hamper, 1930, AAVK W3493, D10277
Carving the meat, 1981, Photograph by S. Raynes
AAQT 6418, R11765
Meat display, Borthwicks, Fielding, 1953
AANR 6329, 32/3/60, 636.0823, Box 48
PP.232–3
Soldiers preparing meat pies, France, First World War
IA 76/13, H324
Barbecue, Thames, 1977, Photograph by G. Riethmaier
AAQT 6421, B12181
Maori Women's Welfare League conference, 1954
AAMK W3495, Box 9
School milk delivery, Nelson, 1959, Photograph by John Johns
AAQA 6395, M3572
PP.234–5
Paekakariki Railway Station cafeteria, 1940s–50s
ABIN W3337, Box 44
Hot-dog stand, 1950s, AAAD 699/6d
Kentucky Fried Chicken, Rotorua, 1975
Photograph by G. Riethmaier, AAQT 6421, B7651
PP.236–7
Office party, 1950s, AAUR, W3549, Box 110
Mon Desir Beer Garden, Auckland, 1968
Photograph by G. Riethmaier, AAQT 6401, A84942
Beer tanker, Auckland, 1964, Photograph by G. Riethmaier
AAQT 6401, A75387
Drinks with mates, Waipu Cove, 1976
Photograph by G. Riethmaier, AAQT 6421, B9283
PP.238–9
Drinking tea in a dugout, First World War, IA 76/13, 282
Picnic, pre-1910, TO W2820, 17/1
PP.240–1
Supper, 1950s, AAQT 6401, A29414
Cafeteria, University of Auckland, 1966
Photograph by G. Riethmaier, AAQT 6401, A79463
Picnic, Warrington, 1917, ABKI 667/1

Chapter Seven
PP.242–3
Bastion Point, May 1978, AAMK W3495, Box 8
P.244
Weighing baby, Waterloo Plunket Rooms, 1950s
AALF 6112, 23/1/23, 827, Box 2
P.246
Awaiting the Duke and Duchess of Cornwall and York,
Auckland, 1901, Photograph by Mary Leary, PC 4, 1917/1619

PP.248–9
Unveiling of plaque, Wellington, 1901, AAVK W3493, C1485
Celebration of coronation of George V, Hokianga, 1911
AAMF W3327, Box 201
Opening of Wellington post office, 1912
AAMF W3327, Folder 10(a)
PP.250–1
Cadet inspection, Wellington, 1914
Photograph by Francis Tomlinson, PC 4, 1914/1535
Unveiling Cook memorial, Ship Cove, 1913
Photograph by Arthur McCusker, PC 4, 1913/22
Ohinemuri Engine Drivers' Union and Firemen's Industrial
Union of Workers, Waihi, 1912
Photograph by John Carless, PC 4, 1912/21
Labour Day float, Wellington, 1916
Photograph by Zak Studios, Wellington
AAUR W3549, Box 110
PP.252–3
Front-line trench, the Somme, 1916, IA 76/13, H474
Religious service on a troopship, 1915
Photograph by George Cook, PC 4, 1915/1570
Fund-raising, Wellington, 1918, AAUR W3549, Box 104
PP.254–5
Railways Publicity Studio, Hutt Valley, 1920s
AAVK W3493, C1030
Protest at pay cuts, Wellington, 1931
Photograph by S. C. Smith, NASH 3103/1, No. 146
Gordon Coates, Auckland Railway Station, 1930
AAVK W3493, B5404
PP.256–7
Michael Joseph Savage's prime ministerial rail tour, 1937
AAVK W3493, D663
Sampling school milk, Mangapapa School, 1938
ABDJ W3568, Box 193
Men from the Ratana movement, 1950s, AAMK W3495, Box 5
PP.258–9
Peter Fraser visiting soldiers, Egypt, 1940s, NASH 2063, 0599
Pallo Engineering, Wellington, 1940s
Photograph by F. Barker, IC 67, 4/11a
WAAC Kiwi Company, New Caledonia, 1944, WAII 7/7
PP.260–1
Janet Fraser's funeral procession, Wellington, 1945
FRASER, P., 4/14
Princess Te Puea's funeral, 1952
Photograph by Roberts Photo Engravers
AAMK W3495, Box 8
Royal visitors, Greymouth, 1954, AAQT 6538/1
PP.262–3
Unveiling of Tangiwai Memorial, Wellington, 1957
AAQT 6401, A48690
Anzac Day march and memorial service, 1955
Photographs by Klix Studio, ABHO W3771, Box 13, K7
PP.264–5
Opening of Motu School, Gisborne district, 1955
ABDJ W3568, Box 193
Woodleigh School, Taranaki, 1967, Photograph by B. Neill
AAQT 6401, A81865
Teenage party, Christchurch, 1960s, AAQT 6467, ex 201
PP.266–7
Maori Women's Welfare League meeting, Ruatoria, 1960s
Photograph by John Ashton, AAMK W3495, Box 5
Hui, Te Tairawhiti, 1960s, AAMK W3495, Box 7
Waitangi Day, Waitangi 1959
Photograph by Royal New Zealand Navy
NASH 2164, 0066
PP.268–9
Radio Hauraki 'Awakathon', 1967, ABHJ W3602, Box 11
Women's Division Federated Farmers Christmas lunch,
Christchurch, 1968, Photograph by B. Neill
AAQT 6401, A88554
Escorting a prisoner into Victor Company Base, South
Vietnam, 1969, Army Information Service Photograph
AAMK W3495, Box 6
PP.270–1
Spiral tunnel, Manapouri, 1971, Photograph by J. Waddington
AAQT 6401, A98701
Protests during Springbok tour, Wellington, 1981
P W3104, Box 5
Mr H. Roche, 1960s, Photograph by A. Poole
AAQA 6395, M11109

INDEX